BUTTERFLIES OF BRITAIN AND EUROPE

BUTTERFLIES
OF BRITAIN AND EUROPE
A PHOTOGRAPHIC GUIDE

Tari Haahtela · Kimmo Saarinen · Pekka Ojalainen · Hannu Aarnio

A & C BLACK · LONDON

Butterflies account for only a small part of all insect species in Europe, but they are tremendously important for conservation and research - and for everyone who likes nature. My own favourite is the Glanville Fritillary (see p. 218), which I have studied for 20 years, and which has helped to establish an entirely new field of research, metapopulation biology. Observing and photographing butterflies has become an increasingly popular pursuit for thousands of people. The records made by butterfly enthusiasts add greatly to our knowledge c butterflies as sensitive indicators of what is happening in our environment. This comprehensiv and delightful book is your reliable guide to butterflies wherever you are in Europe.

ILKKA HANSKI, Professor, University of Helsinki

Published 2011 by
A&C Black Publishers Ltd,
36 Soho Square, London W1D 3QY

ISBN (print) 978-1-4081-0474-3

A CIP catalogue record for this book is
available from the British Library

Commissioning Editor: Nigel Redman

Project Editor: Lisa Thomas

Copy Editor: Marianne Taylor

Design by Jukka Aalto, Armadillo Graphics, Finland

Printed in China by Lion Productions Limited

10 9 8 7 6 5 4 3 2 1

Visit www.acblack.com/naturalhistory to find out
more about our authors and their books. You will
find extracts, author interviews and our blog, and
you can sign up for newsletters to be the first to
hear about our latest releases and special offers.

Contents

THE TERMINOLOGY FOR IDENTIFICATION USED IN THIS GUIDE.

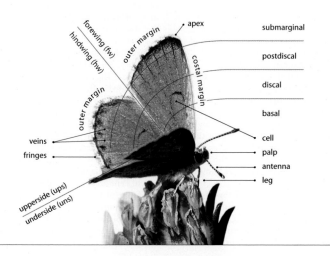

PSEUDOPHILOTES VICRAMA, MONTENEGRO 6/10 JJ

forewing (fw)
hindwing (hw)
outer margin
apex
costal margin
outer margin
submarginal
postdiscal
discal
basal
veins
cell
fringes
palp
antenna
leg
upperside (ups)
underside (uns)

PREFACE

Our ever-shrinking world puts Europe into perspective. It is the second smallest of the seven continents, comprising the westernmost peninsula of Eurasia, an area of 10.3 million square kilometres with around 700 million people. The butterfly fauna is modest compared to the tropics but still fascinating with more than 500 species living in diverse natural habitats.

This book has had a long evolution, beginning in the mid-1980s in southeastern Finland, one of northern Europe's prime butterfly sites with approximately 60 species. At that time, photographing butterflies in the wild was not much practised and to make a sharp photo was not an easy task. But over time the equipment improved and the digital revolution has revealed the beauty of the butterfly world in a way that was never possible before. Twenty-five years ago we published a photographic book of the butterflies of southeastern Finland, then in 1990 a study of the whole Finnish fauna, and in 2006 the Nordic and Baltic fauna. This book now extends the study to all of Europe and has been possible with growing experience of European butterflies.

The book considers Europe in its widest sense, extending as far as the Urals and the Caucasus to the east. It focuses on observation and identification of butterflies in their own environment with the help of close-focusing binoculars and digital photography. Nowadays identification requires less netting of butterflies; although some collecting is needed for scientific purposes, treating butterflies like stamps is not acceptable. In fact, over-collecting is still threatening some local populations of rare butterflies.

Many skippers, blues, fritillaries and graylings are difficult to identify in the field, and even experts make mistakes. Frequently, our senses are simply not sufficient to detect tiny external differences of sibling species. However, with experience a diagnosis can be made with reasonable accuracy, and while relaxing after a hard day in the field, digital photos can be checked for a second opinion. It would take a lifetime to photograph all of the European species something no-one has managed to do. This work is a result of collaboration with a wide network of friends and colleagues.

We have followed the list of European butterflies by Karsholt & Razowski (1996) but updated the nomenclature according to the *Distribution Atlas of European Butterflies* (Kudrna 2002) and the *European Red List of Butterflies* (van Swaay et al. 2010). As a result, some former subspecies have received full species status, especially those on isolated islands, while some species have been downgraded to subspecific level. With new genetic characterisation techniques, this debate is heated and highlights the problems of man-made definitions of species, subspecies and forms.

The organisation of the species is different from any other book. In a given genus, the butterflies that have a wide range and are most likely to be seen come first, followed by those with a more restricted distribution from west to east. If the observer is somewhere in the Pyrenees, for example, what would be the local speciality? And what could they expect in Cyprus? The major islands have been treated individually, as have the adjacent regions of Northern Africa and Mediterranean Turkey. Interest in the eastern fauna is also growing, and we give a glimpse to those species that do not occur west of Ukraine and Belarus. Finally there is a bonus waiting for the amateur lepidopterist: Lapland. The northernmost area of Fennoscandia is a harsh living environment and yet it has 15 unique species of butterfly, while another 15 have a stronghold in the far north or exist as a distinct subspecies that only thrives there – a fascinating place for a butterfly trip.

The world's butterfly fauna is in a state of slow but constant change, interrupted by sudden human impacts, which usually destroy the habitats. The vitality of a population decreases if local populations become extinct more often than new colonies emerge. The fragmentation becomes crucial when distances between the colonies increase. The population as a whole starts to suffer with poor gene flow between isolated colonies. The disequilibrium becomes a doomed spiral and sooner or later the species is lost. This island effect and extinction can even be mathematically predicted. Protecting butterflies by restoring habitats, favouring flower-rich gardens and other environments, and simply by letting them fly free, is preserving the crucial biodiversity on which human life also depends.

TARI HAAHTELA, KIMMO SAARINEN
PEKKA OJALAINEN & HANNU AARNIO

ACKNOWLEDGEMENTS

We are grateful to the following collaborators for permission to reproduce their photographs: HANNU AARNIO (HA), PEKKA ALESTALO (PA), ULRIKE ANDRE (UN), JUAN CARLOS VICENTE ARRANZ (JVA), MUKADDER ARSIAN (MA), AHMET BAYTAS (AB), OZ BEN-YEHUDA (OBY), PEDRO CARDOSO (PC), MARTIN CASCOIGNE-PEES (MCP), MARIBEL CASTILLA (MC), MILAN DJURIC (MD), RAFAEL ESTEVEZ (RE), BERHARD FRANSEN (BF), MIGUEL-JACOBO SANJURJO FRANCH (MSF), URSULA GOENNER (UG), PAVEL GORBUNOV (PG), PETER GROENENDIJK (PG), ALI GUVEN (AG), TARI HAAHTELA (TH), TAMAS HAPKA (TAH), JEFF B. HIGGOT (JBH), JUHA JANTUNEN (JJ), EDDIE JOHN (EJ), DAVID JUTZELER (DJ), EVRIM KARACETIN (EK), ZDRAVKO KOLEV (ZK), OLEG E. KOSTERIN (OEK), ILKKA KOTANEN (IK), TOM NYGAARD KRISTENSEN (TNK), JAAKKO KULLBERG (JK), TRISTAN LAFRANCHIS (TL), VACLAV MASEK (VM), YERAY MONASTERIO LEON (YML), ALBERT MIQUEL LOEWE (AML), CHRISTODOULOS MAKRIS (CM), JUSSI MURTOSAARI (JM), RAFAEL OBREGON (RO), PEKKA OJALAINEN (PO), JAVIER OLIVARES (JO), HANS VON OOSTERHOUT (HO), ALEX OZ (AO), GUY PADFIELD (GP), JOSEP PIQUE PALACIN (JPP), LAZAROS PAMPERIS (LP), GUILLERMO BOOTH REA (GBR), HERNANDEZ ROLDAN (JHR), MATT ROWLINGS (MR), MARKUS SCHAEFER (MS), VALTER SCHÖN (WS), JOSE MANUEL SESMA (JMS), MARCIN SIELEZNIEW (MS), MARC TOEROEC (MT), JUHA TYLLINEN (JT), RUDI VEROVNIK (RD), OLLI VESIKKO (OV), WOLFGANG WAGNER (WW), OLCAY YEGIN (OY) and WALTER ZORN (WZ) Help and advice have been given by DIDEM AMBARLI, RAMON CERVELLÓ, SIMON COOMBES, JORDI DANTART, TERESA FARINO, CHRISTER HUBLIN, URMAS JURIVETE, KAURI MIKKOLA, MORTEN S. MØLGAARD, KARI NISSINEN, KARI NUPPONEN, NILS RYRHOLM, JAAN VIIDALEPP, ARI-JUSSI VÄÄNÄNEN and MUGE ZENGIL Their contribution is gratefully acknowledged and indicates the growing number of experts and nature lovers interested in photographing and observing butterflies.

The old drawings of larvae are taken from Hofmann E, & Spuler A. *Die Raupen der Schmetterlinge Europas.* E. Schweizerbartsche Verlagsbuchhandlung, Stuttgart 1904.

THE expert help of AHMET BAYTAS, JUHA JANTUNEN, DAVID JUTZELER, ZDRAVKO KOLEV, JAAKKO KULLBERG, TRISTAN LAFRANCHIS, ALBERT MIQUEL LOEWE, LAZAROS PAMPERIS, MATT ROWLINGS, RUDI VEROVNIK, OLLI VESIKKO and OLCAY YEGIN has been essential. They have also guided us, and sometimes joined us, to the finest butterfly sites in Europe. We also thank LEIGH PLESTER for improving the language. Any errors that remain in the book are ours.

Fauna · There are approximately 515 species of butterflies in Europe, though this number changes as our knowledge grows, and as butterflies' distribution changes over time. Species in the eastern parts of the continent and those confined to the North Caucasus countries in particular are less well documented than the traditionally well known fauna in the western range. In addition, there are dozens of species of Africa and Asia whose ranges just reach Europe, or they appear as migrants or irregular vagrants in marginal areas of the continent. Finally, recent molecular and chromosome studies have revealed important differences between certain taxa. Thus many subspecies or geographical forms have now been reclassified as full species, such as Brimstones in the Canary Islands or isolated Zephyr Blue colonies in southern Europe. Conversely, some taxa have lost their specific status, such as *Phengaris* (*Maculinea*) *rebeli* and *Polyommatus menelaos*.

European butterflies represent six families. Almost half of the species belong to the family Nymphalidae ('brush-footed butterflies'), which contains the previous families and current subfamilies of Satyrinae (browns, heaths, graylings and ringlets) and Libytheinae (snout butterflies). The family Lycaenidae (blues, coppers and hairstreaks) is represented by more than 100 species. The remaining 110 or so species are representatives of the families Pieridae (whites, yellows), Hesperiidae (skippers), Papilionidae (apollos, festoons, swallowtails) and Riodinidae (metalmarks).

One third of Europe's butterfly species (142) is endemic to the continent, in other words these particular species are found nowhere else in the world. Most endemics are alpine or montane species with a restricted distribution in the Pyrenees, the Alps and the highest mountains of the Balkans. Endemism is most characteristic among ringlets of the genus *Erebia*, but endemics are also frequent among blues and graylings.

This high rate of endemism is one of the reasons for the high diversity of butterfly fauna in the mountain ranges in the south. As far as the EU is concerned, the butterfly species richness is highest in Italy, France, Spain, Greece and Bulgaria.

Threatened species · According to the latest European Red List of Butterflies (van Swaay et al. 2010), a declining trend predominates in butterflies: unfortunately 31 % of our species have declining populations. Half of the species are more or less stable, and only 4 % are increasing. At the time of writing 37 species, almost a tenth of European butterflies are classified as Endangered or Vulnerable. In addition, 44 species are considered Near Threatened.

Europe is the most densely populated continent in the world. More than 80 % of land is under some form of direct management and only a tiny fraction of the land surface can be considered as wilderness. However, many butterflies thrive in semi-natural habitats created and maintained by human activity, especially non-intensive forms of land management such as livestock grazing. Extensive intensification of agriculture and other anthropogenic activities are the main cause for butterfly decline. The most important factor throughout Europe is the loss of habitat or connectivity between patches of habitat, mostly due to changes in agricultural practices .Climate change is already challenging the arctic and alpine species and increased frequency and intensity of fires and tourist development particularly affects species in the Mediterranean region.

Size · Most European butterflies are small to average in size. The average wingspan of the 444 European butterfly species described more detail in this guide is 41 mm, about the size of the

Wood White (*Leptidea sinapis*), Marsh Fritillary (*Euphydryas aurinia*) or Ringlet (*Aphantopus hyperantus*). The extremes are represented by the Grass Jewel (*Chilades trochylus*) with its 10-mm span, and the impressive 110 mm of the Monarch (*Danaus plexippus*). It would take more than 30 Grass Jewels to cover the wings of just one Monarch! The majority of species, including coppers, blues and most *Erebia* species, are somewhere between 30 to 40 mm. However, one

should remember that size is often strongly affected by both sexual, regional and individual variation. For example, some male Common Swallowtails (*Papilio machaon*) are barely half of the size of the largest females. In addition, many butterflies in nature are rarely seen with their wings fully open. Thus it is sometimes difficult to get an impression of true size, especially for those that always rest with their wings closed.

The average wingspan of butterflies by groups

Skippers (Hesperiidae)	28 mm
Swallowtails (Papilionidae)	65 mm
Whites and yellows (Pieridae)	47 mm
Coppers and hairstreaks (Lycaenidae)	31 mm
Blues (Lycaenidae)	29 mm
Fritillaries and allies (Nymphalidae)	47 mm
Heaths, browns, ringlets and graylings (Satyrinae)	45 mm

Total number of butterfly species in the current EU Member States, according to van Swaay et al. 2010, European Red List of Butterflies.

Austria	197	Latvia	105
Belgium	88	Lithuania	114
Bulgaria	211	Luxembourg	78
Cyprus	48	Malta	18
Czech Republic	140	Netherlands	55
Denmark	63	Poland	147
Estonia	98	Portugal	147
Finland	110	Romania	180
France	244	Slovakia	164
Germany	178	Slovenia	172
Greece	230	Spain	243
Hungary	152	Sweden	108
Ireland	30	United Kingdom	55
Italy	264		

Critically Endangered (CR), Endangered (EN) and Vulnerable (VU) butterfly species in Europe, as listed in European Red List of Butterflies (van Swaay et al. 2010).

Hesperiidae
Pyrgus cirsii – Cinquefoil Skipper (VU)

Pieridae
Pieris wollastoni – Madeiran Large White (CR)
Colias myrmidone – Danube Clouded Yellow (EN)
Gonepteryx maderensis – Madeiran Brimstone (EN)
Pieris cheiranthi – Canary Islands Large White (EN)
Colias chrysotheme – Lesser Clouded Yellow (VU)

Euchloe bazae – Spanish Greenish Black-tip (VU)
Gonepteryx cleobule – Canary Brimstone (VU)

Lycaenidae
Lycaena helle – Violet Copper (EN)
Phengaris arion – Large Blue (EN)
Plebejus zullichi – Spanish Glandon Blue (EN)
Polyommatus humedasae – Piedmont Anomalous Blue (EN)
Turanana taygetica – Odd-spot Blue (EN)
Tomares nogelii – Nogel's Hairstreak (VU)
Phengaris teleius – Scarce Large Blue (VU)
Polyommatus galloi – Higgin's Anomalous Blue (VU)
Polyommatus golgus – Sierra Nevada Blue (VU)
Polyommatus orphicus – Rhodopi Anomalous Blue (VU)
Polyommatus violetae – Andalusian Anomalous Blue (VU)

Nymphalidae
Coenonympha phryne * (CR)
Pseudochazara cingovskii – Macedonian Grayling (CR)
Boloria improba – Dusky-winged Fritillary (EN)
Coenonympha oedippus – False Ringlet (EN)
Pararge xiphia – Madeiran Speckled Wood (EN)
Pseudochazara euxina * (EN)
Boloria polaris – Polar Fritillary (VU)
Coenonympha hero – Scarce Heath (VU)
Erebia christi – Rätzer's Ringlet (VU)
Erebia sudetica – Sudeten Ringlet (VU)
Hipparchia bacchus – El Hierro Grayling (VU)
Hipparchia tilosi – La Palma Grayling (VU)
Lopinga achine – Woodland Brown (VU)
Pseudochazara amymone – Brown's Grayling (VU)
Pseudochazara orestes – Dils' Grayling (VU)
Coenonympha tullia – Large Heath (VU)
Euphydryas maturna – Scarce Fritillary (VU)
Coenonympha orientalis – Balkan Heath (VU)

* Eastern species not included in the species section of this guide

HESPERIIDAE

SKIPPERS

DINGY SKIPPER · *Erynnis tages* – MILLET SKIPPER · *Pelopidas thrax*

A total of 46 species in Europe · 10 endemics, 5 Threatened or Near Threatened

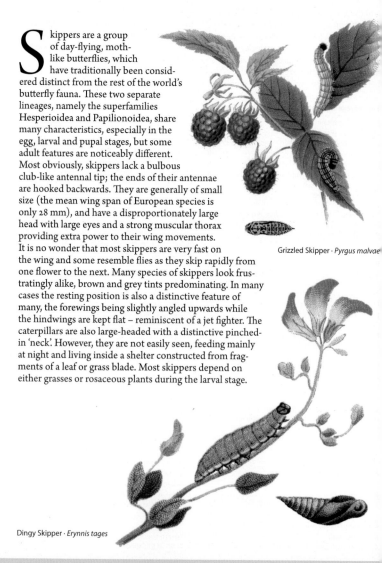

Skippers are a group of day-flying, moth-like butterflies, which have traditionally been considered distinct from the rest of the world's butterfly fauna. These two separate lineages, namely the superfamilies Hesperioidea and Papilionoidea, share many characteristics, especially in the egg, larval and pupal stages, but some adult features are noticeably different. Most obviously, skippers lack a bulbous club-like antennal tip; the ends of their antennae are hooked backwards. They are generally of small size (the mean wing span of European species is only 28 mm), and have a disproportionately large head with large eyes and a strong muscular thorax providing extra power to their wing movements. It is no wonder that most skippers are very fast on the wing and some resemble flies as they skip rapidly from one flower to the next. Many species of skippers look frustratingly alike, brown and grey tints predominating. In many cases the resting position is also a distinctive feature of many, the forewings being slightly angled upwards while the hindwings are kept flat – reminiscent of a jet fighter. The caterpillars are also large-headed with a distinctive pinched-in 'neck'. However, they are not easily seen, feeding mainly at night and living inside a shelter constructed from fragments of a leaf or grass blade. Most skippers depend on either grasses or rosaceous plants during the larval stage.

Grizzled Skipper · *Pyrgus malvae*

Dingy Skipper · *Erynnis tages*

ERYNNIS TAGES **TH**

CARCHARODUS ORIENTALIS **PO**

MUSCHAMPIA PROTO **PO**

PYRGUS SERRATULAE **HA**

PYRGUS CIRSII **HA**

PYRGUS ARMORICANUS **PO**

PYRGUS ANDROMEDAE **PO**

HETEROPTERUS MORPHEUS **HA**

CARTEROCEPHALUS PALAEMON **TH**

THYMELICUS SYLVESTRIS **HA**

HESPERIA COMMA **HA**

PELOPIDAS THRAX **PO**

DINGY SKIPPER · *Erynnis tages*

Visit a warm meadow with plenty of bare earth or patches of limestone and there you may find this fast skipper on the wing. Resting with wings fully open, it spends long periods basking on soil or stones, but in bright sunshine it is flighty and difficult to approach. Although the larval host plants are also good nectar sources for the adults, male butterflies are frequently disturbed by rival suitors defending their territories. Individuals normally show very little variation. Subspecies *baynesi* in western Ireland, however, has a brownish-black upper-side and very pale markings.

⊘ *Erynnis marloyi*

① Ups dark greyish-brown with grey bands on fw
② Ups a series of small pale dots in outer margin of both wings
③ Uns pale brown with small white dots around the outer margins
✱ Sexes similar
✱ Flies like a moth

🦋 Mostly one generation from late April to mid-June; a 2nd brood rather common in July-August in S Europe. Calcareous rocky meadows and grasslands, coastal landslips, abandoned quarries, limestone pavements, woodland clearings and rides up to 2,000 m.

⊕ Widespread and common through most of Europe except Mediterranean islands (excl. Corfu) and N Fennoscandia. Declined in many countries in the northern range, including the British Isles, Netherlands and Baltic states.

◈ Low-growing legumes, mainly *Lotus* species, *Coronilla varia* and *Hippocrepis comosa*.

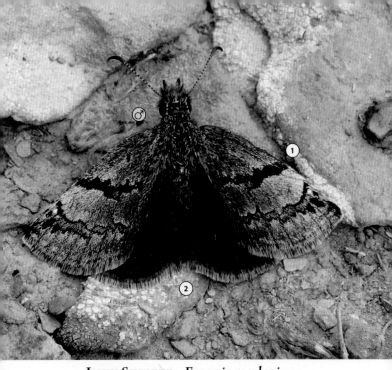

INKY SKIPPER · *Erynnis marloyi*

A second European represent-ative of a widespread genus ranging from the main regions of North America, throughout Asia and into eastern Europe. Greece is the best place to encounter the species, whose habits resemble those of the Dingy Skipper. Individuals fly rapidly in open, barren country, but despite resting constantly on white limestone rocks, they are easily disturbed even if approached with great care. They become more approachable when making a nectar stop, becoming particularly settled when feeding on *Thymus*. Sometimes males gather in large numbers at the summits of hills (so-called hilltopping).

⊖ *Erynnis tages*

① Fw ups grey/blackish/ brownish with two black bands
② Hw ups uniform dark
✱ Uns uniform brown with a white streak or few dots near to the tip on fw
✱ Sexes similar
☙ One or two generations between late March and August; sometimes as late as October. Hot and dry stony slopes, dried-up riverbeds and rocky calcareous mountains between 600 and 2,100 m, in Bulgaria even lower altitudes.
⊕ Restricted to SE Europe; Albania, Greece (including islands of Corfu, Chios, Lesbos, Samos), Macedonia, Bulgaria and Turkey. Distribution patchy but locally common.
◭ Small, bushy Rosaceae, such as *Pyrus spinosa*, *Prunus cocomilia*.

EK TURKEY KAYSERI PALI 6/08

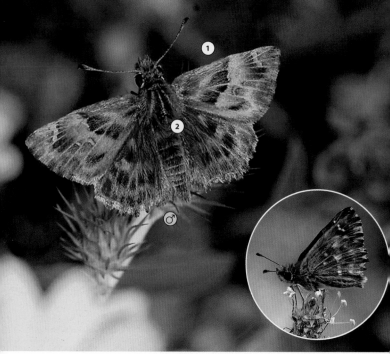

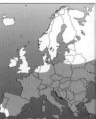

MALLOW SKIPPER · *Carcharodus alceae*

HA S SPAIN 5/08 · **PO** N ITALY 6/06

The Mallow Skipper usually starts the skipper season off in Europe. Once the first individuals emerge in March, there may be three or even more generations over the next eight months. In contrast to most other skippers, this one flies vast distances, thereby easily colonising new regions. It also loves warmth and, together with its larval foodplants, it is well adapted to harsh terrain. Due to individual, ecological and seasonal variation in size and colour, several subspecies have been described, notably in Asia.

⊙ *Carcharodus tripolinus*
 Carcharodus lavatherae

① Ups brown with pink or purple tinge
② Hw ups a white spot small or missing
⊛ Sexes similar
⊛ Closely resembles *C. tripolinus*
☞ Several generations from March to October, disappearing between the broods; recorded all year round on Cyprus. Various habitats from lush to very dry, but mostly on dry flower-rich grasslands and south-facing slopes, also amongst scrub or woodland, up to 2,000 m.
⊕ Widespread and common in S and C Europe, including most Mediterranean islands. No records from SW Iberian Peninsula inhabited by *C. tripolinus*, which is externally inseparable.
⬧ Mallows and related species, such as *Malva, Althaea, Lavatera* and *Hibiscus*.

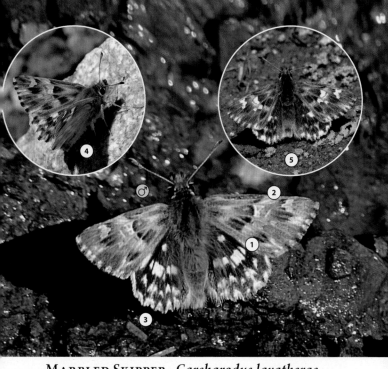

Marbled Skipper · *Carcharodus lavatherae*

Many skippers of the *Carcharodus* genus look alike, but in the field their behaviour provides some clue as to their identity. 'Puddling' is particularly typical of Marbled Skippers; lots of males can be seen at the same time sucking vital salts and minerals from the damp ground. These valuable substances are passed to the female during mating, improving mating success and subsequent egg survival. Another typical feature is the conspicuous resting position, the wings being wrapped around the body and the abdomen curving high up in the air.

⊙ *Carcharodus alceae*
Carcharodus flocciferus

① Ups olive-brown, a row of white spots across the centre of hw
② A transparent spot on the fw cell
③ Triangular white spots around the outer margin
④ Uns pale grey
⑤ ssp. *tauricus*
✷ Sexes similar

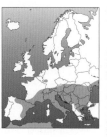

PO N SPAIN PYRENEES 7/08 · TH S FRANCE MARITIME ALPS 5/06 · TN E GREECE 6/06

🦋 One generation from mid-May to late July; 2nd brood possible in favourable conditions. Rocky gullies, dry grassy banks and hot dusty tracks, often on limestone in plains and mountains up to 1,600 m.

⊕ Rather widespread but patchy and local in S Europe from Spain to most of Balkans (ssp. *tauricus*); a few distinct populations in W Germany. Evaluated as Near Threatened in Europe.

🜨 Several woundworts, such as *Stachys recta*, *S. germanica* and *S. arvensis*.

TUFTED MARBLED SKIPPER · *Carcharodus flocciferus*

TH S BULGARIA PIRIN 7/09 · **PG** S BULGARIA PIRIN 7/09

This species is named for the dark tuft of hair on the underside of each forewing, which guides the forewing and hindwing during flight. Males are very territorial, constantly perching on flower heads or grass heads, where they are ready to dash after all butterflies intruding on their territory. Individuals tend to be smaller in size and lighter in colour in the more southern regions, where they may be easily confused with Southern Marbled Skipper and Oriental Marbled Skipper. In hot conditions, the latter species, however, prefers to sit on stones or soil.

⊙ *Carcharodus baeticus*
 Carcharodus orientalis

① Ups greyish-brown
② Fw ups a dark patch and white spots in the middle
③ Hw ups dark with two or more white spots in the middle, discal spot prominent
④ Hw uns white spots well defined
⑤ Wing margins toothed
✱ Sexes similar

🦋 Two generations; 1st brood in late May–June, 2nd brood in August, but univoltine in Greece in July–August. Various grasslands rich in flowers, railway banks, forest edges and clearings, warm slopes on plains and damper places in the mountains up to 2,000 m.

⊕ Rather widespread but patchy and generally uncommon in S Europe; mainly a mountain species from Spain to France, throughout the Alps and the Balkans. In E Europe the distribution extends to lowlands in Poland and all Baltic countries. Evaluated as Near Threatened in Europe.

◈ Mainly woundworts (*Stachys*), but also *Marrubium* species and *Ballota nigra*.

Southern Marbled Skipper · *Carcharodus baeticus*

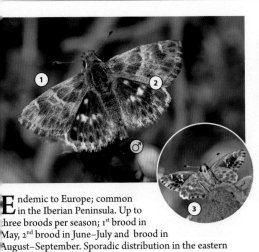

HA S SPAIN 5/08 · HA S SPAIN 5/08

① Male fw ups
greyish-brown

② Hw ups dark with
two white bands; the
outer one wavy

③ Hw uns pale brown
or yellowish with a
characteristic network of
white bands and veins

✱ Sexes similar

Endemic to Europe; common in the Iberian Peninsula. Up to three broods per season; 1st brood in May, 2nd brood in June–July and brood in August–September. Sporadic distribution in the eastern range, often with one brood in July. Dunes, rocky slopes and other hot and dry environments up to 1,600 m. Larva feeds on horehounds (*Marrubium*). The species has been imported into Australia in order to control horehounds.

False Mallow Skipper · *Carcharodus tripolinus*

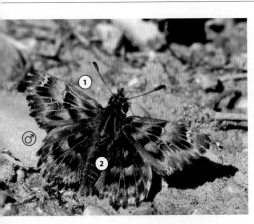

TH W MOROCCO AGADIR 1/09

① Ups ground colour brown

② Hw ups white spot
weak or missing

✱ Inseparable from *C. alceae*
in the field; identification
based on male genitalia

✱ Sexes similar

Species status in relation to *C. alceae* has been uncertain, but stable genital differences are present. Distribution confined to a narrow strip along the coast of SW Portugal and Spain. Several broods from March to September, usually on rocky gullies and other hot and dry environments. Larva feeds on *Malva sylvestris*.

ORIENTAL MARBLED SKIPPER · *Carcharodus orientalis*

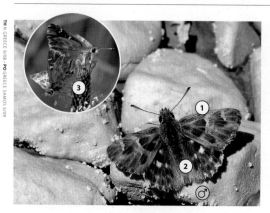

① Fw ups a dark band in the middle and a few light spots

② Hw ups an arc of white spots in the centre

③ Hw uns pale greyish-brown, white markings indistinct (cf. *C. flocciferus*)

★ Sexes similar

Resembles *C. flocciferus*; no feature of the wing pattern is constant enough as a discriminate character. Mainly restricted to S Balkans and Greece, where it is widespread and locally common. Some isolated populations in Hungary and E Europe. Two or three broods between March and October in hot dry grasslands of steppe or mediterranean types up to 2,000 m. Larva feeds on woundworts (*Stachys*).

EASTERN MARBLED SKIPPER · *Carcharodus stauderi*

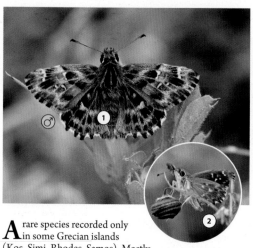

① Hw ups two white bands; the outer one wavy

② Hw uns light grey, reticulate pattern poorly developed

★ Sexes similar

A rare species recorded only in some Grecian islands (Kos, Simi, Rhodes, Samos). Mostly one brood in May–June in hot and dry shrubland and rocky landscapes near to sea level (<450 m). Larva probably feeds on *Marrubium* and *Nepeta* species.

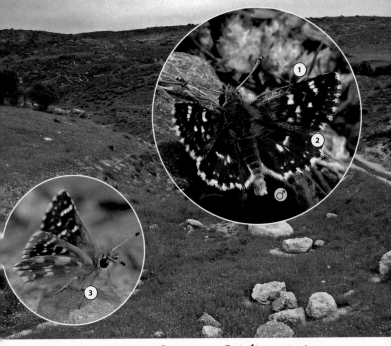

RED UNDERWING SKIPPER · *Spialia sertorius*

HA S SPAIN 5/07 · HA SPAIN SEGURA 5/08 · HA S SPAIN 5/07

Spialia is a widespread skipper genus of the Old World, with its centre of diversity in Africa. All four species in Europe are rather similar in appearance, but identification is made easier by their differing geographical locations. In western Europe, the small Red Underwing Skipper flies very fast close to the ground, thereby easily escaping detection. Every now and then it settles on hot ground. However, females are more often seen on burnet plants (*Sanguisorba*). The species can reproduce only during the flowering season of its host plant, as it lays its eggs solely on the flower buds.

⊘ *Spialia therapne*
 Spialia orbifer

① Ups dark brown with scattering white spots
② A row of submarginal small white spots on both wings
③ Hw uns reddish with ragged large white spots
✴ Sexes similar

𝓦 Two generations; 1st brood from April to June, 2nd brood in July–August. Representatives of the latter are generally smaller. Various grassy habitats in scrubland, woodland clearings and flower-rich meadow slopes up to 1,600 m.

⊕ Widespread and common in W Europe from Portugal to France, Germany, Italy and Slovakia in the east. A few records around the Balkans may be confused with *S. orbifer*.

⊕ Mainly salad burnet (*Sanguisorba minor*), occasionally other rosaceous plants.

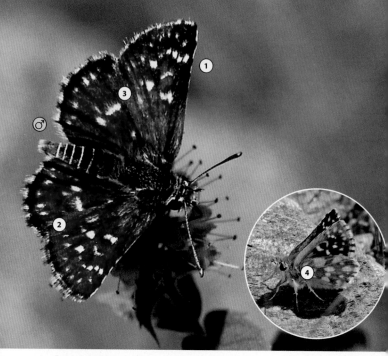

TH S TURKEY ANTALYA 9/09 · PO S TURKEY ALANYA 4/09

ORBED RED UNDERWING SKIPPER · *Spialia orbifer*

This species is named for the rounded white markings on its underside – it otherwise resembles the Red Underwing Skipper. The two species have only recently been separated, but they are unlikely ever to be seen at the same site. This is the more eastern species, and flies very fast and low in hot places, typically in the Balkan region. Dried-up riverbeds in particular are worth checking. In bright sunshine, hot rocks are irresistible and both males and females continuously rest on these with open wings. Mallow Skippers, White-banded Graylings and Freyer's Graylings are typical companions in the same sites.

⊗ *Spialia sertorius*

① Ups dark brown or black with scattered white spots
② Ups a row of submarginal white spots on both wings
③ A narrow white spot in the middle of hw
④ Hw uns olive-green or reddish with a conspicuous round white spot on the front margin
✱ Sexes similar

🦋 Two generations; 1st brood from April or May to June, 2nd brood from mid-July to August. Various warm and open environments usually in uplands, such as roadside verges, scrubby grassland and steppe rivulet valleys up to 2,000 m.

⊕ Rather widespread and common in E Europe; Greece, including most of Aegean islands, most of Balkans, extending to Slovakia in north. A few isolated populations on Sicily and possible records from coastal Cyprus.

◈ Usually *Sanguisorba minor*, seldom other rosaceous plants (*Rubus*, *Potentilla*).

CORSICAN RED UNDERWING SKIPPER · *Spialia therapne*

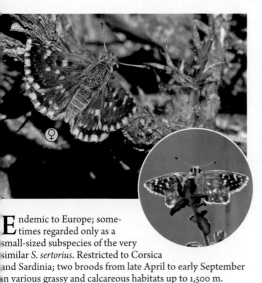

(★) Closely resembles
S. sertorius but
more colourful

(★) Very small

(★) Sexes similar

E ndemic to Europe; some-
times regarded only as a
small-sized subspecies of the very
similar *S. sertorius*. Restricted to Corsica
and Sardinia; two broods from late April to early September
in various grassy and calcareous habitats up to 1,500 m.
Larva feeds on *Sanguisorba* and other rosaceous plants.

PERSIAN SKIPPER · *Spialia phlomidis*

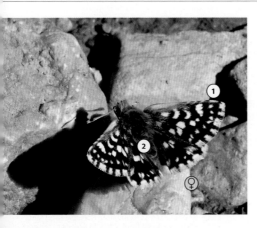

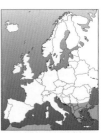

(1) Ups dark brown with
a complete series of
submarginal pale spots

(2) Hw ups a large
rectangular white
spot in the centre

(★) Hw uns olive-green or
grey with unbroken
white discal band

(★) Sexes similar

S cattered distribution in the Balkan Peninsula; most
common but local in Greece. Mostly one brood in
June–July, sometimes two broods between May and
October, in dry scrub, hot rocky slopes and dry steppe habi-
tats and grasslands at moderate elevations up to 2,200 m.
Larva probably feeds on bindweeds (*Colvolvulus*).

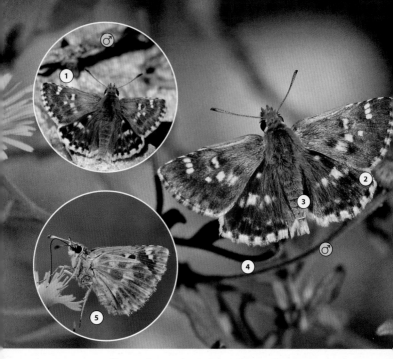

SAGE SKIPPER · *Muschampia proto*

The Sage Skipper is a true dry habitat specialist with a predilection for bleak, sparsely vegetated places, which look at first glance to be unsuitable spots for any butterfly. The Sage Skipper is generally one of the few species that may be seen in such situations, its only companions being one or two species of graylings (subfamily Satyrinae). Some authors describe the species as having a soft furry appearance, a distinctive feature of *Pyrgus* species. In other respects the butterfly varies throughout its range from North Africa to Palestine and Iran, and there are several recorded subspecies.

⊙ *Muschampia tessellum*

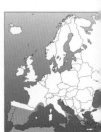

① Ups grey or brownish with white spots on both wings
② Ups submarginal spots obscure or missing
③ Hw rectangular spots link up to form cross-lines
④ Fringes chequered
⑤ Hw uns brownish with light veins
✷ Sexes similar

🦋 A long flight period from April to September with one or two generations depending on the locality; individuals in the late summer are usually smaller in size. Various xerophytic habitats on both plains and in the mountains up to 1,800 m.

⊕ Restricted to S Europe from Portugal to S France in the west and from S Italy to Greece in the east, including islands of Karpathos, Kithira and Simi. Widespread and common in Spain, sporadic and rare in elsewhere. Replaced by *M. proteides* in Asian Turkey, Ukraine and eastwards.

🌿 Several *Phlomis* species and *Hypogomphia purpurea*.

TESSELLATED SKIPPER · *Muschampia tessellum*

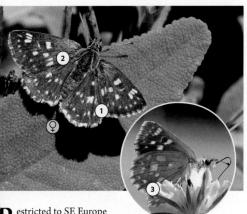

TH S TURKEY ANTALYA 6/10 · OY S TURKEY ANTALYA 6/07

① Ups grey or brownish with a row of submarginal white spots on both wings
② Fw ups a single pair of elongated white spots
③ Hw uns yellowish green with a broad white discal band and a white outer margin
★ Sexes similar
★ Large for a skipper

Restricted to SE Europe with sporadic distribution in N Greece (and the island of Simi), Macedonia, Bulgaria, Romania and eastwards. A locally common species with one brood from late April to early July, sometimes prolonged to August, in dry grassland slopes with scrubby patches up to 1,900 m. Larva feeds on *Phlomis samia*.

SPINOSE SKIPPER · *Muschampia cribrellum*

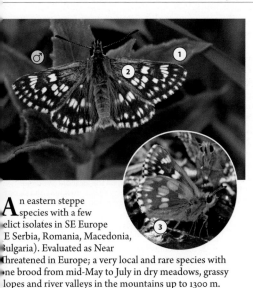

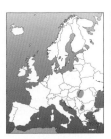

ZK S BULGARIA 6/09 · ZK S BULGARIA 6/09

① Ups dark grey with a row of submarginal white spots on both wings
② Male fw ups two pairs of elongated white spots, usually one pair in female
③ Uns yellowish grey with large white markings and white border
★ Sexes similar
★ Smaller than *M. tessellum*

An eastern steppe species with a few relict isolates in SE Europe (E Serbia, Romania, Macedonia, Bulgaria). Evaluated as Near Threatened in Europe; a very local and rare species with one brood from mid-May to July in dry meadows, grassy slopes and river valleys in the mountains up to 1300 m. Larva may feed on cinquefoils (*Potentilla*), unconfirmed.

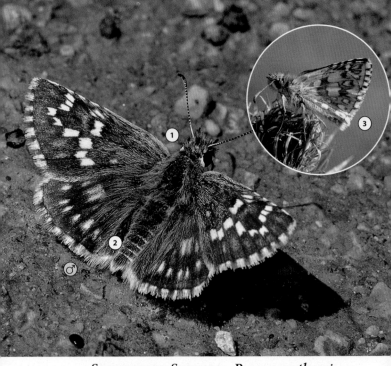

HA HUNGARY 7/06 · PO N SPAIN PYRENEES 7/08

SAFFLOWER SKIPPER · *Pyrgus carthami*

Identifying individuals from the genus *Pyrgus* in the wild is difficult, and sometimes impossible without capturing individuals for a closer peek. The Safflower Skipper, however, is one of the less frustrating subjects. Its most characteristic feature is an unbroken white margin on the hindwing underside, this being incomplete in all the other species. It is also noticeably robust for a skipper. It inhabits the warm, sheltered fringes of woods. In the eastern parts of the range the subspecies *moeschleri* is transitional to the nominate subspecies in Europe.

⊙ *Pyrgus alveus*
　Pyrgus sidae

① Ups brownish grey with dense grey hair at the wing base
② A well-marked row of white elongated spots on hw outer margin
③ Hw uns yellowish-brown with white marginal spots linked up to produce a pale border
✶ Sexes similar
✶ Large for a skipper

🦋 One generation with a long flight period from May to August depending on the location. Sheltered grasslands, open grassy slopes, meadows and steppe habitats usually between 600 and 1,800 m.

⊕ Widespread through most of S and C Europe except British Isles, extending to S Lithuania in the north. Usually common but not seen in great numbers.

◈ Many cinquefoils (*Potentilla*), sometimes mallows (*Malva sylvestris*, *Althaea officinalis*, etc.).

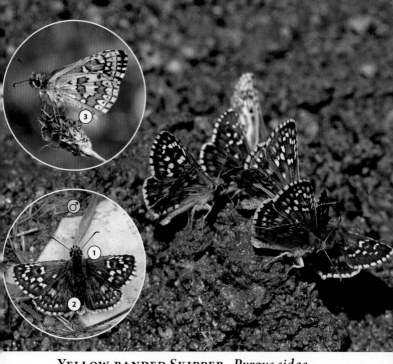

YELLOW-BANDED SKIPPER · *Pyrgus sidae*

Despite variability in its size and white markings, this skipper is unmistakable. The name says it all: two yellow or orange bands on a white background on the underside hindwing make it completely unlike any other *Pyrgus*. Unfortunately, this distinctive feature is obvious only in overcast weather when individuals are sitting with closed wings. Some experts say that males patrol particular areas in flowery grasslands. This may indicate territorial behaviour or they may just prefer sites where females stay close to the larval foodplants.

⊝ *Pyrgus carthami*

① Ups sooty brown with greyish hair at the base
② Hw ups a series of white submarginal spots
③ Hw uns two black-bordered yellow or orange bands and white margins
✹ Sexes similar
✹ Large for a skipper

🦋 One generation from mid-May to early July depending on the altitude; April–May in Greece. Grasslands characterised with scrub or light woodland, usually rich in flowers including cinquefoils; rocky gullies and sunny slopes up to 1,800 m.

⊕ Rather widespread but patchy in S Europe from SE France to Turkey; some isolated colonies in W Spain (ssp. *occiduus*). Locally common especially in the Balkans; populations usually tied to larval foodplants.

🌸 Cinquefoils, especially *Potentilla recta*.

TH N GREECE VARNOUS 6/06 · TH N GREECE VARNOUS 6/06 · TH N GREECE VARNOUS 6/06

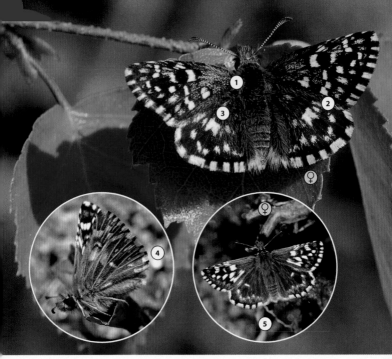

GRIZZLED SKIPPER · *Pyrgus malvae*

TH'S FINLAND SALO 5/08 · TH'N GREECE VARNOUS 6/06 · TH'N GREECE VARNOUS 6/06

F ast and small, giving the impression of an erratic fly as it dashes conspicuously about, the Grizzled Skipper is the spring's first skipper in the northernmost parts of its range. It is often seen in the company of the Green Hairstreak. Sometimes dozens of individuals are zooming around wild strawberries and other nectar sources blooming on warm rocky slopes in woodland. It is not uncommon in peat bogs either. Able to withstand the cold spring nights of the north, this is the most widespread *Pyrgus* in Europe.

⊙ *Pyrgus malvoides*

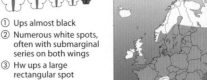

① Ups almost black
② Numerous white spots, often with submarginal series on both wings
③ Hw ups a large rectangular spot near to the centre
④ Hw uns brownish with white ragged spots and brown veins
⑤ f. *taras*; fw ups extended white markings
⊛ Sexes similar
⊛ Small for a skipper

� Mainly one generation from April to June; a possible 2nd brood in July–August in favourable conditions (cf.*P. malvoides*). Dry meadows and rocky slopes, forest edges and clearings up to 2,000 m.

⊕ Widespread though not always common through most of Europe from C France to S Britain and C Fennoscandia, but absent from the Iberian Peninsula and Italy. Declined in many countries.

⬠ Many low-growing rosaceous species (*Fragaria*, *Potentilla*, *Comarum*, *Rubus*, etc.).

Southern Grizzled Skipper · *Pyrgus malvoides*

TH S ITALY SICILY 5/10

(★) Externally inseparable from *P. malvae*; identification based on genitalia

E ndemic to Europe; sometimes regarded as a double-brooded subspecies of *P. malvae*. The range extends from Portugal and Spain to peninsular Italy. It flies in April–June and again from late July to September (2nd brood not in high altitudes) in flower-rich meadows up to 2,500 m. Larva feeds on many rosaceous plants.

Olive Skipper · *Pyrgus serratulae*

PO N ITALY 6/05 · TH N GREECE VARIOUS 6/06

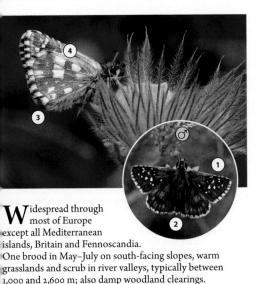

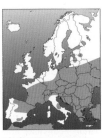

① Ups dark brown with a variable number of white spots

② Hw ups with some obscure pale patches or without markings

③ Hw uns olive-green or yellowish-green

④ Hw uns an oval spot near costa and quadrangular central spot

(★) Sexes similar

W idespread through most of Europe except all Mediterranean islands, Britain and Fennoscandia. One brood in May–July on south-facing slopes, warm grasslands and scrub in river valleys, typically between 1,000 and 2,600 m; also damp woodland clearings. Larva feeds on various cinquefoils (*Potentilla*).

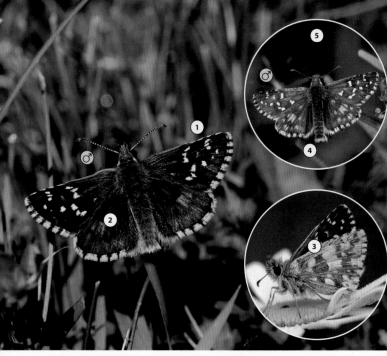

Large Grizzled Skipper · *Pyrgus alveus*

One of the largest *Pyrgus* species, this is also one of the most confusing due to its erratic arrangements of spots, not to mention its variable size. The Large Grizzled Skipper is probably a superspecies containing several elements which have not yet reached a stage of complete differentiation. Sometimes authors describe these as being closely related species like *P. accretus* and *P. trebevicensis*, while others regard them as subspecies, *scandinavicus* in Fennoscandia being one such example. Many more forms of the butterfly occur within its eastern haunts in Asia.

⊙ *Pyrgus armoricanus*
 Pyrgus cinarae
 Pyrgus bellieri

① Ups grey-brown with variable pattern of white spots
② Hw ups markings faint
③ Hw uns brownish-green with large white spots (f. *centralhispaniae*)
④ Male has a short tuft of white hairs at the anal tip of abdomen
⑤ f. *scandinavicus*
✷ Sexes similar

♈ Mainly one generation with a prolonged emergence between May and August, but usually in late June–August. Meadows and other grassy habitats, forest edges and clearings especially in uplands between 1,000 m and 2,000 m. A lowland species in the northern range.

⊕ Widespread but local and scarce throughout most of Europe; absent from the British Isles, Mediterranean islands and N Fennoscandia.

⬙ Various low-growing species in the genus of *Fragaria*, *Agrimonia*, *Helianthemum* and *Potentilla*.

FOULQUIER'S GRIZZLED SKIPPER · *Pyrgus bellieri*

1. Fw ups hairy wing base
2. Hw ups markings complete but suffused
- (*) Sexes similar
- (*) Closely resembles *P. alveus*
- (*) The name *P. folquieri* has also been used

Endemic to Europe; an alpine species with a limited distribution in NE Spain, SE France, C Italy and Albania. Very local but sometimes abundant populations with one brood from mid-July to August in alpine meadow slopes between 500 and 2,000 m. Larva feeds on cinquefoils (*Potentilla*).

ROSY GRIZZLED SKIPPER · *Pyrgus onopordi*

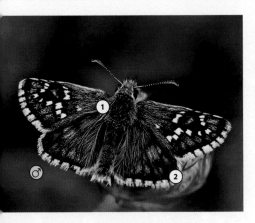

1. Ups sooty brown or reddish with white spots on both wings
2. Hw ups a pale spot near costa
3. Hw uns yellowish-brown; white markings with dark borders
4. Hw uns a discal white area anvil-shaped
- (*) Sexes similar
- (*) Small for a skipper

Widespread and locally common in SW Europe from Portugal to Switzerland and peninsular Italy. Either two or three broods between April and September in dry grasslands and meadows up to 2,000 m, late-summer broods usually more abundant. Larva feeds on mallows, rockroses and cinquefoils.

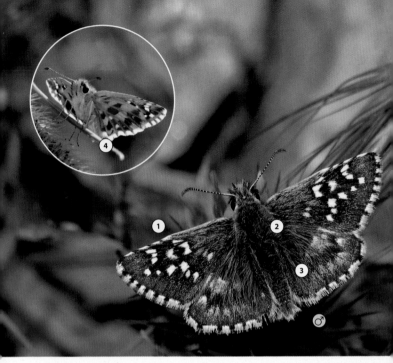

OBERTHÜR'S GRIZZLED SKIPPER · *Pyrgus armoricanus*

Identification problems with skippers cannot be avoided, especially in this case. Oberthür's Grizzled Skipper breeds over vast areas of Europe throughout the summer from April to October and inhabits various dry environments, causing confusion as some of its relatives also have a preference for such habitats. More abundant during the late summer, members of the second generation are easily confused with the Large Grizzled Skipper. Adults of later generations, however, are usually smaller. A characteristically bright upperside and underside, with light veins on the underside, is also indicative to the Oberthür's Grizzled Skipper, sometimes abundant in the southern regions.

⊙ *Pyrgus alveus*

① Fw ups numerous white spots
② A wing base covered with pale scales
③ Hw ups markings faint but a row of pale spots near to the margin
④ Hw uns two white arc-shaped spots near to the anal angle
⊛ Sexes similar

🦋 Mostly two generations; 1st brood in May–June, 2nd brood from July to October. In favourable conditions there may be three generations, but there is only one between June and July in the northern range. Hot and rocky habitats with scrub such as meadows, steppe and dry slopes usually at lowlands, but up to 1,600 m.

⊕ Widespread and rather common in S and C Europe, including many Mediterranean islands, the range extending to southernmost Scandinavia in the north. Very sporadic and local in the northern range.

🌿 Woodland strawberry (*Fragaria vesca*), several *Potentilla* species and *Helianthemum nummularium*.

Cinquefoil Skipper · *Pyrgus cirsii*

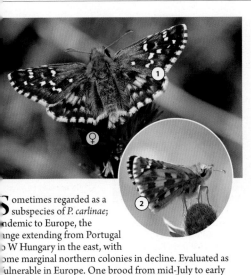

① Fw ups postdiscal white spots joined together in a sinuous mark

② Hw uns reddish with very small white marks near to the anal angle

★ Sexes similar

Sometimes regarded as a subspecies of *P. carlinae*; endemic to Europe, the range extending from Portugal to W Hungary in the east, with some marginal northern colonies in decline. Evaluated as vulnerable in Europe. One brood from mid-July to early September in similar habitats to those of *P. carlinae* at lower altitudes (<1,300 m). Larva feeds on cinquefoils (*Potentilla*).

Sandy Grizzled Skipper · *Pyrgus cinarae*

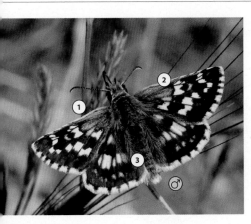

① Ups white markings very large

② Fw ups white cell spot broad and constricted to the middle

③ A white band near to the centre on hw ups

★ Basal and discal white markings well defined on hw uns

★ Sexes similar, but white markings smaller and more numerous on female

A rare and local species in S Balkans and N Greece; isolated populations in E Spain are regarded as a smaller subspecies *clorinda*. One brood from early July to early August in woodland clearings, rocky terrain and stony slopes, grassy hillsides and dry steppe habitats up to 1,900 m. Larva feeds on *Potentilla recta*.

DUSKY GRIZZLED SKIPPER · *Pyrgus cacaliae*

HA S SWITZERLAND 7/09 · HA S SWITZERLAND 7/09

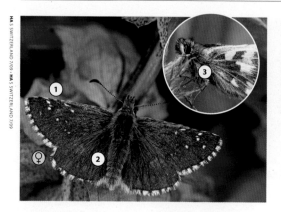

① Fw ups small white spots
② Hw ups white markings weak or missing
③ Hw uns no white spot at the base (cf. *P. andromedae*)
★ Sexes similar
★ Only on alpine grassland

Endemic to Europe, its range extends from SE France to Austria in the Alps, very sporadic in the highest mountains in SE Europe. Newly reported from Bosnia & Herzegovina. One brood from July to August in dry alpine grassland and screes on slopes, often near lakes and streams, typically between 1,000 and 2,800 m. Larva feeds on alpine *Potentilla* and *Sibbaldia* species.

ALPINE GRIZZLED SKIPPER · *Pyrgus andromedae*

HA N ITALY 6/06 · HA N ITALY 6/06

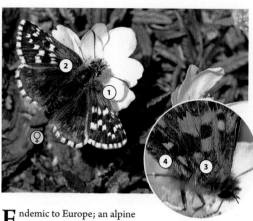

① Ups dark brown with abundant pale hairs
② Fw ups three discal white spots below the cell
③ A white spot at base of on hw uns (cf. *P. cacaliae*)
④ A white streak and a spot (a horizontal exclamation mark) on hw inner margin
★ Sexes similar
★ Only on the mountains

Endemic to Europe; an alpine species with scattered distribution in the Pyrenees, C European Alps, SW Bulgaria, the Carpathians and N Fennoscandia. One brood in June–July in alpine grasslands and moorlands between 1,000 and 2,700 m. Sporadic but locally common, often with *P. cacaliae* in the Alps. Larva feeds on *Dryas octopetala*.

Warren's Skipper · *Pyrgus warrenensis*

HA AUSTRIA 7/07 · TH SWITZERLAND VALAIS 7/07

① Ups dark brown with small white markings
② Hw ups with faint grey patches and without white spots
★ Sexes similar
★ Small for a skipper
★ Only in the high Alps

Endemic to Europe; a very local alpine species in C European Alps from SW Switzerland to Slovenia. One brood between late June and early August in montane grasslands, sheltered alpine meadows and embankments beside streams, usually above 1,800 m. Larva feeds on rockroses (*Helianthemum*).

Carline Skipper · *Pyrgus carlinae*

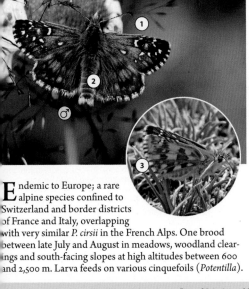

TH N ITALY MONTE BALDO 8/07 · TH N SPAIN 8/08

① Fw ups c-shaped white spot
② Hw ups poorly marked
③ Hw uns reddish-brown with a white patch on hw outer margin
★ Sexes similar

Endemic to Europe; a rare alpine species confined to Switzerland and border districts of France and Italy, overlapping with very similar *P. cirsii* in the French Alps. One brood between late July and August in meadows, woodland clearings and south-facing slopes at high altitudes between 600 and 2,500 m. Larva feeds on various cinquefoils (*Potentilla*).

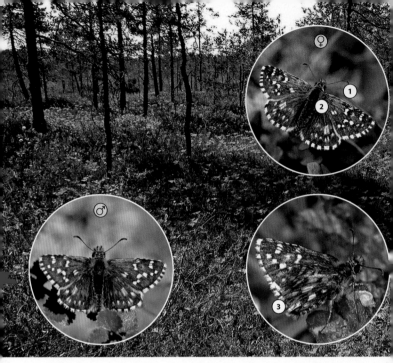

NORTHERN GRIZZLED SKIPPER · *Pyrgus centaureae*

A sudden encounter with this northern species is always a pleasant surprise. Usually only a few individuals are seen at the same time in any one location, typically on the edge of a treacherously boggy open mire. The butterfly's rapid flight usually ends at some cranberry or cloudberry flowers. Since the species has a two-year life cycle, adults are often on the wing only in either odd or even years. In some mires untouched by man, however, the Northern Grizzled Skipper is commonly found every year. Mire drainage leads to the extinction of a population.

⊖ *Pyrgus andromedae*
Pyrgus malvae

① Ups greyish-brown with coating of pale hairs
② Fw ups two white spots just below the cell
③ Hw uns white veins (cf. *P. malvae*)
★ On open bogs and damp heaths
★ Sexes similar

♈ One generation from early June to mid-July. Mainly undrained open peat bogs and damp heaths and meadows in the lowlands; also moors, tundra heaths and wet mountain slopes up to 1,000 m in the eastern range.

⊕ Restricted to Fennoscandia in N Europe; distribution extends to Far East and northern North America. Always local, and has declined in southern parts due to large-scale drainage of mires.

◍ Exclusively cloudberry (*Rubus chamaemorus*).

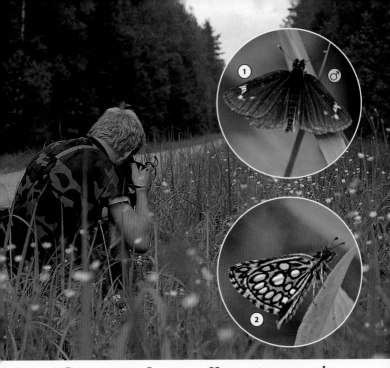

LARGE CHEQUERED SKIPPER · *Heteropterus morpheus*

This is often described as the most striking skipper in Europe, primarily because of two distinctive characteristics. Firstly, it is instantly identified by its unusual, characteristic bounding flight, as though the insect was bouncing up and down at the end of a piece of elastic just above some lush vegetation. Secondly, even in flight the dozen strong white ovals on the hindwing underside are obvious. As these features are relatively constant throughout the species' range, the Large Chequered Skipper is unlikely to be confused with any other skipper species.

① Ups dark brown with a few small white or yellowish spots on fw, more in female
② Hw uns yellowish with large black-bordered white spots
✴ A bouncing flight pattern
✴ Sexes rather similar

One generation from late June to early August. Damp meadows and other sheltered grasslands in the transition between forest and high moorland, river banks, forest edges and clearings with tall grasses up to 1,000 m.

Scattered distribution in C Europe from the Pyrenees and C Italy to S Scandinavia and Estonia in the north. Very sporadic and local with low density of individuals throughout the range, in particular in the west; widely threatened by the drainage of the habitat.

Several tall grasses of the genera *Calamagrostis*, *Molinia*, *Phragmites*, etc.

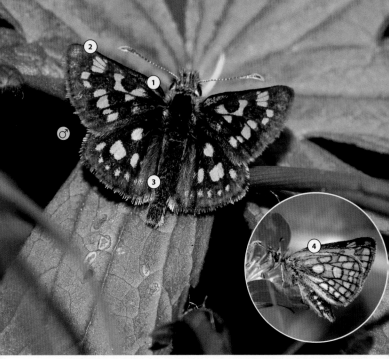

CHEQUERED SKIPPER · *Carterocephalus palaemon*

Chequered Skippers live in grasslands and swamps sheltered by nearby woodland, in cold and temperate regions right across the northern hemisphere. Males tend to congregate in small patches, making frequent short, investigative sorties from convenient perches. Females are unlikely to fly far from their natal habitat patch either. Like the larvae of the Large Chequered Skipper, it may be more than ten months before caterpillars are large enough to pupate. Fresh, growing food for a period of this length is provided only by favourably humid conditions.

⊙ *Carterocephalus silvicolus*

① Ups dark brown with yellow patches
② Fw ups yellow patches divided by black veins (cf. *C. silvicolus*)
③ Hw ups an arc of yellow spots on outer margin
④ Hw uns grey-yellow with dark-ringed yellowish spots
✳ Sexes rather similar

🦋 One generation between May and June, at high altitudes till the end of July. Various semi-shaded environments, such as forest edges and clearings, grassy damp meadows and river valleys. In the southern range often in uplands above 1,000 m.

⊕ Widespread all over C and N Europe except most of the British Isles and the surroundings of the Baltic Sea. Sporadic with local populations in calcareous and alpine regions; declined in many countries, extinct in England.

⚘ A wide range of grasses of the genus *Molinia*, *Calamagrostis*, *Brachypodium*, *Bromus*, *Dactylis*, *Alopecurus*, etc.

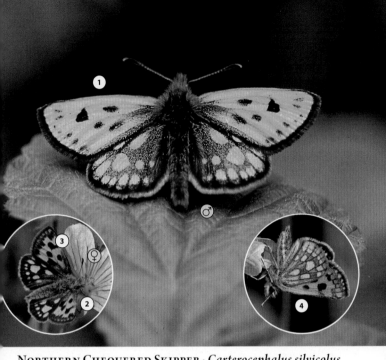

♂

♀

NORTHERN CHEQUERED SKIPPER · *Carterocephalus silvicolus*

In Finland one can hardly miss this common species during the early summer. It is inevitably found visiting wood cranesbill flowers in precisely the same spot from one butterfly season to the next, although its numbers tend to vary between years. Males are more noticeable than females, which like to hide in the shadows between forest and meadow. Although eggs are laid on different grass species, one easily gets the impression that the nectar-giving wood cranesbill is the most important thing for the Northern Chequered Skipper – at least as far as the adults are concerned.

→ *Carterocephalus palaemon*

① Male ups yellow with black spots
② Female ups yellow with lots of brown patches
③ Fw ups yellow areas not divided by black veins (cf. *C. palaemon*)
④ Hw uns greyish-yellow with numerous yellow spots

⚘ One generation from late May to late June. Luxuriant forest edges and clearings, woodland rides, damp meadows with tall grasses and river valleys at lowlands below 200 m.

⊕ Rather widespread around the Baltic Sea, including most Baltic islands, from NE Germany and Poland to C Fennoscandia. Common and abundant in Finland and the Baltic countries, endangered in Denmark.

⬡ A range of grasses such as *Milium effusum*, *Calamagrostis*, *Elytrigia*, *Cynosurus*, etc.

TH S FINLAND KIRKKONUMMI 6/06 · HA SE FINLAND JOUTSENO 6/05 · HA E FINLAND KERIMÄKI 6/06

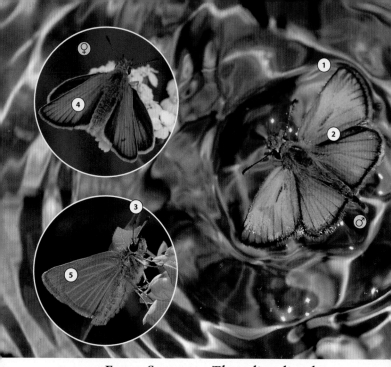

ESSEX SKIPPER · *Thymelicus lineola*

TH.5 TURKEY ANTALYA 6/10 · H.4 SE FINLAND (MATRA) 6/07 · H.4 N ITALY 6/05

This is a widespread 'golden skipper'. Male Essex Skippers, as with many other butterfly species, frequently congregate at muddy puddles, stream edges, carrion and animal droppings, where they imbibe moisture with minerals dissolved in it. In particular, they are taking in sodium ions. During their first mating, males transfer 32 % of their abdominal sodium to virgin females, causing both increased fecundity and longevity. Access to sodium ions increases the total number of matings by 50% for males living more than two weeks.

⊛ *Thymelicus sylvestris*

① Ups bright orange with black margins
② A male sex brand short and broken
③ Antennal tip black underneath (cf. *T. sylvestris*)
④ Female fw ups a diffuse dark marginal border extends along veins (cf. *T. hyrax*)
⑤ Hw uns orange with dusting of greyish scales

🦋 Mainly one generation between May and August depending on the locality, mostly in June–July. All kind of grass-dominated habitats; hayfields, meadows, roadsides and other cultural biotopes, forest edges and clearings up to 2,200 m.

⊕ Widespread and very common through most of Europe except many Mediterranean islands, N British Isles and N Fennoscandia; distribution expanded recently northwards in Britain and Finland. Introduced to N America, where it is a pest of hayfields.

◐ A wide variety of grasses, including *Agropyron repens*, *Phleum pratense*, *Dactylis glomerata*, *Holcus*, *Calamagrostis*, *Agrostis*, *Brachypodium*, etc.

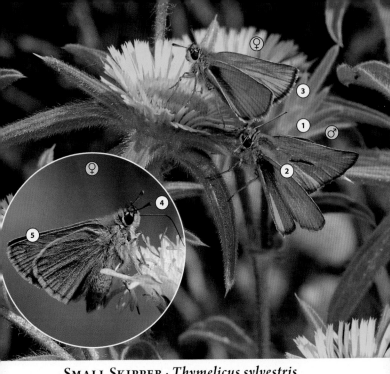

SMALL SKIPPER · *Thymelicus sylvestris*

To separate this species from Essex Skipper, check the undersides of the antennae tips – they are light orange-brown in this species but jet black in Essex Skipper. Both species are sometimes so numerous that they become pests of cultivated grasslands, most unusual in butterflies. Their larvae are small and largely nocturnal. Although these can survive on an array of grass species, the adult females fastidiously choose the right place and plant – probably according to their own experience during the larval stage. The problem is that timothy grass is among their favourite species. A well-irrigated and fertilized field of it is irresistible to these skippers.

↪ *Thymelicus lineola*
 Thymelicus hyrax

① Ups bright orange with black margins
② Male sex brand long and curved
③ Female fw ups a well defined dark marginal border (cf. *T. lineola*)
④ Antennal tip orange beneath (cf. *T. lineola*)
⑤ Uns orange with dusting of greyish scales at the tip of the fw and much of the hw

🦋 One generation between late April and July, depending on the location. Usually emerges slightly earlier than *T. lineola*. Various grass-dominated habitats, dry grasslands and meadows, sunny slopes, forest edges and clearings up to 2,000 m.

✛ Widespread and very common through much of Europe, but absent from most Mediterranean islands, northern parts of the British Isles and Fennoscandia except Denmark.

◈ A wide variety of grasses, including *Phleum pratense*, *Holcus*, *Brachypodium*, *Festuca*, etc.

LULWORTH SKIPPER · *Thymelicus acteon*

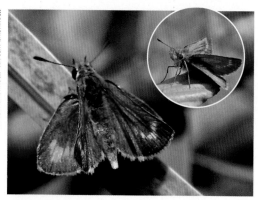

① The smallest 'golden skipper', ups brown with dusting of golden scales
② Male sex brand slightly wavy
✱ Female pale brown

E valuated as Near Threatened in Europe, but still widespread and locally common in S Europe, including Sicily, Crete and Cyprus. One brood with a long flight period between April (Cyprus) and August, usually from mid-May to July. Hot scrubby grasslands, steppe and grassy clearings in woodland up to 1,700 m. Larva feeds on a range of grasses, mainly *Brachypodium pinnatum*.

CANARY SKIPPER · *Thymelicus christi*

✱ Only golden skipper on the Canary Islands

E ndemic to Europe; sometimes regarded as a subspecies of *T. acteon*. Restricted to the Canary Islands, recorded on Hierro, La Palma, Gomera, Tenerife and Gran Canaria. Two or three broods between February and October in grassy habitats on forest margins up to 1,000 m. Larva feeds on various grasses.

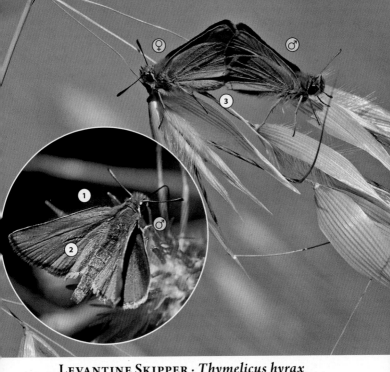

LEVANTINE SKIPPER · *Thymelicus hyrax*

The Levantine Skipper is the exception among the four mainland European *Thymelicus* skippers. While the rest are relatively commonplace, usually ranking high in butterfly counts, this one is a rarity. Its range extends from Greece eastwards across Asia Minor to Iran and Israel. The Levantine Skipper may be more common than expected, but its close resemblance to the Small Skipper makes it difficult to identify. Both sexes are strongly attracted to flowers in hot dry gullies.

⊘ *Thymelicus sylvestris*

① Ups orange-brown, intermediate colour between *T. lineola/sylvestris* and *T. acteon/christi*, with elongated light-yellow patch in discal cell and along costa

② Male a short, broken sex brand

③ Uns greenish-yellow (female) or greyish-green (male)

⊛ Male has a short broken sex brand

⊛ Larger than other 'golden skippers'

✿ One generation between early May and early July. Olive groves, vineyards and various hot and dry scrubby grasslands up to 1,700 m in the far east; mostly between 600 and 800 m in Greece, but at lower altitudes in the islands.

⊕ Distribution confined to Greece; Parnassos and Askion Mts, islands of Chios, Samos, Lesbos and Rhodes. Sporadic and uncommon, but probably underestimated due to confusion with *T. sylvestris*.

⬥ Unknown, but most likely one or more species of grass.

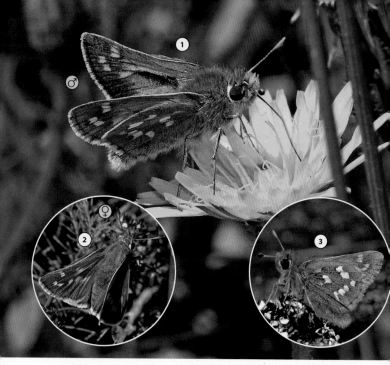

SILVER-SPOTTED SKIPPER · *Hesperia comma*

HA SWITZERLAND 7/07 · TH N SPAIN 8/08 · HA N NORWAY 7/05

A sunny late summer day in a dry calcareous meadow with plenty of thistle flowers is an ideal time and place to meet this nimble skipper, which occurs from the Mediterranean region to the shores of the Arctic Ocean. Distributed over an enormous area, it is a highly variable species, with many forms described. Besides the nominate subspecies inhabiting most of Europe, the subspecies *catena* flies close to the ground in alpine meadows in northern Fennoscandia rich in flowers. At least six more subspecies have been named in the Asian parts of its range. The sexes are easily distinguished by the presence of the androconial sex brand in the males.

⊘ *Ochlodes sylvanus*

① Male ups orange brown with a ridged sex brand
② Female ups warm brown with pale yellowish spots
③ f. *catena*; hw uns greenish with numerous silver-white spots

♈ One generation in the late summer between July and September, usually earlier in the high altitudes. Warm grasslands and meadows, typically on calcareous grazed lands with bare soil, railroad banks, forest edges and open grassy slopes up to 2,500 m in the Alps.

⊕ Widespread and common through most of Europe; sporadic or absent from most southern lowlands, Mediterranean islands (except Sicily) and most of Fennoscandia. Declined dramatically in Britain, but may be numerous in good habitat patches.

◈ Mainly *Festuca ovina*, seldom other grass species of *Lolium*, *Poa*, etc.

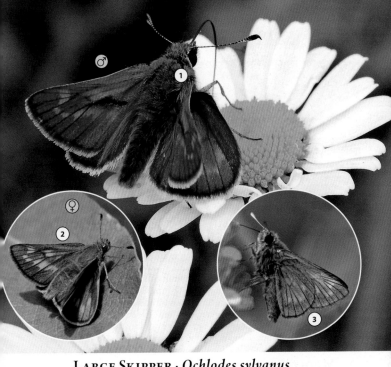

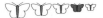

LARGE SKIPPER · *Ochlodes sylvanus*

All butterfly species have global binomial scientific names, but in the case of the Large Skipper there is a great deal of taxonomical confusion. European lepidopterists called it *O. venatus* for a long time, a name given the species by Bremer & Grey in 1853. However, there is no true *O. venatus* anywhere in Europe. Thus, based on an earlier description by Esper in 1778, the name was changed to *O. sylvanus*. Some authors have even adopted a third name, *O. faunus*, created by Turati (1905). This confusion is, however, understandable in a species displaying several individual and local forms across its vast range.

⊘ *Hesperia comma*

① Male ups bright orange with a large sex brand
② Female ups dark-brown with yellowish spots
③ Uns greenish-orange with faint yellow spots (cf. *H. comma*)

☙ Mainly one generation between June and early September; a small 2nd brood more likely in the southern part of its range. Various grass-dominated habitats, roadsides and meadows, usually associated with woodland up to 1,800 m.

⊕ Widespread and generally common through most of Europe except most Mediterranean islands and northernmost Fennoscandia.

⟁ A wide range of grasses including *Dactylis glomerata*, *Festuca*, *Poa*, *Calamagrostis*, *Molinia*, *Agropyron repens*, *Brachypodium*, *Holcus*, etc.

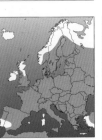

PYGMY SKIPPER · *Gegenes pumilio*

① Ups dark brown
(cf. *G. nostrodamus*)

② Fw elongated

③ Female fw ups pale
postdical spots, no
spots on male

④ Hw uns plain grey-brown
with some small
postdiscal spots

★ Very small
(cf. *G. nostrodamus*)

Widely dispersed colonies in Mediterranean coastal regions and islands from SE Spain to Cyprus. Still common, but many populations are threatened by human activities. Two or three broods between April and October, later broods being more abundant, in extremely hot rocky environments at lowlands. Larva probably feeds on grasses.

MEDITERRANEAN SKIPPER · *Gegenes nostrodamus*

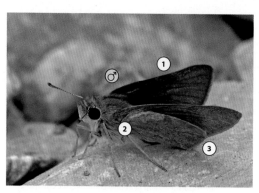

① Male ups uniform
greyish-brown without
spots, some white
spots on female

② Hw costa with dense
brush of hairs

③ Hw uns plain
grey-brown, no spots

★ Bigger and lighter in
colour than *G. pumilio*

Scattered distribution around Mediterranean from the Iberian Peninsula to Greece and Crete (absent from Cyprus); mostly on coastal regions and islands, some inland populations in Spain and Bulgaria. Two or three broods between April and November, later broods being more abundant, in extremely hot rocky environments. The two *Gegenes* species are not usually seen in the same habitats. Larva feeds on grasses (*Poa*, *Briza*, etc.).

Zeller's Skipper · *Borbo borbonica*

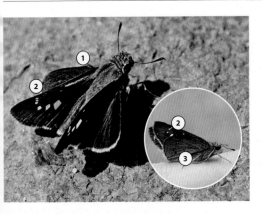

TNK MADAGASCAR 7/05 · AO ISRAEL HAIFA 9/09

1. Ups dark-brown with white spots on fw
2. Fw costal spots co-linear
3. Hw uns brown with three dark-ringed whitish spots
(★) Closely resembles *Pelopidas thrax*, but smaller

Mostly in SE Spain and Gibraltar (UK), probably an occasional immigrant from N Africa; vagrants recorded seldom along the Mediterranean coast. Several broods from June to November, mostly between August and September, in rocky or sandy habitats with bushes near coast. Larva feeds on grasses such as *Sorghum* and *Leersia* in N Africa.

Millet Skipper · *Pelopidas thrax*

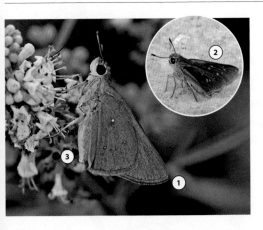

TH S TURKEY KEMER 9/09 · PO CYPRUS 9/08

1. Fw elongated
2. Ups dark-brown with whitish spots on fw
3. Female uns uniform brown with small whitish spots. No spots in male

A locally common species restricted to SE Europe in Grecian islands (Kos, Samos, Rhodes) and Cyprus; a tendency for migrations. Two broods between May and October in hot and dry agricultural land, roadsides and reed beds at coastal regions, but up to 800 m in Cyprus. Larva feeds on *Panicum miliaceum* and other grasses.

PAPILIONIDAE

FESTOONS, APOLLOS AND SWALLOWTAILS

SPANISH FESTOON · *Zerynthia rumina* – SCARCE SWALLOWTAIL · *Iphiclides podalirius*

A total of 12 species in Europe · 2 endemics, 5 Threatened or Near Threatened

T he group containing the world's most glorious and striking butterflies displays tremendous diversity in the tropics, with more than 550 species. These include the largest butterflies in the world – the birdwing butterflies of Australasia. The group's European fauna is very limited yet its colourful species are among the largest butterflies (mean wing span 65 mm) here as well. Adults feed eagerly on nectar from flowers. They rest with their wings spread but constantly flutter them while feeding. The more or less yellow swallowtails are characterised by elongated 'tails' on the hind-wing. Combined with an eye-spot, each tail resembles a false head, thus distracting predators from the more crucial body parts. It is quite common to see swallowtails with one or both tails missing. The festoons possess less significant tails, while apollos have none at all. Yet two features are common to all the European species of the family: all three pairs of legs are fully functional, with a pair of claws on each tarsus (ankle), and the inner margin of the hindwing is concave. The caterpillars usually display warning colours and, in contrast to all the other butterfly groups, an active defense mechanism: they can extrude an antenna-like structure called an osmaterium situated behind the head. At the same time they secrete pungent chemicals.

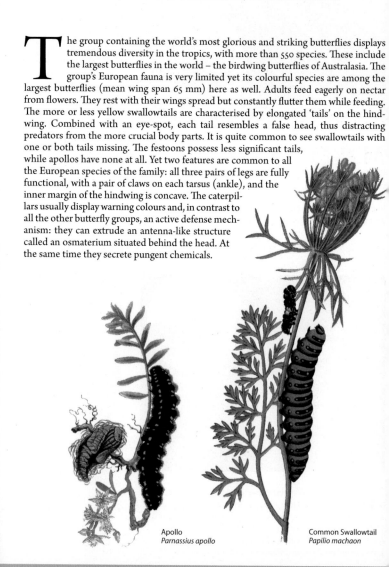

Apollo
Parnassius apollo

Common Swallowtail
Papilio machaon

ZERYNTHIA RUMINA **TH**

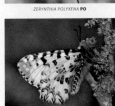

ZERYNTHIA POLYXENA **PO**

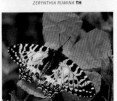

ZERYNTHIA CERISY **TH**

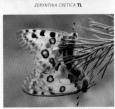

ZERYNTHIA CRETICA **TL**

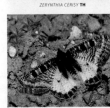

ARCHON APOLLINUS **TH**

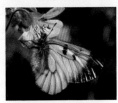

PARNASSIUS APOLLO **TH**

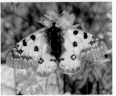

PARNASSIUS PHOEBUS **HA**

PARNASSIUS MNEMOSYNE **HA**

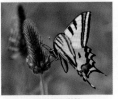

PAPILIO ALEXANOR **PO**

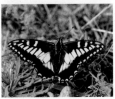

PAPILIO MACHAON **PO**

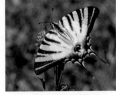

PAPILIO HOSPITON **IK**

IPHICLIDES PODALIRIUS **HA**

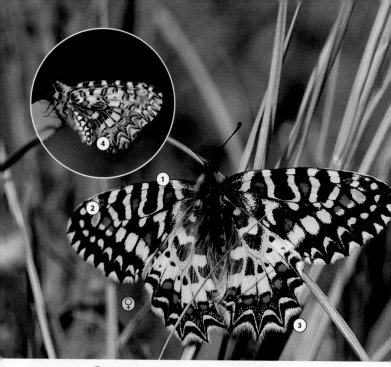

SPANISH FESTOON · *Zerynthia rumina*

TH S SPAIN 3/07 • HA S SPAIN 5/07

In February at Gibraltar, the European butterfly season starts with a vivid pageant. All festoons have a striking appearance and this species has a stunning combination of red and black spots on a yellow background, together with transparent 'windows' at the forewing apex. However, the bright patterns progressively wear out with time, and the colours finally blur into dull greyish mediocrity. The bizarre wing patterns effectively break up its shape, the better to thwart sharp-eyed predatory birds. Several forms have been described: f. *medesicaste* (hw ups extra red spot, f. *honnoratii* (red markings extended, f. *canteneri* (yellow-ochreous), f. *africana* (N Africa).

⊙ *Zerynthia polyxena*

① Fw ups yellow or pale orange with black markings and red spots
② A semi-transparent spot near to the apex
③ Hw scalloped
④ Hw uns black submarginal lines sinuous
★ Male less heavily marked

🦋 Usually one generation between late March and May, but records span from February to July; a small 2nd brood in September in the southern range. Coastal gullies, dry grasslands with scrub, edges of woodland and cultivations, generally below 1,000 m.

⊕ Restricted to SW Europe from the Iberian Peninsula to parts of S France. Widespread and locally common, sometimes abundant in its habitat.

🌿 Many species of birthworts (*Aristolochia*).

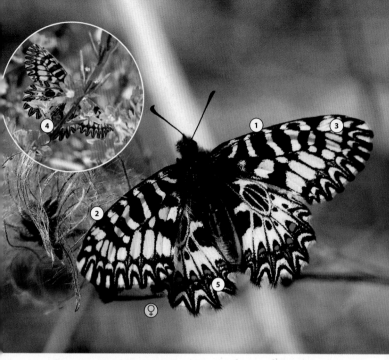

SOUTHERN FESTOON · *Zerynthia polyxena*

TH SLOVENI 4/07 · TH ITALY SICILY 5/10

The two widespread festoon species are very similar in regard to their habitat selection and behaviour. Fortunately for us, the ranges of the Eastern and Western Festoons overlap only in parts of southern France. There the Southern Festoon is usually the first on the wing, April being its peak time, although some stragglers are still found in May amongst the then numerous Spanish Festoons. Because of variability in the number and position of the red spots, at least 30 subspecies have been described. Names like *bosniensis*, *macedonia* and *taygetana* reveal the limited range of each. In S Europe ochreous females are common (f. *ochracea*).

➲ *Zerynthia rumina*

① Fw ups yellow with black spots and bars, f. *cassandra*
② Only one small red spot near to the apex (*cf. Z. rumina*)
③ No translucent spot (*cf. Z. rumina*)
④ Hw uns black submarginal lines very wavy (*cf. Z. rumina*)
✱ Male less heavily marked

🦋 One generation between February and early July with prolonged emergence. Various dry and bushy habitats at low altitudes, meadows, roadsides and neglected cultivations, sunny slopes of gorges and ravines up to 1,500 m .

⊕ Rather widespread but local in S and E Europe from SE France eastwards covering most of the Balkans; most common in Greece and Turkey. Sometimes numerous in good habitat, but has generally declined throughout the range.

✿ Many species of birthworts (*Aristolochia*).

Eastern Festoon · *Zerynthia cerisy*

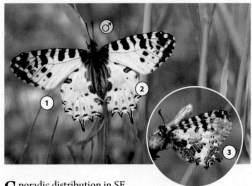

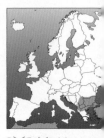

① Male ups pale yellow
② Hw ups red
 postdiscal spots
③ An outer margin strongly
 scalloped with a short tail
★ Female more
 heavily marked

Sporadic distribution in SE Europe in the Balkans, Grecian islands from Lesbos to Rhodes and Cyprus where fairly common. Evaluated as Near Threatened in Europe; sometimes common but generally local and in decline. One brood between March and July in cultivations and dry grasslands with thick scrub, river valleys, rough hillsides and mountain slopes up to 1,700 m. Larva feeds on several birthworts (*Aristolochia*).

Crete Festoon · *Zerynthia cretica*

① Male ups pale yellow
 with black spots
② No tail on hw
③ Red spots missing or faint
★ Female more
 heavily marked

Endemic to Europe; very closely related to *Z. cerisy* and *Z. caucasica*, sometimes treated only as a subspecies confined to Crete. One brood mostly between March and June in hot and dry scrub, olive groves, vineyards and rocky mountain slopes up to 1,700 m. Larva feeds on birthworts (*Aristolochia cretica, A. sempervirens*).

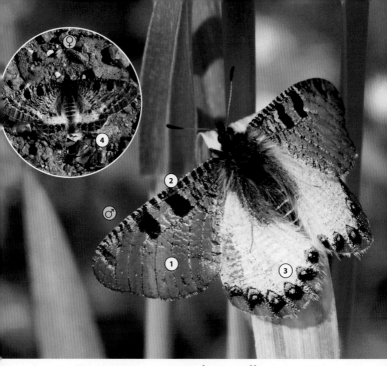

False Apollo · *Archon apollinus*

This butterfly looks like a combination of a festoon and a true apollo. A freshly emerged individual has festoon-like yellowish hindwings, some females often bearing obvious red mottling as well. However, some scales on the apollo-like forewings are lost during every flight. Eventually, the forewings may be almost transparent, especially in the males, resulting in 'ghostly' wings. Despite the False Apollo's dense 'fur', individuals constantly warm up on the ground with their wings extended in both sunny and overcast weather.

→ *Parnassius mnemosyne*

① Male fw translucent grey
② Variable amount of grey speckling and two black spots in the cell
③ Hw ups yellowish with conspicuous arc of red and blue spots near to the margin
④ Female more heavily marked

POS TURKEY ANTALYA 4/09 · TM TURKEY ANKARA 4/10

✿ One generation between early March and early June. Olive groves, orchards and vineyards, open woodland with oaks, stony dry grasslands and rocky slopes with bushes and rough hillsides up to 1,100 m.

⊕ Very local from NE Greece to European Turkey, also in E Aegean islands (Lesbos, Chios, Samos, Kos, Rhodes). Locally common, but widely declined due to herbicide use in tree cultivations; evaluated as Near Threatened in Europe.

◗ Several birthworts, such as *Aristolochia bodamae*.

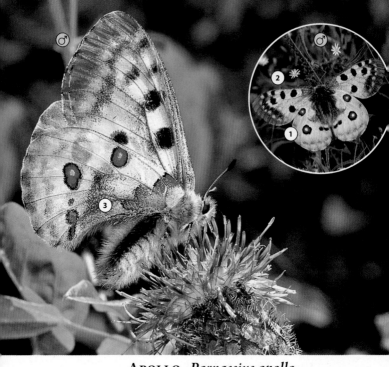

APOLLO · *Parnassius apollo*

HA SLOVENY 7/06 · HA SW FINLAND HUITTINEN 7/87

The Apollo is a magnificent, large butterfly mainly inhabiting mountain ranges. Due to its narrow ecological requirements, vulnerability to anthropogenic disturbances, a clumsy flight and easy approachability while nectaring on thistles and knapweeds, this attractive butterfly is susceptible to local extinction. As a result, its wide range over Eurasia is split into numerous small local populations representing several forms and subspecies. Having already become extinct in many countries, it is now one of Europe's most endangered butterflies. The Apollo is evaluated as Near Threatened and protected by European legislation.

⊙ *Parnassius phoebus*

① Hw ups two red or orange black-ringed spots

② Fw ups no red spots beyond the cell (*cf. phoebus*)

③ Hw uns two red spots ringed with black and some small red spots at the base

⊛ Female larger and more suffused

♆ One generation between late April and September depending on both altitude and latitude; usually in July–August in mountains and in the northern range. Rocky meadows and stony slopes in alpine grassland screes and cliffs typically between 1,000 and 2,400 m; scrubby hills in the Mediterranean region.

⊕ Rather widespread but very sporadic over the mountain ranges from the Iberian Peninsula to the Balkans; sometimes locally abundant. Very local in S and C Fennoscandia, including some Baltic islands (ssp. *finmarchicus*).

⬧ A range of stonecrops and houseleeks, such as *Sedum album*, *S. telephium* and *Sempervivum*.

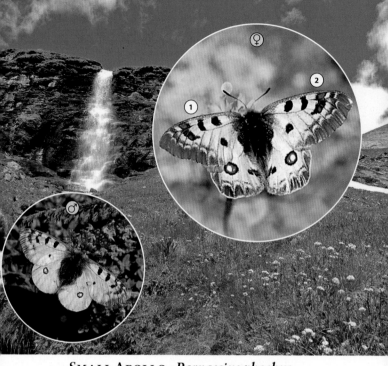

SMALL APOLLO · *Parnassius phoebus*

The Small Apollo is a variable mountain species with more than 40 subspecies described over the northern hemisphere. Thriving best above the tree line, it sometimes shares a high alpine meadow with the Apollo. In such circumstances one needs to make an examination of the antennae. These have black and white stripes in the Small Apollo but are uniform grey in the Apollo. A meadow rich in flowers is the best place to find them, since both species are very approachable while nectaring, and can easily be closely studied and photographed.

⌖ *Parnassius apollo*

① Ups pale cream or white
② Fw ups one or two red spots near to the cell (cf. *P. apollo*)

🦋 One generation between July and August. Various grassy habitats in the shelter of gulleys and cliffs, moist margins of streams, alpine meadows and calcareous mountain tundras usually between 1,800 and 2,200 m, but sometimes up to 2,800 m.

⊕ An alpine species with a patchy distribution in the C European Alps of France, Switzerland, Italy and Austria. Usually very local but sometimes common in the right habitat. Has declined greatly in Germany; evaluated as Near Threatened in Europe.

🌿 Mainly *Saxifraga aizoides*, seldom other saxifrages and stonecrops (*Rhodiola rosea, Sedum, Sempervivum*).

HA AUSTRIA GROSSGLOCKNER 7/08 · TH N ITALY 7/07 · HA N ITALY 7/07

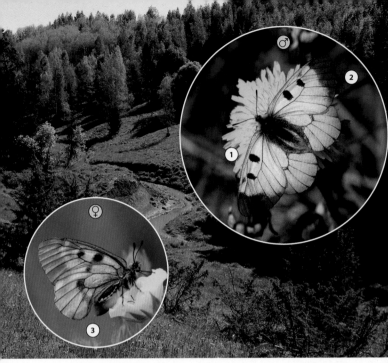

CLOUDED APOLLO · *Parnassius mnemosyne*

Geographical and individual variation between local populations across this rather unremarkable-looking species' vast range in Europe and Asia has resulted in the designation of a large number of subspecies. However, many of these are actually no more than local forms adapted to specific conditions. One prominent feature, however, is characteristic of all populations – a hard structure called the 'sphragis', deposited on the female's abdomen by the male during mating, which physically prevents the female from mating again. This is a feature of all apollo species, and makes it easy to recognise the females once they have mated.

⊙ *Aporia crataegi*
 Archon apollinus

① Male fw white with two black costal spots
② Outer margin widely semi-transparent
③ Mated female with a sphragis

♀♂ One generation between late April and July depending on climatic conditions. Forest edges and clearings, scrubby grasslands and mountain slopes typically between 1,000 and 1,700 m, but up to 2,200 m; moist meadows and river valleys in the northern range.

⊕ Widely distributed in most of Europe, especially in eastern parts extending from Greece to C Fennoscandia; very sporadic in the western and the northern ranges. Evaluated as Near Threatened in Europe; colonies are very local but sometimes abundant in good habitat.

⬦ Several species of corydalis, such as *Corydalis solida*, *C. bulbosa* and *C. intermedia*.

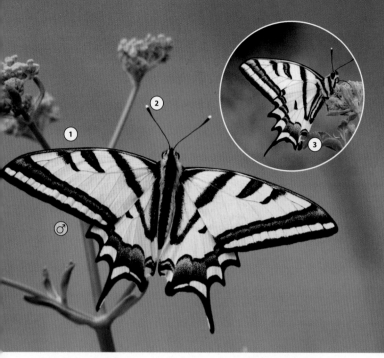

Southern Swallowtail · *Papilio alexanor*

Swallowtails are amongst the most spectacular butterflies, comprising several hundred principally tropical species. The few European representatives offer only a glimpse of their glory, but they do share the spur-like hindwing 'tails'. These have a purpose: combined with the large red 'eyes' at the base of the wings, the tails on the Southern Swallowtail can trick birds into attacking their intended victim's wings instead of their heads, and loss of the 'tails' does the butterfly little harm. Tails on or off, Southern Swallowtails are still masters of the air with a strong gliding flight. Flying activity peaks in the hottest hours of the day.

⊙ *Iphiclides podalirius*

① Fw yellow with transverse black stripes
② White tip to the antennal club
③ Hw uns a blue anal lunule above orange spot and long tails
⊛ Sexes similar

🦋 One generation between late April and July. Open woodland in hilly country, forest clearings, grazed fields and stony and steep mountain slopes in calcareous land with xerophytic vegetation up to 2,400 m.

⊕ Scattered distribution in S Europe; mainly in the Balkan Peninsula, Grecian islands (incl. Corfu, Lesbos, Samos), Croatian coast and an isolated range in SE France and adjacent Italy. Extremely sporadic and very local throughout the range; probably extinct in Sicily.

⬙ A range of umbellifers in the genus *Opopanax*, *Ferula*, *Pimpinella*, *Seseli*, *Ptychotis*, *Torilis*, *Trinia* etc.

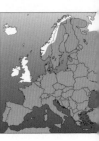

COMMON SWALLOWTAIL · *Papilio machaon*

TH N GREECE ZAGORA 7/2010 · PO SE FINLAND RUOKOLAHTI 6/86

Flying with powerful determination, the Common Swallowtail may cover several kilometres without pause. A characteristic of males is the habit of visiting mountain tops or high hills, where several may gather round the highest point (a habit known as hilltopping). The restless butterfly is almost invariably difficult to photograph. It can be most easily approached early in the morning while nectaring on cranesbills and other flowers, where it is a joy to behold. In the northern part of the range, only a few individuals are seen each summer.

⊙ *Papilio hospiton*

① Male fw ups yellow with black basal area
② Hw ups with a red anal spot and a blue lunule
③ Long tails
✱ Sexes similar
♉ Often two generations; 1st brood from late May to July, 2nd brood from August to September. Dry habitats around cultivated land in the Mediterranean region; conversely moist environments further north; damp meadows, fens and mires, lake shores, parks and gardens, also fell summits in the far north.
⊕ Widespread but generally uncommon throughout Europe, including most Mediterranean islands and Cyprus, but very rare in Britain and Denmark. A strong tendency to migrate, thus recorded up to northernmost Fennoscandia.
⬥ Several umbellifers, including *Peucedanum*, *Angelica*, *Foeniculum*, *Anethum* etc.

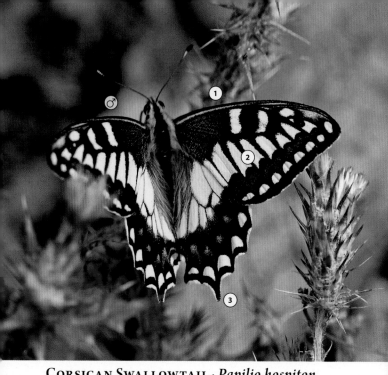

Corsican Swallowtail · *Papilio hospiton*

Hybrids observed now and then indicate a close relationship with the Common Swallowtail, but the Corsican Swallowtail is endemic and restricted to Corsica and Sardinia only. As extinction on these islands would therefore spell the end for the species, legal measures have been established to protect the Corsican Swallowtail. However, the species currently appears to be under no particular human threat. Sometimes dozens of males may gather round the highest point on hills and mountains. After hilltopping for several hours, individuals are thirsty for nectar, mostly provided by thistles.

 Papilio machaon

① Fw ups yellow, basal area largely black, dusted with yellow scales
② Dark markings thick, especially along the veins
③ Short tails
✱ Sexes similar
🦋 One generation with a long flight period between March and August; usually seen from mid-May to July. River valleys, grassy hillsides and slopes with low-growing scrub usually between 500 and 1,200 m.

⊕ Endemic to Europe; confined to Corsica and Sardinia. Rather common but sporadic, usually in low numbers.

🌿 Some umbellifers (*Ferula communis*, *Peucedanum paniculatum*) and *Ruta corsica*.

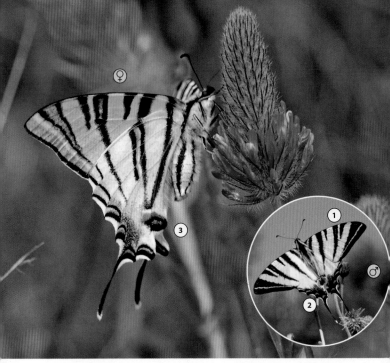

HA: GREECE SAMOS 5/09 • HA 5: BULGARIA 7/10

Scarce Swallowtail · *Iphiclides podalirius*

This urban butterfly is frequently seen feeding on flowers in parks and gardens. Of similar size to the Common Swallowtail, it is distinguished by its paler colour and unmistakable black 'tiger stripes'. Long tails on the hindwings give strength and direction to its flight. Both sexes exploit air currents, a rapid ascent being followed by a graceful glide. Males are typical 'hilltoppers'. The Scarce Swallowtail is a wanderer which has even been recorded as a vagrant in southern Finland. Although it is quite abundant in some years, the Scarce Swallowtail is getting rarer and the species is now protected by law in many European countries.

Papilio alexanor

① Fw with transverse black stripes
② Hw outer edge blue markings and very long tails
③ Hw uns with the blue anal lunule topped by an orange spot
⊛ Sexes similar

🜋 Two generations; 1st brood from mid-May to June, 2nd brood from late July to September; northern vagrants are usually representatives of the 2nd brood. Field margins, ruderal areas, parks and gardens, scrub, orchards and scattered light woodland up to 1,500 m.

⊕ Widespread and locally common throughout S and C Europe, but absent from the Iberian Peninsula, Sardinia and Cyprus. Recorded only as a vagrant or as an accidental import in N Europe; occasionally noted in Britain and the Baltic states, very rare in S Fennoscandia.

⬡ Woody rosaceous plants, such as *Crataegus*, *Prunus spinosa* and several cultivated *Prunus* species in orchards.

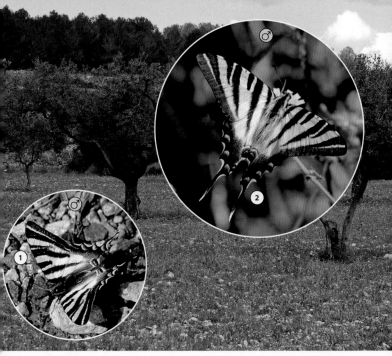

Southern Scarce Swallowtail · *Iphiclides podalirius feisthamelii*

The debate about this beautiful species still swings to and fro, with some authorities declaring it a subspecies of the Scarce Swallowtail, and others considering it an independent species in its own right. Whatever the truth, this North African butterfly is somewhat paler than its more widespread European relative and may sometimes appear almost white. Both are among the strongest fliers in the butterfly world and they have a passion for many nectar-bearing flowers, *Buddleia* in particular. Females looking for suitable places to lay their eggs are easily photographed flying around fruit trees in orchards.

⊝ *Iphiclides podalirius podalirius*

① Ground-colour white with bold black stripes
② Very long tails
⊛ Sexes similar
⊛ Mostly on the Iberian Peninsula

🦋 Two generations; 1ˢᵗ brood from April to June, 2ⁿᵈ brood in July–September. Cultural environments, orchards and meadows, bushy gorges, ravines and mountain slopes.

⊕ Rather widespread in the Iberian Peninsula from Gibraltar to SW France. Generally common, but has probably declined like the nominate form due to changes in agricultural practices.

◭ Many arboreal rosaceous plants in the genus *Prunus*, *Pyrus*, *Malus*, *Sorbus* and *Crataegus*.

TH SPAIN CATALONIA 4/08 · TH N SPAIN 8/08 · TH N SPAIN 5/05

PIERIDAE

WHITES AND YELLOWS
WOOD WHITE · *Leptidea sinapis*– BRIMSTONES · *Gonepteryx*

A total of 57 species in Europe · 15 endemics, 11 Threatened or Near Threatened

Whites and yellows (sulphurs in North America) are worthy of their names, with white, yellow or orange wings, often with the addition of black spots. Many also have ultraviolet patterns, which are used in courtship but are undetectable to the human eye. Females often have more extensive or complex dark wing markings than males. Most are of average size (mean wing span 47 mm) and are easily observed in environments modified by mankind as many broods throughout the summer. The males of many whites display gregarious mud-puddling behaviour, imbibing valuable salts from moist soil to improve their reproductive success. There are many excellent fliers and strong migrants among both whites and yellows. The Large White and Brimstone are among the most widely recognised butterfly species in Europe, the latter species probably being responsible for the original notion of a 'butter-coloured fly'. Caterpillars may either be well-camouflaged or exhibit bright warning colours. Two groups of plants are preferred, either vetches and other leguminous plants, or crucifers. Those relying on the latter include some notorious pests of crops – a rather exceptional circumstance among European butterflies.

Small White
Pieris rapae

Black-veined White
Aporia crataegi

Large White
Pieris brassicae

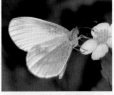

LEPTIDEA SINAPIS **PO**

ANTHOCHARIS CARDAMINES **HA**

EUCHLOE CHARLONIA **HA**

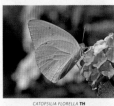

CATOPSILIA FLORELLA **TH**

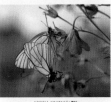

APORIA CRATAEGI **TH**

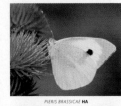

PIERIS BRASSICAE **HA**

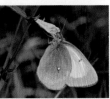

PIERIS NAPI **HA**

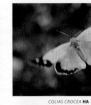

PONTIA CALLIDICE **TL**

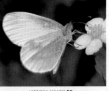

COLIAS PALAENO **HA**

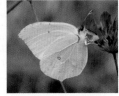

COLIAS CROCEA **HA**

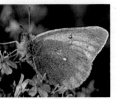

COLIAS TYCHE **PO**

GONEPTERYX CLEOPATRA **PO**

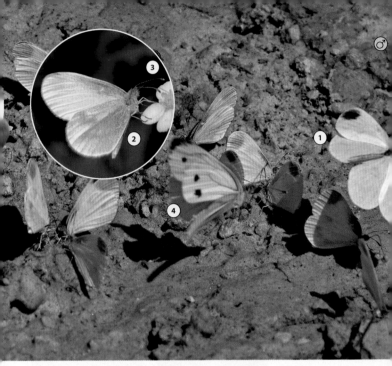

WOOD WHITE · *Leptidea sinapis*

A small and delicate-looking white butterfly, with a pearly grey sheen to its undersides and subtle dark wingtips. In 1988, a French entomologist named Réal determined that Wood Whites in Europe actually comprise two near-identical species (the newly discovered variant has since been named after him). Although slight differences exist in their wing markings and habits, distinguishing between the two species in the wild is almost impossible, unless only one or the other is known to exist in the location. At the outset detailed examination of the genital structure is necessary for establishing which of the two is actually present.

⊙ *Leptidea reali*
 Leptidea morsei

① Ups pure white with dark or black smudge near to the tip of fw
② Uns white, smudged with grey
③ A black antennal club with white patch on uns (cf. *L. duponcheli*)
④ Note *Pieris napi*
✶ Sexes similar
✶ 1st brood darker

🦋 One to three generations between April and September depending on latitude. Two broods, 1st brood in May–June and 2nd brood in July–August. Woodland edges, clearings and rides, damp scrub an meadows, but also dry rocky habitats up to 2,300 m.

⊕ Widespread and generally common through most of Europe; absent only from parts of Britain, Netherland Denmark and northernmost Fennoscandia. Species may be in decline in many European countries.

🌿 Many common legumes, such as *Lathyrus pratensis* and other *Lathyrus* species, *Lotus corniculatus* and *L. uliginosus*.

RÉAL'S WOOD WHITE · *Leptidea reali*

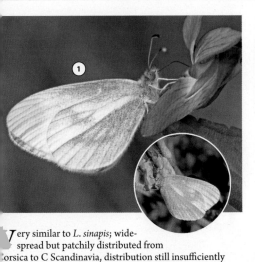

PG SE FINLAND LAPPEENRANTA 5/09 · JBH N IR ELAND 6/02

① Uns more greyish or yellowish than *L. sinapis*; specific identification based on genitalia
⊛ Fw ups black apical patch darker and more square than that of *L. sinapis*
⊛ Sexes similar
⊛ Ups rarely seen at rest
⊛ 1st brood darker
⊛ In the northern range starts to fly 1-2 weeks earlier than *L. sinapis*

Very similar to *L. sinapis*; wide-spread but patchily distributed from Corsica to C Scandinavia, distribution still insufficiently known. One to three broods between April and August in diverse bushy grasslands. Larva feeds on *Vicia cracca* and *Lathyrus pratensis*, probably on other legumes as well.

EASTERN WOOD WHITE · *Leptidea duponcheli*

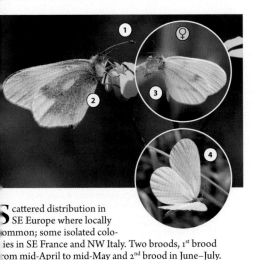

OV GREECE ASKION 5/2008 · TH N GREECE HALKIDIKI 6/06 · PO N GREECE 7/09

① Antennal club dark grey and brown with no white uns (cf. *L. sinapis*)
② 1st brood hw uns greyish with a white patch
③ 2nd brood uns with yellow tinge and faint markings
④ Ups rarely seen at rest, black smudge faint near to the tip
⊛ Sexes similar

Scattered distribution in SE Europe where locally common; some isolated colonies in SE France and NW Italy. Two broods, 1st brood from mid-April to mid-May and 2nd brood in June–July. Arid sparse woodland and forest edges, hot and rocky gullies and upland dry meadows, but usually below 1,200 m. Larva feeds on legumes (*Lathyrus*, *Lotus uliginosus*).

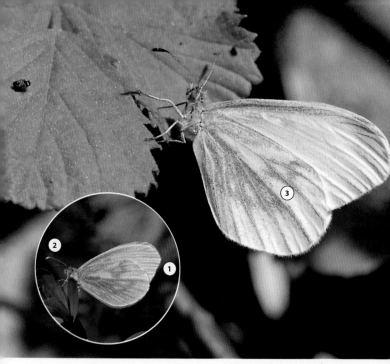

FENTON'S WOOD WHITE· *Leptidea morsei*

Another typical member of the distinctive wood white group. Like the other species, it has a weak-looking, fluttering flight, quite distinct from the other pierid butterflies. It is a slender-bodied insect, and tends to fly at low levels along the margins of its woodland habitat, rarely pausing despite the apparent lack of power in its flight. When it does make a pit-stop at a flower or on damp ground, the butterfly keeps its wings tightly closed. The markings on the hindwing underside assist in recognising Fenton's Wood White from other wood white species, especially in the first brood.

⊙ *Leptidea sinapis*
Leptidea reali

① Fw slightly falcate under the apex
② Antennal club dark with white (male) or grey (female) patch beneath
③ Hw uns grey veins in distal half
★ Sexes similar
★ Ups rarely seen at rest
★ 1st brood darker

🦋 Two generations; 1st brood between mid-April and May, 2nd brood in June–July. Open deciduous woodland, humid meadows in forests, sunny edges of mixed forests and forested steppe up to 1,500 m.

⊕ Scattered distribution in central E Europe from Slovenia and S Poland to C Ukraine (ssp. *major*). The range of the nominate form extends from E Ukraine to Far East. Evaluated as Near Threatened in Europe; typically very local.

◒ Exclusively *Lathyrus niger*.

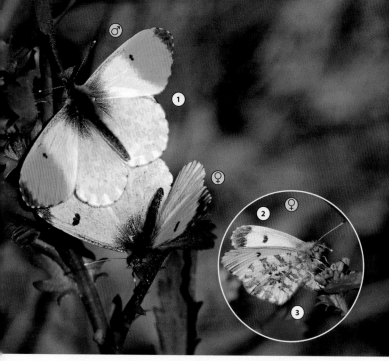

ORANGE TIP · *Anthocharis cardamines*

In most European countries, from the Mediterranean islands to Finland in the far north, the Orange Tip is uniformly welcomed as the 'herald of spring'. Males are easily recognised due to their bright orange wing tips, easily discerned even at a fair distance. The females emerge somewhat later, but they are less distinctive and may be confused with other white pierids. Spending the long winter months as a dormant pupa, the Orange Tip is one of the few butterflies of the early summer keeping to a uniform one-brood tactic right over its vast European range.

➤ *Anthocharis damone*
 Anthocharis euphenoides

① Male ups white, fw apex deep orange
② Female fw ups apex black
③ Hw uns marbled yellowish green

🦋 One generation as a rule, between late March and July depending on both latitude and altitude. Woodland margins, forest clearings and rides, hedgerows, damp meadows and alpine grasslands up to 2,000 m.

⊕ Widespread and generally common through almost all of Europe. Absent only from the Balearic islands, Malta, Crete and Rhodes.

🜂 A wide range of wild crucifers of the genera *Cardamine, Alliaria, Isatis, Sinapis, Arabis, Lunaria, Biscutella, Hesperis,* etc.

TH S FINLAND SALO 6/07 · TH S FINLAND SALO 5/08

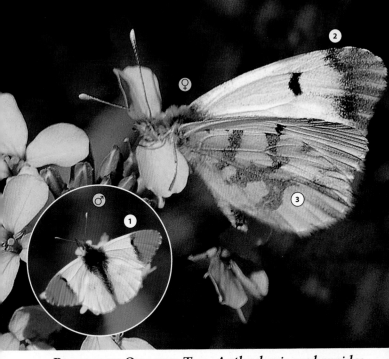

TH 5 FRANCE 5/06 • TH 5 SPAIN SIERRA NEVADA 3/07

PROVENCE ORANGE TIP · *Anthocaris euphenoides*

With its splendid yellow wash, this southern cousin of the Orange Tip was previously regarded as a subspecies of the Moroccan Orange Tip (*A. belia*). In Europe, it is unmistakable since its range does not overlap with that of any of its yellow relatives. The Provence Orange Tip is a well-known hilltopper, producing dazzling displays on the hilltops of Provence, for example. Although hilltop courting grounds are often densely populated, the males try to avoid each other by adopting a small individual territory within the general habitat.

⊛ *Anthocaris damone*
 Anthocaris gruneri

① Male ups sulphur yellow with the orange-red apex innerside bordered black
② Female ups white with greyish tip
③ Hw uns yellow with grey stripes

♈ One generation with emergence dependent on locality; usually between late March and May, but observations span from February in Gibraltar to July in the mountains. Uncultivated land, field margins and dry flowery hillsides up to 1,800 m.

⊕ Endemic to Europe; widespread and generally common in SW Europe from most of the Iberian Peninsula to S France; scattered and very local in Italian Alps and mid-Italy.

⊕ Exclusively crucifers of *Biscutella* genus, including *B. laevigata*, *B. auriculata*, *B. ambigua*.

Eastern Orange Tip · *Anthocharis damone*

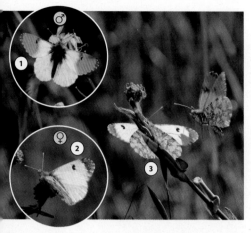

TH ITALY SICILY 5/10 · TH ITALY SICILY 5/10 · TH ITALY SICILY 5/10

① Male ups yellowish (cf. *A. gruneri*), apex orange-red

② Female ups white, apex dark brown; discal spot sharply defined (cf. *A. gruneri*)

③ Hw uns yellow, thinly marbled with grey

Very patchily distributed but locally common in S Italy, E Sicily, Macedonia, Grecian mainland and Corfu. One brood between April and May in arid sparse forests, open maquis and other xerophytic habitats, usually on calcareous slopes up to 1,300 m. Larva feeds only on *Isatis tinctoria*.

Gruner's Orange Tip · *Anthocharis gruneri*

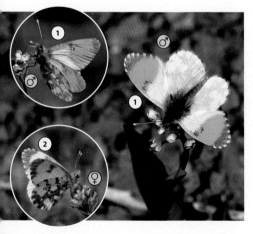

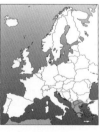

TH TURKEY ANKARA 4/10 · PO GREECE PELOPONNESE 6/09 · OV GREECE ASKION 5/08

① Male ups pale yellow, apex orange, a black discal spot linked with dark suffused costa

② Female ups white, apex dark brown; discal spot large and suffused (cf. *A. damone*)

⊛ Like *A. cardamines* but smaller

Distribution restricted to S Balkans and Greece; locally common in various dry grassy habitats amongst scrub in hills and calcareous slopes in mountains up to 1,800 m, with one brood between April and early June. Larva feeds on candytufts (*Aethionema saxatile*, *A. orbiculatum*).

SOOTY ORANGE TIP · *Zegris eupheme*

The Sooty Orange Tip is the only representative of this pierid genus in Europe. With a rather narrow distribution in northern Africa (ssp. *maroccana*) extending to southern Spain, it is more common in the Middle East and in the surroundings of the Black Sea and Caspian Sea. More than ten subspecies have been described: the nominate one occurs in southern Russia, whereas Spanish individuals belong to ssp. *meridionalis*. These are very strong flyers and are attracted to the flowers of many crucifers in particular. Smaller Provence Orange Tips are often more abundant companions.

① Fw ups a sooty smudge with orange centre at the tip

② A curved black spot at the end of cell

③ Hw uns yellow with irregular grey markings

✱ Both sexes white

☘ One generation between mid-March and mid-June depending on altitude and location. Dry open grasslands predominated by crucifers; meadows, neglected cultivations and edges of fields, olive plantations and semi-desert landscape usually below 1,000 m.

⊕ Confined to Spain; usually low in numbers in separate local colonies. Evaluated as Near Threatened in Europe. Distribution extends from Ukraine towards east.

🌢 Some crucifer species, mainly *Isatis tinctoria* and *Hirschfeldia incana*.

TH SPAIN MIRAFLORES 4/04 · TH SPAIN MIRAFLORES 4/04

DESERT ORANGE TIP · *Colotis evagore*

This is an exquisite small African species that just edges into southern Europe. In South Africa, the game park Lion Sands is a spectacular place to observe butterflies as well as larger and more imposing wildlife. Dozens of fiery reddish African Monarchs (*Danaus chrysippus aegyptius*) hang in the bushes of tiny red flowers, but here and there are smaller dots of bright orange – Small Orange Tips (*Colotis evagore antigone*), a true African species as well. The common name for the subspecies *C. evagore nouna*, which occupies a more northerly range, is the Desert Orange Tip.

① Ups white, fw tip black with elongated red spots
② Hw ups triangular black spots on outer border
★ Sexes similar
🦋 Several broods between April and November; more numerous in the late summer. Hot coastal environments such as rocky slopes, steep gullies and also on cultivated land, usually in the lowlands.
⊕ An African species with a very limited range in SW Europe (ssp. *nouna*); confined to coastal districts of S Spain, but expanding northwards.
🌿 Exclusively *Capparis spinosa*.

GBR: S SPAIN ALMERIA 10/08

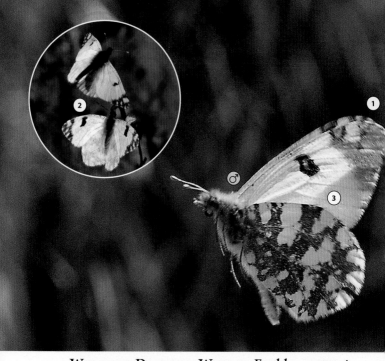

WESTERN DAPPLED WHITE · *Euchloe crameri*

Three very similar dappled whites have been lumped into the 'ausonia complex', but their common names reveal fundamental differences. This widespread species has a western distribution and its 'identical twin' the Eastern Dappled White, logically enough, occurs further east in similar habitats. The Mountain Dappled White, however, is found only in mountain ranges. The species' ranges overlap in very restricted parts of Spain, France and Italy. The densest populations of Western Dappled White occur on the Iberian Peninsula, but two other dappled whites are also found there, increasing the risk of misidentification.

⊙ *Euchloe simplonia*
 Euchloe tagis

① Fw uns white with green apical markings
② Black discoidal spot not reaching costa (cf. *E. simplonia*)
③ Hw costa angled (cf. *E. tagis*)
☿ Usually two overlapping generations; 1st brood from March to May, 2nd brood in June– July. Various cultural biotopes; agricultural crops and cultivated land, scrubby meadows and other grasslands with abundant crucifers, south-facing slopes up to 2,000 m.

⊕ Restricted to SW Europe, the range extending from northern Africa through the Iberian Peninsula to France and NW Italy. Widespread and generally common.

◈ Flowers and seeds of many crucifers, including *Sinapi arvensis*, *Biscutella laevigata*, *Erucastrum nasturtiifolium*, *Isatis tinctoria*, *Raphanus*, *Moricandia*, *Iberis* etc.

Mountain Dappled White · *Euchloe simplonia*

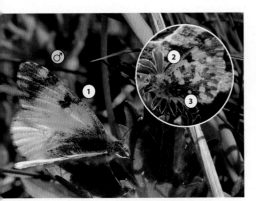

BF N ITALY 6/06 · BF N ITALY 4/06

① Fw discoidal spot
reaching costa and
usually projecting
along costal vein
(cf. *E. ausonia*, *E. crameri*)
② Hw costa angled
③ Hw uns green with
irregular white spots
⊛ Sexes similar

Closely resembles *E. crameri*; endemic to Europe, confined to the mountain ranges in W Alps, the Pyrenees and Cantabrian Mts. One brood between early May and July, depending on altitude, in alpine meadows, mountain slopes and rocky outcrops usually above 1,500 m. Larva feeds on many crucifers (*Aethionema*, *Iberis*, *Biscutella*).

Eastern Dappled White · *Euchloe ausonia*

TN TURKEY ANKARA 4/10 · PO S TURKEY ALANYA 4/09

① Fw outer margin slightly
rounded or straight
② A black spot with white
centre not reaching
costa (cf. *E. simplonia*)
⊛ Sexes similar

Very similar to *E. crameri*; widespread and common in SE Europe from peninsular Italy and Sicily eastwards. Two overlapping broods between March and July in hot and dry agricultural land, roadsides and warm south-facing slopes up to 1,600 m. Larva feeds on many crucifers in the genera *Aethionema*, *Isatis*, *Iberis*, *Sinapis*, *Biscutella* etc.

Portuguese Dappled White · *Euchloe tagis*

R esembles *E. crameri* and *E. ausonia*; very patchily distributed and locally uncommon from S Portugal to S France and NW Italy. One brood in April-May in agricultural land, dry rocky slopes and gullies typically on calcareous land below 1,000 m. Larva feeds on flowers and young seed capsules of several *Iberis* species.

① Ups chalky white with a dusting of black scales at the base
② Black spot rectangular at fw cell
③ Hw costa smoothly rounded
④ Hw green with small white rounded spots
★ Sexes similar
★ Marked regional variation in hw uns white markings
★ Smaller than *E. crameri*

Corsican Dappled White · *Euchloe insularis*

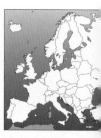

E ndemic to Europe; confined to Corsica and Sardinia, where common and widespread in dry scrub, rocky mountain slopes and gullies up to 1,300 m. Two broods; 1st brood in March–April more abundant than partial 2nd brood in May–June, sometimes recorded in the late summer. Larva feeds on crucifers (*Sinapis*, *Iberis*, *Hirschfeldia incana*).

① Hw uns green spotted with white
② Hw costa angled
★ Sexes similar

PO S SPAIN 5/08 · YML SPAIN 6/2006

WS FRANCE CORSICA 5/08 · WS FRANCE CORSICA 5/08

GREEN-STRIPED WHITE · *Euchloe belemia*

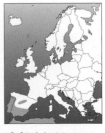

TH S SPAIN SIERRA NEVADA 4/10 · HA S SPAIN 5/08

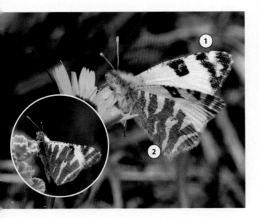

① Ups white with a black tip containing white spots
② Hw uns green with white stripes
✶ Sexes similar

estricted to SW Europe; generally common in S Spain and S Portugal, also recorded on Malta. Two overlapping broods from February to early June, rarely in the late summer, in agricultural land, scrubby grasslands and open woodland up to 1,300 m. Larva feeds on crucifers (*Sisymbrium*, *Biscutella*, *Diplotaxis*, etc.).

GREEN-STRIPED WHITES ON THE CANARY ISLANDS
Euchloe eversi · *Euchloe grancanariensis* · *Euchloe hesperidum*

① *Euchloe eversi*
② *Euchloe hesperidum*
✶ Similar to *E. belemia* but somewhat smaller
✶ On the Canary Islands only

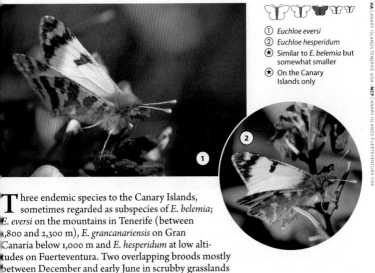

HA CANARY ISLANDS TENERIFE 3/04 · MCP CANARY ISLANDS FUERTEVENTURA 1/09

hree endemic species to the Canary Islands, sometimes regarded as subspecies of *E. belemia*; *E. eversi* on the mountains in Tenerife (between 1,800 and 2,300 m), *E. grancanariensis* on Gran Canaria below 1,000 m and *E. hesperidum* at low altitudes on Fuerteventura. Two overlapping broods mostly between December and early June in scrubby grasslands and open woodland. Larva feeds on local crucifers.

Greenish Black-tip · *Euchloe charlonia*

TH W MOROCCO AGADIR 1/09 · TH W MOROCCO AGADIR 1/09

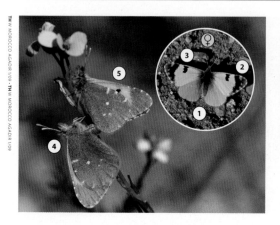

① Ups sulphur-yellow
② An apical patch dark brown with pale distal markings
③ A discoidal spot solid black (cf. *E. penia*)
④ Hair-collar rose-pink (cf. *E. penia*)
⑤ Fw uns a black discoidal spot
★ Sexes similar

I n Europe recorded only on the Canary Islands (Fuerteventura, Lanzarote, Graciosa); widespread in N Africa. Usually two broods between December and May in dry habitats, including cultivated land, arid valleys and hot rocky slopes with sparse vegetation below 400 m. Larva feeds on *Reseda* and *Carrichtera*.

Spanish Greenish Black-tip · *Euchloe bazae*

BF S SPAIN 4/09 · BF S SPAIN 4/09

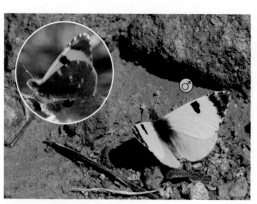

★ Externally similar to *E. charlonia*; sometimes regarded only as a subspecies or form

E ndemic to Europe; only two isolated areas in Spain (Granada, Lleida district), probably representing distinct subspecies. Evaluated as Vulnerable in Europe; very local but sometimes common and observed outside the habitat. Mostly two broods between late February and late May in hot and dry hills and gulleys up to 800 m. Larva feeds on *Eruca vesicaria*.

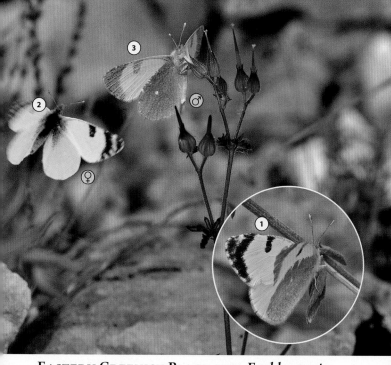

EASTERN GREENISH BLACK-TIP · *Euchloe penia*

This butterfly inhabits spectacular limestone slopes in Greece, where sparse vegetation grudgingly provide sustenance for grazing animals. As the grazing pressure reaches its limits nothing readily accessible is left growing, only the most precipitous slopes providing precarious footholds for tessellated stock (*Matthiola tessela*), the host plant of the Eastern Greenish Black-tip's caterpillar. The adults fly rapidly over the rocky landscape and are practically unapproachable in sunny weather, but in cloudy conditions both sexes pause for a moment now and then to bask on warm rocks with their wings half-open.

⊗ *Euchloe charlonia*

① Ups sulphur-yellow
② Hair-collar pale yellow (cf. *E. charlonia*)
③ Fw uns a discoidal spot shadowy, not solid black (cf. *E. charlonia*)
⊛ Sexes rather similar

🦋 One or two overlapping generations with a prolonged emergence between March and August. Dry scrub, calcareous slopes and precipitous gullies in the mountain ranges between 700 and 1,800 m.

⊕ Very patchy distribution in SE Europe, including Greece, Macedonia, Albania and Bulgaria. Very local and usually uncommon; sometimes males hilltop in larger numbers.

⧆ Exclusively *Matthiola tessela*.

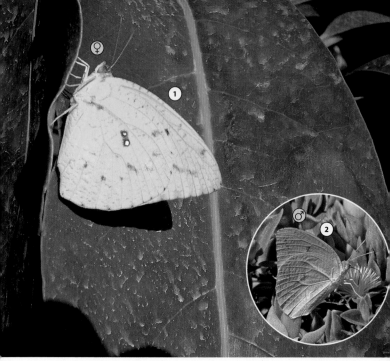

♀ ①

♂ ②

African Migrant · *Catopsilia florella*

A strong migrant species of tropical Africa – sometimes called African Emigrant or Common Vagrant – which has colonised many of the Atlantic islands since the 1960s. The expansion of its range is at least partly due to the fact that many introduced legumes are being widely used as ornamental trees in gardens. It is interesting to note that the colours of the larvae vary according to the plant parts ingested. The colour difference between the sexes is opposite to that of the Brimstone, the males usually being greenish-white on the uppersides and the females deeper yellow.

① Female uns yellow with weak brown markings
② Male uns greenish white
★ Ups never seen at rest
★ Fast on the wing
🦋 Several broods throughout the year without diapause. Natural habitats include savannah, flowery mountainsides and unimproved grasslands; vagrants recorded mostly in lowland cultural environments, such as parks and gardens.

⊕ Resident only in the coastal regions of most Canary Islands. A few migrants recorded in Madeira and Malta; only records from Cyprus at Liopetri, Frenaros and Ayia Napa in Oct/Nov 1986.

◐ Some introduced legumes (*Cassia*).

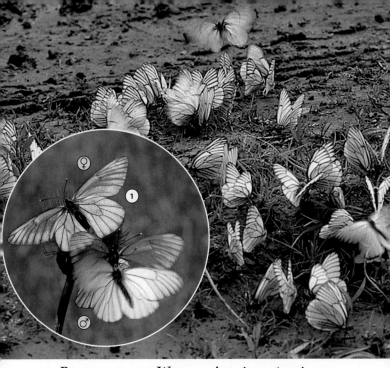

BLACK-VEINED WHITE · *Aporia crataegi*

This elegant 'white' has conquered the entire Palaearctic region. In Russia it is one of the most abundant butterflies, sometimes causing significant damage in fruit orchards due to sudden outbreaks. It is not uncommon to see hundreds or even thousands of Black-veined Whites clustered on puddles along gravel roads or sandy beaches. This puddling habit is particularly typical of males. Dozens of individuals can also be found roosting communally overnight, making this a truly social butterfly. The white wings become almost transparent with age-related wear.

↪ *Parnassius mnemosyne*

① Ups and uns white with strong black veins; female wings more translucent

♈ One generation between late April and July depending on latitude. Various open to semi-shaded habitats often near woodland; forest clearings, orchards, meadows with scrub, roadsides and mountain slopes up to 2,000 m.

⊕ Widespread and generally common throughout Europe, but absent or scarce in most Mediterranean islands, Britain (extinct) and northernmost Fennoscandia (only vagrants); undertakes irruptive migrations in some years.

🜨 Several *Prunus* cultivars and a variety of other woody rosaceous plants of the genera *Prunus*, *Malus*, *Crataegus*, *Pyrus* and *Sorbus*.

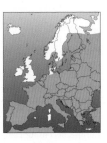

HA RUSSIA VALDAI 6/02 · PO SE FINLAND LAPPEENRANTA 6/10

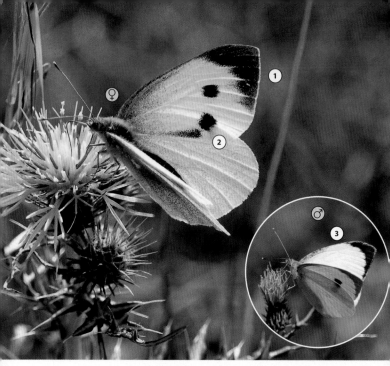

TH S SPAIN 3/07 · TH S GREECE PELOPONNESE 7/10

LARGE WHITE · *Pieris brassicae*

The largest white in Europe is not always as welcome a sight as most butterflies are. Butterflies are usually considered charming creatures. They are beautiful, useful and harmless, enhancing any sunny day. In some years, though, droves of migrating Large Whites arrive in Britain and northern Europe, becoming a serious pest of cultivated cabbages, much to the farmers' and gardeners' annoyance. Within the space of a few short weeks the fresh, juicy cabbage plants may have been thoroughly defoliated by millions of Large White larvae. Thankfully, these huge populations are effectively controlled by natural enemies, mostly parasitic braconid *Apanteles* wasps.

⊙ *Pieris cheiranthi, Pieris rapae*

① Fw ups an apical border black and extensive, extending along the outer margin

② Female ups two black spots and black streak on rear end

③ Male fw ups no spots

🦋 Many overlapping generations from March to October, usually more abundant in the late summer. Several broods almost all year round on the Azores (ssp. *azorensis*) and Cyprus. Vagrants in all types of open landscapes up to 2,500 m in the mountains, but mostly in cultivations and arable land, parks and gardens, roadsides.

⊕ Widespread, resident and generally common over most of Europe, including the Azores (ssp. *azorensis*); an abundant pest of crops during outbreaks. In northern ranges (the British Isles, Fennoscandia) populations are reinforced by annual migrations, sometimes reaching Iceland; a partial southwards migration in autumn.

⚑ A serious pest. A range of cultivated *Brassica* species, *Tropaeolum majus* and *Capparis spinosa*.

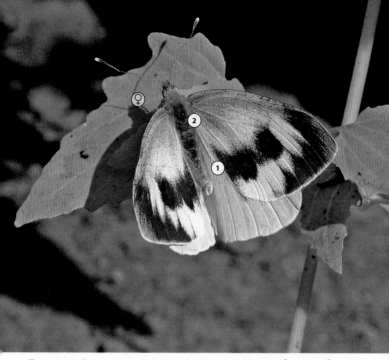

CANARY ISLANDS LARGE WHITE · *Pieris cheiranthi*

Endemic to the Canary Islands; most common in La Palma and N Tenerife, very rare in Lanzarote and extinct in Gomera. Generally in decline; evaluated as Endangered. Several overlapping broods throughout the year in shaded gullies and wet deeply excavated barrancos in the laurel forest up to 1,400 m. Larva feeds on *Tropaeolum majus* and *Crambe strigosa*.

① Female fw ups postdiscal black spots fused into solid band
② Fw ups basal area suffused with grey

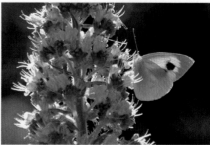

MADEIRAN LARGE WHITE
Pieris wollastoni (no picture)

Endemic to Madeira; sometimes regarded as a subspecies of the Large White, inhabiting north-facing valleys of laurel forest. Probably already extinct due to the virus infection following an introduction of the Small White in the 1950s.

GREEN-VEINED WHITE · *Pieris napi*

An immense range spanning the entire Palaearctic region, combined with adaptations to almost all environment types from sea level to high mountains has led to high variability between local Green-veined White populations. Thus, a large number of forms, subspecies and even potential new species are associated with the broad Green-veined White concept. For example, the fuzzy grey f. *adalwinda* flies only as a single brood in northernmost Fennoscandia. A feature common to the Green-veined White, however, is that it is almost unfailingly among the most abundant butterflies everywhere. The summer brood is easier to distinguish from the Dark-veined White.

⊙ *Pieris bryoniae, Pieris rapae*

① Ups white with dark tips and veins dusted black. In male, fw ups no or a faint black spot, in female two spots

② Hw uns yellowish with veins lined with dark scales

③ f. *adalwinda* (more suffused gray)

🦋 Mainly two or three generations between April and September, depending on altitude and latitude; a partial 4th brood in the southern ranges. Open to semi-shaded habitats; arable land, pastures, roadsides, hedgerows, forest edges and woodland rides, flood-plains, river valleys and various grasslands up to 2,000 m.

⊕ Extremely widespread and generally common throughout the whole Europe; absent only from Atlantic and some Mediterranean islands (incl. Balearic islands, Sardinia, Crete).

🍃 A wide range of wild crucifers, such as *Cardamine, Barbarea, Hesperia, Sisymbrium, Sinapis, Lunaria, Capsella, Arabis, Armoracia,* etc. Seldom a pest on cabbage cultivations.

TH S FINLAND SALO 5/08 · HA SE FINLAND JOUTSENO 5/05 · TH N FINLAND KILPISJÄRVI 7/87

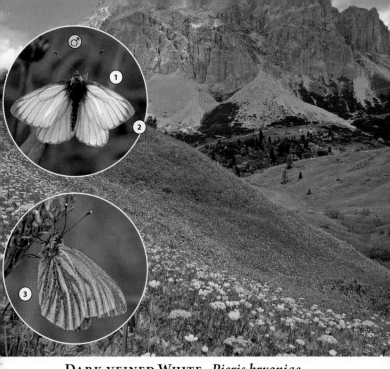

DARK-VEINED WHITE · *Pieris bryoniae*

Sometimes aptly called Mountain Green-veined White, as this species replaces its more common relative at higher altitudes in the Alps and Carpathian Mountains. The heavy suffusion on the wings, especially in females, is very distinctive, but some lepidopterists do not consider these as two separate species. Although the two hardly interbreed, the northernmost Green-veined Whites near the Arctic Ocean do closely resemble Dark-veined Whites. A darker colouration is an obvious adaptation to harsh and colder conditions at higher altitudes, as darker tones absorb warmth more readily.

⊘ Pieris napi

① Ups grey-white with dark base, male
② Tips of the veins black on both wings
③ Hw uns distinctive dark-bordered veins
★ Closely resembles the spring brood of *P. napi*; the two taxa hybridize where ranges overlap

✶ Usually one generation between early June and late July, a small 2nd brood in August–September at lower altitudes. Stream margins, boggy areas near damp alpine meadows and tundras typically between 800 and 2,700 m.

⊕ A montane species confined to Jura Mts and the Alps in C Europe and Tatra Mts and the Carpathians in the east; also in Ural Mts. and the Caucasus in Russia. Widespread and generally common in the habitat.

⬥ Many crucifers, such as *Arabis*, *Biscutella*, *Cardamine* and *Thlaspi*.

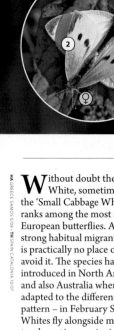

SMALL WHITE · *Pieris rapae*

Without doubt the Small White, sometimes called the 'Small Cabbage White', ranks among the most successful European butterflies. As it is a strong habitual migrant, there is practically no place one can avoid it. The species has been introduced in North America, and also Australia where it has adapted to the different seasonal pattern – in February Small Whites fly alongside many spectacular native species in Sydney. In Britain it is one of the most commonly encountered species in gardens. Small Whites are very fond of all kinds of flowers but the species has a soft spot for lavender in particular.

> *Pieris mannii, Pieris ergane*

① Fw ups a greyish apical patch extends further along costa than outer margin (cf. *P. mannii*)

② Female fw ups with two black spots, male with one

🦋 Up to five consecutive generations from March to November; all year round on the Canary Islands and Cyprus. Vagrants almost everywhere up to 3,000 m; mostly in cultivated lands and arable fields, various grasslands, roadsides, gardens and other urban areas.

⊕ Widespread and generally very common across all of Europe, including all Atlantic islands. In the northern ranges populations are reinforced by annual migrations. Usually most abundant in the late summer.

⋔ A common pest on cultivated cabbages (*Brassica*). A wide range of other crucifers (*Sinapis, Raphanus*), *Tropaeolum majus* and species of *Capparis, Reseda, Atriplex*, etc.

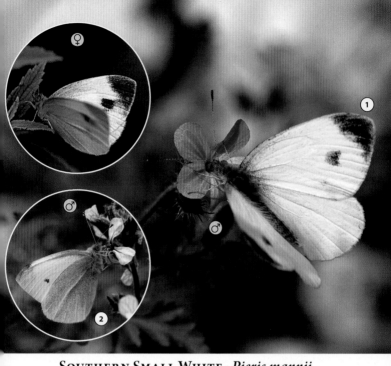

SOUTHERN SMALL WHITE · *Pieris mannii*

The small whites are common butterflies that are seen in vast numbers in various environments almost throughout the summer. Their identification on the wing, however, is no easy matter, as there are several species of rather similar appearance. Confusion is increased by differences between both sexes and broods during the course of the summer. In general, the wings of males and spring generation butterflies sport less black markings than females and representatives of subsequent broods. In the spring brood, however, the hindwing underside is more yellow and suffused with black scales.

⊙ *Pieris rapae*
 Pieris ergane

① Fw ups a black apical patch extends as far along outer margin as along costa (cf. *P. rapae*)

② Hw uns grey dusting equally dense on both sides of the cell

🦋 Two to four consecutive generations from March to October. Dry scrubland, open woodland and rocky slopes up to 2,000 m.

⊕ Widespread but rather local in SE Europe, including Mediterranean islands Sicily and Samos; very patchily distributed in the western range. Usually numerous in its habitat, with puddling habit typical of males on damp soil.

◐ A few candytufts (*Iberis sempervirens* and *I. saxatilis*)

OV: S BULGARIA 6/06 · ♂♀: E BULGARIA STARA PLANINA 7/99 · TH: S SPAIN SIERRA NEVADA 3/07

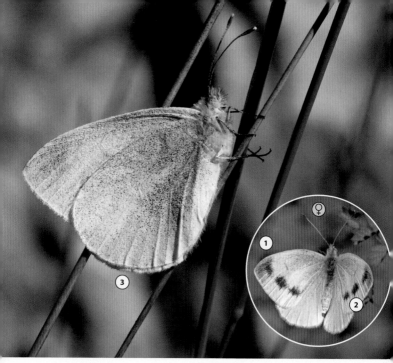

MOUNTAIN SMALL WHITE · *Pieris ergane*

Mountain Small Whites are usually noticeably smaller and whiter than other pierids, thus rather easy to distinguish in alpine regions. This and six other 'small whites' have been described by some authors as comprising a distinct genus (*Artogeia*) based on their adult morphology. This separation, however, has not convinced the majority of lepidopterists, which retain them in the genus *Pieris*. Males of this species often gather in large numbers on damp soil and extract valuable minerals from the moist earth to improve their reproductive success.

⊙ *Pieris rapae*
 Pieris mannii

① Fw ups a grey apical mark square
② Female fw ups two black spots, none or faint in male
③ Hw uns yellowish/grey
★ A weak flight pattern
★ A small mountain species

♈ Two or three generations from April to August, depending on locality. Hot and dry rocky slopes and scrubby grasslands with xerophytic vegetation on calcareous land, typically between 1,000 and 2,000 m in the mountains.

⊕ An alpine species with very patchy distribution in S and SE Europe. Very local and rare in the western range (Spain, France, Italy), more common and sometimes locally abundant in the Balkans.

◈ Usually *Aethionema saxatile*, seldom other *Aethionema* or *Isatis* species.

Balkan Green-veined White · *Pieris balcana*

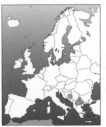

PO S BULGARIA 7/09 · PO S BULGARIA 7/09

- ★ Closely resembles *P. napi*; hw uns veins less defined
- ★ Note. There is no reliable evidence that *P. balcana* is a separate species. The original character, chromosome number, has been shown to be variable and to overlap with *P. napi*

Taxonomic status unclear; sometimes treated as a subspecies of *P. napi*. Endemic to Europe; recorded only from Croatia to SW Bulgaria and N Greece. Very local in the mountain ranges near woodlands, up to 2,100 m in typical *P. napi* habitats, has two or three broods from April to October. Larva feeds on various crucifers.

Krueper's Small White · *Pieris krueperi*

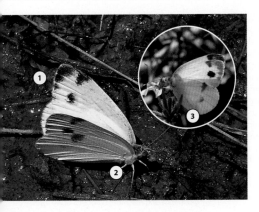

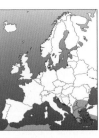

AB TURKEY OZLUCE 8/06 · TH S TURKEY ANTALYA 9/09

- ① Ups white with a series of black triangles at outer part of fw
- ② Hw uns with greenish basal and discal areas
- ③ Hw uns spots reduced in summer and autumn broods

Confined to SE Europe in S Balkans and Greece, including Corfu, Samos, Chios, Kos and Crete; widespread but very local. Three to four overlapping broods between late February and early October in arid habitats with scanty vegetation, such as screes, rocky hillsides and steep slopes, usually on calcareous soils up to 2,000 m. Larva feeds on crucifers (*Alyssum*).

BATH WHITE · EASTERN BATH WHITE
Pontia daplidice · Pontia edusa

TH S ITALY ARGENTARIO 6/09 · TH SPAIN CATALONIA 10/07

The western *Pontia daplidice* and eastern *P. edusa* are considered biologically distinct sibling (semi)species. As they cannot be distinguished from each other by any traditional means and their ranges probably overlap in parts of Europe, they are usually treated as a *daplidice* complex. To be certain which one you have encountered, you need to have the butterfly tested in a hi-tech laboratory! Biochemical differences between the species are said to be strong enough to preclude interbreeding. Both are very fast fliers with nomadic tendencies, continuously searching for young *Reseda* plants for their offspring.

⊙ *Pontia chloridice*
 Pontia callidice

① Hw uns olive-green with white regular markings broadening inwards (cf. *P. chloridice*)
② Fw uns a black discoidal spot reaching costa
③ Ups white with black tip containing a number of white spots broadening inwards

🦋 Two to four overlapping generations between March and October; all year round on the Canary Islands and Cyprus. Summer and autumn broods are usually more numerous. Most types of open landscapes; sandy beaches and barren grounds, arable land, neglected cultivations, grasslands and roadsides, vagrants up to 2,900 m.

⊕ Widely distributed across most of Europe, but fluctuates more in northern parts of the range; annual migrations reinforce populations in NW Europe, the Baltic states and S Fennoscandia. Most common in southern parts of the range.

⬥ Several species of *Reseda*, also many crucifers (*Descurainia, Sisymbrium, Arabis, Alyssum, Iberis, Sinapis* etc.).

■ daplidice
■ edusa

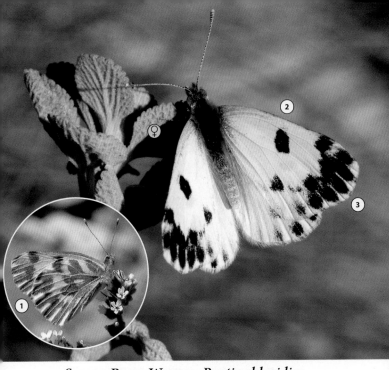

SMALL BATH WHITE · *Pontia chloridice*

One of Europe's rarest butterfly species, this species has very local colonies in Greece, Macedonia and Bulgaria only. However, further east it inhabits boundless dry steppe from Ukraine through the whole Asia to Mongolia. In 1970, a huge migration of Eastern Bath Whites originated from areas south of Moscow and reached Finland in late July. During the next two weeks, at least 15 Small Bath Whites were spotted among thousands of the commoner species. It was estimated that one percent of the total influx comprised this rarity, which has not been recorded in Finland since.

⊙ *Pontia daplidice/edusa*

① Fw uns outer region green with white linear stripes (cf. *P. daplidice*)

② Fw ups and uns a black discoidal spot far from costa

③ Fw ups marginal white spots broadening outwards (cf. *P. daplidice*)

★ Smaller than *P. daplidice*

♈ Mostly two generations; 1st brood in April–May, 2nd brood in June–July. Hot and dry environments under regular disturbance; gravely river banks and riverbeds under periodic water flows, usually at lowlands below 600 m, but considerably higher in Cyprus and more eastern range.

⊕ Restricted to SE Europe, including Cyprus, C and E Balkan Peninsula and E Ukraine; more widely distributed in S Russia. Recorded as a rare vagrant in E Europe up to S Finland in the north.

⚭ *Cleome ornithopodioides* is the only confirmed foodplant in Europe.

MCP CYPRUS 11/09 · MA TURKEY 7/08

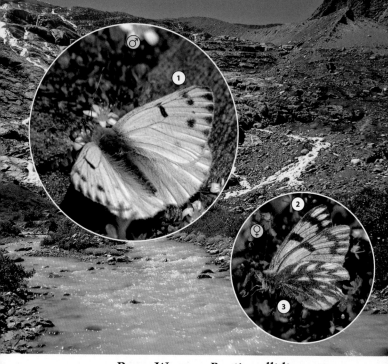

① ♂

② ♀

③

PEAK WHITE · *Pontia callidice*

HA SWITZERLAND 8/07 · HA N ITALY 7/07 · TM N ITALY 7/07

To be sure of seeing this beautiful but fast flying butterfly, one would have to climb among the highest peaks in the Alps. However, it occasionally wanders to other areas. In 2004 Finnish lepidopterists were astounded by the arrival of a huge migration of Black-veined Whites from the Ural mountains. There were probably millions of individuals, some of which were recorded up to northernmost Lapland, and during the migration, one Peak White was captured in Utsjoki! This was a strong indication of the flying power of this and related pierids, a group known as the 'bath whites'.

⦿ *Pontia chloridice*
 Pontia daplidice

① Male fw ups white with black spots and triangles on the tip
② Female fw ups heavily marked with oval or triangular white spots in brown tip
③ Hw uns greenish chevrons

✠ Usually one generation from early June to late July, often amongst the first alpine species; a partial 2ⁿᵈ brood in the Pyrenees. Alpine grasslands and slopes, barren terrain near glaciers and mountain summits, usually between 1,500 and 3,400 m.

⊕ An alpine species with scattered distribution in high mountains of the Alps and the Pyrenees. Rather local and uncommon. Climbs up to 4,500 m in the far east.

⬘ Mainly some crucifers (*Erysimum, Cardamine, Hutchinsia*), but also *Reseda glauca*.

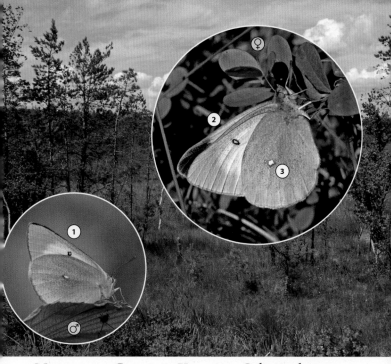

Moorland Clouded Yellow · *Colias palaeno*

In the Fennoscandian region, the Moorland Clouded Yellow is without doubt the most common representative of the yellows' right up to the shores of the Arctic Ocean, though it becomes scarcer in the south. Landscapes in the region are dominated by huge peat bogs and mires, especially further north, where bog bilberry, a widespread dwarf scrub of wetlands, also commonly grows in woodlands. Since there is plenty of food for the larvae, the adults also fly in large numbers. Roving by nature, individuals settle only to fuel up briefly at wetland or woodland flowers. The short summer produces smaller and paler individuals compared to the species' southern relatives.

① Male wings greenish-yellow with thin reddish borders
② Female ups white
③ Hw uns white spot in the centre
★ Ups never seen at rest
★ Male looks yellow and female white on the wing

🦋 One generation between late June and early August, depending on altitude and latitude. Peat bogs, mires and moorland at low altitudes in the northern range, also shrubby areas and heathy sites at higher altitudes up to 2,500 m in the southern range.

⊕ Widespread in E and N Europe extending from N Romania to most of Fennoscandia; very local in southern parts of the range, most western populations in Jura Mts in France. Substantial declines throughout its range due to drainage of wetlands.

🍂 Mainly northern bilberry (*Vaccinium uliginosum*), seldom *Vaccinium myrtillus*.

CLOUDED YELLOW · *Colias crocea*

L̲ike all its kin, the Clouded Yellow is an excellent flier. It is a notable migrant that can easily travel up to thousands of kilometres, reaching the British Isles and southern Finland during favourable years. The most wide-spread *Colias* species in Europe, it is also the only one recorded on all the Atlantic islands from the Canaries to the Azores, where the pale yellow form of the female (*helice*) is commonest. Since the larvae are unable to survive the winter north of the Alps, the Clouded Yellow is a permanent resident only of the warm Mediterranean region.

⊙ *Colias myrmidone*
 Colias chrysotheme
 Colias aurorina

① Uns yellow with greenish tinge on hw and outer edge of fw
② Male fw base broadly orange, black spots on outer part
③ Male on the wing
④ Female f. *helice*, fw base whitish
✷ Ups never seen at rest

🦋 Several consecutive broods from March to November; all year round on the Canary Islands and Cyprus. Mostly on the late summer in the northern range. A wide range of open warm and dry flowery grasslands up to 3,000 m in the mountains, but usually at low altitudes.

⊕ Generally widespread and very common in most of Europe, including almost all oceanic islands; a strong tendency to irruptive migrations. In the north of the range annual numbers fluctuate greatly depending on migrations and season.

⬙ A wide range of legumes (*Vicia*, *Lotus*, *Medicago*, *Trifolium*, *Coronilla*, *Astragalus*, *Melilotus*, *Hippocrepis*, etc.).

DANUBE CLOUDED YELLOW · *Colias myrmidone*

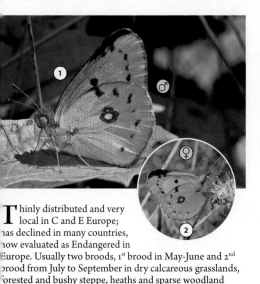

① Fw uns largely orange with a yellow or greenish border
② Female hw uns a row of light patches on outer margin
★ Female f. *alba* whitish
★ Ups never seen at rest

Thinly distributed and very local in C and E Europe; has declined in many countries, now evaluated as Endangered in Europe. Usually two broods, 1st brood in May-June and 2nd brood from July to September in dry calcareous grasslands, forested and bushy steppe, heaths and sparse woodland at lowlands. Larva feeds on brooms (*Chamaecytisus*).

LESSER CLOUDED YELLOW · *Colias chrysotheme*

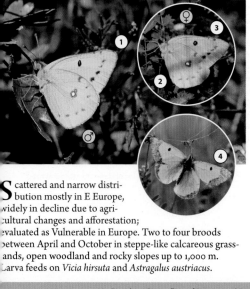

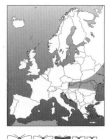

① Fw apex pointed
② Uns pale yellow, female heavily dusted with grey scales
③ Dark postdiscal spots well developed
④ Male ups dark borders crossed by yellow veins
★ Female ups dark borders with yellow spots
★ Ups never seen at rest

Scattered and narrow distribution mostly in E Europe, widely in decline due to agricultural changes and afforestation; evaluated as Vulnerable in Europe. Two to four broods between April and October in steppe-like calcareous grasslands, open woodland and rocky slopes up to 1,000 m. Larva feeds on *Vicia hirsuta* and *Astragalus austriacus*.

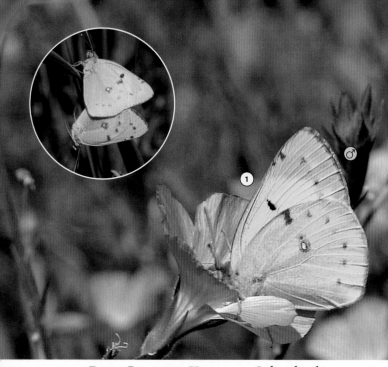

PO SLOVENIY 6/06 · TH S ESTONIA 7/06

PALE CLOUDED YELLOW · *Colias hyale*

Y ou spot a speeding 'clouded yellow', but which one is it? Berger's Clouded Yellows looks almost identical to Pale Clouded Yellows, especially the females. The ecology of the two species, however, differs. While *C. alfacariensis* predominates in the Alps and more southern regions as sedentary colonies associated with horseshoe vetch, *C. hyale* roves rapidly over a wide range of open terrain, the larvae being less choosy about their diet. Although both species have a tendency to migrate, only the Pale Clouded Yellow has occasionally reached the Arctic Circle in the far north.

⊙ *Colias alfacariensis*

① Male uns bright lemon yellow, with a row of blackish spots on both wings

⊛ Resembles closely *C. alfacariensis*; a wing tip somewhat sharper

⊛ Ups never seen at rest

⊛ Male looks yellow and female white on the wing

♈ Two or three generations between May and October. Usually more common in the late summer. Disturbed grounds, arable land and cultivations, especially alfalfa and clover fields up to 2,000 m.

⊕ Widespread and locally common through most of C and E Europe; generally absent from the Mediterranean region. Mainly as a rare migrant in S Britain and S Fennoscandia; annual numbers vary markedly in the northern range.

⬙ A range of leguminous plants in the genus *Medicago*, *Lotus*, *Trifolium*, *Vicia*, etc.

BERGER'S CLOUDED YELLOW · *Colias alfacariensis*

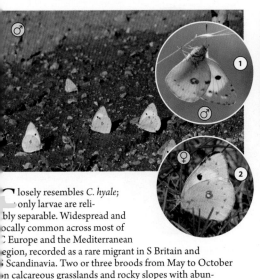

TM5 TURKEY ALANYA 9/08 · PO5 GREECE PELOPONNESE 6/10 · TM5 FRANCE 5/06

① Male uns lemon yellow
② Female fw uns whitish with yellow tip
✱ Hw ups discoidal spot large and deep orange
✱ Very similar to *C. hyale*; fw outer margin and apex more rounded
✱ Ups never seen at rest

Closely resembles *C. hyale*; only larvae are reliably separable. Widespread and locally common across most of C Europe and the Mediterranean region, recorded as a rare migrant in S Britain and S Scandinavia. Two or three broods from May to October on calcareous grasslands and rocky slopes with abundant LHPs, *Hippocrepis comosa* (rarely *Coronilla varia*).

EASTERN PALE CLOUDED YELLOW · *Colias erate*

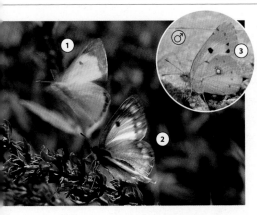

BF HUNGARY 8/02 · PO5 BULGARIA 7/09

① Male ups lemon yellow with black marginal border
② Female ups yellow or whitish, dark borders with pale spots
③ Uns bright yellow, with large black spots on fw
✱ Closely resembles *C. crocea* (natural hybrids recorded); usually no oval androconial patch at the base of hw ups

Very polymorphic species with scattered distribution in E Europe, but expanding westwards via regular migrations. Three or more broods from March to October, usually most numerous in the late summer, in alfalfa fields, grassy slopes and various lowland grasslands often with scrub. Larva feeds mainly on *Medicago*, rarely on other legumes (*Trifolium, Onobrychis, Melilotus*, etc.).

BALKAN CLOUDED YELLOW · *Colias caucasica*

TH N GREECE VARNOUS 6/06 · LP GREECE MACEDONIA PERISTERI 7/93 · TH N GREECE VARNOUS 6/06

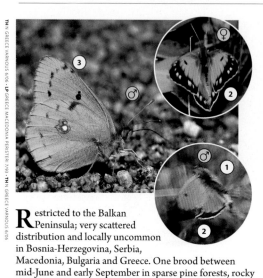

R estricted to the Balkan Peninsula; very scattered distribution and locally uncommon in Bosnia-Herzegovina, Serbia, Macedonia, Bulgaria and Greece. One brood between mid-June and early September in sparse pine forests, rocky slopes and alpine grasslands usually near to the tree line between 800 and 2,300 m. Larva feeds on *Chamaecytisus*.

① Ups deep orange, flying male looks like a large copper

② Ups dark marginal borders, yellow spots on female but not on male

③ Uns submarginal spots dark and strong (cf. *C. myrmidone*)

(★) Ups never seen at rest

(★) The name *C. balkanica* has been used of the Balkan populations

GREEK CLOUDED YELLOW · *Colias aurorina*

TH S TURKEY CIMI 6/07 · TH S TURKEY CIMI 6/10

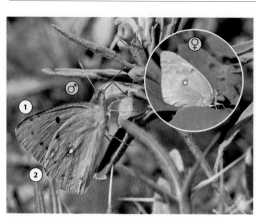

C onfined to the mountain ranges in Greece with local colonies between 500 and 2,400 m. More common in the Caucasus, where climbs up to 3,000 m. One brood from early May to mid-August in mountain fields and open xerophilous habitats with scrub and abundant LHPs, *Astragalus thracicus* and *Astracantha rumelica*.

① Fw uns greenish-yellow with golden discal flush

② Hw outer margin slightly angled

(★) Closely resembles *C. crocea*; somewhat sharper fw tip

(★) Male ups deep orange with purple iridescence

(★) On the wing shining gold with pinkish iridescence

(★) The name *C. libanotica* has also been used

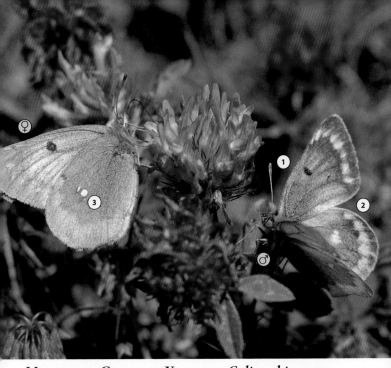

MOUNTAIN CLOUDED YELLOW · *Colias phicomone*

Many closely related *Colias* species hardly differ at all in regard to their general morphology, but do so markedly in their sexual traits. Ultraviolet patterns on the wings, in particular, are involved in species recognition and sexual selection. Based on these features, the European *Colias* species form three monophyletic clades corresponding broadly to their geographical distributions. The Scandinavian clade is the oldest in Europe, having later on radiated over the rest of Europe to give rise to an eastern and a western clade. The Mountain Clouded Yellow is a member of the latter.

→ *Colias tyche* (but the ranges do not overlap)

① Male ups greenish yellow, heavily dusted with grey

② Dark bands on the outer margin contain pale spots

③ Hw uns yellow-green with white spot bordered with red

✱ Ups rarely seen at rest

🦋 One generation between early June and mid-August, a small 2nd brood possible in favourable conditions. Alpine/subalpine meadows and pastures and mountain slopes typically between 1,000 and 2,500 m.

⊕ Endemic to Europe; an alpine species with very scattered distribution in Cantabrian Mts, the Pyrenees, the Alps and limited parts of Carpathians in Romania. Evaluated as Near Threatened in Europe; generally local but sometimes common in its habitat.

◮ Several legumes (*Hippocrepis comosa*, *Trifolium repens*, *Lotus corniculatus*).

HA AUSTRIA 7/07

PALE ARCTIC CLOUDED YELLOW · *Colias tyche*

HA N FINLAND KILPISJÄRVI 7/05 · HA N SWEDEN ABISKO 6/03 · PO N FINLAND KILPISJÄRVI 7/10

A real enigma for arctic lepidopterists. At first this species was considered a hybrid between *Colias hecla* and *C. nastes*. Then it was regarded as a subspecies of *C. nastes*, but Russian entomologists later declared it a subspecies of *C. tyche*, a species inhabiting Siberia and Mongolia. Some morphological studies, however, indicate that the Pale Arctic Clouded Yellow is distinct from both *C. nastes* and *C. tyche*, and and the butterfly should be called *C. werdandi*. In the butterfly's restricted European range in Fennoscandia yellow-orange forms (f. *christiernssoni*) are sometimes seen. These are regarded as hybrids between *C. tyche* and *C. hecla*!

⊙ *Colias phicomone*

① Male uns white, hw heavily dusted with grey scales
② Hw uns a small discoidal spot
③ Female fw uns whitish, ups suffused
⊛ Ups never seen at rest
⊛ Only in the most northerly parts of Europe

🦋 One generation from late May to early July. Scrubby heaths at lower altitudes, marshes in the birch zone, grassy humid mountain slopes and alpine grasslands mostly on calcareous soils up to 1,100 m.

⊕ Restricted distribution in N Fennoscandia; very patchily distributed but locally common in N Norway N Sweden and N Finland. Overgrazing by reindeer may pose a threat to the species.

🌿 Mainly *Astragalus frigidus* and *A. alpinus*.

NORTHERN CLOUDED YELLOW · *Colias hecla*

The great fells of north-ernmost Scandinavia are the places to see the Northern Clouded Yellow, existing at that altitude as the European subspecies *sulitelma*. The insect flies faster than the Pale Arctic Clouded Yellow, which is on the wing at the same time. Only very bright sunshine persuades the butterflies to take wing; if there is even a hint of rain or mist on the way, they take shelter among twigs and leaves. The species is also found in a different lowland habitat, along the thyme-rich sandy river banks by the River Teno on the border between Finland and Norway. The nominate subspe-cies is confined to Greenland.

➔ *Colias tyche*

① Male fw uns greenish yellow with an orange patch in the centre
② Female uns heavily dusted with dark scales
③ Hw uns with an orange discoidal spot
★ Ups never seen at rest
★ Only in the far north of Europe

🦋 One generation from mid-June to late July. Alpine grasslands, rocky slopes and ledges, tundras and fell slopes above the tree line up to 900 m, rarely sandy riverbanks at lower altitudes.

⊕ Very narrow distribution restricted to N Fennoscandia; very scattered distribution but locally common in N Norway, N Sweden and N Finland. The range extends eastwards to Polar Russia. Evaluated as Near Threatened in Europe; overgrazing by reindeer poses a possible threat to the species.

🌼 Mainly *Astragalus alpinus* and *A. frigidus*.

BRIMSTONE · *Gonepteryx rhamni*

The Brimstone is suspected to be the species on which the name 'butterfly' – or 'butter-coloured fly' – is actually based. Undoubtedly, it is one of the most widely known butterflies throughout its vast range. Since adults overwinter, hibernating in stands of ivy or lingonberry sprigs covered with snow, they are ready to fly on the first warm days of spring. Males, with their bright yellow wings, appear a few days earlier than the greenish-white females. Due to its prolonged hibernation period, an adult Brimstone can live for more than a year, giving it one of the longest lifespans among European butterflies.

⊙ *Gonepteryx farinosa*
 Gonepteryx cleopatra

① Ups brilliant yellow, flying male

② Fw costa slightly concave (cf. *G. farinosa*)

③ Apical hook well developed (cf. *G. farinosa*)

✪ Ups never seen at rest

♋ One generation between May and September, and after hibernation from March to early June, both depending on locality. Open mixed and deciduous woodland, forest edges and clearings, bushy damp meadows and also various cultural environments, up to 2,500 m in the mountains.

⊕ Widespread and generally very common through most of Europe, but more irregular in N Fennoscandia and N British Isles (mostly vagrants). Absent only from the Atlantic islands, Balearic islands and Crete.

◭ Various buckthorns including *Frangula alnus*, *Rhamnus catharticus*, *R. alaternus*, etc.

TM S FRANCE MARITIME ALPS 5/06 · HA SE FINLAND RUOKOLAHTI 7/07

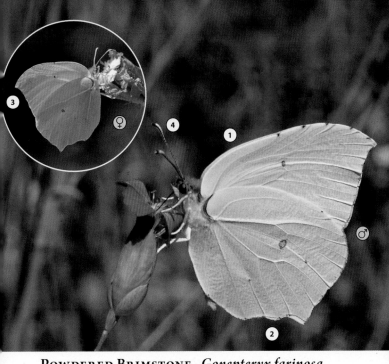

POWDERED BRIMSTONE · *Gonepteryx farinosa*

It is a headache to separate this species from the Brimstone in the field. The two species fly in the same habitat. The Powdered Brimstone is a little larger and more rounded in shape, and the male is also more lemon yellow compared to the deep yellow Brimstone, but these differences are subtle. In the male, forewings and hindwings have slightly contrasting colouring in flight, but this too is difficult to detect. However, with a close view the Powdered Brimstone' hindwing has a distinctively shaped outer margin – the tail is somewhat shorter than in Brimstone, and the margin is clearly scalloped, giving a wavy edge.

➢ *Gonepteryx rhamni*
Gonepteryx cleopatra

① Fw costa rounded
(cf. *G. rhamni*)
② Hw margin scalloped
③ A weak apical hook
(cf. *G. rhamni*)
④ Antennal club white or
pink above (cf. *G. rhamni*)
⊛ Male bright yellow,
female greenish yellow
⊛ Ups never seen at rest

🦋 One generation between June and August, and again in March–April after the hibernation. Arid light woodland, hot coastal hills, scrubby slopes and rocky canyons up to 2,300 m.

⊕ A limited range in SE Europe; patchily distributed and locally uncommon in Greece and S Balkans.

✿ Various buckthorns (*Rhamnus*) and *Paliurus spina-christi*.

PO GREECE PELOPONNESE 6/09 · TH S TURKEY ANTALYA 6/10

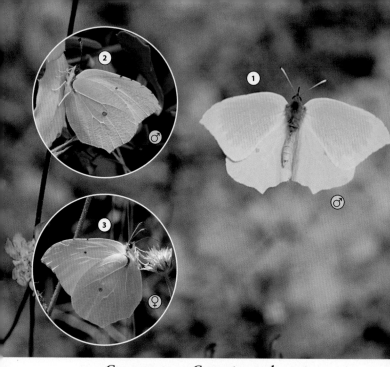

CLEOPATRA · *Gonepteryx cleopatra*

AML SPAIN CATALONIA 7/10 · HA GIBRALTAR 5/08 · HA SPAIN TERUEL 7/08

This dazzling butterfly of the Mediterranean emerges from hibernation in early spring, just as the first colourful flowers are coming into bloom. It is very similar to the Brimstone in general shape and pattern, but is somewhat larger, and the males have an extensive bright orange flush across the forewings that stands out from a distance when the butterfly is in flight. At rest, the orange area is much less obvious and the Cleopatra may then be confused with the Brimstone. Altogether ten subspecies of the Cleopatra include *insularis* in Crete, *fiorii* in Rhodes and *taurica* in Cyprus.

⊙ *Gonepteryx farinosa*
Gonepteryx rhamni

① Male on the wing
② Male fw uns pale green with an orange flush
③ Female uns pale yellow with blue-green tinge
★ Ups never seen at rest
★ Larger than *G. rhamni*

🜨 One generation between mid-May and early August, and again in February–April after hibernation; recorded all year round on Cyprus. Open woodland, scrubby and rocky hills up to 1,600 m.

⊕ Rather widespread and locally common in S Europe across the Mediterranean region, extending from Iberian Peninsula in west to peninsular Italy, Greece and Cyprus in east. Northernmost records from Switzerland and Bulgaria are probably mostly of vagrant individuals.

🜂 Various buckthorns (*Rhamnus*) such as *R. catharticus*, *R. alaternus*, etc.

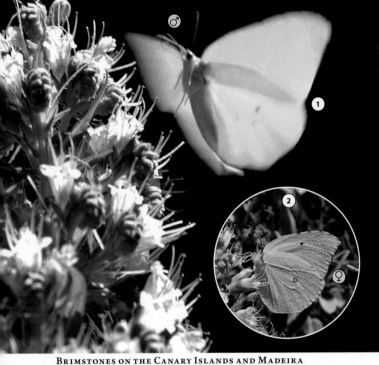

BRIMSTONES ON THE CANARY ISLANDS AND MADEIRA
Gonepteryx cleobule · G. palmae · G. eversi · G. maderensis

Studies on molecular phylogeny have revealed three endemic brimstone species on the Canary Islands; *G. cleobule* on N Tenerife, *G. palmae* on La Palma and *G. eversi* on Gomera. Recorded all year round, mostly between April and September, in open laurel woodland between 300 and 2,000 m. Uncommon and probably in decline; evaluated as Vulnerable.

Madeiran Brimstone (not illustrated) is endemic to Europe; very rare in Madeira with only five local populations, in decline, threatened by habitat loss of pristine laurel forests. Evaluated as Endangered. Recorded all year round, but most often between April and September in dense laurel forests between 500 and 1,500 m.

① *G. palmae*
② *G. cleobule*
③ *G. eversi*
✱ Fw ups both sexes orange, male colour very bright, extending almost to margins
✱ *G. maderensis* male ups largely orange with narrow yellow marginal borders
🍃 Larva feeds on *Rhamnus glandulosa, R. crenulata.*

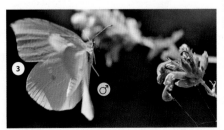

LYCAENIDAE · I

METALMARKS, COPPERS AND HAIRSTREAKS
DUKE OF BURGUNDY · *Hameiaris lucina* – ORANGE-BANDED HAIRSTREAK · *Satyrium ledere*

A total of 27 species in Europe · 1 endemic, 2 Threatened or Near Threatened

There is only one metalmark in Europe, the Duke of Burgundy, which represents the tropical family Riodinidae. The family Lycaenidae, on the other hand, is represented by more than 100 rather small species – worldwide there are approximately 6,000 species, constituting about 40% of known butterfly diversity. The adults of coppers and hairstreaks are small, the average wing span being only 31 mm. The sexes are usually easily separated, especially in coppers, where the males tend to be more brilliant red or orange with a strong metallic sheen. Hairstreaks are generally dull brown in colour, with more or less obvious fine antenna-like tails on their hindwings. Together with an eye-spot at the base of the tail, this creates a 'false head' and as individuals turn around upon landing, predators are duped into attacking the wrong end. Hairstreaks usually live hidden in the shelter of woodlands, whereas coppers are more visible inhabitants of open grasslands. The caterpillars are small and flat, tapering at both ends. Coppers mostly depend on docks and sorrels in their larval stage, whereas hairstreaks have a wider diet covering a range of bushes and trees.

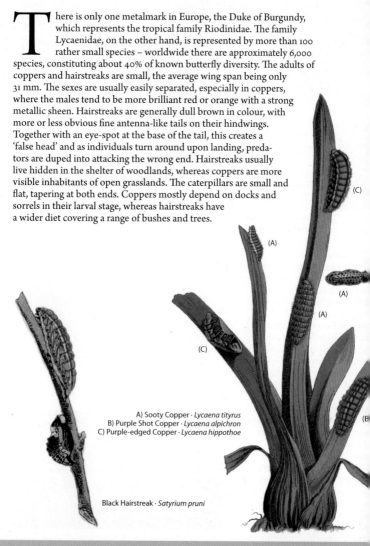

A) Sooty Copper · *Lycaena tityrus*
B) Purple Shot Copper · *Lycaena alpichron*
C) Purple-edged Copper · *Lycaena hippothoe*

Black Hairstreak · *Satyrium pruni*

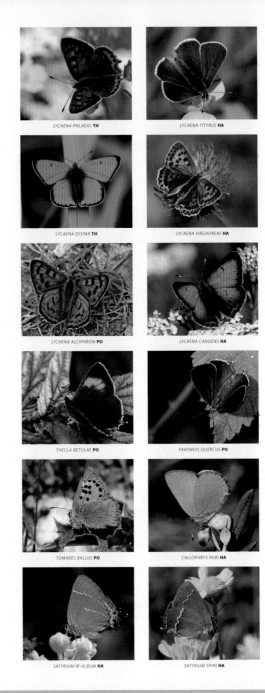

LYCAENA PHLAEAS **TH**

LYCAENA TITYRUS **HA**

LYCAENA DISPAR **TH**

LYCAENA VIRGAUREAE **HA**

LYCAENA ALCIPHRON **PO**

LYCAENA CANDENS **HA**

THECLA BETULAE **PO**

FAVONIUS QUERCUS **PO**

TOMARES BALLUS **PO**

CALLOPHRYS RUBI **HA**

SATYRIUM W-ALBUM **HA**

SATYRIUM SPINI **HA**

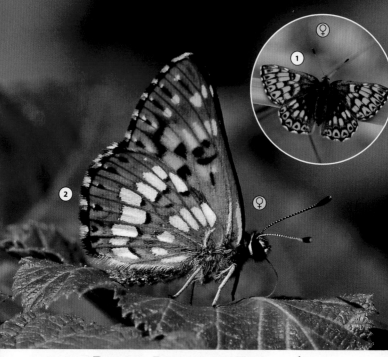

DUKE OF BURGUNDY · *Hamearis lucina*

HA N ITALY 8/07 · TM S FRANCE 5/06

A touch of the tropics among European butterflies, this species was once regarded as a fritillary but is now known to be our continent's sole representative of the so-called metalmarks (family Riodinidae). The diversity among these glamorous species, patterned in brilliant metallic blues, greens and reds in the tropics, peaks in South America, where the closest relatives of the Duke of Burgundy are also found. This species is most active early in the morning, basking on low herbage. The males are highly territorial, perching on hawthorns or hazel bushes, typically in some sunny glade in sparse woodland.

① Ups dark brown with numerous orange spots on three rows

② Hw uns orange-brown with two transverse rows of white spots

⊛ Sexes similar

♈ Either one generation in May–June or two generations in April–June and July–September, depending on locality and season. Scrubby calcareous grasslands, old chalk quarries, open woodland with oak and hazel, coppices and forest clearings up to 1,500 m.

⊕ Widespread in S and C Europe, extending to S Britain, the Baltic states and S Scandinavia in the north. Locally common, but more sporadic and rare in the edges of range. Has declined in many countries, including Britain, possibly extinct in Belarus (last observed in 1953).

♠ Several primroses, such as *Primula vulgaris*, *P. veris*, *P. elatior*, *P. auriculata*.

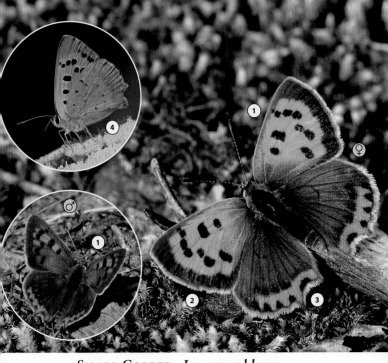

SMALL COPPER · *Lycaena phlaeas*

Small but hardy, this is one of the most northerly butterflies in the world, being recorded up to Greenland. It is common across the whole of Europe, and also occurs over large parts of North America. Aside from native populations in the Arctic, some eastern populations probably resulted from an accidental introduction from Scandinavia during the colonial period. More than 20 subspecies have been described over a vast range extending to Africa and Asia. Although not a migratory species, the Small Copper can readily colonise new territories in suitable habitat patches, in climatic conditions ranging from Mediterranean heat to arctic cold.

➤ *Lycaena helle*
 Lycaena tityrus

① Male fw ups gleaming coppery red or orange with black dots
② Outer margin sooty brown
③ Hw dark brown with orange submarginal band
④ Hw uns pale grey with small black dots
✹ Small for a copper
✹ Dark forms in high altitudes

𝕎 Two or three generations between February and October; all year round on the Canary Islands and Cyprus, univoltine in July in the northernmost range (ssp. *polaris*). A wide range of open habitats; roadsides, neglected cultivations, chalk downlands, heathland, woodland clearings and various grasslands up to 2,400 m.

⊕ Widespread and generally very common all over Europe, including most of Mediterranean islands, Lanzarote and Madeira.

⬥ A wide range of sorrels and docks (*Rumex acetosella*, *R. acetosa*, etc.), seldom *Polygonum* species.

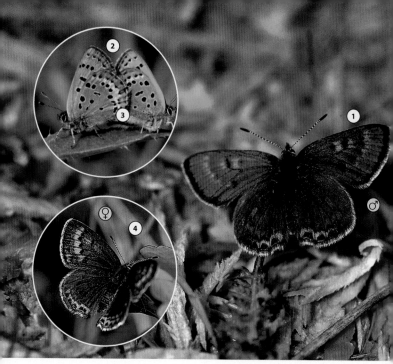

VIOLET COPPER · *Lycaena helle*

TH N FINLAND KUUSAMO 6/03 · **MCP** S FRANCE PYRENEES ORIENTALES 6/10 · **TH** N FINLAND KUUSAMO 6/03

The ecology of this beautiful species with its very local and widely dispersed colonies was recently investigated in western Germany. Habitat patch occupancy was primarily determined by patch size and the connectivity between different patches and abundance of the larval host plant, while other habitat quality parameters were of subordinate importance. The authors stated that even for an extremely sedentary species like the Violet Copper, habitat networks are decisive and need to form an integral part of any conservation management for this species, nowadays one of the rarest of European butterflies. Legal protection already covers at least six countries.

⊙ *Lycaena phlaeas, Lycaena tityrus*

① Male ups bright purple sheen on both wings
② Fw uns orange with heavy black spots
③ Hw uns brown with an orange submarginal band
④ Female ups dark brown with orange submarginal bands

🦋 One generation between May and late June. Damp meadows and moors, springs and bogs, marshy grasslands and riverbeds, moist clearings in forests up to 1,800 m.

⊕ Very scattered distribution from S France to C Fennoscandia and Russian Karelia; common in local colonies, but declining throughout the range due to drainage and afforestation of habitats. Extinct in many countries; evaluated as Endangered in Europe.

🌿 *Polygonum bistorta* in the southern range, *P. viviparum* in the northern range.

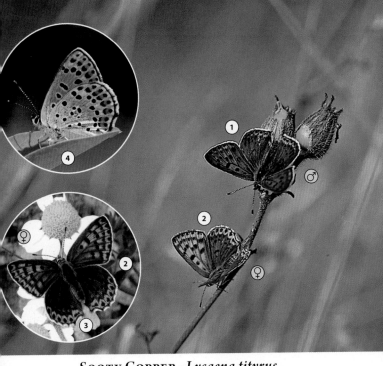

SOOTY COPPER · *Lycaena tityrus*

This widespread copper stands out with its very dark coloration. In early August in the southeast of Estonia, a suitable patch of habitat on sandy ground with masses of flowers like thyme and stonecrops will attract hundreds of skippers, fritillaries, blues and browns, and among them will be individuals from the second generation of the Sooty Copper, the males almost black. The species occurs here at its northern limit, but this situation looks set to change as the species has expanded northwards, probably because of warming summers. A Sooty Copper was captured for the first time in Finland in the summer of 2009.

⊘ *Lycaena alciphron*
Lycaena hippothoe

① Male ups sooty brown with black spots and white fringes
② Female fw ups brown with black spots and cross-line at outer part
③ Hw ups dark brown with orange submarginal lunules and black dots
④ Uns yellowish-grey with black spots and orange submarginal spots (cf. *L. alciphron*)

♀ One to three generations depending on altitude and latitude; in the southern localities three broods between mid-April and October, at highest altitudes only one brood in the late summer (ssp. *subalpinus*, darker). Meadows and grasslands typically with scrub, heathlands and sheltered canyons up to 2,500 m.

⊕ Rather widespread and generally common through most of Europe. From Portugal and Spain (ssp *bleusi*) to Denmark and the Baltic states in the north; absent from Britain and Mediterranean islands except Sicily and Samos.

◮ Mainly *Rumex acetosa*, rarely other docks and sorrels (*Rumex*).

TM S ITALY 9/00 · **TM** SLOVEN 4/07 · **TM** N GREECE 6/06

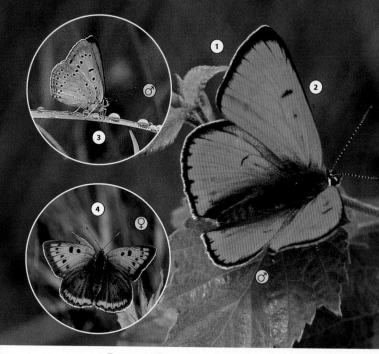

LARGE COPPER · *Lycaena dispar*

The female of this species is a giant among the coppers, and a fresh male is a pure flash of fire. However, nowadays it is difficult to encounter the species at all. The Large Copper, which is endemic to Europe, is a widely quoted example of butterfly decline. The subspecies *dispar* became extinct in Britain as early as 1851, *batavus* has been reduced to only two sites in the Netherlands, and *rutilus* is declining in many European countries. In Greece, for example, all the colonies are now at risk. By contrast, the butterfly has recently expanded in Finland – this is due, however, to a warming climate, leaving experts with mixed feelings.

⊙ *Lycaena virgaureae*

① Male ups brilliant coppery red or orange with black borders
② A slender black streak on the cell of both wings
③ Hw uns pale grey with black spots and an orange submarginal band
④ Female reddish-brown with black markings, hw dark grey

✿ Usually two generations; 1st brood in June–July and 2nd brood in August–September; a partial 3rd brood may occur in the southernmost range. Various wetlands; damp meadows, fens and marshes, canals and large ditches, peaty banks of lakes and rivers up to 1,000 m.

⊕ Widespread but generally scarce in very small widely dispersed colonies in C and E Europe extending to S Finland in north. Endangered throughout the range declined seriously through drainage of wetlands, many failed reintroduction attempts to Britain.

◊ A variety of docks, mainly *Rumex hydrolapathum*, *R. aquaticus*, *R. crispus*.

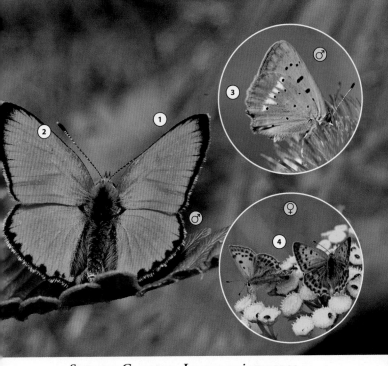

PO SE FINLAND TAIPALSAARI 7/09 · HA N ITALY 7/07 · TM S FINLAND SALO 7/06

SCARCE COPPER · *Lycaena virgaureae*

O ne of the most strikingly coloured butterflies in Europe – and not at all scarce around high summer at northern latitudes. Males and females are separated by their wing patterns. This systematic difference in form between the sexes in the same species is called sexual dimorphism. In addition to differences in colouration, the animal kingdom is full of examples based on other features, including size and the presence of body ornamentation with a role in courtship displays. As far as the Scarce Copper is concerned, the males strive to be as attractive as possible, while the females seem to find willing suitors despite their less flamboyant looks.

⊙ *Lycaena dispar*
 Lycaena ottomana

① Male ups gleaming coppery red or orange with dark borders
② Fw cell black streak weak or missing (cf. *L. dispar*)
③ Hw uns an arc of white spots
④ Female ups orange with dark sooty spots on both wings
✷ Smaller than *L. dispar*

🦋 One generation between late June and early September. Meadows and other grasslands, neglected cultivations and roadsides, forest clearings and sheltered hollows and gullies, typically between 1,000 and 2,000 m in the southern range.

⊕ Widespread through most of Europe extending from Spain to C Fennoscandia; very sporadic and local in the southern and the western range, absent from most Mediterranean islands, Atlantic coast and the British Isles.

◓ Usually sorrels (*Rumex acetosa, R. acetosella*), seldom docks (*Rumex*).

HA · ESTONIA 6/04 · PO N SPAIN PYRENEES 7/08 · TM ITALY SICILY 5/10

PURPLE SHOT COPPER · *Lycaena alciphron*

Like other European coppers (excluding the Fiery Copper in Greece) larvae of the Purple Shot Copper exclusively eat plants of the Polygonaceae family, most often sorrels and docks. After hatching, young larvae graze only at the surface of the leaves, resulting in a characteristic feeding pattern on the leaf. Larger caterpillars consume entire leaves but are found hiding at the base of the plant during the daytime. They have a rather weird flattened shape with a thick cuticle and glands that may produce secretions attractive to ants. They are also capable of producing sounds, with which they communicate with ants.

⊘ *Lycaena hippothoe*
 Lycaena tityrus

① Male ups heavily suffused with purple or violet
② Female ups golden brown ssp. *gordius*, in nominate form dark brown
③ Fw ups and uns black submarginal spots in irregular series (cf. *L. hippothoe*)
④ Hw uns grey with an even orange submarginal band (cf. *L. tityrus*)

🦋 Usually one generation from June to early August. Meadows and grasslands of varying conditions, sandy hillsides with scrub, forest clearings and rocky slopes and gullies up to 2,500 m.

⊕ Widespread but sporadic through most of Europe; scarce in the Iberian Peninsula, absent from Mediterranean islands (except Sicily), Atlantic coast, the British Isles and Fennoscandia. Mostly on mountains in the western range (ssp. *gordius*), common in the Balkans (ssp. *melibaeus*).

♠ Mainly *Rumex acetosa*, rarely other docks and sorrels (*Rumex*).

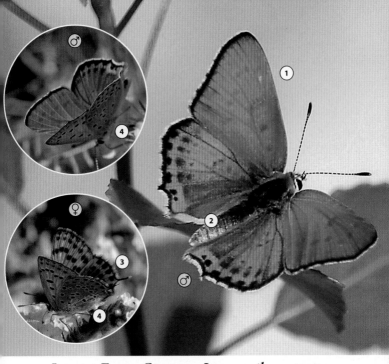

LESSER FIERY COPPER · *Lycaena thersamon*

Nearly any given butterfly of the large family Lycaenidae can be identified roughly as a copper, hairstreak or blue. The Lesser Fiery Copper, however, is a bit of a mixture, at least in Greece, where late summer individuals have a conspicuous combination of bright copper coloration accompanied by hairstreak 'tails' on the hind-wings. Similar tails are also borne by its closest relative, the Fiery Copper. The Lesser Fiery Copper's range is limited to southeastern Europe, where it exists in widely dispersed local colonies. While the adults share an avid interest in nectar-bearing thyme and danewort, their larvae are dependent on knotweed.

⊙ *Lycaena hippothoe*
Lycaena alciphron

① Male ups golden orange with a narrow black outer border
② Hw ups reddish-brown with coppery submarginal border
③ Female ups brown with black spots on both wings and sometimes a filamentous tail at hw
④ Hw uns greyish-brown with an orange submarginal band and black spots outside (cf. *L. ottomana*)

🦋 Three or more generations between April and October. Various meadows and grasslands, waste land, open scrub, sandy and rocky hillsides and mountain slopes up to 1,700 m.

⊕ Scattered distribution in E and SE Europe extending to E Czech Republic in north, also in C Italy and some Grecian islands (Rhodes, Kos, Thasos). Generally uncommon; colonies very local and small. More common at low altitudes in C and W Cyprus.

⬧ Mainly knotweed (*Polygonum aviculare*).

TH TURKEY ANATOLIA 6/07 · **TH** S TURKEY ISPARTA 6/10 · **TH** GREECE RHODOS 10/05

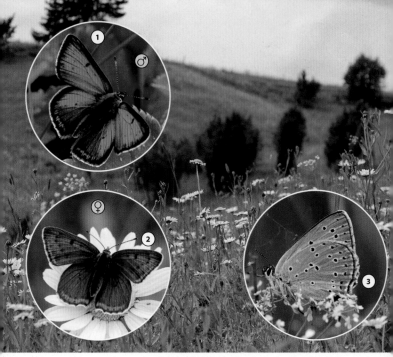

PURPLE-EDGED COPPER · *Lycaena hippothoe*

This species thrives in cooler climates. When three geographically separated subspecies were compared recently, their characteristics differed substantially in terms of fecundity, egg weight, the hatching success of eggs, and adult (offspring) weight. Heavier eggs of the alpine subspecies *eurydame* showed strikingly increased hatchability, especially at high temperatures. The reasons for this remain to be discovered, whether it occurs as a result of direct selection for egg size, as a correlated response based on other selective pressures, or simply reflects relaxed selection for maximised fecundity.

↻ *Lycaena candens*
(the ranges do not overlap)
Lycaena alciphron

① Male ups gleaming flame-red with dark borders and purple sheen
② Female fw ups black submarginal spots in regular series (cf. *L. alciphron*)
③ Hw uns grey-brown, orange submarginal band weak (cf. *L. alciphron*)

🦋 Mainly one generation between June and early September, depending on latitude and altitude; a partial 2nd brood in favourable conditions and SE Europe. Damp and dry grasslands, marshy meadows along rivers and lakes, neglected cultivations, roadsides and moist subalpine/alpine meadows up to 2,500 m.

⊕ Widespread through C and N Europe to the Arctic Ocean. Most common in the northern parts of its range (ssp. *stiberi* in Lapland), very sporadic but locally common in the mountain ranges of S and W Europe (ssp. *eurydame* in the Alps).

🜨 Mainly *Rumex acetosa* and *Bistorta vivipara*.

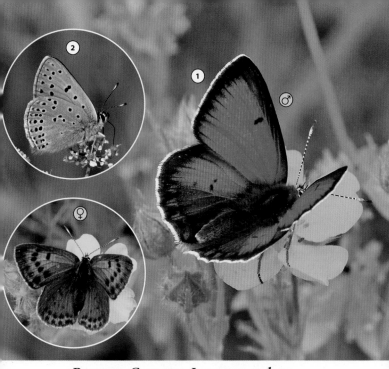

BALKAN COPPER · *Lycaena candens*

U p to the 1990s, European butterfly field guides almost invariably regarded the Balkan Copper as subspecies *leonhardi* of the Purple-edged Copper. Granted, the two species are externally very similar, yet the purple colouration in the male and the markings in the female are slightly different. Balkan individuals are also generally larger than those of *L. hippothoe*. The identification is simplified by the fact that the ranges of the two species do not overlap anywhere. Even if they were to meet, these two close relatives would probably not hybridise, since the male genitalia of Balkan Copper is incompatible with the female the Purple-edged Copper.

⤳ *Lycaena hippothoe*
(the ranges do not overlap)
Lycaena alciphron

① Male ups strong violet iridescence on the black borders

② Hw uns pale yellow-brown

★ Closely resembles *L. hippothoe*, but generally larger

♈ One generation between June and late August. Marshy meadows and glades, damp grasslands and forest clearings in the upper deciduous and coniferous forest zone and alpine meadows close to the tree line, usually between 800 and 2,200 m.

⊕ Locally common mountain species confined to S Balkans in SE Europe, the range extending from Greece to Serbia and Bulgaria where only a few lowland colonies. Common in the Caucasus between 1,000 and 2,600 m.

⬡ Mainly *Rumex acetosa* and its close relatives.

GRECIAN COPPER · *Lycaena ottomana*

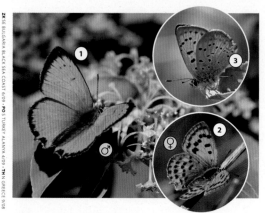

A limited range in the Balkan Peninsula, extending from Greece to S Croatia and Bulgaria. Two broods, 1st brood in March–May and 2nd brood from June to September in roadsides, maquis, cultivated areas, dry grasslands with scrub and open woodland. Generally uncommon with local colonies up to 2,200 m. Larva feeds mainly on *Rumex acetosella*.

① Male ups with crenulate black borders and small black dots on fw subapical area

② Female fw ups orange brown with a black submarginal line (cf. *L. thersamon*);

③ Hw uns pale grey with an uneven orange submarginal band without black dots outside (cf. *L. thersamon*); hw tail variable

FIERY COPPER · *Lycaena thetis*

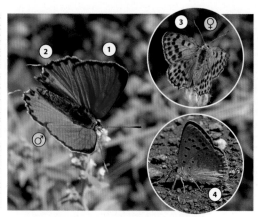

U ncommon and very local, high mountain species confined to S Greece. One brood from late June to early September on calcareous rocky slopes and other exposed scrubby habitats close to the tree line between 1,000 and 2,400 m. Larva feeds only on *Acantholimon androsaceum*.

① Male ups flame-red with fw black marginal border expanded at apex

② Hw ups small black spots around the edges and a slender tail

③ Female ups light brown with two parallel rows of black spots

④ Hw uns light grey (washed-out) with faint ocelli

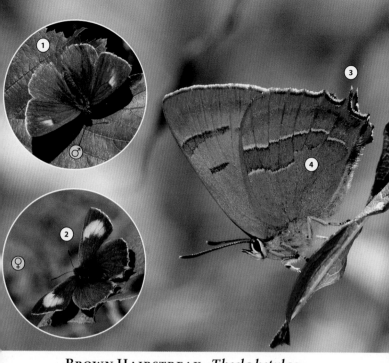

Brown Hairstreak · *Thecla betulae*

The largest of European hairstreaks and the last to emerge each year, this hairstreak has appropriately autumnal colours in its wings. Females may emerge from their pupae just a few weeks before winter in the northern range. After mating they begin laying eggs, each egg being deposited in the forks of twigs or at the base of buds, usually a few metres above the ground. If you are aware of the location of a colony, the white, disc-shaped eggs can be found fairly easily in winter time. Despite heavy frosts, a miniature caterpillar has already formed inside each egg, where it is waiting for the buds to burst open in the spring.

① Male fw ups dull brown with yellowish smudge
② Female fw ups with a broad orange crescent
③ Male and female an orange tail on hw
④ Uns unique bright orange with narrow white streaks on hw

♉ One generation between late July and September.
Semi-open habitats related to deciduous woodland; forest clearings and edges, scrub, hedgerows and bushy meadows up to 1,500 m.

⊕ Widespread but very sporadic through most of Europe; widely absent around Mediterranean region, N British Isles and N Fennoscandia. Colonies are very local; usually seen in low numbers due to secretive habits.

⚘ Blackthorn (*Prunus spinosa*), in the northern range mainly *Prunus padus*.

PURPLE HAIRSTREAK · *Favonius quercus*

H airstreaks are generally secretive woodland residents, and this species is no exception. The Purple Hairstreak is one of the commonest of the group, and can be found where mature oak trees are growing. The adult butterflies, however, are difficult to get close to, since both sexes spend most of their time high up in the tree tops. Their favourite source of food is the sugary honeydew excreted by aphids living on trees, popular aphid-ridden sites sometimes attracting dozens of males. However, they do occasionally descend to ground level, most often in the early morning, to take advantage of the minerals contained in damp soil.

⊙ *Laeosopis roboris*

① Uns silvery grey with a dark-edged white streak on both wings
② Hw uns a black-centered orange spot near to the slender tail
③ Female ups sooty black with a deep-purple iridescence
★ Sexes rather similar
★ Swarms around the tree tops

🦋 One generation between late June and early September, depending on altitude and latitude. Woodland habitats with mature oaks; oak forests and dry scrub, forest edges, even single oaks in parks and gardens, with vagrants up to 2,100 m in the mountains.

⊕ Widespread and locally common across most of Europe; absent only in a few Mediterranean islands, N British Isles and N Fennoscandia. Individuals in the Iberian Peninsula south of the Pyrenees have been described as ssp. *ibericus*.

🍂 A wide range of oaks, such as *Quercus robur*, *Q. coccifera*, *Q. ilex*, *Q. pubescens*, etc.

<div style="writing-mode: vertical">

HA HUNGARY 7/06 · PO SLOVENY 6/06 · PO SLOVENY 6/06
</div>

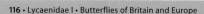

SPANISH PURPLE HAIRSTREAK · *Laeosopis roboris*

This Spanish version of the Purple Hairstreak, known locally as 'Moradilla del Fresno', belongs to a monotypic genus and is endemic to southern Europe. Despite the vast overlap in the ranges of the two 'purple hairstreaks' on the Iberian Peninsula, they are easily distinguished by their ecological characteristics. As it depends on ash trees, the Spanish Purple Hairstreak is most often recorded near water courses in the Mediterranean climate. The butterflies usually dash around the tree tops and are mainly attracted by honeydew, but sometimes they come down in large numbers to feed on umbellifers, *Thapsia* in particular.

⊃ *Favonius quercus*

① Uns brownish-grey with black and white triangles and an orange submarginal band on hw
② No tails
③ Male ups sooty black with violet iridescence at basal area
⊛ Ups rarely seen at rest
⊛ Sexes similar

⟆ One generation from May to July depending on the season. Various open and semi-open habitats with ash trees; parks and gardens, damp deciduous woods near streams and rivers, open woodland and forest edges up to 1,900 m.

⊕ Endemic to Europe; restricted to SW Europe in Portugal, Spain and SE France. Localised but colonies usually dense.

⚘ Primarily ash tree (*Fraxinus excelsior*), seldom other *Fraxinus* species and *Ligustrum vulgare*.

HA SPAIN 7/08 · TN N PORTUGAL DOURO 6/04 · PO SPAIN 7/08

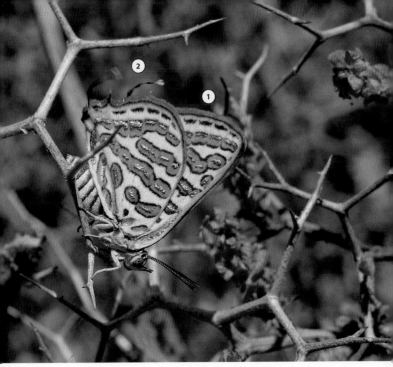

TAWNY SILVER-LINE · *Apharitis acamas*

I n Africa and Asia, there are approximately 70 species in the genus *Apharitis*, sometimes also called *Cigaritis*. Cyprus is by far the best place in Europe to find this gorgeous 'Levantine leopard' with its long hind-wing tails. Ants play a crucial role in the life cycle, the caterpillar spending almost its entire life inside a *Crematogaster* ant colony. The guest is willingly fed by the ants but at the same time it feeds voraciously on the ants' larvae. The ants continue to groom caterpillars, sometimes more than one in a single nest, and make no attempt to protect their larvae from this onslaught – most likely due to special chemicals secreted by the Tawny Silver-line larvae.

① Uns white with brown spots in linear rows

② Two slender tails on hw

✪ Ups light brown with black spots

✪ Sexes similar

✿ One or more generations from June to November. Hot and dry environments such as hillsides, steppe, maquis and other sclerophyllous Mediterranean scrub, also cultivations and abandoned agricultural land.

⊕ Recorded only in Cyprus and parts of Turkey with scattered local colonies; rather uncommon. Distribution extends from Sahara to India in the east.

✦ Most likely some legumes or species in Cistaceae family; later stages dependent on *Crematogaster* ants.

PROVENCE HAIRSTREAK · *Tomares ballus*

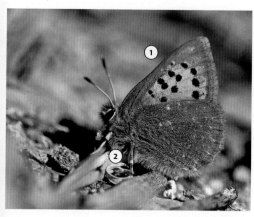

① Fw uns orange with
bold black spots

② Hw uns base green,
outer part brown-grey

★ Male ups dull brown,
female ups brown with
large orange patches.
Never seen at rest

Restricted to SW Europe, extending from the Iberian
Peninsula to Mediterranean coasts of France. One
brood from January to early May in abandoned agricultural
land, dry meadows, old vineyards and rocky grassy slopes
up to 1,300 m. Rather common but with very localised colo-
nies. Larva feeds on legumes, mainly *Medicago* species.

NOGEL'S HAIRSTREAK · *Tomares nogelii*

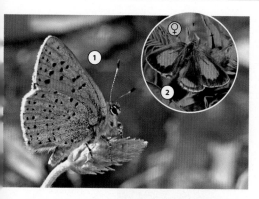

① Uns grey-brown with
orange-red stripes
bordered with black
dots on both wings

② Female ups orange
patches, lacking in male

Evaluated as Vulnerable in Europe; recorded only
in small isolated colonies in E Romania and
Moldova (ssp. *dobrogensis*), but probably extinct in
both countries. Distribution extends from Ukraine
and Asian Turkey eastwards. Uncommon and very
local with one brood from May to July in grasslands,
grassy scrub, sunny steppe in dry woodland and slopes
of ravines. Larva feeds on *Astragalus ponticus*.

Green Hairstreak · *Callophrys rubi*

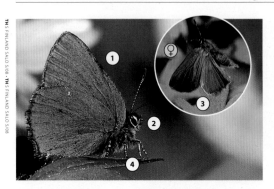

Widespread and common all over Europe; absent only from Crete, Cyprus and most Atlantic islands. One brood between March and late June, with a partial 2ⁿᵈ brood in the late summer, in almost all habitat types; from scrubby grasslands, woodland clearings and edges, heaths, marshes and peat bogs to high alpine meadows up to 2,300 m. Larva feeds on a wide range of plants, including legumes (*Cytisus*, *Genista*, etc.) and shrubs (*Vaccinium*, *Rhamnus*, *Rubus*, etc.).

① Uns bright green, sometimes a row of tiny white dots, especially on hw
② Eyes bordered with white (cf. *C. avis*)
③ Ups greyish-brown, only seen at flight
④ Striped legs (cf. *C. avis*)
★ Ups never seen at rest
★ Sexes similar

Chapman's Green Hairstreak · *Callophrys avis*

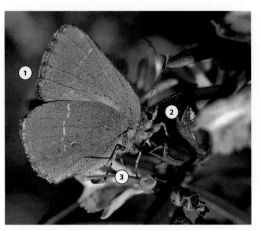

Rare and very sporadic in mostly coastal regions in Portugal, Spain and France. One brood from early April to late May in dry scrubland usually with abundant larval food plant, strawberry tree (*Arbutus unedo*). Larva also feeds on *Salvia* and *Coriara*.

① Uns bright green with a greyish patch at the rear of fw
② Eyes bordered with reddish-brown (cf. *C. rubi*)
③ Legs uniform brown (cf. *C. rubi*)
★ Ups never seen at rest
★ Sexes similar

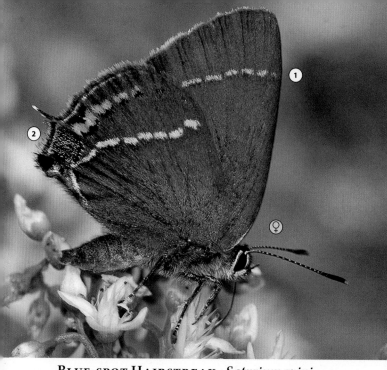

BLUE-SPOT HAIRSTREAK · *Satyrium spini*

A distinctive species that has a false 'head' with a large blue 'eye' on each hindwing, the Blue-spot Hairstreak provides a good example of the uneven challenge facing butterfly conservation across Europe. In its southeastern range it is widespread, prolific and under no particular threat, whereas in its northern range it is generally in decline and often sedentary with, for example, only one locality left in Belgium. There the species is evaluated as Critically Endangered, if not already extinct. Unlike many of its shy relatives, this hairstreak is easy to photograph while taking nectar or resting on foliage.

Satyrium acaciae

① Uns greyish-brown with a bold white streak on both wings

② A square blue spot near to the tail of hw

✷ Ups never seen at rest

✷ Sexes similar

♈ One generation from late May to late July. Bushy meadows, dry scrub near woodland margins and scrubby meadow slopes up to 2,000 m in the mountains.

⊕ Rather widespread and common in S and C Europe, the range extending to Poland and Lithuania in the north. Declining in the northwestern range.

♠ Mainly buckthorns (*Rhamnus catharticus*, *R. alaternus*, *R. alpinus*), but also *Paliurus*.

WHITE-LETTER HAIRSTREAK · *Satyrium w-album*

MA N ITALY 6/06

Another secretive tree-dwelling hairstreak, invariably seen around elm trees and easily identified by its well-formed 'W'-shaped white wing marking – if one can get close enough without disturbing the insect. The butterflies tend to fly high in the canopy, sucking up honeydew secreted on leaves by aphids, but now and then they dash down from the treetops to take bramble nectar. In Finland the White-letter Hairstreak has expanded rapidly due to the widespread planting of elms. Strangely enough, the butterfly is nowadays an urban resident here, and sometimes one of the few species observed in a hostile concrete city centre.

⊙ *Satyrium pruni*

① Uns dull brown with a white streak forming distinct W-shape on hw
② Hw uns orange lunules outlined with black
✶ Ups never seen at rest
✶ Sexes similar
🦋 One generation between mid-June and late July. Woodland openings, forest edges and rides, hedgerows and even single elm trees in parks and gardens, up to 1,500 m in the mountains.

⊕ Widespread and common across most of Europe, but generally sporadic and local; absent from most Mediterranean islands (except Sicily) and the Iberian Peninsula, N British Isles and N Fennoscandia. Has declined widely due to loss of elms to Dutch elm disease.

◈ Exclusively elm trees, mainly *Ulmus glabra*, seldom other *Ulmus*.

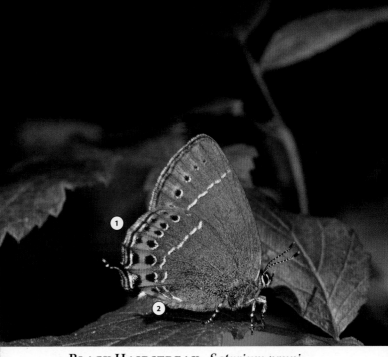

BLACK HAIRSTREAK · *Satyrium pruni*

An extremely sedentary butterfly, restricted to dense blackthorn thickets. Its westernmost populations in Europe are located in the British Isles, where the butterfly has around 40 colonies between Oxford and the East Midlands. The species relies on traditional coppicing techniques that enable the butterflies to move around suitable areas as old patches of blackthorn become unsuitable for them. Modern coppicing and the elimination of mature scrub due to public demand have put pressure on the species throughout its range. Fortunately, all the remaining UK sites are now being properly managed so that the species is not seriously threatened here.

⊙ *Satyrium w-album*

① Hw uns brown with a black-edged white streak and a distinctive orange submarginal band
② Bold black spots inside the band
✱ Ups never seen at rest
✱ Sexes similar

🦋 One generation between mid-May and late July, depending on the locality. Deciduous woodland with blackthorn; sheltered woodland clearings, forest edges and rides, hedgerows, usually at lowlands below 750 m.

⊕ Widespread but very patchily distributed in most of continental Europe; absent from Mediterranean regions, most of the British Isles and Fennoscandia. Colonies usually dense.

🜨 Mainly blackthorn (*Prunus spinosa*), also *Prunus padus* in the northern range.

Ilex Hairstreak · *Satyrium ilicis*

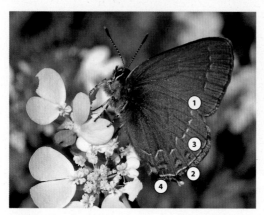

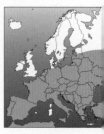

① Hw uns dark brown with a wavy white line
② Hw uns a row of reddish marginal lunules
③ Lunules bordered with black on both sides (cf. *S. esculi*)
④ A white line in outer margin of hw (cf. *S. esculi*)
★ Ups never seen at rest
★ Sexes similar

Widespread and generally common, with scattered but abundant colonies through S and C Europe up to S Sweden and Estonia in the north. One brood from late May to late July in light woodland, warm and dry forest margins and clearings, heaths and oak scrub up to 1,600 m. Larva feeds on several oaks (*Quercus*).

False Ilex Hairstreak · *Satyrium esculi*

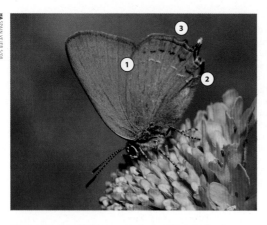

① Hw uns greyish-brown with a weak white streak
② Hw uns bright-red or orange, lunules bordered black only by inner side (cf. *S. ilicis*)
③ Hw uns white line vestigial or absent (cf. *S. ilicis*)
★ Ups never seen at rest
★ Sexes similar

Restricted to SW Europe in Iberia, Balearic islands and the Mediterranean coast of France. One brood from late May to August in hot dry oak scrub or light woodland, usually with abundant local colonies up to 1,300 m in the mountains. Larva feeds on low-growing oaks (*Quercus ilex, Q. coccifera*).

SLOE HAIRSTREAK · *Satyrium acaciae*

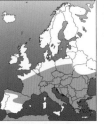

① Uns pale grey-brown
② Hw uns a dark-edged, rather straight white streak
③ A grey spot and a black dot near to the short tail
⊛ Ups never seen at rest
⊛ Smaller than *S. ilicis* and *S. esculi*
⊛ Sexes similar

Widely distributed and locally common in S and C Europe except Portugal and Mediterranean lands. One brood from late May to early August in abandoned vineyards, open woodland, scrub, bushy hillsides and open rocky slopes up to 2,000m. Larva feeds on blackthorn (*Prunus spinosa*).

ORANGE-BANDED HAIRSTREAK · *Satyrium lederi*

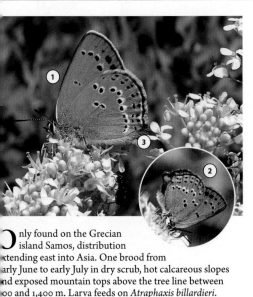

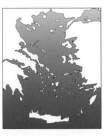

① Male uns uniform grey
② Female uns brownish
③ Hw uns an orange band and black spots bordered with white
⊛ Ups never seen at rest
⊛ Sexes similar

Only found on the Grecian island Samos, distribution extending east into Asia. One brood from early June to early July in dry scrub, hot calcareous slopes and exposed mountain tops above the tree line between 200 and 1,400 m. Larva feeds on *Atraphaxis billardieri*.

LYCAENIDAE · II

BLUES
LONG-TAILED BLUE · *Lampides boeticus* – SMALL DESERT BLUE · *Chilades galba*

A total of 88 species in Europe · 28 endemics, 23 Threatened or Near Threatened

Blues are generally small butterflies, having an average wing span of only 29 mm. The Large Blue female, however, may reach 46 mm, whereas the Grass Jewel is the smallest in Europe, sometimes hardly reaching 10 mm. The males are usually variably blue, often with a shiny metallic coloration, but the females tend to be brown (sexual dimorphism). In some cases this rule does not apply, both sexes being brown. The identification of blue species is sometimes problematic, even for experts. The best clues to identification are found on the hindwing underside. However, the differences are often negligible and a great deal of field experience is needed to make a correct identification. The brown-coloured 'anomalous blues' are especially difficult – separating *Polyommatus ripartii*, *P. aroaniensis*, *P. nephohiptamenos*, *P. eleniae* and *P. orphicus*, all of which fly in the mountains of N Greece, is a demanding task. The situation is even worse in Turkey. In southern Europe dozens of male blues commonly congregate on damp ground or a gravel road to suck up dissolved salts. This habit is less common in the north. Many blues are dependent on ants (a relationship called myrmecophily), which are attracted by chemical signals and a sugary fluid secreted by the butterfly larvae. The ants repay the larvae by giving them some protection against parasitic flies. The Large Blue is entirely dependent on certain ant species, some other blues less so. Many blue larvae feed on leguminous plants, flowers, fruits or leaves.

Holly Blue
Celastrina argiolus

Cranberry Blue
Plebejus optilete

Silver-studded Blue
Plebejus argus

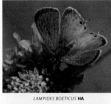

LAMPIDES BOETICUS **HA**

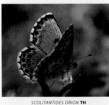

SCOLITANTIDES ORION **TH**

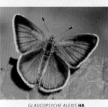

GLAUCOPSYCHE ALEXIS **HA**

ARICIA CRAMERA **PO**

POLYOMMATUS BELLARGUS **TH**

TARUCUS THEOPHRASTUS **PO**

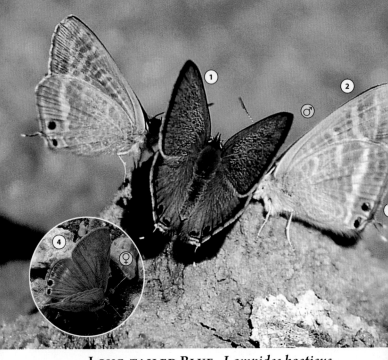

LONG-TAILED BLUE · *Lampides boeticus*

HA SPAIN TERUEL 7/08 · TM GREECE RHODOS 10/05

The Long-tailed Blue, which flies so quickly it appears more grey than blue, is a real wanderer. It is one of the few species to reach the Azores, which lie in the Atlantic 1,400 km from the mainland. Some migrant individuals have been observed flying at higher than 3,300 metres on the slopes of Mount Everest. At the opposite extreme, the Long-tailed Blue is a pest of cultivated broad beans in Hawaii! It is indeed a truly successful species. Although numerous in flower-rich locations, it is restless and difficult to examine, rarely pausing for more than a brief moment.

⊙ *Leptotes pirithous*

① Male ups violet-blue
② Uns greyish-brown with a broad wavy white line on hw outer margin (cf. *Leptotes pirithous*)
③ Two colourful eye-spots near to the slender tail on hw
④ Female ups sooty brown with variable amount of blue or violet

🦋 Several overlapping broods through most of year, especially on the Canary Islands and Cyprus; usually from February to November in the southern range and during the late summer in the northern range. Mostly hot and dry grasslands rich in flowers, also cultivations, parks and gardens, migrants up to 2,700 m in the mountains.

⊕ Widespread and generally common, but resident only in Mediterranean regions. Occurrence in most of Europe depends solely on regular migrations, reaching S Britain and even S Baltic states in favourable seasons.

⬧ A variety of legumes in the genus *Cassia, Colutea, Lathyrus, Medicago, Pisum, Phaseolus*, etc.

LANG'S SHORT-TAILED BLUE · *Leptotes pirithous*

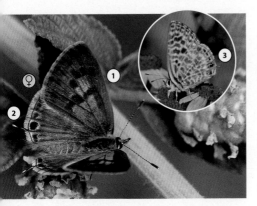

① Female ups blue with broad brown margins and dark spots
② Two black spots near the tail on hw
③ Uns light brown with numerous wavy white lines (cf. *Lampides boeticus*)
✱ Male ups uniform violet-blue

A strong African migrant; locally common and prob-ably resident in the Mediterranean region, widespread south of the Alps but occurrence depends on migrations. Several broods between February and October in arable fields, cultivations, hot and dry grasslands and scrub up to 1,200 m. Larva feeds on legumes (mostly *Medicago sativa*) and a wide range of wild low-growing plants.

HA CANARY ISLANDS, FUERTEVENTURA 11/07 · HA CANARY ISLANDS TENERIFE 4/10

GERANIUM BRONZE · *Cacyreus marshalli*

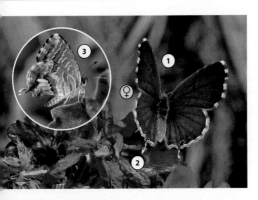

① Ups dark chocolate-brown, fringes chequered with white
② A prominent tail on hw
③ Uns brownish-grey with white undulate streaks
✱ Sexes similar
✱ Usually near to *Pelargonium* plants

A South African species introduced to Mallorca in the late 1980s. Spreading rapidly; sporadic but locally common, even a pest, in S European coasts from Portugal to Italy, Balearic islands, Malta and the Canary Islands. Occasional records up to S Britain. Recently recorded from the Greek island of Corfu. Consecutive broods all year round, usually between March and October in populated areas around culti-vated and wild *Pelargonium*, the only foodplants of larvae.

PO ITALY SICILY 6/08 · HA CANARY ISLANDS FUERTEVENTURA 11/07

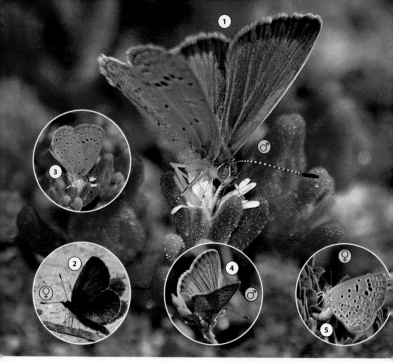

AFRICAN GRASS BLUE · *Zizeeria knysna*

HA CANARY ISLANDS, LANZAROTE 11/07 · HA CANARY ISLANDS, LANZAROTE 11/07 · HA CANARY ISLANDS, LANZAROTE 11/07 · TM S TURKEY KEMES 9/09 · PO CYPRUS 9/08

African Grass Blue is an abundant and tiny species well adapted to hot environments. It is attracted to desert oases or, less glamorously, to irrigation ditches or watered lawns along the African coast from Morocco to Tunisia in the east. It has expanded to most of the southern parts of Europe in the Mediterranean region, although it is still most readily observed in the Canary Islands.

DARK GRASS BLUE
Zizeeria karsandra

Confined to Mediterranean islands (Malta, Sicily, Crete, Cyprus) at low altitudes. Almost all year round in hot environments, usually near streams or other damp spots. Larva probably feeds on *Oxalis* or *Polygonum* species.

① *Z. knysna* male ups dark violet-blue with wide sooty-black borders

② *Z. knysna* female ups sooty brown with blue suffuse at the base

③ *Z. knysna* uns uniform greyish-brown with wavy white lines and black dots

④ *Z. karsandra*

⑤ *Z. karsandra* ovipositing female

▨ Both species have several consecutive broods all year round or three to four generations between February and October. Damp spots in hot gullies and coastal valleys, irrigated cultural environments, such as parks, gardens, arable fields and plantations, up to 1,800 m.

⊕ *Z. knysna* very sporadic and local in coastal ranges of Canary Islands, Portugal and Spain. Most common on Tenerife and Gran Canaria.

◑ *Z. knysna* usually amaranths (*Amaranthus*) or medicks (*Medicago lupulina, M. sativa, M. minima*).

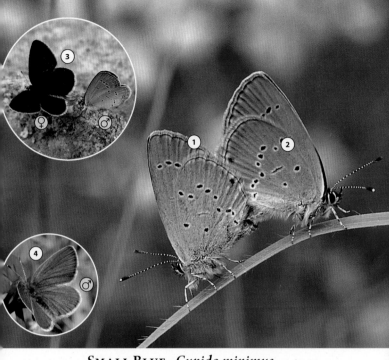

SMALL BLUE · *Cupido minimus*

This is one of the smallest butterflies in Europe. Both sexes may have a wingspan of only 10 mm, with just a hint of blue in the basal scales in males. It is usually easy to find, as long as there are kidney vetches growing nearby, but despite still being fairly common, the Small Blue has declined in recent years. It is vulnerable because it is so closely dependent on the hot microclimates of its larval food plant, which flourishes only on calcareous soils. Eggs are laid only on the open flowers, on which the caterpillars grow very quickly. These are frequently attended by ants, like most larvae of European blues.

➤ *Cupido osiris*
 Cupido lorquinii

① Uns pale grey with small white-ringed black dots
② Uns black dots on fw and four dots on hw not in a straight line (cf. *C. osiris*)
③ Female ups sooty brown with white fringes
④ Male ups grey-brown with silvery-blue scales near to the base
✴ Small for a blue

🦋 One or two generations; 1st brood from April to June, 2nd brood in July–September. Dry grasslands and meadows in calcareous terrain, bushy glades, forest clearings and rocky grassy slopes up to 2,800 m.

⊕ Widespread and locally common through most of Europe; sporadic and rare in the western and the northern ranges, absent from most Mediterranean islands (except Sicily, ssp. *trinacriae*).

🌸 Kidney vetch (*Anthyllis vulneraria*); also *Oxytropis campestris* in the northern range.

PO HUNGARY 7/06 · HA N GREECE 7/10 · HA AUSTRIA 7/08

Osiris Blue · *Cupido osiris*

TH SLOVENY 4/07 · PG GREECE PELOPONNESE 6/09

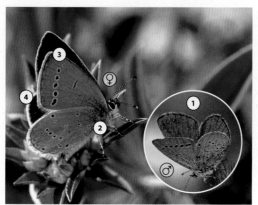

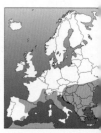

① Male ups bright violet-blue with narrow black margins

② Uns pale bluish-grey; flush of blue at the base of both wings

③ Fw uns black spots almost in a straight line (cf. *C. minimus*)

④ Female ups dark sooty brown

★ Very variable in size

Rather widespread but generally local and uncommon in S Europe from Spain to the Balkans and Greece, and up to Slovakia in north. One or partially two broods between April and August in warm rocky grasslands and road verges, typically on calcareous soils between 500 and 1,800 m. Larva feeds on several sainfoins (*Onobrychis*).

Eastern Short-tailed Blue · *Cupido decoloratus*

HA S BULGARIA 7/10 · HA N GREECE 7/10

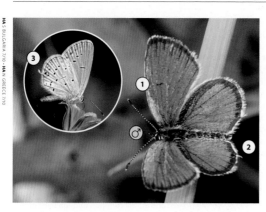

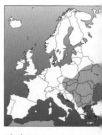

① Male ups pale blue with a small black discoidal spot (cf. *C. alcetas*) and narrow black borders indenting along veins

② A short tail on hw

③ Hw uns a black spot topped with arrow-shaped lunule

★ Female ups dark chocolate brown

A limited range in E Europe; patchily distributed but locally common from Greece to Austria and Belarus and eastwards. Evaluated as Near Threatened in Europe. Three broods between May and September in woodland margins and clearings, road verges, dry and rocky river valleys and mountain slopes up to 1,000 m, often on calcareous soils. Larva feeds on *Medicago* species.

SHORT-TAILED BLUE · *Cupido argiades*

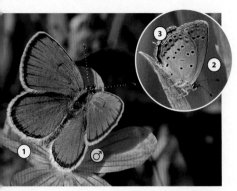

TM 5 ESTONIA VESKI 7/06 · PO HUNGARY 7/06

① Male ups purplish-blue with very fine short tail
② Uns pale greyish-blue
③ Hw uns one to three distinctive orange spots near tail (cf. *C. alcetas*)
★ Female ups sooty brown with dusting of blue scales near base
★ Somewhat larger than other short-tailed blues

A notable spring migrant; widespread but generally sporadic and uncommon in S and C Europe, recorded north to S Britain and C Finland in favourable seasons. Mainly two broods in April–June and July–August in cultivated fields (alfalfa, clover), bushy meadows and grasslands, open scrub and forest edges usually at lowlands below 1,000 m. Larva feeds on many legumes (*Lotus, Medicago, Coronilla varia, Trifolium, Astragalus*, etc.).

PROVENÇAL SHORT-TAILED BLUE · *Cupido alcetas*

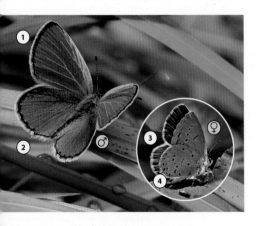

HA N ITALY MONTE BALDO 8/07 · TN N ITALY MONTE BALDO 8/07

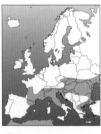

① Male ups bright violet-blue with narrow dark borders
② A short tail on hw
③ Female ups sooty black or dark brown
④ Hw uns a very small orange spot near to the short tail (cf. *C. argiades*)

Very patchy in S Europe, extending from NE Spain to Slovakia, Romania and N Greece; a single vagrant recorded in S Finland. Three broods between May and September in woodland clearings and edges, usually near streams or lakes at lowlands. Larva feeds on legumes (*Coronilla varia, Galega*).

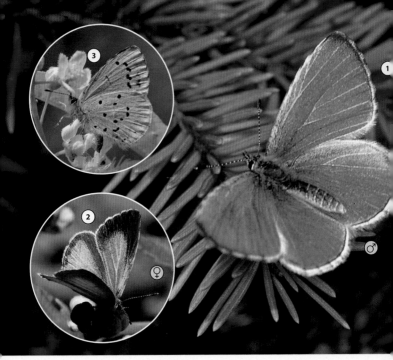

PO 5 FINLAND TAMPERE 5/86 • HA SE FINLAND JOUTSENO 5/05 • TH 5 BULGARIA PIRIN 7/09

Holly Blue · *Celastrina argiolus*

The name 'Ivy Blue' would be just as appropriate for this species, as the second larval generation feeds on ivy while the first eats holly. This species is unusual among blues in other ways too. It very rarely flies at ground level around grass and flowers but is often seen flying higher around trees and shrubs. In much of its range it is a commoner garden visitor than other blues. Both males and females look very blue in flight. When clouds obscure the sun the warmth-gathering wings tend to be held out flat, revealing a clear difference between the sexes: males have only a fine black border on the forewing, but in females (especially later in the year) it is broad.

⊙ *Cupido argiades*

① Male ups bright blue with very narrow black margins; fringes chequered

② Female ups light blue with wide black borders

③ Uns pale blue with small elongated black spots (ovals) (cf. *Cupido argiades*, *C. alcetas*)

★ Looks pale blue on the wing

☝ Two or three generations; 1st brood in April–June, 2nd brood in July–August and a partial brood in September–October. Deciduous woodland, forest glades and margins, bushy grasslands, gardens and parks, up to 1,900 m in the mountains.

⊕ Widespread and generally common all over Europe; absent only in N British Isles and N Fennoscandia, but expanding northwards.

◐ A wide range of unrelated plants, especially *Ilex* and *Hedera*, also *Rhamnus*, *Cornus*, *Rubus*, *Filipendula*, *Genista*, *Ulex*, *Euonymus*, etc.

Baton Blue · *Pseudophilotes baton*

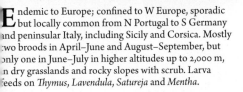

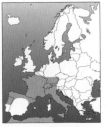

BF ITALY SICILY 4/02 · **GP** SWITZERLAND VALAIS 4/10

① Male ups pale blue with the dark bar at the end of cell
② Chequered fringes
③ Uns pale grey, heavily spotted with black
④ Hw uns a conspicuous arc of orange submarginal spots
✶ Female brown

Endemic to Europe; confined to W Europe, sporadic but locally common from N Portugal to S Germany and peninsular Italy, including Sicily and Corsica. Mostly two broods in April–June and August–September, but only one in June–July in higher altitudes up to 2,000 m, in dry grasslands and rocky slopes with scrub. Larva feeds on *Thymus*, *Lavendula*, *Satureja* and *Mentha*.

Eastern Baton Blue · *Pseudophilotes vicrama*

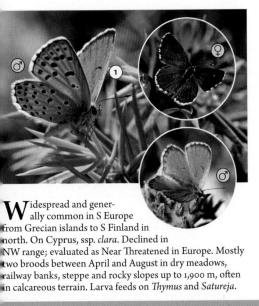

JJ MONTENEGRO 6/10 · **TH** SE FINLAND RUOKOLAHTI 6/96 · **JJ** MONTENEGRO 6/10

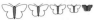

① Male ups pale blue-grey with the dark bar at the end of cell
✶ Closely resembles *P. baton*; more eastern distribution in Europe

Widespread and gener- ally common in S Europe from Grecian islands to S Finland in north. On Cyprus, ssp. *clara*. Declined in NW range; evaluated as Near Threatened in Europe. Mostly two broods between April and August in dry meadows, railway banks, steppe and rocky slopes up to 1,900 m, often in calcareous terrain. Larva feeds on *Thymus* and *Satureja*.

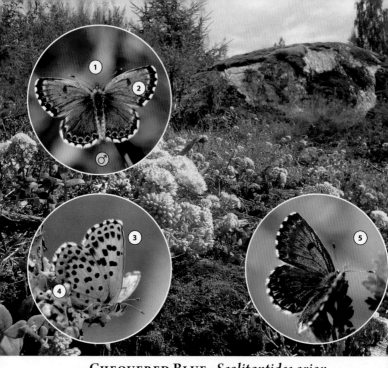

① ②
♂

③ ④

⑤

HA SE FINLAND LAPPEENRANTA 6/08 · TM S FINLAND SALO 6/07 · HA SE FINLAND LAPPEENRANTA 6/04 · TM SLOVENY 4/07

CHEQUERED BLUE · *Scolitantides orion*

The warm south-facing slope of a huge bedrock formation on an island on Lake Saimaa, in south-eastern Finland, provides a home for one of the world's northernmost populations of the Chequered Blue. Individuals avoid wind by flying very close to the ground and they frequently bask on lichens that provide perfect camouflage for the species' distinctive underside. Now and then they take nectar from wild strawberries, but an abundance of orpines (a kind of stonecrop) are necessary to ensure the survival of the offspring. The Chequered Blue is evaluated as Endangered in all the Nordic countries, mostly due to overgrowth of its fragmented habitat patches.

① Male ups flushed dark blue with chequered fringes
② Fw ups a black spot in the cell
③ Uns almost white, black spots contiguous
④ Hw uns orange submarginal lunules in a continuous row
⑤ *S. orion lariana*
✱ Sexes similar

🦋 Mostly one generation in May–June, but a small 2nd brood in July–August possible. Coastal cliffs, rocky screes, abandoned stone-pits, dry stony or sandy slopes and glades with sparse vegetation and scrub, often on calcareous soils near woodland or waters.

⊕ Two separate populations; rather widespread but locally uncommon in S Europe from NE Spain extending to Balkans (ssp. *lariana*), but very sporadic, rare and in decline in coastal districts of S Fennoscandia in north.

⚜ Many stonecrops (*Sedum album*, *S. telephium*, *S. hispanicum*); a close relationship with ants.

GREEN-UNDERSIDE BLUE · *Glaucopsyche alexis*

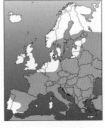

HA SE FINLAND (MATRA) 6/05 · HA HUNGARY 7/06 · TH S FRANCE MARITIME ALPS 5/06

① Male ups bright blue with sooty brown borders
② Female ups sooty brown with a faint blue flush at the base
③ Hw uns greenish-blue flush at the base
④ Uns black ocelli much larger on fw than on hw

Widespread and common through much of Europe, but declining in western and northern parts. One brood from April to early July in dry to damp meadows and grasslands, roadsides, bushy glades and scrub, forest margins and clearings and rocky slopes up to 1,500 m. Larva feeds on many legumes (*Vicia*, *Astragalus*, *Coronilla*, *Galega*, *Spartium*, *Onobrychis*, etc.).

BLACK-EYED BLUE · *Glaucopsyche melanops*

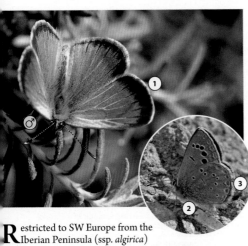

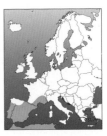

TH S SPAIN 3/07 · HA S SPAIN 5/07

① Male ups clear violet-blue with brown borders
② Hw uns bluish suffusion limited to wing base (cf. *G. alexis*)
③ Hw uns outer margin small light spots (cf. *G. alexis*)
✱ Female ups blue with wide borders dusted with brown

Restricted to SW Europe from the Iberian Peninsula (ssp. *algirica*) to SE France and NW Italy; rather widespread but very local. Mostly one brood in April-May in heaths, open shrub and open woodland up to 1,200 m. Larva feeds on legumes such as *Lotus*, *Dorycnium*, *Anthyllis*, etc.

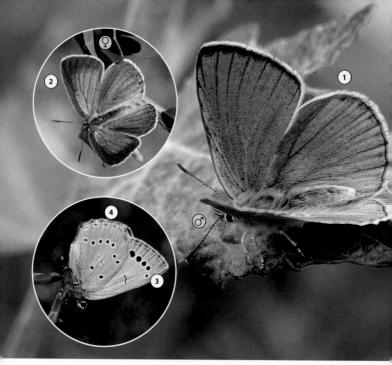

IOLAS BLUE · *Iolana iolas*

MR SWITZERLAND VALAIS 5/08 · MR FRANCE VAR 5/06 · OY TURKEY SULTANDAĞ AFYON 6/10

This is the largest blue in Europe, and is a magnificent sight on the wing. The deep blue tone of the male combined with a powerful, direct flight makes the butterfly veritably majestic. Sadly, this regal species is not often there to be appreciated, with only two or three individuals a day occurring in even the best localities. The best way to locate this species is to look for bladder senna bushes with their conspicuous large, bladder-like seed pods. The butterflies do not congregate in colonies, but tend to wander for long distances, probably in search of both nectar and mates, and this coupled with their strong flight means sightings are often brief.

① Male ups pale violet-blue with narrow brown borders

② Female ups wing borders dark brown and extensive

③ Uns grey with white-ringed black spots in a straight row on fw

④ Grey dots on outer margin of hw (cf. *Phengaris* species)

★ Largest blue in Europe

♈ Mostly one generation from early May to late June; a partial 2nd brood in August–September. Woodland openings and hot rocky slopes in calcareous terrain with bushes of the larval host-plant up to 1,800 m.

⊕ Rather widespread but sporadic in S Europe, extending from E Spain to peninsular Italy and the Balkans. Evaluated as Near Threatened in Europe; generally uncommon and very local throughout the range, some colonies threatened by vineyards.

◈ Seeds of bladder senna (*Colutea arborescens*), rarely *C. cilicica*.

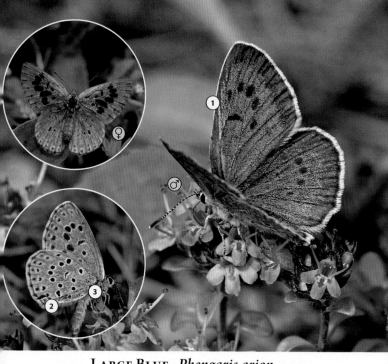

LARGE BLUE · *Phengaris arion*

The best example of myrmecophily, taking the relationship between caterpillar and ants to the extreme. The caterpillar eats thyme up until its third instar. If it is not then discovered by *Myrmica sabuleti* ants, it will die. The ants are attracted by the larva's sugary secretion, but once carried inside the nest the caterpillar becomes carnivorous, feeding on ant larvae. In this unequal partnership, the caterpillar is assured of a plentiful food supply combined with a well-guarded environment populated by hundreds of defenders! The caterpillar pupates in the nest, and a newly emerged butterfly crawls out, totally unmolested by the ants.

⊋ *Phengaris teleius*
 Phengaris nausithous

① Male fw ups sharp arc of wedge-shaped (oval) black spots
② Uns greyish-brown with submarginal and marginal black spots on both wings (cf. *P. alcon*, *P. teleius*)
③ Blue flush at the base of hw
⊛ Large for a blue

♺ One generation between June and early August. Sandy or rocky patches with sparse vegetation in meadows, bushy forest margins and glades, hillsides and south-facing mountain slopes up to 2,000 m.

⊕ Widespread but very patchy in most of Europe; reintroduced to the British Isles. Evaluated as Endangered in Europe; declining in the western and the northern ranges, mostly due to agricultural changes and afforestation. Legally protected in at least 13 countries.

⊕ Mainly thyme (*Thymus*), sometimes *Origanum vulgare*; later stages myrmecophilous in *Myrmica sabuleti* nests.

SCARCE LARGE BLUE · *Phengaris teleius*

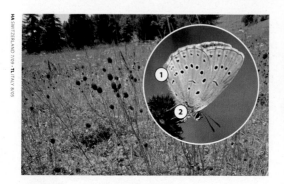

A very scarce and widely declining species with patchy distribution in C Europe from France eastwards extending to S Poland and C Romania; isolated colonies in Lithuania and Latvia. Evaluated as Vulnerable in Europe; widely protected. One brood from mid-June to August in damp and marshy meadows, usually accompanied with *P. nausithous*, between 700 and 1,500 m. Larva feeds on *Sanguisorba officinalis*; later stages myrmecophilous in *Myrmica* nests.

① Uns greyish-brown with black submarginal spots, marginal spots missing (cf. *P. arion*)

② No blue flush on hw base (cf. *P. arion*)

★ Ups pale blue, blackish-grey borders, broader in female

★ Ups a row of elongated spots on both wings

★ Large for a blue

★ Always associated with *Sanguisorba* plants

DUSKY LARGE BLUE · *Phengaris nausithous*

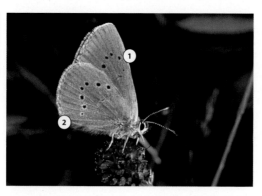

C losely resembles *P. teleius*; local and very rare in C Europe with isolated populations in N Spain and Bulgaria. Declined due to habitat drainage throughout the range; evaluated as Near Threatened in Europe, thus widely protected. One brood from late June to August in damp bushy meadows, usually accompanied with *P. teleius*, between 600 and 1,600 m. Larva feeds on *Sanguisorba officinalis*; later stages myrmecophilous in *Myrmica rubra* nests.

① Uns a series of black postdiscal spots and a black discoidal spot on both wings

② Uns no submarginal spots

★ Male ups blue, wide dark brown borders

★ Female ups uniform brown

★ Large for a blue

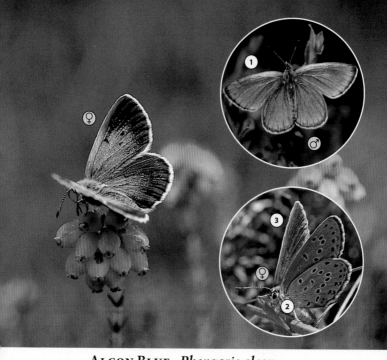

TH N DENMARK 7/98 · TH N DENMARK 7/98 · TH N DENMARK 7/98

ALCON BLUE · *Phengaris alcon*

The known sites for the Alcon Blue are legally protected in many countries. The species, like its close relatives, is highly dependent on co-operation from ants during its later larval stages. When attended by a suitable host, a caterpillar produces a sweet droplet as a welcoming gift, prior to distorting its body to give the illusion of being an ant larva – it also produces chemical signals mimicking those of ant larvae. The ant is invariably fooled and the caterpillar is immediately carried inside the nest, where it lives alongside the ant larvae – but hardly in harmony with them, as it feeds upon them. The Alcon Blue accepts only *Myrmica ruginodis*, *M. rubra* or *M. scabrinodis* ants as its hosts, depending on locality.

① Ups pale violet blue with narrow (male) or broad (female) black borders

② Hw uns blue basal flush reduced or absent (cf. *P. arion*)

③ ssp. *rebeli*

★ Large for a blue

☿ One generation between mid-June and late August, depending on locality. Damp meadows, edges of marshes and wet heathland, usually near water and woodland at lower altitudes (<1,000 m).

⊕ Extremely sporadic throughout the range from N Spain to C Balkans and S Scandinavia in north. Generally uncommon with very local threatened colonies. An alpine subspecies (ssp. *rebeli*) very sporadic and local in mountain ranges at alpine levels (between 600 and 2,200 m), extending from Cantabrian Mts eastwards to N Greece.

⊕ Mainly marsh gentian (*Gentiana pneumonanthe*, nominate form) or cross gentian (*Gentiana cruciata*, ssp. *rebeli*), seldom other *Gentiana*; later stages myrmecophilous in various *Myrmica* nests.

ZEPHYR BLUES

The zephyr blues form an enigmatic species complex which in Europe includes four geographically distinct forms (here treated as species): *Plebejus pylaon*, *P. sephirus*, *P. trappi* and *P. hespericus*. All share the attribute of showing no silver scaling in the submarginal black lunules on the underside of the hindwing, unlike other *Plebejus* species. Otherwise they mostly resemble *P. idas* and *P. argus*.

ZEPHYR BLUE · *Plebejus pylaon*

This is an eastern steppe species which range extends to SE Ukraine and eastern parts of European Russia in the west. The range overlaps with *P. sephirus* in parts of E Turkey, where some other close relatives also occur. *P. pylaon* is evaluated as Near Threatened in Europe. It flies with one brood from May to August in hot dry grasslands, steppe and scrub. Larva feeds on milkvetches (*Astragalus*).

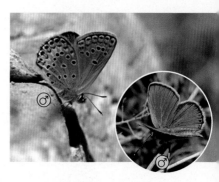

SPANISH ZEPHYR BLUE · *Plebejus hespericus*

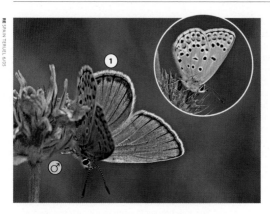

① Males bright blue (cf. *P. trappi*, *P. sephirus*)
⊛ A limited range in Spain

Endemic to Europe; restricted to Spain with extremely sporadic and local colonies in S of Madrid and the Montes Universales. One brood in May–June in dry scrubby grasslands and hillsides, sparse woodland and rocky gullies between 700 and 1,500 m; colonies restricted by availability of larval host plants. Larva feeds on milk vetches (*Astragalus alopecuroides*, *A. turolensis*, *A. sempervirens*, etc.).

Alpine Zephyr Blue · *Plebejus trappi*

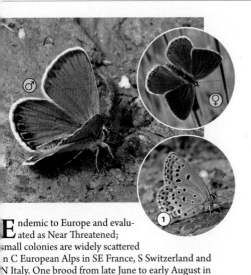

MR SWITZERLAND VALAIS 5/07 · MR SWITZERLAND VALAIS 6/04 · MR SWITZERLAND VALAIS 5/07

① Hw uns orange band broken near lower margin, characteristic to Zephyr Blues (*pylaon* group)

★ Larger than *P. hespericus* and *P. sephirus*

★ A range limited to S Alps

Endemic to Europe and evaluated as Near Threatened; small colonies are widely scattered n C European Alps in SE France, S Switzerland and N Italy. One brood from late June to early August in grassy clearings of coniferous woodland between 1,000 and 2,000 m. Larva feeds on *Astragalus exscapus*.

Balkan Zephyr Blue · *Plebejus sephirus*

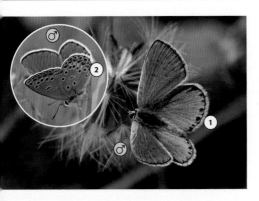

TH N GREECE 6/06 · PO GREECE PELOPONNESE 6/09

① Male ups bright blue with some black spots along the black marginal border on hw

② Hw uns a complete series of black submarginal spots without silvery blue-green pupils (cf. *P. argus*, *P. idas*, *P. argyrognomon*)

★ Female hw ups brown with orange submarginal lunules

★ Closely resembles *P. argus* and *P. idas* but larger

A scattered distribution in SE Europe; sporadic but locally common in most of the Balkans extending from Greece and W Turkey to Hungary. One brood between mid-May and July, depending on altitude, in stony or sandy hot grassland spots with larval host plants in scrub and sparse woodland, usually in calcareous terrain, between 500 and 2,000 m. Larva feeds on milkvetches (*Astragalus exscapus*, *A. parnassi*, *A. angustifolius*, etc.).

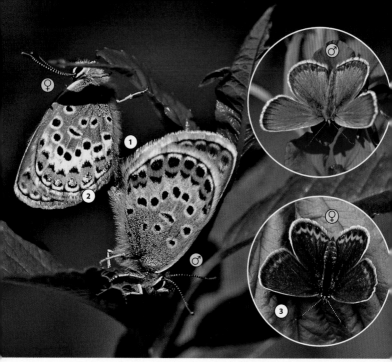

SILVER-STUDDED BLUE · *Plebejus argus*

TH15 FINLAND SALO 7/06 · HÄ:E FINLAND KERIMÄKI 8/04 · PO:SE FINLAND PUUMALA 7/06

This is one of three common species with lovely silver studs on the underside hindwing. In parts of its northern range, the Silver-studded Blue is the most numerous 'blue' around high summer. Sometimes thousands of individuals may congregate on the ground where heather is blooming in open, dry pine forests or on peat bogs. A damp spot on a gravel road is almost irresistible to males. One should bear in mind that the Idas Blue, a closely allied species distinguished by a hookless foreleg tibia, is almost as common in the same localities.

⊘ *Plebejus idas*
 Plebejus argyrognomon

① Male uns bluish-grey, female uns smoky brown
② Hw uns marginal black spots contain blue or greenish centres – 'the silver studs'
③ Female ups chocolate brown with orange submarginal lunules
★ Smaller than *P. pylaon* and *P. argyrognomon*

🦋 One or two generations depending on latitude and altitude; 1st brood in May-June and 2nd brood in July–August; June–August where single-brooded. A wide range of very damp to hot habitats in grasslands, scrub, heaths and peat bogs, woodland and alpine slopes up to 2,000 m.

⊕ Widespread and often nationally among the commonest blues through most of Europe except N Britain and N Fennoscandia, including many subspecies; *caernensis* (Wales), *aegidion* (Alps), *hypochionus* (Iberia), *corsicus* (Corsica).

◊ A range of legumes (*Lotus, Ulex, Cytisus, Colutea, Coronilla*, etc.), sometimes heather (*Calluna vulgaris*); later stages myrmecophilous in *Lasius* nests.

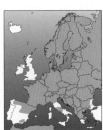

HAN NORWAY 7/05 · TH S FINLAND SALO 7/08 · TH ITALY ELBA 6/09

Idas Blue · *Plebejus idas*

These vivid little butter-flies sometimes swarm in massive numbers amongst Silver-studded Blues, making positive identification a lepidopterist's nightmare. The situation is exacerbated by the fact that the Idas Blue varies enormously within its vast range around the northern hemisphere. In Europe, a heterogeneous complex of taxa may consist of six sibling species or even more! Among these are *P. bellieri* in Corsica and Sardinia and two ecologically different species in the Balkan region, *P. baldur* and *P. croatica*. Also many subspecies, including *villai* (Elba) and *calliopis* (the Alps).

⊖ *Plebejus argus*
 Plebejus argyrognomon

① Male ups blue with narrow black borders and wide white fringes (cf. *P. argus*)
② Hw uns pale brownish-grey with black marginal spots containing shining blue or green centres, ssp *lapponicus*
③ ssp. *villai*
★ Smaller than *P. pylaon* and *P. argyrognomon*

🦋 One or two generations depending on latitude and altitude; 1st brood in May–June and 2nd brood in July–August; June–August where single-brooded. A wide range of damp to hot habitats in grasslands and woodland, scrub, heaths and peat bogs, alpine and arctic slopes up to 2,100 m.

⊕ Locally common all over Europe except in the British Isles, Mediterranean islands and coastal regions; sporadic in the southern range.

🍂 A range of legumes (*Lotus*, *Melilotus*, *Genista*, *Cytisus*, *Chamaecytisus*, etc.), sometimes heather (*Calluna vulgaris*); later stages myrmecophilous in *Lasius* and many *Formica* nests.

REVERDIN'S BLUE · *Plebejus argyrognomon*

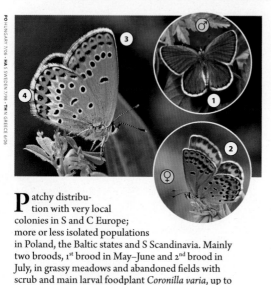

Patchy distribution with very local colonies in S and C Europe; more or less isolated populations in Poland, the Baltic states and S Scandinavia. Mainly two broods, 1st brood in May–June and 2nd brood in July, in grassy meadows and abandoned fields with scrub and main larval foodplant *Coronilla varia*, up to 1,500 m. Larva also feeds on *Astragalus glycyphyllos*.

① Male ups violet-blue with narrow black borders and white fringes
② Female ups brown
③ Uns grey with orange band on both wings
④ Hw uns marginal spots with shiny blue centres (cf. *P. pylaon*)
⊛ Bigger than *P. argus* and *P. idas*

CRANBERRY BLUE · *Plebejus optilete*

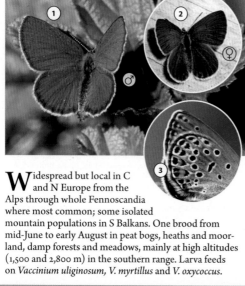

Widespread but local in C and N Europe from the Alps through whole Fennoscandia where most common; some isolated mountain populations in S Balkans. One brood from mid-June to early August in peat bogs, heaths and moorland, damp forests and meadows, mainly at high altitudes (1,500 and 2,800 m) in the southern range. Larva feeds on *Vaccinium uliginosum*, *V. myrtillus* and *V. oxycoccus*.

① Male ups violet-blue with black borders
② Female ups sooty brown with violet dusting at the base
③ Hw uns orange submarginal lunules and black spot with silvery blue centre

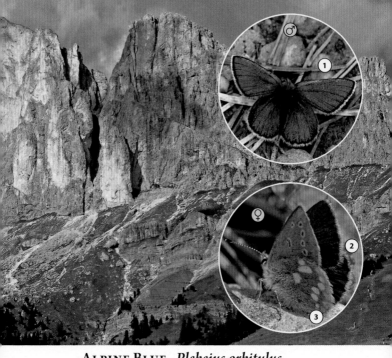

ALPINE BLUE · *Plebejus orbitulus*

This species is another example of the strong sexual dimorphism so typical of blues. The male is readily identified among the high alpine species, being a very vivid shining blue, whereas the females are almost uniformly brown. Alpine Blues are seldom numerous, but in favourable conditions they can gather at damp soil to take on water and minerals. Unusually, there may also be many females drinking alongside the males. When closed, the wings reveal a conspicuous underside with large white spots but no black pupils whatsoever.

① Male ups shining blue with narrow black borders

② Female ups uniform brown with white fringes

③ Hw uns conspicuous white spots

🦋 One generation between June and August, depending on locality and altitude. Damp gravel and slate slopes along streams, alpine and subalpine meadows between 800 and 2,800 m in the mountain ranges.

⊕ Distributed in two separate areas; sporadic and local in C Scandinavia (Sweden, Norway) and in the Alps ranging from France to Austria and Slovenia. Recorded also in the northern Urals.

⊕ Mainly *Astragalus alpinus*, but also *A. norvegicus* in Scandinavia.

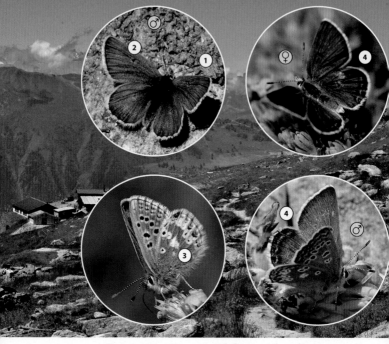

GLANDON BLUE · *Plebejus glandon*

TH (SWITZERLAND VALAIS 8.01) · TH (SWITZERLAND VALAIS 8.07) · PO (SWITZERLAND 8.07) · JVA (SWITZERLAND 7.08) · JO (SPAIN SIERRA NEVADA 7.08) · JO (SPAIN SIERRA NEVADA 7.07)

A sister species of the Arctic Blue, sometimes considered as a subspecies only. Glandon Blue has a preference to the highest altitudes in Europe. In the Alps one must climb above 1,900 metres to find conditions suitable for the species. Although similar habitat conditions seem to continue all around, colonies of the Glandon Blue are often very local and isolated from each other, probably restricted by larval food plants.

SPANISH GLANDON BLUE
Plebejus zullichi

P reviously regarded as a subspecies of the Glandon Blue confined to S Spain.

⊖ *Plebejus pyrenaicus*
Plebejus aquilo

① *P. glandon* ups uniform bluish-grey
② *P. glandon* fw ups a small black spot in the cell
③ *P. glandon* hw uns brown with a white spot in the centre
④ *P. zullichi* rather similar to *P. glandon*

🦋 *P. glandon* one brood from early July to late August. Gravel fields and muddy banks along streams, steep road verges and other barren soils, rocky grounds and scree slopes up to 2,700 m in the mountain ranges. *P. zullichi* one brood from late June to late July in barren soils and rocky wind-swept grounds between 2,500 and 3,000 m.

⊕ Both species endemic to Europe. *P. glandon* is restricted to the Pyrenees and the Alps in France, Switzerland, Germany, Austria and Italy. *P. zullichi* is confined to Sierra Nevada and Granada in S Spain.

◈ *P. glandon* rock-jasmines, including *Androsace obtusifolia*, *A. chamaejasme* and *A. vitaliana*. *P. zullichi* larva feeds on *A. vitaliana*.

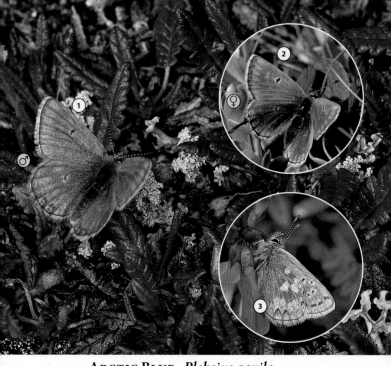

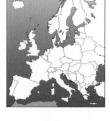

① ♂
② ♀
③

PO N FINLAND KILPISJARVI 7/85 • PO N FINLAND KILPISJARVI 7/70 • PO N FINLAND KILPISJARVI 7/88

ARCTIC BLUE · *Plebejus aquilo*

A tiny Lapland 'pearl' which is hard to find, only in the Fennoscandian fell region and the eastern coast of Greenland. Not only are the butterfly's colonies extremely local, but it favours habitats that are rather dangerous for the lepidopterist to search. It typically flies on very steep south-facing slopes, with sparse vegetation but a surface layer of scree which is poised to slide downhill if disturbed. Well adapted to harsh conditions, the Arctic Blue flies just a few centimetres above the ground surface, almost invariably in bright sunshine. Individuals are fond of basking and, when observed enjoying the sun's warm rays, demonstrate how well they blend in with their stony wilderness.

⊋ *Plebejus glandon*

① Male ups uniform grey
② Female grey-brown
③ Hw uns white spots and a white belt

⚘ One generation in July. Rocky slopes, eroded ledges and slate fields along fells, barren alpine meadows usually on calcareous soils up to 900 m.

⊕ Confined to Norway, Sweden and Finland in N Fennoscandia; the range extends eastwards to N Kola Peninsula, Polar and Sredniy Urals and the arctic parts of Asia. Colonies are very local but sometimes numerous in its habitat.

♠ Probably *Saxifraga oppositifolia* and *S. aizoides*, rarely *Astragalus alpinus*.

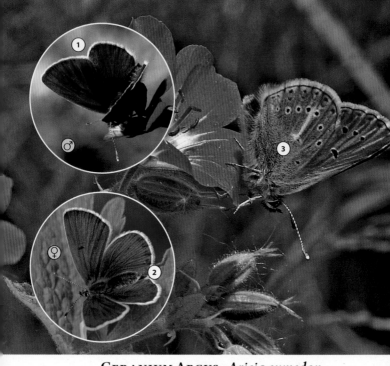

GERANIUM ARGUS · *Aricia eumedon*

From the Mediterranean to arctic Lapland, Europe hosts a few hundred species of cranesbills (Geraniaceae). Wherever you see these blooming in dense patches, look out for the Geranium Argus. This small 'blue' – both male and female are uniformly brown on the upperside – is very fond of cranesbills from the caterpillar to the adult stage. Crawling inside a flower, a female lays her eggs at the base of the ovary. The caterpillar then bores its way into the ovary for the next week or so. Individuals in small colonies are easily approached and examined while nectaring. A distinctive white streak on the underside hindwing is the key to identification.

① Male ups dark brown with white fringes

② Female ups brown with faint orange lunules on hw

③ Hw uns a white streak running from the cell to postdiscal spots (cf. *A. artaxerxes*)

⊛ Typically close to *Geranium* plants

🦋 One generation between May and August, depending on locality and altitude. Habitats near woodlands with abundant larval host plants; sheltered forest clearings and margins, damp grasslands with scrub, usually at low altitudes, but up to 2,400 m in moors and alpine meadows.

⊕ Widespread through much of Europe, most common in the eastern and northern ranges. Absent from Atlantic coast and very sporadic in Mediterranean region from S Spain to S Balkans, mostly confined to the mountain ranges.

🌿 A range of cranesbills, such as *Geranium sylvaticum*, *G. sanguineum*, *G. pratense*, *G. palustre*, etc.

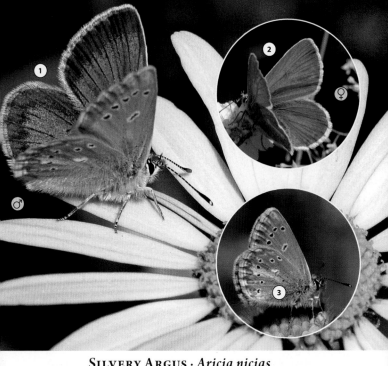

① ② ③ ♀ ♂

SILVERY ARGUS · *Aricia nicias*

HA E FINLAND KITEE 6/04 · **HA** E FINLAND KITEE 6/04 · **HA** E FINLAND KITEE 6/04

This is a distinctive north European blue, most commonly found in Finland and Sweden. Butterfly-watchers generally are well advised to don Wellington boots while they search for the species in lush vegetation on damp ground. Local colonies also turn up in sheltered forest meadows and hillsides. Silver Argus populations vary greatly from one year to another, sometimes only a few males being seen perched on birch twigs and leaves. They are difficult to approach, very cautious, and fast-flying once disturbed. Many males often already look worn by the time the first females start to emerge.

⊘ *Aricia eumedon*

① Male ups silvery blue with broad black borders
② Female ups uniform grey brown
③ Hw uns a white streak continues to the basal area

♈ One generation from early July to mid-August. Damp meadows in hillsides and various clearings (glades, roadsides, power lines, etc.) in deciduous woodland; damp sunny slopes near streams usually between 1,000 and 2,000 m in southern range.

⊕ Very scattered distribution in Europe; rare and local at lowlands in C Fennoscandia (ssp. *scandicus*), very sporadic in the high mountains of E Pyrenees and C Alps.

⬙ Mainly wood cranesbill (*Geranium sylvaticum*) or meadow cranesbill (*G. pratense*).

Brown Argus · *Aricia agestis*

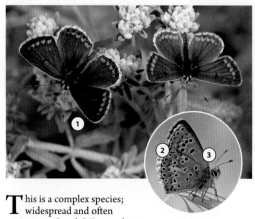

① Ups chocolate-brown with a full set of orange lunules on both wings

② Uns greyish-brown with orange submarginal lunules and white-ringed black spots

③ Fw uns no cell-spot (cf. *Polyommatus icarus*)

✴ Both sexes brown

This is a complex species; widespread and often common in S and C Europe but absent from N British Isles and most of Fennoscandia. Two or three broods from April to October in heaths, dunes, cliffs and various damp to dry grasslands typically on calcareous soils up to 1,700 m. Larva feeds on *Erodium*, *Geranium* and *Helianthemum* species.

Southern Brown Argus · *Aricia cramera*

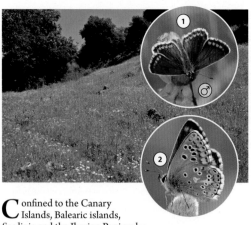

① Ups brown with large orange submarginal lunules forming a continuous band on both wings

② Fw uns no cell-spot (cf. *Polyommatus icarus*)

✴ Closely resembles *A. agestis* but smaller

✴ Both sexes brown

✴ Sexes similar

Confined to the Canary Islands, Balearic islands, Sardinia and the Iberian Peninsula; also reported from France and Italy. All year round on the Canary Islands, but generally two or three broods from April to October in rocky flowery places in calcareous terrain up to 1,800 m. Larva feeds on *Erodium*, *Geranium*, *Helianthemum* and *Tuberaria* species.

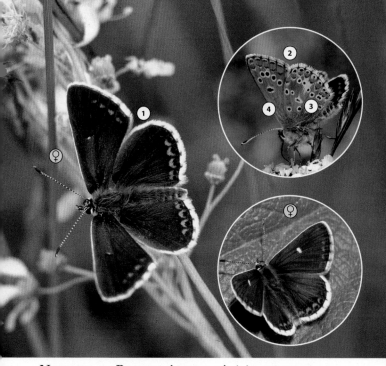

NORTHERN BROWN ARGUS · *Aricia artaxerxes*

The status of the Northern Brown Argus, with its many subspecies, has been a subject of heated debate for ages, especially in the UK. Many authors are unwilling to grant it more than subspecific status under *A. agestis*, but these two differ markedly in regard to their life cycles. The Brown Argus is generally double-brooded, whereas the Northern Brown Argus, limited by more extreme conditions, produces only one generation per season. Their ranges broadly overlap in southern Europe. Subspecies *allous* is most widespread, ssp. *montensis* at high altitudes, from Spain to Balkans; regarded as species in their own right by some authors.

➲ *Aricia agestis*
 Aricia morronensis

① Female ups orange submarginal lunules on both wings; lacking or only on hw in male.

② Uns pale grey or brown with orange submarginal lunules, ssp. *allous*

③ Hw uns a submarginal white streak and a white patch in the centre not joined (cf. *A. eumedon*)

④ No cell-spot on fw uns (cf. *Polyommatus icarus*)

☂ One generation between June and September, depending on both altitude and latitude. Luxuriant forest clearings and glades, woodland margins and scrubby grasslands, coastal cliffs, dry and rocky mountain slopes usually between 1,000 and 2,000 m in the southern ranges.

⊕ Very sporadic in the mountain ranges in S and C Europe; more widespread in lowlands in Scotland and most of Fennoscandia and Baltic states.

✿ Many cranesbills (*Geranium sylvaticum*, *G. sanguineum*, etc.), *Erodium cicutarium* and *Helianthemum nummularium*.

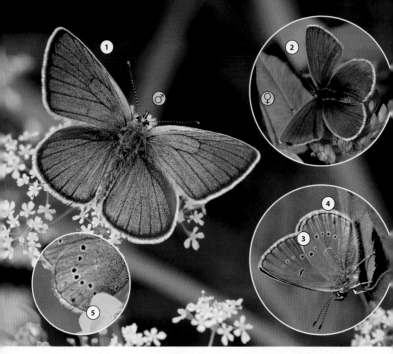

MAZARINE BLUE · *Cyaniris semiargus*

TH S FINLAND SOMERO 6/08 • HA E FINLAND KERIMAKI 6/06 • PO GREECE PELOPONNESE 6/09 • PO SE FINLAND JOUTSENO 6/06

The 60 or so butterfly species in Britain undoubtedly rank among the best known insect groups in the world. The Mazarine Blue, sometimes described as an oversized Small Blue, formed part of the British fauna up until the mid 18th century, when it became extinct for reasons unknown. It is still a mystery to scientists why this fairly common and widely distributed European blue continues to avoid Britain. At the other edge of the species' range, the delightful subspecies *helena* is prolific on some Grecian mountains. It has most peculiar fuzzy orange markings on the underside.

⌖ *Cupido minimus*
 Cupido osiris

① Male ups blue with black veins and white fringes
② Female ups brown with a faint violet flush at base
③ Hw uns greyish-brown with an angled row of black, white-bordered spots
④ No marginal markings
⑤ ssp. *helena*
✳ Closely resembles *Cupido osiris*, but larger and uns black spots more conspicious and white-ringed

🦋 Usually one generation between May and early August, depending on altitude and latitude; a 2nd and partial brood possible until October. Various dry to damp grasslands, hayfields and cultivations, roadsides, scrub, forest clearings and margins, hills and mountain slopes up to 2,300 m.

⊕ Widespread and locally common through most of Europe except the British Isles, N Fennoscandia and most Mediterranean islands (excl. Sicily). Mostly in the mountain ranges in S Europe.

🌿 Mainly clovers, in particular *Trifolium pratense*, occasionally other legumes.

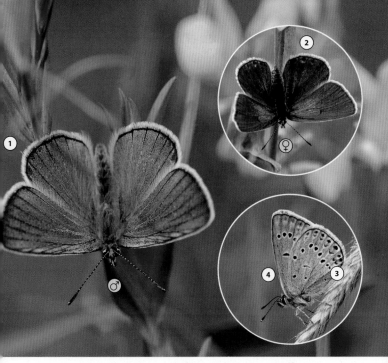

AMANDA'S BLUE · *Polyommatus amandus*

Amanda's Blue neatly combines almost all the typical features of the 'blues': marked sexual dimorphism between conspicuous pale blue males and brown females, caterpillars feeding on legumes with constant attendance by ants, and adult behaviour including communal roosting on the same grass stem at night, as well as the habit of puddling on muddy ground. On hot summer days many hikers and butterfly enthusiasts have noticed that Amanda's Blue is inordinately fond of settling on sweaty clothes, human limbs or even faces to take advantage of valuable minerals!

① Male ups shining sky blue with a dark and diffuse marginal band

② Female ups brown with orange submarginal lunules on hw, sometimes also fw

③ Hw uns blue flush at the base and incomplete row of orange submarginal lunules

④ Fw uns no cell-spot (cf. *P. icarus*)

★ Large for a blue

🦋 One generation from late May to early August. Meadows and grasslands with scrub, roadsides, forest clearings and margins, sheltered gullies and slopes up to 2,000 m.

⊕ Widespread through most of E Europe except N Fennoscandia; mostly in mountains in the southern range. Sporadic and rare in W Europe from S Spain to C Alps, absent from the British Isles and Mediterranean islands.

◈ Many vetches (*Vicia cracca, V. villosa, V. tetrasperma*, etc.), also *Lathyrus pratensis* in the northern ranges.

HA: E FINLAND KERIMÄKI 6/07 · HA: SE FINLAND IMATRA 7/09 · TH: S FINLAND SOMERO 6/08

ESCHER'S BLUE · *Polyommatus escheri*

ZK SW BULGARIA PIRIN 7/06 · TH N SPAIN 8/08 · HA SPAIN HUESCA 7/08

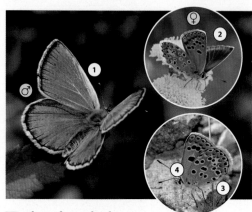

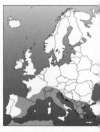

Rather widespread and locally common in S and C Europe from Spain to S Balkans (ssp. *dalmaticus*). One brood from mid-May to August in dry rocky habitats sheltered with scrub on calcareous soils, or damp woodland clearings, usually between 500 and 2,000 m in the mountains. Larva feeds on milk-vetches (*Astragalus*).

① Male ups sky blue with a thin white stripe along fw costa, ssp. *dalmaticus*
② Female ups brown with orange lunules on both wings
③ Hw uns black ocelli bold and white-bordered (cf. *P. thersites*)
④ Fw uns no cell-spot (cf. *P. icarus*)

TURQUOISE BLUE · *Polyommatus dorylas*

HA GREECE PHALAKRON 7/10 · HA SWITZERLAND 7/07 · HA SWEDEN ÖLAND 7/96

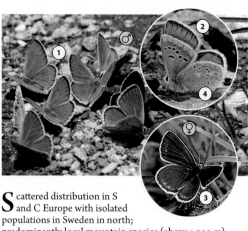

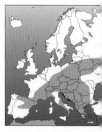

Scattered distribution in S and C Europe with isolated populations in Sweden in north; predominantly local mountain species (above 1,000 m). Evaluated as Near Threatened in Europe. One brood in July–August, or two broods in May–June and July–August at lower altitudes, in scrubby calcareous grasslands, flowery hillsides and sheltered hollows in alpine meadows up to 2,200 m. Larva feeds on *Anthyllis vulneraria*.

① Male ups shiny sky blue with slight turquoise sheen
② Fw ups narrow black borders and black scales extend inwards along veins
③ Female ups brown with blue dusting at the base
④ Uns brownish-grey with broad white borders

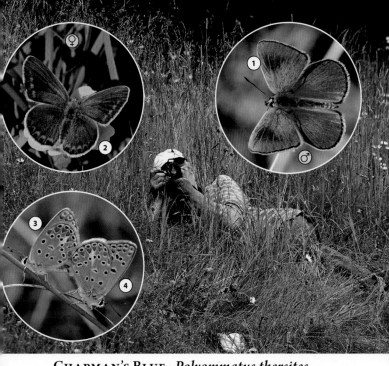

CHAPMAN'S BLUE · *Polyommatus thersites*

Some blues are particularly tricky to identify, no matter how experienced one is. By contrast, Chapman's Blue can be described quite simply as being just like the Common Blue but without that distinctive black cell spot in the basal area of the forewing'. The unfortunate thing is that some, if not a considerable percentage, of Common Blues may also lack this extra spot! Problems are thus likely to arise in the southern part of Europe, where the ranges of these two commonly overlap. However, a suggestion of large androconial patch and no cell-spot on forewing underside in the males are generally given as indicative of Chapman's Blue.

⊝ *Polyommatus escheri*
Polyommatus icarus

① Male ups light blue and tinged with violet; an androconial patch on fw (cf. *P. icarus*)
② Female ups dark brown, dusted with blue, with large submarginal lunules, 1st brood
③ Uns pale brownish-grey with orange submarginal lunules and white-ringed black spots
④ Fw uns no cell-spot (cf. *P. icarus*, *P. escheri*)

🦋 Mostly two generations; 1st brood from April to late May and 2nd brood in June–August. Warm meadows and grasslands, neglected cultivations and fields of sainfoins, roadsides and scrub up to 1,600 m.
⊕ Widespread and common in S and C Europe, but absent from Mediterranean islands except Malta, Samos, Kos and Rhodes.
🍃 Some sainfoins (*Onobrychis viciifolia*, *O. caput-galli*).

TM N ITALY DOLOMITES 7/07 · TM SPAIN CATALONIA 10/07 · HA SPAIN 7/08 · HA SPAIN ALBARACIN 7/08

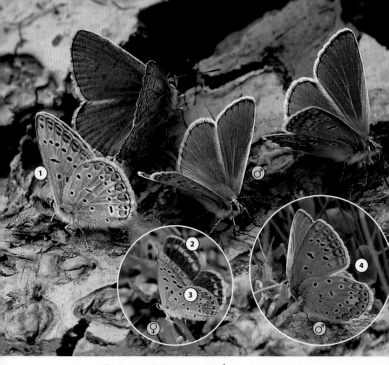

COMMON BLUE · *Polyommatus icarus*

The Common Blue is worthy of its name, occurring from the scorching edge of the Sahara to the icy slopes of fiords along the Arctic Ocean – and everywhere in between. As Europe has around 90 blue species, it is worth learning to recognise the commonest one. Other blues are handily identified according to how they differ from this standard blue with its typical pattern on the underside. The Common Blue can be seen in almost any kind of environment, even frequently visiting parks and gardens. Only a few moments before sundown dozens of individuals may gather together to roost on the same grass stem.

⊘ *Polyommatus escheri*
 Polyommatus thersites

① Fw uns two cell-spots (sometimes only one)
② Female ups brown with orange submarginal lunules on both wings
③ Hw uns a white wedge
④ *P. icarus andronicus*; probably a separate species with stable genital differences from *P. icarus* (Kolev 2005)

☙ Mostly two or three generations between late March and November; a single brood in June–July in highest altitudes. A wide variety of habitats up to 3,000 m.

⊕ Widespread and very common over the whole of Europe, including most Mediterranean islands and some Canary Islands (Fuerteventura, Lanzarote, Tenerife). Highly variable across the vast range, including many taxa sometimes regarded as species of their own; *andronicus* in NE Greece and SW Bulgaria, *abdon* in SE Spain, *celina* in Canary Islands and NW Africa.

⊕ A wide range of legumes (*Lotus, Medicago, Anthyllis, Astragalus, Genista, Onobrychis, Ononis, Trifolium*, etc.).

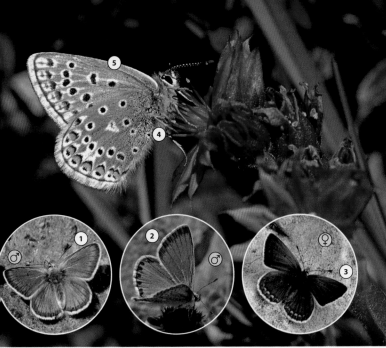

EROS BLUE · FALSE EROS BLUE · TAYGETOS BLUE
Polyommatus eros · Polyommatus eros eroides · Polyommatus eros menelaos

Closely resembles *P. icarus*; sporadic distribution with very local colonies in the higher mountains of S Europe from the Pyrenees to S Balkans; also in the Ural Mts and the Caucasus. Evaluated as Near Threatened in Europe. One brood from July to September on calcareous mountain slopes with sparse vegetation and alpine grasslands typically above 1,800 m. Larva feeds on milk-vetches (*Oxytropis*).

There are two subspecies which are sometimes regarded as species in their own right. Ssp. *eroides* has a scattered distribution in N Greece and S Balkans with a close relative *P. boisduvalii* in Belarus and eastwards. Ssp. *menelaos* is restricted to Mt Taygetos on Peloponnese.

① Male ups pale shining blue with black borders and white fringes, *P. eros*
② Male ups dark scales extend inward along the outer parts of the veins, ssp. *eroides*
③ Female ups grey brown, ssp. *menelaos*
④ Uns brownish-grey with blue dusting at the base, *P. eros*
⑤ Fw cell a black spot (cf. *P. icarus*)

🦋 Ssp. *eroides* (black spots larger than those in *P. eros*; female greyish-brown with little or no blue dusting). One brood from mid-June to late July in sandy grasslands, river banks, forest margins and rocky mountain slopes between 1,200 and 2,100 m. Larva feeds on *Genista depressa*.

🦋 Ssp. *menelaos* is rather common with one brood in June–July in Mt Taygetos alpine meadows and gullies usually near the tree line (between 1,100 and 2,000 m). Larva feeds only on endemic *Astragalus taygetos*.

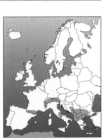

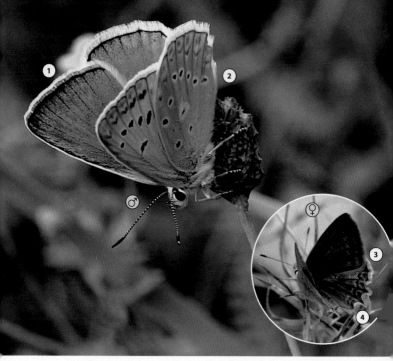

PO HUNGARY 7/06 · TN GREECE PELOPONNESE CHELMOS 7/10

MELEAGER'S BLUE · *Polyommatus daphnis*

This species is unusual among the blues in that the female is even more eye-catching than the male. The female has a strongly marked blue and brown upperside and possesses uniquely shaped hindwings with strongly scalloped margins, that give the impression of multiple short pointed 'tails'. The light blue male has less pronounced scalloping. Colonies of the butterfly are concentrated on sites with an abundance of the foodplant, crown vetch. Females immediately proceed to lay their eggs, but the caterpillars do not hatch until the following spring as fresh foodplants begin to sprout.

① Male ups shiny blue with black borders

② Uns light brown with black postdiscal spots and grey marginal markings

③ Female f. *steeveni* ups greyish-brown with blueish tint. Nominate female ups blue with broad brown borders

④ Hw strongly scalloped

🦋 One generation from mid-June to August. Dry and warm rocky grasslands typically near woodland on calcareous soils up to 1,900 m.

⊕ Widespread and locally common in SE Europe, sporadic and rare in S Europe extending from N Sicily westwards to N Spain.

🍃 Exclusively crown vetch (*Coronilla varia*).

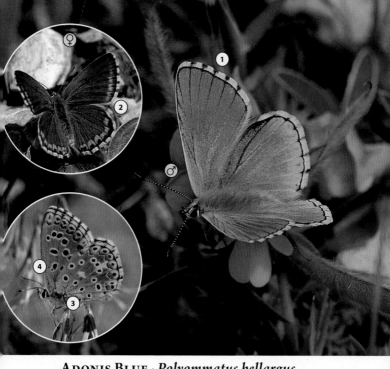

ADONIS BLUE · *Polyommatus bellargus*

This species, with its dazzlingly brilliant blue males, takes its name from the figure from Greek mythology who epitomised male beauty. While its colonies are often limited in extent, hundreds of individuals may inhabit situations with a favourably hot microclimate. Adonis Blues are known to hybridise with some other blues. Sterile male hybrids with the Chalk-hill Blue, in particular, have even been treated as a species in their own right! Other hybrids of intermediate appearance are occasionally produced with chalk-hill blue species of more restricted distribution.

↪ *Polyommatus coridon*

① Male ups brilliant sky-blue with strongly chequered fringes
② Female ups chocolate brown with orange submarginal lunules on both wings
③ Uns greyish-brown with a hint of blue at the base of hw
④ Fw uns one or two cell-spots

🦋 Mostly two generations; 1st brood from mid-May to June and 2nd brood (often more abundant) from July to September; some single-brooded populations in S Greece. Warm and dry grasslands sheltered by woods or shrub on calcareous soils up to 2,000 m.

⊕ Widespread and locally common in S and C Europe up to S Britain and E Baltic states in north, but absent from most Mediterranean islands (excl. Balearic islands).

🌿 Some legumes (*Hippocrepis comosa*, *Coronilla varia*); later stages myrmecophilous in *Lasius*, *Plagiolepis* and *Myrmica* nests.

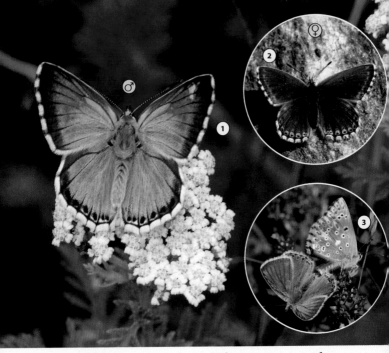

CHALK-HILL BLUE · *Polyommatus coridon*

A very complex 'superspecies' endemic to Europe. Despite extensive chromosome studies on numerous populations, the confusion only seems to increase among lepidopterists. For example, the '*philippi*' morph present in the Balkan region is probably merely a colour form of the Chalk-hill Blue rather than a subspecies. Only the butterflies themselves do not worry about their own systematics. The females lay eggs in which fully formed larvae are destined to remain, at times, for as long as eight months. After emergence the larvae feed only by night, grazing the surface of the leaf. A close association with ants continues even at the pupal stage.

⊙ *Polyommatus hispanus*
Polyommatus caelestissimus

① Male fw ups silvery blue with a wide brown border
② Female hw ups brown with orange submarginal lunules more distinct
③ Female fw uns brownish (cf. *P. hispanus*)
⊛ Closely resembles *P. hispanus*

☿ One generation between early July and late September, depending on latitude and altitude. Warm and dry habitats only in calcareous terrain; grasslands with short turf, chalk downs, hillsides and dry woodland margins up to 2,000 m.

⊕ Widespread and locally common through much of Europe but declined in the northwestern range. Many subspecies and forms over the vast range, including *gennargenti* in Sardinia, *nufrellensis* in Corsica, *asturiensis* in N Spain, etc.

◈ Exclusively *Hippocrepis comosa*.

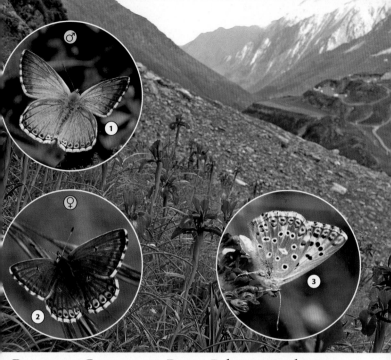

PROVENCE CHALK-HILL BLUE · *Polyommatus hispanus*

epidopterists keep searching for, and arguing about, distinctive features that separate different chalk-hill blue types. Evidence for the existence of the Provence Chalk-hill Blue is largely circumstantial; if a butterfly is on the wing before June, it cannot be a Chalk-hill Blue! The two very similar-looking species fly together later in the summer, but males of the first named appear very pale in flight, combined with a much darker underside. Females, on the other hand, are said to be indistinguishable in the field. However, a dense colony is more indicative of the Provence Chalk-hill Blue.

→ *Polyommatus coridon*
Polyommatus caelestissimus

① Male fw ups pale bluish-grey with broad smoky-grey borders
② Female hw ups brown with orange submarginal lunules, more distinct
③ Fw uns pale grey with black spots (cf. *P. coridon*)
⊛ Closely resembles *P. coridon*

🦋 Two generations;
1st brood in April–June, 2nd brood from August to October. Warm and dry grasslands scattered with bushes, mostly on calcareous soils between 500 and 1,200 m in the mountains.

⊕ Endemic to Europe; confined to SW Europe, where locally common from NE Spain and the Pyrenees through S coast of France to NW Italy.

🌱 Exclusively *Hippocrepis comosa*.

HA S FRANCE PILAU 7/08 · TH N SPAIN PYRENÉES 8/08 · TH FRANCE MARITIME ALPS 5/06 · HA SPAIN TERUEL 7/08

Anomalous Blue · *Polyommatus admetus*

HA N GREECE 7/10 · PO GREECE 17/5 7/09

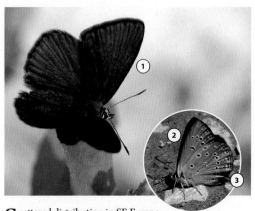

S cattered distribution in SE Europe extending from Greece to Hungary and Slovakia. Widespread but local and generally low in numbers in dry and stony glades in river gorges, woodland clearings and scrubby mountain slopes between 400 and 1,800 m, with one brood between mid-June and September. Larva feeds on various sainfoins (*Onobrychis*).

① Male ups plain brown with brown fringes
② Uns yellowish-brown with white-ringed postdiscal spots
③ Hw uns pale with brown submarginal lunules in two rows
★ Sexes similar
★ Restricted to the Balkans

Ripart's Anomalous Blue · *Polyommatus ripartii*

PO S BULGARIA 7/09 · PO SPAIN ALBARRACIN 7/08 · ZK S BULGARIA RHODOPI 7/08

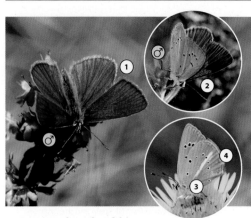

V ery sporadic with widely dispersed local populations in S and C Europe; presumably a superspecies with several closely related species. Often found in large numbers in the habitat. One brood between late June and late August in dry meadows, glades and mountain slopes up to 2,000 m. Larva feeds on many perennial sainfoins (*Onobrychis*).

① Both sexes ups plain brown with brown fringe
② Male fw ups base has a hairy scent-scales patch
③ Uns yellowish-brown with a white stripe through the centre of hw
④ Hw uns with faint submarginal lunules (cf. *P. damon*, *P. dolus*, *P. fulgens*)

Furry Blue · *Polyommatus dolus*

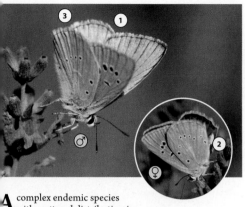

TNK FRANCE PROVENCE 7/07 · TNK FRANCE PROVENCE 7/07

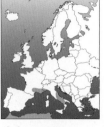

① Male ups silvery white or blue with brown borders and brown-whitish veins,

② Female brown

③ Both sexes have white fringes

★ Male fw base a large brown androconial patch

A complex endemic species with scattered distribution in the mountain ranges of S France (ssp. *vittatus*) and C Italy (ssp. *virgilius* and *gargano*) in widely dispersed and local populations. One brood from mid-July to August in woodland clearings, hot spots in scrubby grasslands and mountain slopes between 500 and 1500 m. Larva feeds on sainfoins (*Onobrychis*).

Damon Blue · *Polyommatus damon*

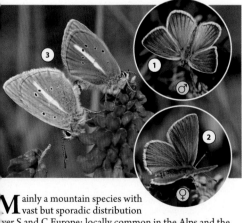

PO SWITZERLAND EVOLENE 7/07 · TM SWITZERLAND EVOLENE 7/07 · HA SWITZERLAND EVOLENE 7/07

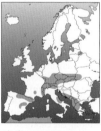

① Male ups pale shiny blue with wide greyish-brown borders and brown veins

② Female uniform dull brown

③ Hw uns greyish-brown with a prominent white stripe on both sexes

Mainly a mountain species with vast but sporadic distribution over S and C Europe; locally common in the Alps and the Pyrenees, some isolated populations in SE Latvia. Evaluated as Near Threatened in Europe. One brood in July–August in neglected cultivations, dry scrub, forest clearings and subalpine grassy slopes usually in calcareous terrain between 1000 and 2,100 m. Larva feeds on sainfoins (*Onobrychis*).

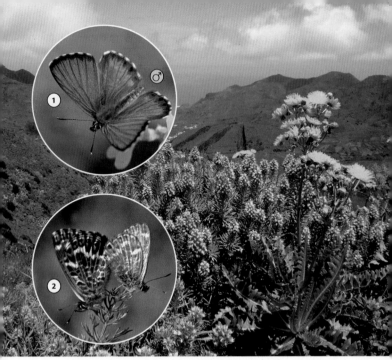

CANARY BLUE · *Cyclyrius webbianus*

The butterfly fauna of the
Canary Islands is a mixture
of species of African, North
American and European origin.
In the course of extensive isola-
tion many new endemic species
have evolved, some with a very
limited distribution in these
islands, surrounded as they
are by the vast Atlantic Ocean.
Among the common endemics is
the Canary Blue, with its closest
living relatives on the island
of Madagascar. Although the
insect is frequently seen in large
numbers, good photographs of
the species are rare. The rest-
less individuals do not stay still
for long, but it is worth waiting
near flowers of *Micromeria*.

⊝ *Lampides boeticus*
 Zizeeria knysna

① Male ups violet blue
 with dark borders
 and white fringes
② Female fw uns brown,
 hw grey with white
 undulate markings
⊛ Female ups reddish-
 brown with blue tinge
🦋 Several overlapping
 generations all year
 round. Coastal cliffs,
 rocky scrub and wasteland at lower altitudes,
 sheltered slopes up to 3,500 m in Tenerife.

⊕ Endemic to Europe; restricted to the Canary Islands.
 Locally common in Tenerife, Gran Canaria, La Palma
 and Gomera.

◊ Many low-growing legumes, such as *Lotus*, *Cytisus*,
 Spartocytisus, *Adenocarpus*, etc.

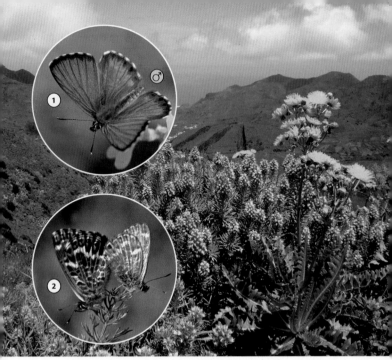

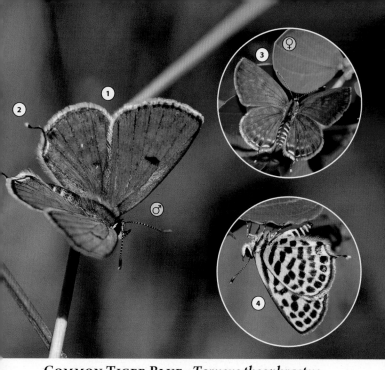

COMMON TIGER BLUE · *Tarucus theophrastus*

In Europe this species is totally unmistakable – although identification problems emerge on the African side of the Mediterranean. There is certainly something exotic in the looks of the Common Tiger Blue. The females fly very rapidly upwind in search of suitable hostplants for their eggs, while males constantly perch at or patrol the downwind side, searching for incoming females or those already sitting on the bush. The tiny butterfly is most easily observed where individuals have gathered en masse on grass stems, a typical roosting habit for many blues.

① Male ups violet blue with large black mark in the cell

② A slender tail on hw

③ Female ups dusky brown with light patches

④ Uns white with black stripes and spots

(★) Very small

(★) Strongly associated with *Ziziphus* plants

(♀) Several consecutive generations from April to September; more abundant in the late summer. Usually in very hot and arid scrubland predominated by jujube bushes, but also in cultivations at low altitudes.

(⊕) Confined to coastal districts of SE Spain; occurrence very sporadic and local colonies associated with larval food plants.

(✿) Mainly jujube bushes (*Ziziphus lotus*, *Z. jujuba*), also *Paliurus spina-christi*.

HA S ALMERIA 5/08 · HA S ALMERIA 5/08 · PO S ALMERIA 5/08

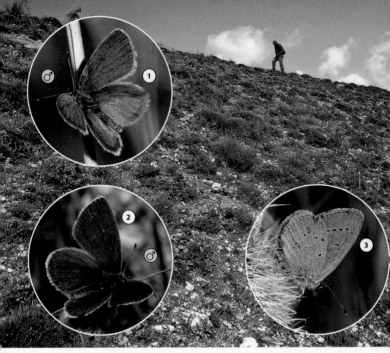

LORQUIN'S BLUE · *Cupido lorquinii*

Lorquin's Blue is restricted to S Spain and S Portugal; uncommon with sporadic colonies. One brood from early April to mid-June in dry grasslands and open flower-rich scrub up to 2,000 m. Larva feeds on *Anthyllis vulneraria*.

CARSWELL'S LITTLE BLUE
Cupido lorquinii carswelli

Carswell's Little Blue is a mountain subspecies of the Lorquin's Blue restricted to SE Spain. It is sometimes regarded as an endemic species of its own. One brood from late April to early June in rocky and scrubby grasslands between 1,000 and 1,800 m. Larva feeds on *Anthyllis vulneraria*.

① Male ups blue with broad sooty black borders, *C. lorquinii* (cf. *C. osiris*)
② Male ups sooty brown, ssp. *carswelli* (cf. *C. minimus*, *C. lorquinii*)
③ Uns pale bluish-grey with a row of small black spots
⊛ Females sooty brown
⊛ Closely resembles *C. minimus*

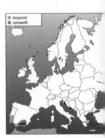

lorquinii
carswelli

FALSE BATON BLUE · *Pseudophilotes abencerragus*

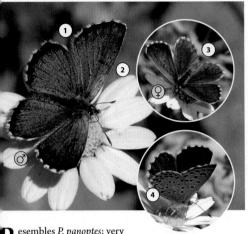

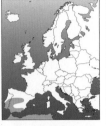

HA S SPAIN VENTA FRAILE 5/08 · HA S SPAIN 5/08 · PO S SPAIN 5/07

① Male ups violet blue with wide sooty-brown borders and fringes chequered with white
② A black spot in the cell
③ Female ups sooty brown with white fringes
④ Hw uns a submarginal orange band weak or missing (cf. *P. baton*, *P. vicrama*)

Resembles *P. panoptes*; very sporadic but locally common in S and C Spain and S Portugal. One brood in April–May in hot and dry habitats amongst open woodland or scrub up to 1,500 m. Larva feeds on *Cleonia lusitanica*.

PANOPTES BLUE · *Pseudophilotes panoptes*

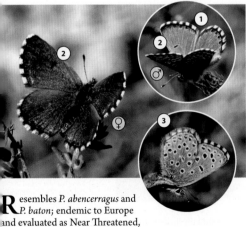

TH SPAIN CATALONIA 4/08 · AML SPAIN CATALONIA 5/08 · TH SPAIN CATALONIA 4/08

① Male ups light blue with narrow dark marginal borders and chequered fringes
② A black spot in the cell
③ Uns pale grey; submarginal orange spots absent or poorly developed (cf. *P. baton*)

Resembles *P. abencerragus* and *P. baton*; endemic to Europe and evaluated as Near Threatened, although widespread and locally common in most of the Iberian Peninsula between 600 and 1,900 m. Mostly one brood from early April to early June, with a small 2nd brood in July-August, in dry scrubby habitats associated with thyme. Larva feeds mainly on *Thymus*.

Gavarnie Blue · *Plebejus pyrenaicus*

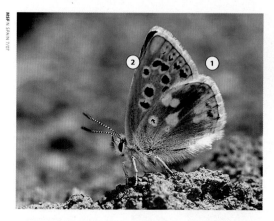

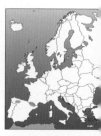

① Uns ground-colour yellowish-grey
② Fw uns black spots bold
⊛ Female ups darker greyish-brown
⊛ Resembles *P. glandon*; restricted to Iberian alpine grasslands

Endemic to Europe; scattered distribution in the mountain ranges between 1,500 and 2,500 m in the Pyrenees and Cantabrian Mts (ssp. *asturiensis*). Widely dispersed but often abundant colonies with one brood between early June and early August in barren alpine grasslands and rocky limestone slopes. Larva feeds on *Androsace villosa*.

Spanish Argus · *Aricia morronensis*

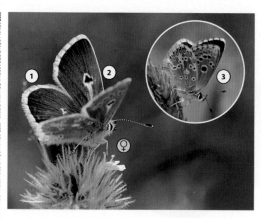

⚲

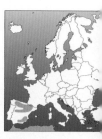

① Both sexes brown with chequered fringes
② Fw ups a black spot in the cell mostly white-ringed
③ Fw uns bold black spot
⊛ Resembles *A. artaxerxes*; more rounded fw tips
⊛ Several local ssp., eg. *ramburi* (Sierra Nevada), *hesselbarthi* (Abejar)
⊛ Close to *Erodium* plants

Endemic to Europe; a variable mountain species with very local colonies between 900 and 3,000 m in the Iberian Peninsula extending to S France in the Pyrenees. Mostly one brood in July–August (sometimes double-brooded at lower altitudes) in barren rocky slopes and alpine grasslands associated with larval host plants, *Erodium* species.

Nevada Blue · *Polyommatus golgus*

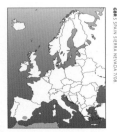

① Male ups sky blue

★ Female dark brown with orange submarginal lunules

★ Closely resembles *P. dorylas*; generally smaller with darker uns

★ Only at high altitudes in Sierra Nevada

A n endemic species restricted to mountains in SE Spain at high altitudes between 2,500 and 3,000 m. Evaluated as Vulnerable in Europe. One brood in June– July in exposed schists and barren rocky slopes on siliciferous or calcareous soils with sparse vegetation. Larva feeds on *Anthyllis vulneraria pseudoarundana*.

Mother-of-pearl Blue · *Polyommatus nivescens*

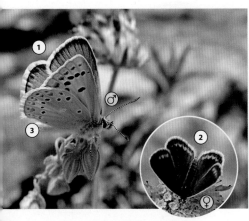

① Male ups shining light grey with dark borders

② Female ups brown with orange submarginal lunules at both wings

③ Uns pale yellowish-grey with white marginal border

★ Resembles *P. dorylas* and *P. golgus*, but lighter in colour; male appears almost white on the wing

E ndemic to Europe; rather wide-spread but local in the mountain ranges of Spain. Evaluated as Near Threatened in Europe. One brood between May and August in rocky mountain slopes with scrub in calcareous terrain up to 2,100 m. Larva feeds on *Anthyllis vulneraria*.

AZURE CHALK-HILL BLUE · *Polyommatus caelestissimus*

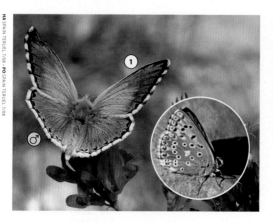

① Male ups sky blue with broad marginal borders and fringes chequered on fw

⊛ Female ups dark brown or blue (f. *deliciosa*) with orange submarginal spots on hw

⊛ Restricted to Montes Universales

Sometimes regarded as a subspecies of *P. coridon*; endemic to Europe, confined to C Spain in the Montes Universales. One brood in July–August only in calcareous soils in sheltered gullies and slopes in pine forest clearings between 1,000 and 1,800 m. Larva feeds on *Hippocrepis comosa*.

SPANISH CHALK-HILL BLUE · *Polyommatus albicans*

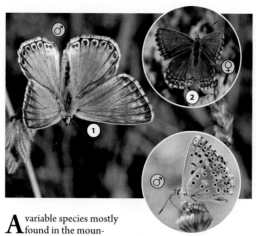

① Male ups almost white with bluish tint in basal area

② Female hw ups orange lunules with whitish surround (cf. *P. hispanus*)

⊛ Large for a blue, male very pale on the wing

A variable species mostly found in the mountain ranges; widespread and locally common in most of Spain. One brood between June and August in open scrub and damp patches of grassy slopes and rocky formations between 500 and 2,000 m. Larva feeds mainly on *Hippocrepis comosa*.

Oberthur's Anomalous Blue · *Polyommatus fabressei*

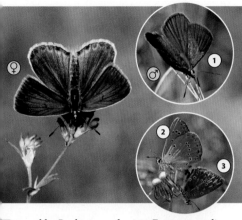

① Male and female brown with brown fringes. Male fw ups with large androconial patch

② Uns brown with white-ringed black postdiscal spots

③ Female hw uns with a weak white stripe, not on male

Resembles *P. admetus*; endemic to Europe, sporadic and locally common mostly in the northern mountain ranges of Spain. One brood between late June and August in rocky gullies, scrubby mountain slopes and barren roadsides between 900 and 1,500 m. Larva feeds on sainfoins (*Onobrychis viciifolia, O. argentea*).

Forster's Furry Blue · *Polyommatus fulgens*

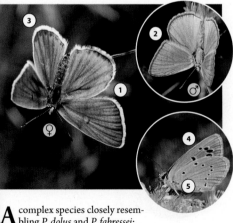

① Female ups plain brown with dark veins in the outer regions

② Male silvery blue or white with brown borders

③ White fringes

④ Uns pale brown with black spots

⑤ Hw with or without a white stripe

A complex species closely resembling *P. dolus* and *P. fabressei*; endemic to E Cantabrian Mts. and the Pyrenees, NE Spain, including ssp. *ainsae, pseudovirgilius*, etc. Abundant colonies with one brood in July–August in rough hillsides, scrub and forest clearings between 600 and 1,800 m. Larva feeds on *Onobrychis viciifolia*.

Andalusian Anomalous Blue · *Polyommatus violetae*

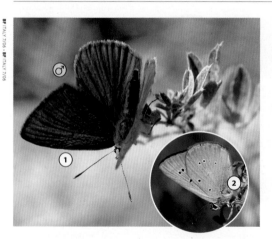

① Both sexes brown with brown fringes

② Uns pale brown with a white streak across the hw

✱ Externally identical to *P. ripartii*, but the ranges do not overlap

Closely resembles *P. ripartii* and *P. fabressei*; endemic to Europe, restricted to the mountains of SE Spain (incl. ssp. *subbaeticus*). Evaluated as Vulnerable in Europe. One brood from late June to early August in dry grassy and rocky slopes between 1,200 and 1,800 m. Larva feeds on endemic *Onobrychis argentea*.

Piedmont Anomalous Blue · *Polyommatus humedasae*

① Both sexes dark brown with black mark in the cell

② Uns pale brown without a white stripe

Endemic to Europe and evaluated as Endangered; distribution confined to Cogne Valley in NW Italy with five or less local populations only. One brood in July–August in scrubby slopes between 800 and 1,000 m. Habitats are legally protected. Larva feeds on *Onobrychis viciifolia*.

GALLO'S ANOMALOUS BLUE · *Polyommatus galloi*

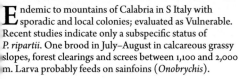

① Both sexes chestnut brown with cream-white fringes

② Hw uns with a conspicuous white stripe, also sometimes seen in female fw uns

Endemic to mountains of Calabria in S Italy with sporadic and local colonies; evaluated as Vulnerable. Recent studies indicate only a subspecific status of *P. ripartii*. One brood in July–August in calcareous grassy slopes, forest clearings and screes between 1,100 and 2,000 m. Larva probably feeds on sainfoins (*Onobrychis*).

TNK S ITALY 7/09 · TNK S ITALY 7/01

BAVIUS BLUE · *Pseudophilotes bavius*

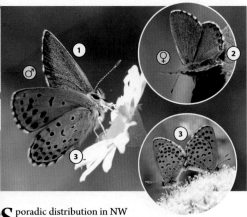

① Male ups violet-blue with dark borders and strongly chequered fringes

② Hw ups orange submarginal lunules, more in female

③ Hw uns an orange submarginal band prominent (cf. *P. vicrama*)

★ Resembles *P. vicrama*; somewhat larger, more violet on ups

Sporadic distribution in NW Romania, S Balkans and S Greece; colonies local and widely dispersed, several subspecies or forms, often threatened by grazing. One brood from mid-May to June in calcareous grasslands, vineyards and valleys, rocky slopes and scrubby gullies between 600 and 1,200 m. Larva feeds on various *Salvia*.

PO S TURKEY ALANYA 4/09 · PO S TURKEY ALANYA 4/09 · TM S TURKEY ANTALYA 6/10

Balkan Blue · *Plebejus dardanus*

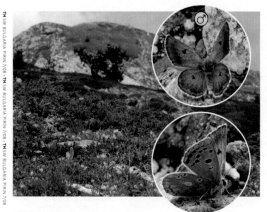

⭐ Closely resembles *P. pyrenaicus* but smaller

⭐ Restricted to the Balkans and surroundings

Sometimes regarded as a subspecies of *P. pyrenaicus*; very local in the Balkan Peninsula from N Greece to Bosnia-Herzegovina, more widespread in Turkey and eastwards. Evaluated as Near Threatened in Europe. One brood from late June to August in very local colonies in barren karst terrain on rocky slopes and ridge crests above 1,600 m. Larva feeds on *Androsace villosa*.

Blue Argus · *Aricia anteros*

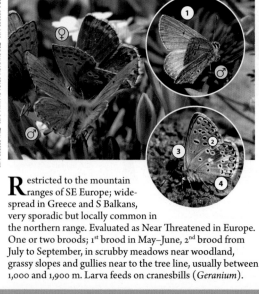

① Male ups shining pale blue with grey margins, a black discoidal spot on fw

② Hw uns a black spot near costa displaced basally

③ Fw uns a cell-spot is variably present (cf. *P. icarus*)

④ Both sexes uns a complete series of orange submarginal spots on both wings

Restricted to the mountain ranges of SE Europe; widespread in Greece and S Balkans, very sporadic but locally common in the northern range. Evaluated as Near Threatened in Europe. One or two broods; 1st brood in May–June, 2nd brood from July to September, in scrubby meadows near woodland, grassy slopes and gullies near to the tree line, usually between 1,000 and 1,900 m. Larva feeds on cranesbills (*Geranium*).

LITTLE TIGER BLUE · *Tarucus balkanicus*

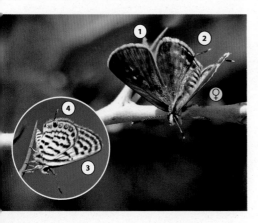

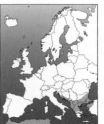

R ather widespread but very sporadic and locally uncommon in SE Europe around the Aegean Sea; more common at low altitudes in N Cyprus. Several broods from April to October mostly in very hot coastal lowland regions, in dry rocky scrub and grasslands with abundant larval host-plant *Paliurus spina-christi*.

① Female ups grey-brown, male lilac-blue or grey
② Slender tails on hw
③ Uns white with numerous black lines
④ Hw a series of submarginal ocelli with silver-blue pupils
⊛ Resembles *T. theophrastus*, very small
⊛ Closely associated with *Paliurus* plants

GRASS JEWEL · *Chilades trochylus*

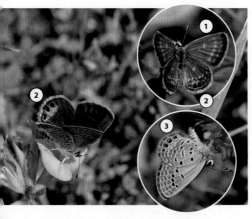

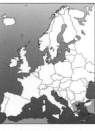

R estricted to Greece and several Grecian islands, Crete and Cyprus; colonies very local but some-times numerous. Two or three broods from March to November in hot and dry disturbed grounds, usually at lowlands near cultivations, but up to 1,900 m in Cyprus. Larva feeds on *Heliotropus* and *Andrachne telephioides*.

① Both sexes brown with faint white dots
② Hw ups orange submarginal spots and black marginal ocelli
③ Hw uns with shining black ocelli and orange spots
⊛ Flies like a fly very close to the ground
⊛ Smallest butterfly in Europe

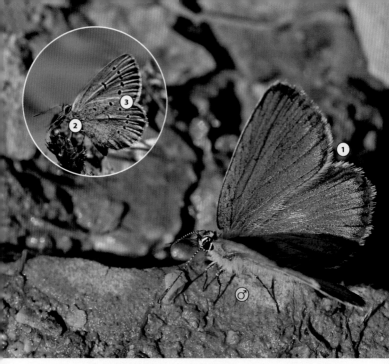

Pontic Blue · *Polyommatus coelestinus*

TM S TURKEY ELMALI 6/10 · TM S TURKEY ELMALI 6/10

In the Peloponnese, Chelmos mountains, the female Pontic Blue (*P. coelestinus hera*) is easily confused with the local subspecies of Mazarine Blue (*Cyaniris semiargus helena*). Both have orange markings on the hindwing underside but the pattern is different. In Pontic Blue the second black spot in the submarginal row on hindwing is not displaced to the base as it is in Mazarine Blue. In Turkey, the Pontic Blue may also be confused with the subspecies *bellis* of Mazarine Blue, sometimes called the Eastern Mazarine Blue.

⊙ *Cyaniris semiargus*

① Male ups shining dark blue with a broad black border, female brown

② Hw uns basal half flushed bright blue (cf. *Cyaniris semiargus helena*)

③ Hw uns second black spot in the submarginal row not displaced to the base (cf. *Cyaniris semiargus*)

✴ Only in NW Peloponnese

✲ One generation between May and July, depending on altitude. Meadows and clearings in woodland, dense shrubland, sheltered grassy mountain slopes and fields, usually on calcareous soils, up to 1,900 m.

⊕ An extremely limited range in Europe, confined to Chelmos Mts in S Greece.

◍ Mostly *Vicia cracca*.

GRECIAN ANOMALOUS BLUE · *Polyommatus aroaniensis*

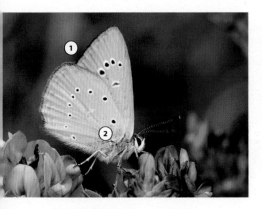

BF GREECE PELOPONNESE 7/05

① Uns uniform yellowish-brown with black spots and dark fringes (cf. *P. nephohiptamenos*)
② Hw uns a white stripe weak or absent
★ Both sexes brown

R esembles other anomalous blues, in particular *P. eleniae;* endemic and very restricted range in Greece, Macedonia and Bulgaria. Local colonies usually in low numbers with one brood from late June to early August in dry scrub, woodland rides, calcareous rocks and mountain slopes mostly between 500 and 2,000 m. Larva feeds on *Onobrychis ebenoides*.

KOLEV'S ANOMALOUS BLUE · *Polyommatus orphicus*

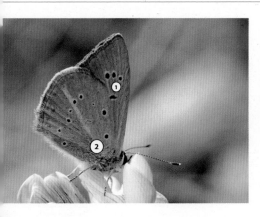

ZK S BULGARIA RHODOPI 6/07

① Fw uns a weak white stripe, outside of the discal spot
② Hw uns white stripe conspicious
★ Note. Main difference between *P. orphicus* and *P. ripartii* is 20% longer male genitalia in *orphicus;* haploid chromosome number 41–42 in *orphicus*, 90 in *ripartii*. Described by Kolev 2005

P reviously regarded as a subspecies of an eastern species *Polyommatus dantchenkoi*; endemic to Europe, restricted to Rhodopi Mts in Bulgaria and Greece. Very local and scarce; evaluated as Vulnerable in Europe. One brood from late June to early August in dry and rocky mountain fields and slopes in calcareous terrain between 300 and 1,500 m. Larva feeds on *Onobrychis alba*.

Phalakron Anomalous Blue · *Polyommatus eleniae*

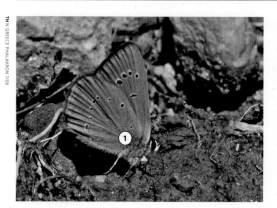

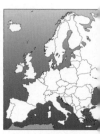

① Hw uns a weak or almost absent white stripe

★ Closely resembles *P. aroaniensis*

★ Described as a new species in 2005 (Coutsis & De Prins)

Resembles other anomalous blues, in particular *P. aroaniensis*; endemic and very restricted range in N Greece (Mt. Falakró and the surroundings) and adjacent Bulgaria. Local but sometimes abundant colonies with one brood from early July to mid-August in rocky mountain slopes between 600 and 1,900 m, usually above 1,000 m. Larva feeds on sainfoins (*Onobrychis*).

Higgins' Anomalous Blue · *Polyommatus nephohiptameno*

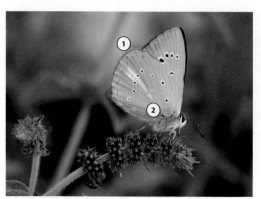

① Uns pale grey; hw ups with white fringes

② Hw uns a white stripe broadening towards the outer margin (cf. *P. iphigenia*)

★ Both sexes brown

Closely resembles *P. ripartii*; endemic and very restricted range in higher mountains of NE Greece and SW Bulgaria. Very local colonies; evaluated as Near Threatened in Europe. One brood in July–August in calcareous grassy mountain slopes between 1,400 and 2,100 m; usually the only anomalous blue well above the tree line. Larva feeds on sainfoins (*Onobrychis alba, O. montana scardica*).

Chelmos Blue · *Polyommatus iphigenia*

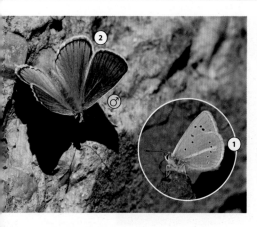

① Hw uns a white stripe, not broadening towards the outer margin (cf. *P. nephohiptamenos*)

② Male ups blue with narrow marginal borders

⊛ Female ups dark brown

⊛ In Europe, restricted to Mt Chelmos on Peloponnese, more widespread in S and E Turkey

Restricted to Mt Chelmos district in Peloponnese, S Greece; rare with very local colonies, sometimes threatened by goat grazing. One brood in June–July in calcareous terrain, rocky mountain slopes and grasslands with short scrub above the tree line between 1,100 and 1,700 m. Larva feeds on *Onobrychis alba*.

Odd-spot Blue · *Turanana taygetica*

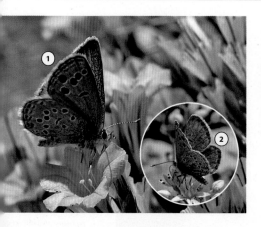

① Fw uns with large black postdiscal spots, the one distinctly displaced (= odd spot)

② Male ups dark blue with broad black-grey marginal border, female dark brown

⊛ Bound to *Acantholimon* plants

⊛ Only on Peloponnese mountains, ssp. *taygetica* on Mt. Taygetos, ssp. *endymionoides* on Mt. Chelmos

Confined to Mt Chelmos and Mt Taygetos, Peloponnese, S Greece with extremely local colonies; evaluated as Endangered in Europe. One brood in June–July in alpine fields and shrubby mountain slopes on calcareous soils and rocks between 1,000 and 2,300 m. Larva feeds on *Acantholimon echinus*.

SARDINIAN BLUE · *Pseudophilotes barbagiae*

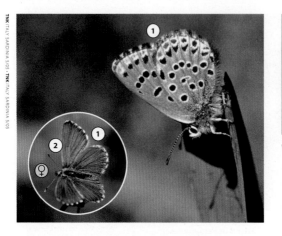

① Both sexes brown
 or greyish with
 chequered fringes
② A black discoidal spot
 small or vestigial
★ Hw uns both sexes dark
 brown; no orange spots
★ Restricted to Sardinia

Endemic to Europe; confined to Mt Gennargentu in Sardinia. Locally common with one brood in May–June in grasslands with scrub, woodland margins and rocky mountain slopes between 800 and 1,500 m. Larva feeds on *Thymus herba-barona*.

SARDINIAN IDAS BLUE · *Plebejus bellieri*

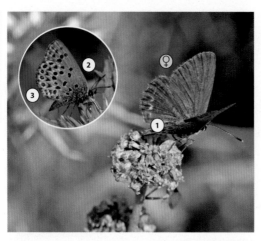

① Female ups darkish
 brown with extensive
 blue basal flush
② Uns brownish-grey
③ Black ocelli very
 prominent on both wings
★ Male ups dark blue with
 broad dark borders

Sometimes regarded as a subspecies of *P. idas*. Endemic to Europe; rare in Corsica, but locally common in Sardinia. One brood in June–July in scrub and forest clearings up to 1,400 m. Larva feeds on local low-growing legumes.

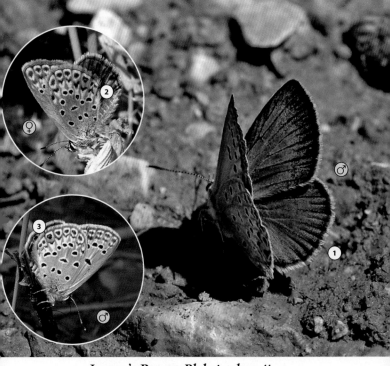

Loew's Blue · *Plebejus loewii*

Islands tend to have distinctive butterfly faunas that include many endemics. Although Loew's Blue is recorded in Europe only in the most eastern Aegean islands, it is not endemic there. It exists at the extreme limit of its range, which extends east to Turkey, Afghanistan and Pakistan. Since the number of butterfly species on a particular island is mainly determined by the island's size, the rates of immigration and extinction, and the distance from a continental source, local colonies of Loew's Blue should be most secure on the largest island, Rhodes.

⊝ *Plebejus eurypilus*

① Male ups blue with black marginal dots on hw
② Hw uns some orange submarginal lunules near anal angle and surrounded with white
③ Hw uns marginal spots with bluish sheen
★ Resembles *P. idas*, *P. argus* and *P. argyrognomon*
★ Female ups brown
★ Restricted to the East Aegean islands

♈ One generation from mid-May to early July; sometimes recorded later in September. Mainly fields at low altitudes, but also dry rocky and scrubby environments up to 1,200 m.

⊕ Restricted to some E Grecian islands (Kalimnos, Kos, Patmos, Rhodes, Tilos), where uncommon with very local colonies. More common in the C Caucasus between 1,000 and 1,500 m.

⬙ Unknown, but probably a legume from the genus *Astragalus* or *Astracantha*.

TM S TURKEY (SPARTA 6/10 · AB E TURKEY VAN 7/05 · AB E TURKEY VAN 7/05

Eastern Brown Argus · *Plebejus eurypilus*

① Hw uns a white band cut by veins
② Hw uns shining blue scales in the black spots
③ Ssp. *pelopides*
✱ Both sexes brown
✱ Restricted to S Greece and Samos

Restricted to Mt Taygetos in S Greece (ssp. *pelopides*) and Mt Kerketefs on the island of Samos. Common but very local with one brood in June–July on calcareous rocky alpine fields and woodland clearings between 1,000 and 2,200 m, generally above the tree line. Larva feeds on *Astracantha rumelica*.

Cretan Argus · *Plebejus psyloritus*

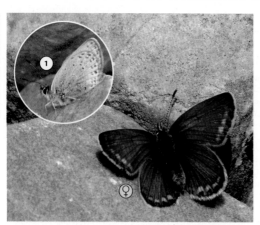

① Uns pale grey with little contrast and minute lunules
✱ Both sexes brown
✱ Restricted to Crete

Endemic to Crete and confined to Mt Ida and Dikti Mts. Locally abundant colonies with one brood in May–July in extremely rocky ground with small shrubs and sparse vegetation in mountain fields between 1,000 and 2,200 m. Larva probably feeds on *Astragalus* or *Astracantha*.

Paphos Blue · *Glaucopsyche paphos*

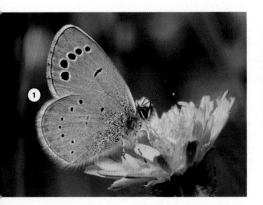

① Fw uns grey with
large black spots;
hw spots smaller

★ Male ups violet blue with
broad dark borders

★ Resembles *G. alexis* which
is not present in Cyprus

Endemic to Cyprus where common in various dry environments. One brood from February to June in a prolonged emergence at lowland grasslands, scrub, clearings in pine forests and rocky mountain slopes up to 1,500 m. Larva feeds on local low-growing legumes, probably *Genista fasselata*.

Small Desert Blue · *Chilades galba*

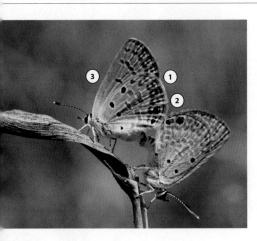

① Uns light grey with
weak brown markings

② Hw uns some black ocelli

③ Fw uns black spots
lacking (cf. *Z. karsandra*)

★ Very small

★ Typically close to
Prosopis plants

★ Restricted to Cyprus

Resembles *Zizeeria karsandra*; recorded only in S Cyprus in locally abundant colonies. Two or three broods between May and November in sclerophyllous scrub near sea level. Larva feeds on *Prosopis stephaniana* and *P. farcta*, maybe also on *Acacia* trees.

NYMPHALIDAE · I

FRITILLARIES, ADMIRALS, EMPERORS, GLIDERS, BROWNS AND HEATHS

NETTLE-TREE BUTTERFLY · *Libythea celtis* – CRETAN SMALL HEATH · *Coenonympha thyrsis*

A total of 108 species in Europe · 16 endemics, 15 Threatened or Near Threatened

One third of the world's butterflies belong to the family Nymphalidae. They are of all sizes and often display bright colours with brown, orange, red, white and black predominating. The sexes usually look alike. There are some widespread migrants like the Painted Lady, as well as species like the Peacock, Small Tortoiseshell and Red Admiral which visit gardens and parks, especially during the late summer and the autumn. Many of them hibernate as adults. The strongly clubbed antennae have longitudinal crests on the underside – this distinguishes the family from other butterfly families. They also have reduced front legs which are useless for walking and which often bear tufts of hair-like scales – hence the name 'brush-footed butterflies'. The wings of fritillaries are orange, decorated with black spots and lines. In this group identification is based mainly on white or silvery spots on the hind-wing underside. The colourful, spiny larvae are toxic to predators and their appearance gives a clear signal: do not touch! Nettles and violets are favourite larval foodplants. Browns and heaths, among others of the subfamily Satyrinae, have duller colours and are less showy, blending in with their grassy and stony environment. They have conspicuous eye-spots (ocelli) either on the upperside or underside of the wings to mislead predators and protect their vulnerable heads and bodies. Grasses are the main source of food for their offspring.

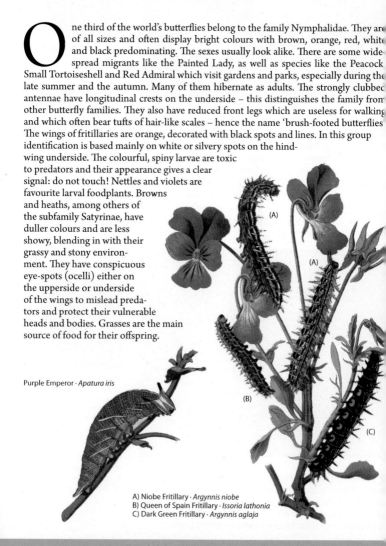

Purple Emperor · *Apatura iris*

A) Niobe Fritillary · *Argynnis niobe*
B) Queen of Spain Fritillary · *Issoria lathonia*
C) Dark Green Fritillary · *Argynnis aglaja*

BRENTHIS DAPHNE **PO**

VANESSA ATALANTA **TH**

VANESSA CARDUI **HA**

LIMENITIS POPULI **HA**

LASIOMMATA MAERA **PO**

PYRONIA TITHONUS **PO**

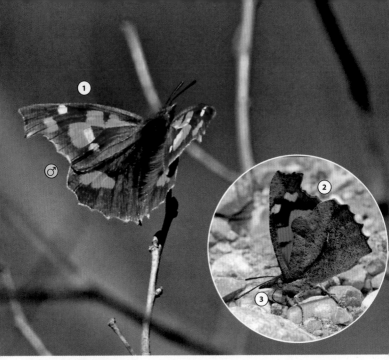

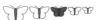

TM SPAIN CATALONIA 4/08 · MA N ITALY 6/06

NETTLE-TREE BUTTERFLY · *Libythea celtis*

The only representative of the snout butterflies (subfamily Libytheinae) in Europe. There are only ten species worldwide in this former family, which is closely related to the Nymphalidae. In June in the Kresna Gorge, S Bulgaria dozens of them can be seen at the riverside sucking at the damp sand. Though commonest in the east of its range it occurs elsewhere in the Mediterranean region, as far west as Spain. Like many nymphalids it hibernates as an adult, emerging on the first warm days of spring to seek a mate. With any close view it is quite unmistakeable, with the very long palps giving its head a distinctive snouted appearance.

① Ups brown with large orange spots

② Both wings toothed and scalloped on outer margin

③ Palpi very long

(★) Sexes similar, female with slightly lighter colours

(★) Resembles *Polygonia c-album* on the wing

🦋 One generation; appears after hibernation in March–April, but most abundant in June-September when the new generation emerges. Bushy open areas, light woodland, dirt roads, damp and sandy patches of riversides, villages and small towns with larval food plants. Usually below 1,000 m, but vagrants may move up to 2,300 m.

⊕ Widespread, but only locally common in S Europe around the Mediterranean region; the most abundant in some parts of Greece and southern Bulgaria. Rare and protected species in N Cyprus; very sporadic and uncommon in the northern range.

🍂 A nettle tree (Celtis australis), seldom other *Celtis* species or *Prunus*, *Ulmus*, etc.

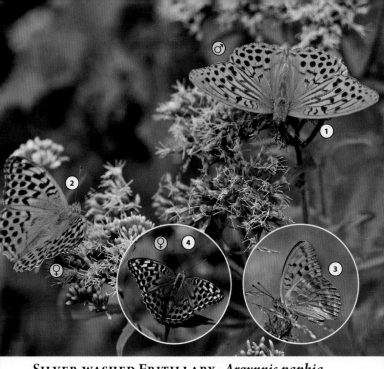

SILVER-WASHED FRITILLARY · *Argynnis paphia*

The long curved wings of the male indicate excellent flying ability. Males patrol large areas but also gather, with females, in small woodland clearings to feed from bramble flowers or thistles. On a sunny day individuals are extremely restless. Early morning visits may meet with more success, as the butterflies bask on vegetation with the wings opened. The form *immacuata* (extensive golden suffusion on hw uns) occurs in Corsica and Sardinia, and in Spain, Italy and S Greece there is f. *argyria* (silver wash well developed on hw uns). The female has two main phenotypes (dimorphism), the greyish-green f. *valesina* being rarer, although it accounts 15 % of all females in some wooded areas.

➜ *Argynnis pandora, Argynnis laodice*

① Male ups bright orange with four black androconial streaks on fw
② Female brown with heavily spotted wings
③ Hw uns greenish with silver stripes
④ Female f. *valesina*, ups heavily coated with dark and green scales
★ Large for a fritillary

One generation between late May and early September, depending on the latitude. Woodland margins and clearings, bushy damp meadows, river valleys and bushy slopes up to 1,700 m.

Widespread and common in most of Europe; absent only in S Iberian peninsula, N British Isles and N Fennoscandia, but expanding northwards.

A range of violets (*Viola*) such as *V. palustris*, *V. canina*, *V. hirta*.

HA N ITALY 8/07 · TH N ITALY 8/07 · TH S ESTONIA VESKI 7/06

Cardinal Fritillary · *Argynnis pandora*

The largest fritillary in Europe, this is a more southerly, greenish-brown version of the yellowish-brown (golden) Silver-washed Fritillary, which is more of a northerly species. Both fly powerfully and engage in elegant glides. In the mid-summer period the Cardinal may be the most abundant butterfly in mountain ranges, for example in late July in Parnassos, Greece, or around Antalya, Turkey, in early September, when almost every roadside thistle has a few visiting. A closer look reveals only a few species, with Cardinals and Painted Ladies usually prominent. While Silver-washed Fritillaries can also occur in the same places, Cardinals are usually more numerous.

⊙ *Argynnis paphia, Argynnis laodice*

① Male ups orange with heavily suffused with green
② Male fw ups two narrow androconial streaks
③ Female ups two complete rows of black spots in the outer part of both wings
④ Hw uns pale green striped with silver
✶ Large for a fritillary

🦋 Mostly one generation between mid-May and mid-September. Flower-rich warm habitats such as gardens, meadows, fringes of cultivated land, woodland margins, bushy clearings, glades and slopes up to 1,700 m.

⊕ Widespread and common in S and C Europe, including most Mediterranean islands and also the Canary Islands. Northernmost vagrants in E Europe recorded in NW Russia near Finland.

◐ Many species of violets (*Viola*).

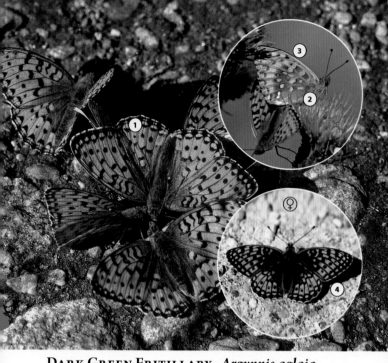

DARK GREEN FRITILLARY · *Argynnis aglaja*

This is a medium sized fritillary which flies powerfully in woodland clearings, meadows and roadsides in mid-summer. It rarely settles for long, even when feeding from thistles, knapweed or red clover. The rich ochreous upperside closely resembles that of other fritilaries of similar size, but the dark green underside of the hindwing with its clearly defined silvery spots is a distinguishing feature. Rather dark forms live high up in mountains like the Alps. Mating takes place low down in the vegetation, making copulating pairs difficult to find.

⊃ *Argynnis adippe*
 Argynnis niobe

① Hw ups orange with five black postdiscal spots; central one small
② Hw uns base green with large silver spots
③ Hw uns postdiscal spots are missing (cf. *A. adippe*, *A. niobe*)
④ A dark form, C Alps
✱ Large for a fritillary
✱ Sexes similar

🦋 One generation between June and late August. Flower-rich woodland margins, clearings and glades, heaths and moorland, coastal cliffs and dunes, damp meadows and bushy mountain slopes up to 2,500 m.

⊕ Widespread and generally common through almost all of Europe. Absent from most of Mediterranean islands, but recorded in Sicily.

✿ A wide range of violets (*Viola*) such as *V. riviniana*, *V. canina*, *V. palustris* and *V. hirta*.

HIGH BROWN FRITILLARY · *Argynnis adippe*

TM 5 FINLAND SALO 7/08 · TM 5 FINLAND SALO 7/10 · MA N ITALY 6/05

High Brown Fritillary and Dark Green Fritillary are around the same size, have the same flight time, and live in much the same habitats. Both are widespread, but in N Scandinavia the High Brown is definitely more warmth-loving than the Dark Green. The species' hindwing undersides differ, being obviously less greenish in the High Brown Fritillary. There are several forms, including *cleodoxa* (no silvery spots and no basal green suffusion on hw uns), which is common in the Pyrenees, likewise in S Fennoscandia. The form *cleodippe* is intermediate between the nominate form and *cleodoxa*. The form *chlorodippe* (suffused olive-green on hw uns) is found south of the Pyrenees.

⊙ *Argynnis niobe, Argynnis aglaja*

① Fw outer margin slightly concave (cf. *A. aglaja*, *A. niobe*)
② Hw uns heavily tinged with green, silver spots large
③ Arc of postdiscal spots with silvery pupils (cf. *A. aglaja*)
④ Male fw ups orange-brown with two faint androconial streaks
⑤ f. *cleodoxa*; hw uns no silver spots
✪ Large for a fritillary
✪ Sexes rather similar

✿ One generation from late May to mid-August. Abandoned agricultural land, dry meadows, forest roads and woodland margins, clearings and glades, preferring high altitudes up to 2,100 m.

⊕ Widespread and common through most of Europe except Mediterranean islands (excl. Sicily), N British Isles and N Fennoscandia. Declined in Britain.

◈ Many species of violets (*Viola*), such as *V. canina*, *V. odorata*, *V. hirta*.

NIOBE FRITILLARY · *Argynnis niobe*

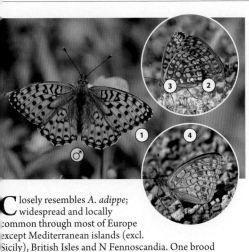

TM ITALY TOSCANA 6/05 · JJ SE FINLAND 7/04 · TM N GREECE VARIOUS 6/06

① Fw outer margin straight or convex (cf. *A. adippe*)
② Hw uns ground colour dark brown, veins black
③ Hw uns a small yellow spot near the cell base, often black-pupilled
④ f. *eris*; hw uns no silver spots
★ Large for a fritillary
★ Smaller and darker than *A. adippe*
★ Sexes similar

Closely resembles *A. adippe*; widespread and locally common through most of Europe except Mediterranean islands (excl. Sicily), British Isles and N Fennoscandia. One brood between late May and mid-August in hot southern slopes, flower-rich dry fields and grasslands mostly in uplands and rocky gullies in mountains above tree line up to 2,400 m. Larva feeds on various violets (*Viola*).

CORSICAN FRITILLARY · *Argynnis elisa*

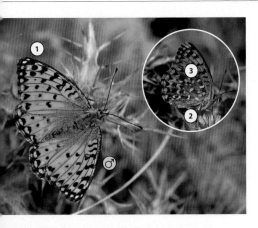

TM ITALY SARDINIA 8/09 · TM ITALY SARDINIA 8/09

① Ups orange with two or three large oval black spots near to the wing tip
② Hw uns yellowish-green with small silver spots
③ Postdiscal area yellow with a row of reddish ocelli
★ Large for a fritillary
★ Sexes similar

Endemic to Europe; restricted to Corsica and Sardinia, where rather common and widespread in mountain ranges between 800 and 1,800 m. One brood between late June and mid-August in maquis, dry open heaths, light woodland and clearings in deciduous woods. Larva feeds on *Viola corsica* and other violet species.

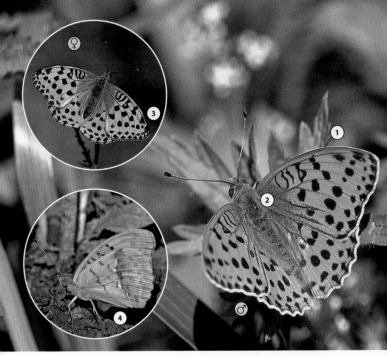

PALLAS'S FRITILLARY · *Argynnis laodice*

TH S ESTONIA 7/02 • TH S ESTONIA 7/06 • PO HUNGARY 7/06

There are well-entrenched colonies of this species in the Baltic area, but they do not normally cross the Gulf of Finland. During the hot summer of 1999 many female Pallas's Fritillaries were observed along the southern coast of Finland. Now climate change may create better opportunities for this fritillary to expand its range. It is of a lighter yellow-brown than all other fritilaries of the same size. The wings also give a more rounded impression in flight. The hindwing undersides are both beautiful and distinctive.

⊙ *Argynnis pandora*
 Argynnis paphia

① Ups bright orange with many rounded or oval black spots

② Male fw ups two slender black androconial streaks near the rear

③ Female fw ups white spot near to the wing tip

④ Hw uns a greenish-yellow basal half and a purplish-brown outer half, separated with white streak

✪ Large for a fritillary

✪ Sexes similar

♈ One generation from early July to late August in damp coastal meadows, luxuriant fields and bushy forest edges usually at lowlands below 500 m.

⊕ Rather widespread in E Europe from Romania to the Baltic region (Poland, SE Sweden and S Finland); an occasional migrant in the range margins, probably expanding northwards.

◈ Mostly *Viola palustris*, seldom other violets.

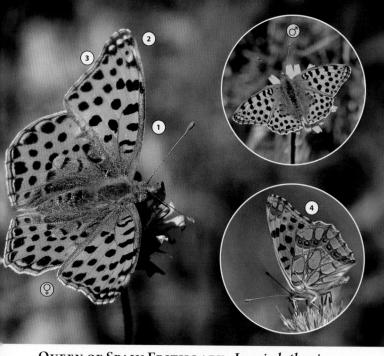

QUEEN OF SPAIN FRITILLARY · *Issoria lathonia*

In the Mediterranean region, this butterfly is commonly encountered on the mountain roadsides from early spring to autumn. It is alert and not easy to approach. Patience is needed to get a good view of the remarkable large silver spots on the hindwing underside, which glitter and shine when struck by the sun's rays. A strong tendency to migrate explains why the species is found almost everywhere on the European continent. Versatility during the early stages may also be the key to its success, as the butterfly can pass the winter in the adult stage, but probably also as an egg, a young caterpillar, or even a pupa.

① Ups bright orange with numerous rounded black spots

② Two complete rows of spots near the outer margin

③ Fw outer margin concave

④ Hw uns large and shiny silver spots

★ Sexes similar

🐛 Up to four overlapping generations between early March and late October, usually most abundant in the late summer months, in all kinds of open environments such as hot dry meadows and fallow land, coastal dunes and rocky slopes up to 2,900 m; migrants and vagrants may reach even higher altitudes.

⊕ Widespread and usually very common through most of Europe; most abundant in the southern range. A rare migrant to N Fennoscandia, S British Isles, Madeira and Canary Islands, absent from E Mediterranean islands.

🍃 A range of violets (*Viola*), such as *V. tricolor* and *V. arvensis*.

Lesser Marbled Fritillary · *Brenthis ino*

HA SE FINLAND (MATRA 7/09 · TM 5 FINLAND SOMERO 6/08

The Lesser Marbled Fritillary is a generalist in terms of its habitat and temperature requirements, disliking extremes. Its upperside pattern is unexceptional, but the underside is strongly patterned and very colourful, though from all angles it is confusingly similar to the Marbled Fritillary. It is easily approached, and can reliably be found at the same sites year after year. Northern Norway and Sweden have the f. *sigurd*, which is smaller with lighter colours, while individuals further south, even as far north as Lithuania, are markedly larger.

⊛ *Brenthis daphne*
 Boloria thore

① Ups with a black marginal border on both wings
② Hw uns no silver spots
③ Hw uns outer half yellow (cf. *B. daphne*)
④ Beyond the middle of hw purplish-brown with a row of eye-spots
★ Sexes similar

🦋 One generation from early June to mid-August. Damp flowery grasslands and meadows, marshes and peat bogs, bushy field edges and woodland margins, also on drier habitats at higher altitudes up to 2,000 m.

⊕ Widespread and common in most of temperate Europe excluding Mediterranean region in south, British Isles and N Fennoscandia. Most common in the northern range; yet declined due to land drainage. A highly variable species with many subtaxa described.

♠ Some rosaceous plants such as *Filipendula ulmaria*, *F. vulgaris*, *Rubus chamaemorus* and *Sanguisorba* species.

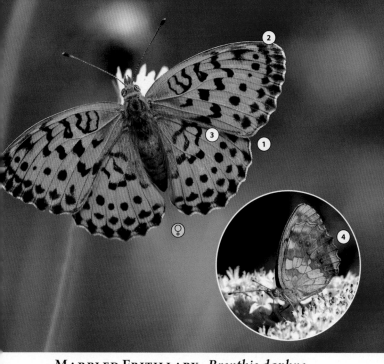

MARBLED FRITILLARY · *Brenthis daphne*

A warmth-loving species common in the south, but a rarity in the northern part of its range (N Poland and Lithuania). The wings are rounded and the hindwing undersides are marbled with yellow, orange, brown and a touch of black. Where bramble bushes grow thickly, the Marbled Fritillary will spend the whole day feeding and resting among the white blossoms. These thorny blackberries and dewberries are one of the grand challenges of systematic botany due to frequent polyploidy, hybridization and facultative apomixis, but the Marbled Fritillaries are much easier to identify. They prefer warm, sheltered valleys with sluggish streams winding along the bottom.

➤ *Brenthis ino, Brenthis hecate*

① Both wings rounded
② Ups orange with a complete arc of submarginal angular spots
③ Hw ups decorative black pattern
④ Hw uns outer half purple (cf. *B. ino*)
★ Larger than *B. ino*
★ Sexes similar

🦋 One generation from late May to early August. Warm and dry woodland margins, bushy forest clearings and glades, scrub and warm river valleys and hillsides usually at low altitudes, but goes up to 1,800 m.

⊕ Widespread and locally common in S and C Europe, extending from N Spain to Poland and S Lithuania in north. Most common in the Balkans and Greece, but absent from most Mediterranean islands except Sicily and Samos.

🍃 Brambles, mostly *Rubus fruticosus*, *R. caesius* and *R. idaeus*.

TH N GREECE 6/08 · HA SLOVENI 7/06

TWIN-SPOT FRITILLARY · *Brenthis hecate*

This is the only fritillary with two complete rows of uniform small black spots parallel to the outer margin of the wings on both the upperside and underside. It is primarily an eastern mountain butterfly, with a preference for medium-altitude flowery fields partially sheltered by bushes or light woodland. Alpine fields near the tree line are suitable habitats as well. Sometimes it is found at dry localities near the sea shore or along river banks. It makes glides of from 5 to 15 metres and flutters somewhat lazily, making it one of the easier fritillaries to approach.

�ола *Brenthis daphne*

① Male ups brown (female suffused grey) with submarginal and postdiscal black spots in a parallel row on both wings

② Hw uns two complete rows of black spots

⚘ One generation from late May to late July. Dry and grassy meadows, steppe-clad slopes in the eastern range, woodland margins and glades, river valleys and grassy hillsides usually between 600 and 1,700 m.

⊕ Rather widespread but sporadic in S Europe from Iberian peninsula to S Balkans and Greece. Locally common in E Europe with isolated colonies in S Lithuania in north.

⬙ Mostly *Filipendula ulmaria*, probably also other rosaceous plants (*Spiraea crenata*, *Rubus*, etc.) and *Dorycnium* species.

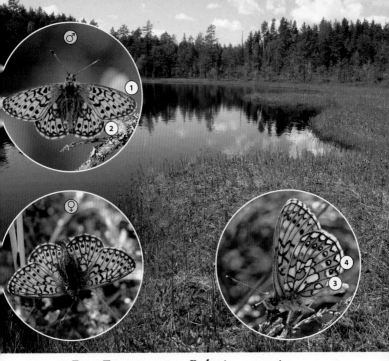

BOG FRITILLARY · *Boloria eunomia*

Appearing in early summer, this is a relatively small inhabitant of pine bogs, fens and marshes in N Europe and Fennoscandia. The butterfly flies when Labrador tea and bog whortleberry are blossoming. In the right place dozens of these butterflies can be seen flying slowly and close to the surface. Southern areas are inhabited by f. *subargentata*, a relatively large form with light colours and sharply defined wing patterns. Further north the smaller and darker subspecies *ossiana* begins to appear. In the far north the Bog Fritillary once again becomes lighter, with sharply defined wing patterns (f. *montana*).

⊗ *Boloria euphrosyne*

① Ups orange with rounded postdiscal spots in a straight line
② Dark zigzag line around the margin of both wings
③ Hw uns a series of circular postdiscal spots with white centres
④ White marginal spots
★ Wet biotopes
★ Sexes similar

🦋 One generation from early June to mid-July. Marshes, peat bogs and fens, swampy meadows near streams and lakes usually at low altitudes; also arctic tundra and moist mountain slopes up to 2,200 m in the southern range.

⊕ Widespread and locally common in C and N Europe, the commonest in Fennoscandia and the Baltic states (ssp. *ossiana*). Very sporadic and rare in the mountains in the southern range; recently recorded from Turkey, eastern Anatolia.

◈ *Vaccinium uliginosum*, *Andromeda polifolia* and *Viola palustris* in the northern range, *Bistorta vivipara* and *B. major* in the southern range.

HA E FINLAND KERIMÄKI 6/09 · PO SE FINLAND PUUMALA 6/10 · HA E FINLAND KERIMÄKI 6/10 · HA E FINLAND KERIMÄKI 6/06

PEARL-BORDERED FRITILLARY · *Boloria euphrosyne*

This fritillary has colonised the entire Nordic region, where it can be seen almost everywhere. It may be the sole species on a stony, barren island – while it certainly prefers more fertile woodland clearings and flower-rich fields, it does not mind harsh conditions. Consequently, the species has spread throughout the continent, occurring also in the northern parts of Spain and Turkey. One reason for its success may be that the larva is not very choosy, but eats a variety of plants. The small, dark f. *lapponica* flies in the forested part of Lapland, and in the fell part of Lapland there is the even smaller but lighter f. *septentrionalis*.

⊙ *Boloria selene, Boloria thore*

① Ups reddish-orange, outer margin with black triangular spots

② Hw uns only one discal silvery spot in the yellow central band (cf. *B. selene*)

③ Hw base a small black yellow-bordered spot (cf. *B. selene, B. titania*)

✦ Sexes similar

🦋 Mostly one generation between early May and late July; a partial 2nd brood in the southern range in August–September. Coniferous woodland margins and clearings, forest roads and glades, wooded peat bogs and heathland, bushy slopes and dry meadows near tree line up to 2,000 m.

⊕ Widespread and common throughout Europe except most Mediterranean islands and S Iberian peninsula.

⬧ Mostly violets (*Viola*); also *Vaccinium uliginosum* and *Ledum palustre* in the northern range.

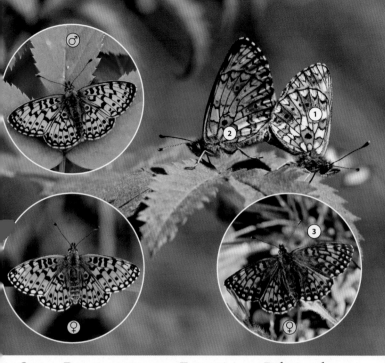

SMALL PEARL-BORDERED FRITILLARY · *Boloria selene*

There is no real size difference between the Pearl-bordered and Small Pearl-bordered Fritillaries. To identify them it is necessary to examine the hindwing underside, where the black spot at the base is larger and clearer in the Small Pearl-bordered Fritillary. These two species behave similarly but differences do exist. The Small Pearl-bordered appears somewhat later and is not such a jack-of-all-trades. It also prefers more lush habitats, but avoids marshes and other very wet environments. It is not found in the Mediterranean region. The forested part of Lapland is home to the small, dark f. *hela*, whereas in Lapland's fell zone the butterfly is paler (f. *hyperborea*).

⊙ *Boloria euphrosyne, Boloria thore*

① Hw uns several silvery-white spots in the yellow central band (cf. *B. euphrosyne*)
② Hw base a large, black spot (cf. *B. euphrosyne*, *B. titania*)
③ Dark form, C Alps
★ Sexes similar
♈ One or two generations depending on latitude and altitude; 1st brood in late April–late June and (a partial) 2nd brood in late July–September; early June to late July where single-brooded. Diverse meadows, fallow land, road verges and woodland clearings; also moorland, humid glades and meadows besides lakes and streams up to 2,300 m.
⊕ Widespread and generally common in most of Europe north of the Alps; rare or absent from Mediterranean region.
♨ Violets (*Viola*) such as *V. canina*, *V. palustris* and *V. riviniana*.

TITANIA'S FRITILLARY · *Boloria titania*

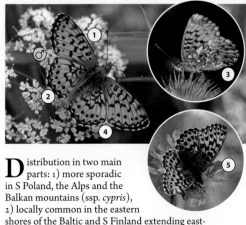

Distribution in two main parts: 1) more sporadic in S Poland, the Alps and the Balkan mountains (ssp. *cypris*), 2) locally common in the eastern shores of the Baltic and S Finland extending eastwards (ssp. *bivina*). Evaluated as Near Threatened in Europe. One brood from mid-June to early August in light woodland clearings, margins and glades, damp meadows besides streams and lakes up to 2,000 m. Larva feeds on *Bistorta major* and violets (*Viola*).

① Ups orange heavily marked with black spots
② Submarginal spots distinctly triangular
③ Hw uns rust-coloured, black submarginal markings strongly triangular
④ Fringes chequered
⑤ ssp. *cypris*
★ Sexes similar

WEAVER'S FRITILLARY · *Boloria dia*

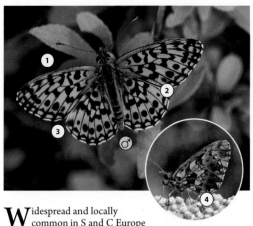

Widespread and locally common in S and C Europe from Cantabrian Mts to S Estonia in north. Mainly two or sometimes three broods between late April and early September in dry grassy meadows, woodland clearings and scrub, roadside fields and warm slopes up to 1,600 m. Larva feeds on violets (*Viola hirta, V. rupestris*, etc.).

① Ups orange with large black markings
② Hw ups a complete arc of large, oval postdiscal spots
③ A sharp angle at the hw front edge
④ Hw uns brown with a violet tinge
★ Small for a fritillary
★ Sexes similar

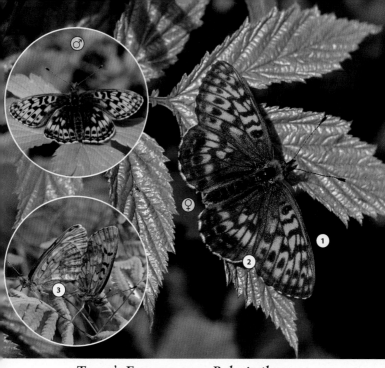

THOR'S FRITILLARY · *Boloria thore*

The nominate subspecies (*thore thore*) of Thor's Fritillary is rare, sporadic and local, occurring in the Central European Alps only. Its status improves in the far north, where the subspecies *borealis* is a true Lapland resident. It is smaller and paler than the nominate form. The habitats are luxuriant meadows with yellow globeflowers (*Trollius*) and deep blue cranesbills in the mountain birch zone. In Norway this fritillary, with its contrasting dark and light tones, flies along the green banks of the sheltered mountain streams but only for two weeks around the height of summer.

⊖ *Boloria euphrosyne*
Boloria selene

① Ups orange with heavy markings and dusted dark brown

② Hw ups a broad brown border

③ Hw uns reddish-brown with yellow discal band and a number of whitish dots

✭ Sexes similar

�幣 One generation between mid-June and early August. Luxuriant forest clearings, humid meadows near streams and lakes, bushy outskirts of bogs and marshes and damp north-facing slopes at low altitudes; in the Alps between 800 and 1,800 m.

⊕ Distribution in two separate parts; rather common but local in N Fennoscandia and eastwards to Russia (ssp. *borealis*) and in the Alps of Switzerland, Italy and Austria (ssp. *thore*).

♦ *Viola biflora* and other violets.

SHEPHERD'S FRITILLARY · *Boloria pales*

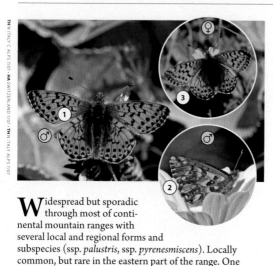

Widespread but sporadic through most of continental mountain ranges with several local and regional forms and subspecies (ssp. *palustris*, ssp. *pyrenesmiscens*). Locally common, but rare in the eastern part of the range. One brood in July–August in stony subalpine and alpine meadows and pastures usually above the tree line between 2,000 and 2,800 m. Larva feeds on violets (*Viola*).

① Ups orange with two rows of postdiscal and submarginal spots on both wings
② Male hw uns reddish with a band of white spots at the outer border
③ Female ups without violet tinge (cf. *B. napaea*)
★ Closely resembles *B. napaea* but smaller
★ Sexes similar

MOUNTAIN FRITILLARY · *Boloria napaea*

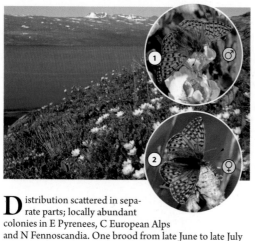

Distribution scattered in separate parts; locally abundant colonies in E Pyrenees, C European Alps and N Fennoscandia. One brood from late June to late July in stony subalpine and alpine flower-rich meadows between 1,500 and 2,500 m in the southern range; also blanket bogs and other wet areas at lower altitudes in the north. Larva feeds mostly on *Viola biflora* and *Bistorta vivipara*.

① Male closely resembles *B. pales* but larger; fw ups submarginal black markings linear, more macular in *B. pales*
② Female heavily marked and suffused with dark and greenish/violet colour (cf. *B. pales*)
★ Only alpine and subalpine areas

CRANBERRY FRITILLARY · *Boloria aquilonaris*

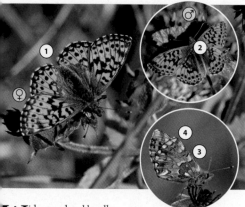

W idespread and locally
common in C and N Europe;
declined due to drainage of mires, but still abundant in
the northern part of the range. One brood from mid-
June to late July in wet meadows and heaths near lakes,
marshes, fens and peat bogs up to 2,000 m. Larva feeds
on *Vaccinium oxycoccos* and *Andromeda polifolia*.

1. Ups reddish-orange with a
 pattern of black markings
2. Fw ups two black
 chevrons near the rear
3. Hw uns rust-red
 with white spots
4. A sharp angle at the
 hw front edge
⊛ Bogs and wet heaths
⊛ Sexes similar

BALKAN FRITILLARY · *Boloria graeca*

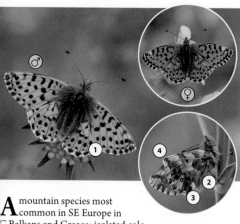

A mountain species most
common in SE Europe in
C Balkans and Greece; isolated colo-
nies in SW Alps of France and Italy (f. *tendensis* with unh
spots better developed). One brood from early June to
late August in woodland clearings near to the tree line
and grassy subalpine and lower alpine meadows between
1,500 and 2,500 m. Larva feeds on violets (*Viola*).

1. Ups two complete rows of
 spots near to the margin
2. Hw uns light yellow
 with rusty and
 greenish marbling
3. Hw uns an arc of brown-
 ringed eye-spots
4. A sharp angle at the
 hw front edge
⊛ Only on mountain
 grasslands
⊛ Sexes similar

Arctic Fritillary · *Boloria chariclea*

HA N FINLAND UTS/OKI 7/05 · HA N FINLAND UTS/OKI 7/05

One of the Lapland rarities, this species lives on exposed mountain and tundra slopes, in places rarely visited by people. Its habitat is always windy and seldom sunny, with no shelter-giving trees, just stones, low scrub, moss and lichen and a few weeks of tiny flowers in mid-summer. The species has a low, rather steady flight, stopping suddenly to bask on the sheltered sides of stones with wings open. Its abundance varies from year to year for no apparent reason. In the national butterfly recording scheme in Finland, altogether 2,500 Arctic Fritillaries were recorded between 1991 and 2010. The extremes were 620 individuals in 1997 and only ten individuals in 2001.

⊙ *Boloria polaris, Boloria freija*

① Ups tawny yellow with a dark area at the base on hw
② Hw ups postdiscal black spots triangular (cf. *B. polaris*)
③ Hw uns rust-brown with a broad silvery white discal band and a silvery margin
④ White submarginal spots flattened
★ Sexes similar

🦋 One generation from early July to early August. Swampy hollows in the birch zone, grassy slopes, dry rocky tundra and alpine fell tops between 300 and 1,400 m.

⊕ Restricted distribution in N Fennoscandia; very sporadic and rare in Norway, Sweden and Finland. Evaluated as Near Threatened in Europe; also in adjacent Russia and the coastal districts of Greenland (a smaller and darker f. *arctica*).

🌿 *Empetrum nigrum, Cassiope tetragona* and *Viola biflora*.

POLAR FRITILLARY · *Boloria polaris*

The most elusive rarity in Lapland, this species has a circumpolaric range. For this book the Polar Fritillary was photographed in Utsjoki, at the most northern point of Finland, on a rare occasion when the weather was exceptionally good. This species is an expert escape artist, blending in well to its bleak and very exposed environment, and able to disappear almost instantly when the weather changes for the worse. When on the move it flies low to keep out of the strong wind that often blows across the tundra, and may even walk from one small flower to another rather than use its wings.

➷ *Boloria chariclea*
　Boloria freija

① Ups tawny yellow, a large dark patch at the base of hw
② Hw ups postdiscal black spots are elliptic, not triangular (cf. *B. chariclea*)
③ Hw uns purplish with small white markings
④ Hw uns submarginal spots resembling white capital Ts
✪ Dry tundra, mostly on tops of fells only
✪ Sexes similar

🦋 One generation from early June to mid-July. Alpine grasslands, rocky slopes, open dry tundra and rocky fell tops above the tree line between 600 and 1,400 m; near to the sea level along the Arctic Ocean.

⊕ Evaluated as Vulnerable in Europe, with a narrow distribution restricted to northernmost Fennoscandia; very sporadic and local in N Norway, N Sweden, N Finland and the adjacent Russia (Kola Peninsula). Recorded also on the E coast of Greenland (a lighter f. *groenlandica*).

♠ *Empetrum nigrum*, *Cassiope tetragona* and *Dryas octopetala*.

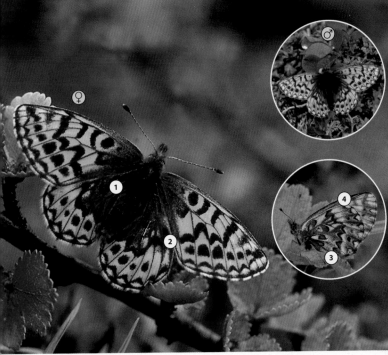

FREJYA'S FRITILLARY · *Boloria freija*

With a northern distribution and a passion for open, damp moorland and wet meadows at the foot of mountains, Frejya's Fritillary is not easily observed. However, it is the most common fritillary in many northern areas, becoming far less frequent in the southern parts of its range. Bogs with cloudberries are worth investigating in the south where, unlike the Pearl-bordered and Small Pearl-bordered Fritillaries, individuals are of reduced size. The males are easily spotted as they fly over low vegetation in search of females. They usually nectar on marsh andromeda or moss campion.

⊙ *Boloria chariclea*
Boloria polaris, Boloria frigga

① Ups orange with extensive brown smudge at the base of hw
② Spots of discal area combined with a black zigzag band
③ Hw uns rust-coloured with a conspicuous black zigzag line
④ Hw uns marginal lunules white and narrow
★ Sexes similar

🦋 One generation from mid-May to mid-June; in Lapland between mid-June and late July. Mostly marshes and pristine peat bogs, swampy hollows in the birch zone, subalpine meadows and tundra typically at lowlands, but goes up to 1,000 m.

⊕ Rather widespread in N Europe in most of Fennoscandia, extending eastwards. Locally common but strongly declined due to mire drainage, especially in the southern range; no longer occurs in Estonia and is threatened in Latvia.

🌿 *Rubus chamaemorus* and *Vaccinium uliginosum*; also *Arctostaphylos alpina* in the northern range.

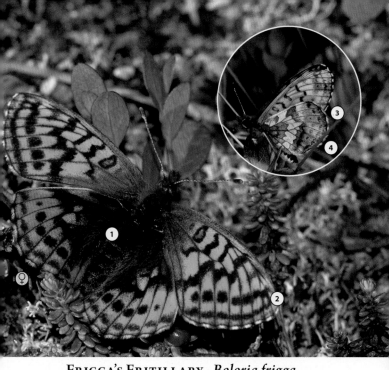

FRIGGA'S FRITILLARY · *Boloria frigga*

Frigga's Fritillary is much more local and scarcer than Frejya's Fritillary. On the wing it gives the impression of being a robust butterfly despite its rather small size. It alternates between strong wing-flapping and lazy glides, and is not easy to follow in a deep wet fen. The butterfly is also expert at disappearing among brushwood or scrub. In the afternoon it finds safe resting places among the branches of stunted pines. In the south smaller and paler individuals (f.*australis*) are already on the wing in the early summer whereas in northern latitudes individuals can still be seen in mid-summer.

⊘ *Boloria freija*

① Female hw ups yellowish-orange with large black spots and an extensive dark area at the base
② A uniform black line on outer part of fw
③ Hw uns reddish-brown with whitish spots and tinted lilac on the outer parts
④ No white marginal markings
✷ Sexes similar

♈ One generation from early June to early July; in Lapland a few weeks later between late June and early August. Undrained marshes, peat bogs and fens, wet heaths, swampy hollows and meadows in the birch zone below 500 m.

⊕ Rather widespread in N Europe in C and N Fennoscandia, extending eastwards; most common in the northernmost range, but populations are local and generally low in numbers. Declined due to mire drainage in the southern range; threatened in Estonia and Latvia, only one locality in Lithuania.

⬡ Mostly cloudberry (*Rubus chamaemorus*).

HANFINLAND UTSJOKI 7/05 · PO SE FINLAND RAUTJÄRVI 6/86

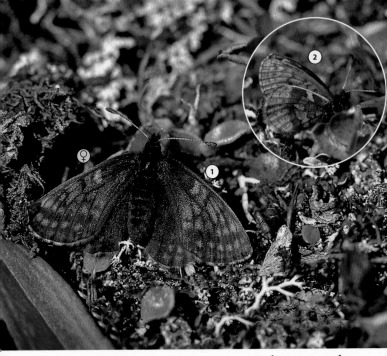

DUSKY-WINGED FRITILLARY · *Boloria improba*

This species is so tiny and inconspicuous that it passes unnoticed by all but the sharpest-eyed butterfly enthusiasts. The subtly attractive Dusky-winged Fritillary is a legendary species in Kuonjarvarri, Finland and Abisko, Sweden, where it withstands harsh weather conditions, flying low against the wind. Rapidly changing weather is the rule in Lapland – within half an hour a sunny morning can turn into freezing rain and fog, the temperature falling by almost ten degrees – and when it does the fritillary vanishes into the vegetation, with its low grass, yellow globeflowers and Lapland violets.

① Ups heavily dusted with brown or grey scales
② Hw uns purplish-brown with dark and light cross-bands
★ Sexes similar
★ Very small and dark, a unique-looking fritillary
★ Arctic grasslands between 600 and 1,000 m

🦋 One generation in July. Hollows characterized with late melting snow, grassy expanses on gentle slopes, dry open tundra and rocky fell tops between 600 and 950 m.

⊕ Very restricted distribution in northernmost Fennoscandia; sporadic and rare in N Norway, N Sweden and N Finland. Evaluated as Endangered in Europe; populations are very local but abundant in favourable years.

🌿 Most probably *Salix reticulata* and *Bistorta vivipara*.

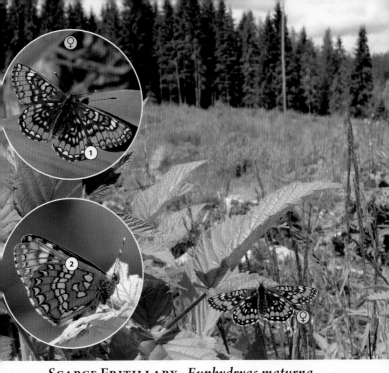

SCARCE FRITILLARY · *Euphydryas maturna*

A very local, never abundant butterfly which is declining in many regions. It cannot tolerate unsuitable forest management and land drainage, needing small, sheltered but sunny woodland clearings or forest edges with bushes and flowers. The male sits on the leaf of a young birch tree guarding his territory, soon returning to the same favourite perch if disturbed. The females are lazy fliers. Finnish specimens, which are a little different from the others in Scandinavia, are considered by some authors to comprise a subspecies called *tenuireticulosa*.

❯ *Euphydryas intermedia*
Euphydryas cynthia

① Hw ups an orange band without black spots
② Hw uns a central yellow band encloses a bold black line (cf. *E. intermedia*, *E. cynthia*)
✱ Sexes similar
✱ Lowland species (cf. *E. intermedia*)

☂ One generation from late May to mid-July. Sheltered edges of forests and fields, woodland fringes and glades, light mixed or deciduous woodland and their openings, bushy outskirts of peat bogs, humid meadows and pastures, usually associated with exposed bedrock and rockmasses up to 1,000 m.

⊕ Rather widespread in C and E Europe, but populations are very local and widely in decline. Evaluated as Vulnerable in Europe; threatened in many countries and protected by the European legislation.

◈ Mostly *Fraxinus excelsior*, *Populus tremula* and other deciduous trees in the summer; *Melampyrum pratense*, *Veronica* and other herbaceous plants after the hibernation.

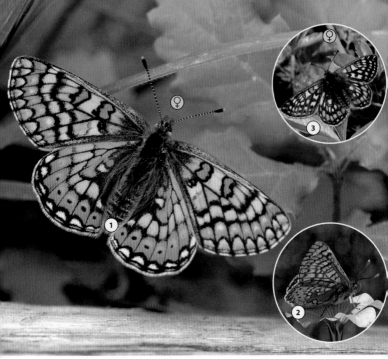

MARSH FRITILLARY · *Euphydryas aurinia*

TM.5 FRANCE MARITIME ALPS 5/06 · MA. AUSTRIA 7/09 · MA.5 SPAIN SEGURA 5/08

Changes in traditional agriculture and abandonment of cattle grazing in forested areas have reduced suitable habitats for the Marsh Fritillary. Both dry and wet flower-rich clearings are the places to search in, but there may not be many individuals in any one locality. It flies close to the ground and stops often providing opportunity for close study. There is a wide range of subspecies, forms and races in Europe: ssp. *provincialis* in SE France (ups pale orange), ssp. *beckeri* in Spain, Portugal, Morocco (large, ups reddish), ssp. *debilis* in the Pyrenees and Alps, usually above 1,800 m (small, pale dusky yellow form). In Öland, on the Swedish coast, the species is represented by f. *suecica*.

⊙ *Euphydryas desfontainii*

① Hw ups an orange-red postdiscal band encloses an arc of black spots

② Hw uns a broad cream and orange band, ssp. *beckeri*

③ *E. aurinia debilis* (Alpine Fritillary); smaller and mainly sooty brown

✱ Sexes similar

One generation between mid-April and mid-July, sometimes as late as August, depending on altitude and latitude. Sheltered lush meadows near woods and forest clearings, open scrub and powerlines, bushy field edges, dry to damp heaths, moors and meadows, exposed mountain slopes up to 2,600 m.

⊕ Widespread and generally rare in S and C Europe; sporadic and scarce in the most southerly parts (not recorded in Mediterranean islands), E British Isles and most of Fennoscandia. Widely in decline due to the drainage of habitats. Threatened in many countries and protected by the European legislation.

Mostly *Succisa pratensis*, seldom other plants such as *Scabiosa*, *Lonicera*, *Gentiana*, *Primula*, etc.

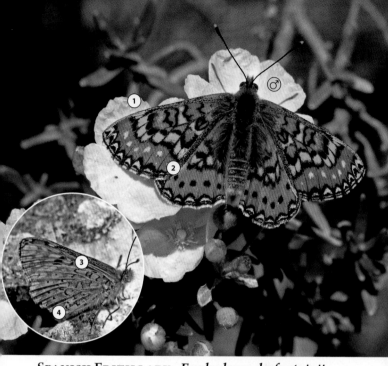

SPANISH FRITILLARY · *Euphydryas desfontainii*

For many, this is the most beautiful of all fritillaries, occupying sunny, flowery slopes in lower mountainous areas. When the Spanish Fritillary appears in April–May, many local flowers are coming into bloom. It is rare, being found in small colonies which appear and disappear in the appropriate regions of S Portugal and Spain (ssp. *baetica*). The nominate subspecies inhabits Morocco and Algeria. The female is larger than any other representative of *Euphydryas*, slow to take flight but expert at hiding in low vegetation.

⊖ *Euphydryas aurinia*

① Ups bright orange or brick-red with black-edged yellow spots on both wings

② Fw ups an orange postdiscal band contains a row of yellow spots, black spots on hw (cf. *E. aurinia*)

③ Hw uns a yellow band edged with black

④ Hw uns a row of black dots on postdiscal band

✱ Sexes similar

☿ One generation from mid-April to early June. Open dry scrub and fallow land, shrubby grasslands, sunny hillsides, rocky gullies and grassy mountain slopes up to 1,800 m.

⊕ Restricted to the Iberian Peninsula; sporadic and generally very local in S Portugal and mountain ranges in S Spain, Andalusia, Catalonia and the Pyrenees extending to French part of E Pyrenees. Evaluated as Near Threatened in Europe.

⟁ Various species such as *Dipsacus*, *Knautia*, *Cephalaria*, *Scabiosa*, *Centaurea*, etc.

Cynthia's Fritillary · *Euphydryas cynthia*

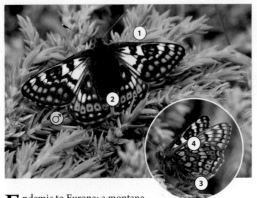

E ndemic to Europe; a montane species restricted to the Alps (France, Switzerland, Italy, Austria) and the highest mountains of Bulgaria (Rila, Pirin). One brood from late June to August in grassy mountain slopes and alpine heaths and meadows dominated by low juniper shrubs, between 900 and 3,000 m; most numerous above the tree line. Larva feeds on *Plantago alpina* and *Viola calcarata*.

① Male ups dark brown or almost black with white bands and two orange patches in the cell; female orange with brown bands

② Hw ups an orange postdiscal band with small black dots

③ Hw uns black dots in an orange band

④ No black line in a pale postdiscal band (cf. *E. intermedia*)

⑨ Almost grey on the wing

Asian Fritillary · *Euphydryas intermedia*

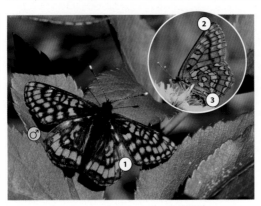

A n alpine species confined to the C European Alps; France, Switzerland, Italy, Austria and Slovenia (ssp. *wolfensbergeri*). One brood in June–July in light mountain woodland and clearings, outskirts of coniferous and mixed forests, open scrub and shrubby alpine meadows above the tree line between 1,400 and 2,400 m. Larva feeds on *Lonicera caerulea*.

① Hw ups dark brown with a broad orange band without black spots (cf. *E. aurinia*, *E. cynthia*)

② Fw uns submarginal lunules in a regular row (cf. *E. maturna*)

③ Hw uns a central yellow band encloses a thin black line (cf. *E. cynthia*, *E. maturna*)

⑨ A high mountain fritillary (cf. *E. maturna*)

⑨ Sexes similar

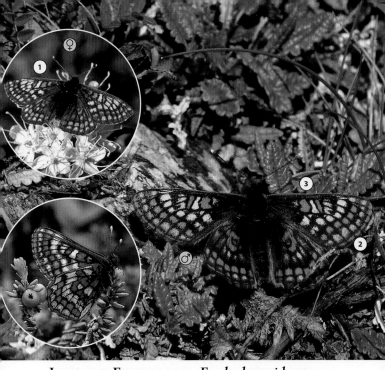

LAPLAND FRITILLARY · *Euphydryas iduna*

The male Lapland Fritillary resembles a large dark fly as it whirls about like a spinning top. The observer may be surprised to discover that the insect in question is a butterfly, when it stops to perch on a dwarf birch leaf. Because its preferred habitat is only found in the far north, this butterfly is one of the species that is particularly vulnerable to the consequences of climate change. Many northern and upland species are already spreading northwards, but for the Lapland Fritillary and others, there is little room left to spread.

⊋ *Euphydryas cynthia*

① Ups whitish with orange and black markings, heavily dusted with grey

② Brick-red margins on both wings

③ Fw ups cell two orange patches

✷ Almost grey on the wing

♈ One generation between early June and mid-July, depending on the season. Moors and swampy hollows in open birch forest, hillside peat bogs, riverbeds and river valleys, mountain tundra with bushes of *Betula nana* and also dry rocky terrain between 300 and 700 m.

⊕ A restricted distribution in N Fennoscandia; sporadic but locally common in N Norway, N Sweden and N Finland, extending to Kola Peninsula in Russia and eastwards. Evaluated as Near Threatened in Europe. Abundance fluctuates markedly from one year to another.

⊕ Some arctic herbs such as *Bartsia alpina*, *Pedicularis hirsuta*, *Veronica alpina* and *V. fruticans*.

KNAPWEED FRITILLARY · *Melitaea phoebe*

A warmth-loving fritillary prone to confusing variability, with ssp. *occitanica* (ups black spotting a little different) occurring on the Iberian Peninsula and f. *alternans* (darker) south of the Alps. The late summer broods in S Europe constitute the small f. *pauper*. Genuine problems with species definition have arisen with recent discoveries. A *Melitaea telona* was described as long ago as 1908 by Fruhstorfer, but being externally so similar to *phoebe* and especially to *M. punica* in N Africa, its specific status was not accepted until a recent comparison of cellular mitochondrial DNA sequences.

⊘ *Melitaea aetherie*
Melitaea cinxia

① Fw ups one marginal lunule larger than others
② Hw ups a well-defined orange band, no black spots (cf. *M. cinxia*)
③ Hw uns black lunules convex along both side of orange submarginal band (cf. *M. cinxia*)
★ Sexes similar
★ Variable in appearance

🦋 Mostly two generations; 1st brood from mid-April to mid-June, 2nd brood from late June to September; univoltine in the northern range and higher altitudes. Sheltered dry meadows, scrub and light woodland, usually on calcareous soils up to 1,900 m.

⊕ Widespread and common in S and C Europe, extending eastwards with tens of subspecies and forms; largely absent from NW Europe (the British Isles, surroundings of the Baltic Sea) and also most Mediterranean islands (except Sicily, Chios and Lesbos). Many populations are in decline.

⬧ A wide range of knapweeds (*Centaurea*), seldom plantains (*Plantago*).

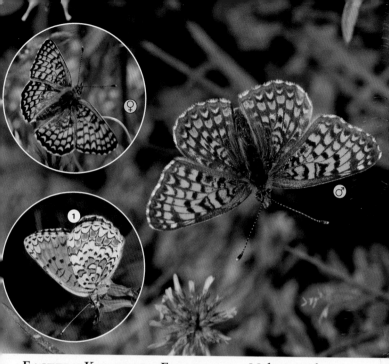

EASTERN KNAPWEED FRITILLARY · *Melitaea telona*

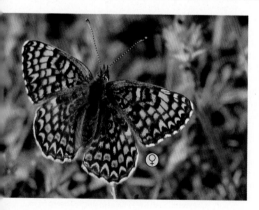

① Hw uns small black triangular spots

Closely resembles *M. phoebe*; somewhat smaller and paler, but the appearance varies markedly (ssp. *kovacsi* in Hungary). The name *M. ogygia* has also been used for the taxon. The range extends from S Italy, Sicily (first described there as ssp. *emipunica*) and SE Europe (Hungary, Romania, Balkan Peninsula) to Turkey and eastwards. Only one brood in May–June in warm and rocky lowland habitats below 900 m. Larva is usually monophagous on *Centaurea* species.

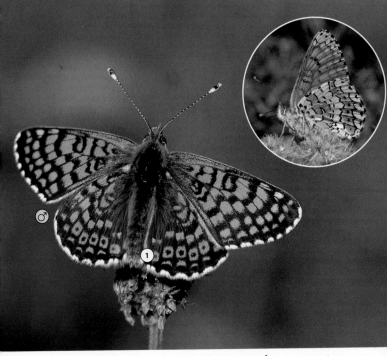

GLANVILLE FRITILLARY · *Melitaea cinxia*

TM S FRANCE 5/06 · MA S SPAIN 5/08

Real-life experiments on Glanville Fritillary in the Åland Archipelago, Finland, formed the basis for the mathematical models for the so-called metapopulation theory. Butterflies form large metapopulations in spatial landscapes where a delicate balance of extinction and colonisation by new populations exists. The vitality of a metapopulation decreases if local populations become extinct more often than new colonies emerge. The fragmentation eventually reaches a critical point as the distances between the remaining colonies increase. The disequilibrium means that sooner or later the species will be lost from the area.

⊙ *Melitaea arduinna*
 Melitaea phoebe

① Hw ups and uns outer margin an arc of orange spots with black dots (cf. *M. phoebe*, *M. didyma*, *M. trivia*)

✴ Sexes similar

☸ Mostly one generation between early May and mid-July; bivoltine in the southernmost range in May–June and August–September. Dry meadows and pastures, road verges and neglected cultivations, sandy heaths and riverbanks, scrub, woodland clearings and flower-rich hillsides up to 2,000 m.

⊕ Widespread and locally common in most of Europe extending to SW Finland in north; absent from Mediterranean islands (except Sicily and Corfu), the British Isles (except Channel Islands and the Isle of Wight) and most of Fennoscandia. Populations are in decline due to changes in agricultural practices.

⬥ A range of plantains (*Plantago*), also *Veronica spicata* and other speedwells.

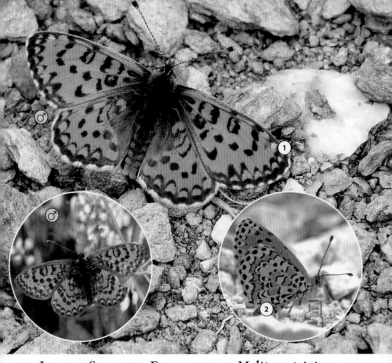

LESSER SPOTTED FRITILLARY · *Melitaea trivia*

I n the Balkans the Lesser Spotted Fritillary inhabits flower-rich grasslands in addition to dry, stony fields and wasteland from sea level to high mountain chains. It has a spotted appearance due to the variable black markings scattered over the wings. The larvae pass the winter months by spinning dead leaves and other plant material together to make a shelter, the hibernaculum. In the far west ssp. *ignasiti* is rather local on the Iberian Peninsula. It is a little smaller and paler than the nominate form, although the black margins are well defined.

⊘ *Melitaea didyma*

① Ups submarginal spots crescent-shaped on both wings (cf. *M. didyma*)
② Hw uns pale yellow with two black-edged orange bands and black spots
✱ Sexes similar
✱ Variable in appearance
🦋 Mostly two generations; 1st brood in April–May, 2nd brood from June to September; a small 3rd brood till October in Greece. Hot and dry meadows and other grasslands, fallow land and waste ground, rocky scrub, bushy forest margins, sunny hillsides and rocky slopes up to 2,000 m.

⊕ Widespread and generally common in SE Europe from Greece, some E Aegean islands and Turkey to S Poland and Ukraine in north; the range continues to Asia with many subspecies and forms of xerothermic environments. More sporadic and uncommon in Italy and N Iberian Peninsula (ssp. *ignasiti*).

🌱 A range of mulleins (*Verbascum*).

HA · GREECE SAMOS 5/09 · TH N GREECE 6/06 · PO S TURKEY ALANYA 4/09

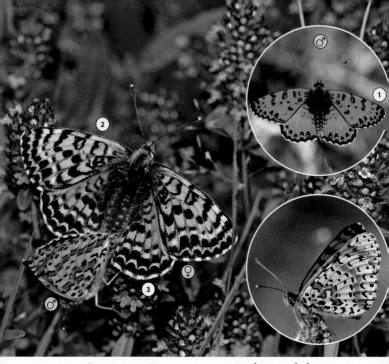

Spotted Fritillary · *Melitaea didyma*

This is the most common representative of *Melitaea* in S Europe, from sea level to high mountains. Sun, flowers and dry open areas are essential to the Spotted Fritillary. The subspecies *meridionalis* in mountainous areas is stunningly red, attracting immediate attention. The lazily flying female has her forewings dusted with deep grey, making a clear contrast to the orange of the hindwings. The nominate form is a more modest yellow-brown, as is ssp. *occidentalis* and the late summer brood f. *dalmatiana* (a smaller variant) in the Mediterranean region. It is likely that the current concept of the Spotted Fritillary is a series of several cryptic species.

⊙ *Melitaea trivia*

① Male fw ups submarginal spots rounded or rectangular (cf. *M. trivia*)
② Female ups dusted with grey; larger black spots
③ Hw very colourful, ssp. *meridionalis*

🦋 One to three generations, depending on latitude and altitude, between mid-April and September; from early June to late July where univoltine. Diverse warm habitats; dry and rocky meadows and hillsides, steppes, edges of fields and fallow land, also woodland clearings mostly at lowlands below 1,000 m; some subspecies on rocky gullies up to 2,400 m.

⊕ Distribution similar to *M. phoebe*; widespread and common in S and C Europe, also in many Mediterranean islands, but largely absent from NW Europe (the British Isles, surroundings of the Baltic Sea). The northernmost records are from Estonia and Russian Karelia near to the lake Ladoga.

⬦ Many low-growing species such as *Plantago*, *Linaria*, *Veronica*, *Antirrhinum*, *Stachys*, etc.

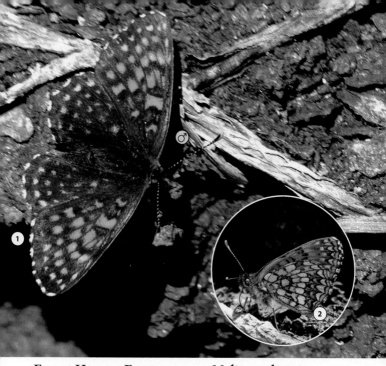

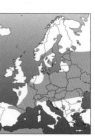

FALSE HEATH FRITILLARY · *Melitaea diamina*

The more or less contiguous distribution of this species in C and E Europe is fragmented in the northern part of its range, i.e. Fennoscandia and the Baltic region. The butterfly needs damp fields with scattered trees and larval food plants, mostly valerian. If secondary growth totally obliterates the habitat, the False Heath Fritillary will be lost too. That is what is happening in Fennoscandia. The species is a weak flyer, staying low and, thanks to its heavily dusted wings, merging with the ever-changing mosaic of light and shade. The ground may still be covered with the morning dew when the False Heath Fritillary crawls up a grass stem to bask.

⊖ *Melitaea athalia*
Melitaea britomartis

① Ups orange with heavily suffused dark brown, fringes chequered white
② Hw uns marginal band darker than the adjacent lunules (cf. *M. athalia*)
⊛ Sexes similar
⊛ Looks dark on the wing
🦋 Mostly one generation from late May to mid-July; in favourable conditions a 2nd brood in August–September. Damp meadows and other grasslands, pastures with shrubs, humid forest edges and clearings in deciduous woodland, edges of marshes and peat bogs and humid alpine meadows up to 2,000 m.
⊕ Widespread in mostly C Europe; very sporadic in the southern, western and northern edges of the range. Declined in northern latitudes; disappeared from Denmark. Populations are generally local but sometimes very abundant.
◈ Many species of valerians (*Valeriana*) such as *V. officinalis*, *V. sambucifolia*, *V. dioica*, etc.

JJSE FINLAND JOUTSENO 6/03 • HÄ E FINLAND KERKMÄKI 7/09

HEATH FRITILLARY · *Melitaea athalia*

The most widespread *Melitaea* in Europe, though it does not thrive on the Mediterranean islands nor in S Greece. It varies a lot in size and darkness of upper-side wing markings. In northern Fennoscandia there is a small, dark ssp. *norvegica*, in S Sweden f. *neglecta* and f. *lachares*, and in Bulgaria f. *boris*. Variable localities and altitudes produce slightly different appearances as an adaptation to a specific environment and microclimate. The former subspecies *celadussa* in the south from N Portugal to Italy, with several forms like f. *biedermanni* and f. *nevadensis*, is a well defined sibling species according to the recent genetic studies.

⊙ *Melitaea deione*
 Melitaea britomartis

① Female ups no contrast between orange-brown bands (cf. *M. deione*)
② Hw uns a marginal band dirty yellow and with same colour as the adjacent lunules (cf. *M. britomartis*, *M. diamina*)
③ Palpi dark brown below (cf. *M. deione*)
⊛ Sexes similar

▽ Mostly one generation with a long flight-period from mid-May to mid-August; a partial 2nd brood possible in the late summer. Very similar *M. celadussa* usually bivoltine (June–July, August-September). Bushy woodland clearings, scrub, edges of forests and field sandy heaths and steppes, dry to moist meadows, flower-rich road verges up to 2,600 m.

⊕ Widespread and common all over Europe from N Iberian Peninsula to the shores of Arctic Ocean; sporadic and rare in Mediterranean region (absent from most islands), S Britain and C Fennoscandia.

⬙ A wide range of plants from the genus *Veronica*, *Melampyrum*, *Plantago* and *Digitalis*.

■ athalia
■ celadussa

Provencal Fritillary · *Melitaea deione*

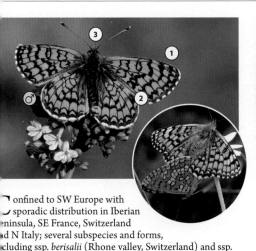

TH S FRANCE 5/06 · HA S SPAIN 5/07

⌐onfined to SW Europe with
⌐sporadic distribution in Iberian
⌐ninsula, SE France, Switzerland
⌐d N Italy; several subspecies and forms,
⌐cluding ssp. *berisalii* (Rhone valley, Switzerland) and ssp.
⌐sinae* (S Portugal). Mostly two broods in May–June and
⌐ugust–September in flower-rich meadows, scrub, wood-
⌐nd margins and hillsides usually in uplands below 1,600
⌐. Larva feeds on *Linaria, Antirrhinum, Digitalis,* etc.

① Ups orange with
 contrast between
 orange and yellow
 bands (cf. *M. athalia,*
 M. parthenoides)
② Usually a dumbbell-
 shaped mark near
 to the centre of the
 hind edge of fw
③ Palpi orange below
 (cf. *M. athalia*)
★ Sexes similar

Meadow Fritillary · *Melitaea parthenoides*

MR SWITZERLAND 5/08 · HA S SPAIN 5/07

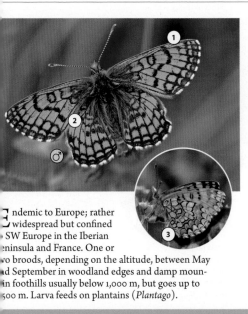

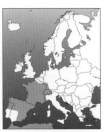

⌐ndemic to Europe; rather
⌐widespread but confined
⌐SW Europe in the Iberian
⌐ninsula and France. One or
⌐o broods, depending on the altitude, between May
⌐d September in woodland edges and damp moun-
⌐in foothills usually below 1,000 m, but goes up to
⌐00 m. Larva feeds on plantains (*Plantago*).

① Ups bright orange with
 irregular network of
 black lines and veins; a
 postdiscal band usually
 broken (cf. *M. deione*)
② Fw ups a black discal spot
 oblique (cf. *M. athalia*)
③ Hw uns a broad and wavy
 yellowish band through
 the centre with orange
 band on both sides
★ Sexes similar
★ Very similar to *M. athalia,*
 M. deione and *M. varia*

NICKERL'S FRITILLARY · *Melitaea aurelia*

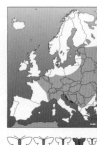

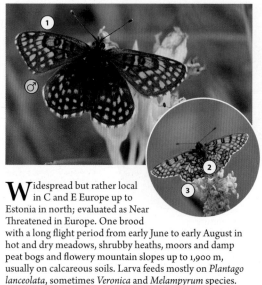

Widespread but rather local in C and E Europe up to Estonia in north; evaluated as Near Threatened in Europe. One brood with a long flight period from early June to early August in hot and dry meadows, shrubby heaths, moors and damp peat bogs and flowery mountain slopes up to 1,900 m, usually on calcareous soils. Larva feeds mostly on *Plantago lanceolata*, sometimes *Veronica* and *Melampyrum* species.

① Ups orange with complete and regular black markings
② Hw uns a central band irregular
③ Marginal lines infilled yellowish, slightly darker than the adjacent lunules
★ Both sexes dusted with dark scales
★ Closely resembles *M. britomartis* and *M. athalia*

ASSMANN'S FRITILLARY · *Melitaea britomartis*

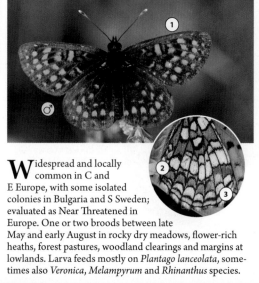

Widespread and locally common in C and E Europe, with some isolated colonies in Bulgaria and S Sweden; evaluated as Near Threatened in Europe. One or two broods between late May and early August in rocky dry meadows, flower-rich heaths, forest pastures, woodland clearings and margins at lowlands. Larva feeds mostly on *Plantago lanceolata*, sometimes also *Veronica*, *Melampyrum* and *Rhinanthus* species.

① Ups orange-brown with bold and regular dark brown markings
② Hw uns orange submarginal spots with dark internal border (cf. *M. diamina*)
③ Marginal lines filled with dirty yellow; darker than adjacent lunules
★ Sexes similar
★ Closely resembles *M. aurelia* and *M. athalia*

OV ESTONIA 6/07 · PG S BULGARIA PIRIN 7/10

OV BULGARIA 6/09 · HA POLAND 7/04

GRISONS FRITILLARY · *Melitaea varia*

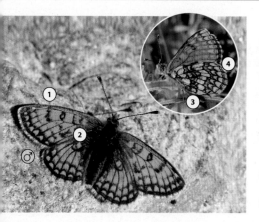

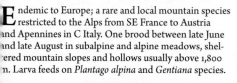

① Ups bright orange with thin regular markings and black veins; female suffused grey

② Fw ups a dark dumbbell-shaped mark on the hind edge

③ Hw uns white discal band

④ Black marginal lines infilled with the same colour as the adjacent lunules (cf. *M. athalia*)

★ Sexes similar

★ Very variable species

Endemic to Europe; a rare and local mountain species restricted to the Alps from SE France to Austria and Apennines in C Italy. One brood between late June and late August in subalpine and alpine meadows, sheltered mountain slopes and hollows usually above 1,800 m. Larva feeds on *Plantago alpina* and *Gentiana* species.

LITTLE FRITILLARY · *Melitaea asteria*

① Ups heavily dusted with sooty-black scales

② Hw uns only a single black marginal line beyond the lunules

★ Sexes similar

★ Tiny for a fritillary

★ Resembles a grey moth on the wing

Endemic to Europe; rare and very local in E Central European Alps (E Switzerland, N Italy and Austria). One brood in July–August in dispersed colonies in alpine tundra and mountain slopes above the tree line between 2,000 and 3,000 m. Larva feeds on *Plantago alpina*.

AETHERIE FRITILLARY · *Melitaea aetherie*

The Aetherie Fritillary (f. *perlinii*) is really a North African species, occurring in the Atlas mountains. The high and hilly Rocca Busambra, located south of Palermo on Sicily, may be the most southerly European locality for it. It is only a short hop from Africa to Sicily, or southern Iberia where another population of Aetherie Fritillary is found. At first glance the insect resembles the Spotted Fritillary, but it lacks the black spots near the wing edge on the underside. Altogether, it is less 'spotty-looking'. The female has two obvious forms, the normal one and another which is heavily dusted with greyish scales, rather like subspecies *meridionalis* of the Spotted Fritillary.

⊙ *Melitaea phoebe*

① Male ups bright orange with dark-brown markings and a zigzag submarginal line on both wings

② Hw ups discal and postdiscal markings obscure or absent

③ Female ups orange, more or less dusted with greyish scales

⊛ Large for a fritillary

🦋 One generation from mid-April to early June; in Sicily two broods in May–June and September. Dry meadows and grasslands, field edges and fallow land, scrub and light oak woodland below 800 m; on higher altitudes in Sicily (800–1,100 m).

⊕ Confined to S Iberian Peninsula (SW Spain, S Portugal and NW Sicily; sporadic with very local populations, often threatened by land use changes.

🍃 Knapweeds (*Centaurea*) such as *C. calcitrapa* and *C. carratracensis*; also *Cynara*.

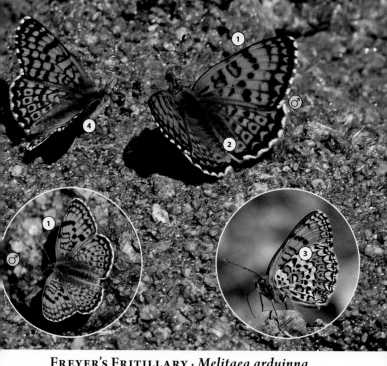

FREYER'S FRITILLARY · *Melitaea arduinna*

Freyer's Fritillary (photo right) is rather similar to the Glanville Fritillary (left), though larger and redder, and usually less common. The two may be seen in the same places at the same times, such as in the Varnous mountains, Greece, in June. Both display a row of black spots near the hindwing border. Freyer's Fritillary is restless and the more difficult of the two to approach. But as it settles and closes its wings, it offers a good view of the creamy pattern adorning its underside (f. *rhodopensis*). Recent genetic studies have confirmed a close relationship to '*phoebe* group'. Both utilize knapweeds in their larval stage – a unique feature among the other *Melitaea* species.

⊝ *Melitaea cinxia*

① Male ups orange with brown borders and dark spots; female yellowish with dark markings and heavy dusting
② Hw ups and uns black spots in the orange submarginal band (cf. *M. cinxia*)
③ Hw uns small black dots within an orange postmedian band (as on *M. cinxia* but not on *M. phoebe*)
④ cf. *M. cinxia*

🦋 One generation from late May to late July. Humid to wet forest clearings and rides, cultivated areas, flower-rich meadows and grassy mountain slopes between 700 and 1,700 m.

⊕ A rare eastern species with scattered and local colonies in mountains of SE Europe; N Greece, Balkan Peninsula, E Ukraine, S Russia and eastwards. Recently recorded in NE and NW Bulgaria along the Black Sea coast. Sometimes abundant in the habitat.

◍ Knapweeds (*Centaurea*), mostly *C. graeca*.

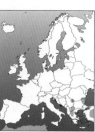

RED ADMIRAL · *Vanessa atalanta*

One of Europe's most showy and colourful butterflies, the Red Admiral's abundance varies a lot. In good years gardens, parks, roadsides and fields with thistles are decorated with dozens of Red Admirals. Individuals emerge from hibernation in March–April, but along the Mediterranean coast, as on the Costa del Sol, the butterfly may be on the wing all year round. In Fennoscandia populations are solely dependent on spring migrations. In 1998 the summer Nordic population was estimated to be among the millions, with Red Admirals occupying every free corner. Since the end of the 20th century the Red Admiral has begun to hibernate in the British Isles.

⊘ *Vanessa vulcania*

① Fw ups velvety black with a red stripe and white spots (cf. *V. vulcania*)

② Hw uns mottled with greyish-brown

⊛ Sexes similar

🦋 Mostly one generation from May to October in areas where it is resident; again in March–April after hibernation, sometimes earlier in winter months. An additional summer generation in July–September in N Europe. Practically all kinds of open and semi-open cultural environments, recorded up to 2,500 m in the mountains.

⊕ Widespread and common throughout most of Europe, yet resident only in the southernmost range. A strong tendency to migrate; recorded in almost all oceanic islands, Iceland and Greenland. In the northern range annual numbers fluctuate greatly depending on migrations and season; southward migrations are recorded in the autumn.

◐ Species of Urticaceae family such as *Urtica*, *Parietaria* and *Humulus lupulus*, rarely thistles (*Cirsium*).

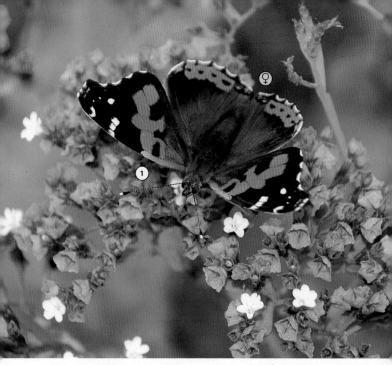

INDIAN RED ADMIRAL · *Vanessa vulcania*

he Indian Red Admiral, *Vanessa indica*, is a widespread species across India, China, Japan and Korea. In Europe it can be seen as a distinct subspecies, or species in its own right in the Canary Islands and Madeira. It can be seen all year round, and noticed by even casual observes as it flies in places where people tend to be, as in gardens and parks. However, its natural habitat could be considered to be the laurel forests where its larval food plants flourish. It has a deeper red forewing band with less white at the apex than does the ordinary Red Admiral. It is most frequent in the springtime when the tree heath (*Erica arborea*) and Aegean wallflower (*Erysimum*) are blooming.

➔ *Vanessa atalanta*

① Fw ups a broad and irregular red band (cf. *V. atalanta*)

✶ Closely resembles *V. atalanta*

✶ Sexes similar

✤ Several overlapping generations all year round. Parks and gardens, meadows and glades in laurel forests up to 1,500 m.

⊕ Sometimes regarded as a subspecies of *Vanessa indica*; endemic to Europe, mostly resident and locally common, or sometimes occasional migrant, in Madeira and all the Canary Islands except Lanzarote.

🍃 Mostly *Urtica morifolia*, sometimes *Parietaria* species.

HA CANARY ISLANDS TENERIFE 3/09

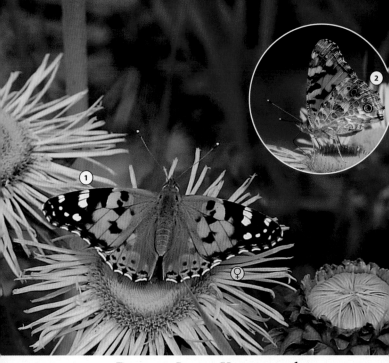

PAINTED LADY · *Vanessa cardui*

PO S POLAND 7/06 · HA 5 POLAND 7/06

In 2009 there was a major irruptive migration of Painted Ladies into Europe. They could be seen virtually everywhere, from the seaside to the mountain tops, from lush gardens to asphalt roads and arid fields devoid of crops. On some days several thousands were seen to arrive every hour on the south and east coasts of England. North Africa is a stronghold for the species, and variable numbers migrate northwards into Europe every year, though in some years few or none will reach the most northern parts of the potential geographic range. The species cannot survive the northern winter, but there is evidence of a southbound return migration at the end of summer.

⊙ *Vanessa virginiensis*

① Fw ups orange-buff with black and white spots and patches
② Hw uns with four bluish postdiscal eye-spots (cf. *V. virginiensis*)
⊛ Sexes similar
🜊 Several overlapping generations after the first migrations in April, almost all year round in the southern range, mostly in June–September in N Europe. Migrants can be seen in all kinds of environments up to 3,000 m in the mountains and even higher, but most numerous in diverse open cultural environments at lower altitudes.
⊕ A cosmopolitan species which is widespread and common throughout Europe; mostly non-resident except in the Canary Islands, Madeira and some Mediterranean regions. A notable migrant of long distances; numbers fluctuate markedly in the northern range, also recorded in all oceanic islands, Iceland, Greenland and Svalbard.
🜬 A wide range of plants of various families, including *Carduus, Cirsium, Artemisia, Echium, Malva* etc.

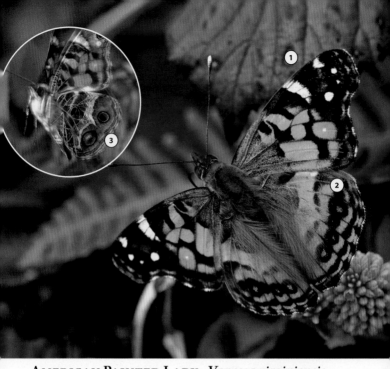

AMERICAN PAINTED LADY · *Vanessa virginiensis*

A powerful, resilient migrant with its stronghold in North America, the American Painted Lady can also be seen on Tenerife, in the Atlantic islands, almost all year round. Migrants occasionally reach the Azores, Portugal and southern Spain, and even the British Isles. It generally spends the winter months in diapause as an adult, but this may be disrupted by warm periods. The butterfly is slightly smaller and somewhat darker than the Painted Lady, and favours flower-rich fields. It also readily visits even small gardens in search of flowers from which to feed.

➔ *Vanessa cardui*

① Ups orange, often with black and white spots and patches on fw

② Hw ups small eye-spots

③ Hw uns two large eye-spots (cf. *V. cardui*)

★ Sexes similar

🦋 All year round in several consecutive generations. Flowery meadows, parks and gardens, other cultural environments and grassy mountain slopes up to 1,500 m.

⊕ Restricted to the Canary Islands (not in Gomera and La Palma) and the Azores; an occasional migrant in the W continental Europe (S and W Portugal, S Spain, Ireland, Wales, S England).

🌿 Probably a wide range of plants like those of *V. cardui*.

JT AZORES 10/07 · JT AZORES 10/07

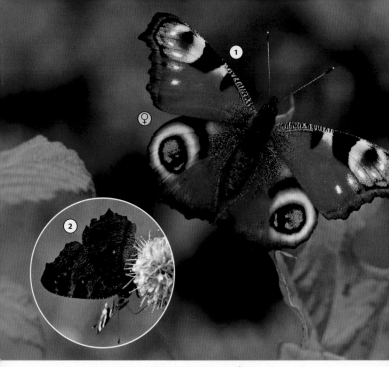

PEACOCK · *Aglais io*

The Peacock is unique and unmistakeable with the big blue eye-spots adorning its dark burgundy-red wings. The underside is in sharp contrast, being almost black with no contrasting markings. This coloration serves to camouflage the butterfly when it closes its wings. The Peacock is believed to be an indicator of global warming. In the 1960s it was a rare migrant in northern Scandinavia. Then in the 1970s it began to acclimatise, beginning to survive hibernation as an adult over the winter. Now it is one of the most abundant Nordic species in late summer. Plant the butterfly bush (*Buddleia davidii*) in your garden and you will attract this species along with other colourful wanderers like Red Admiral, Painted Lady and Small Tortoiseshell.

① Ups with characteristic large blue ocelli on all wings
② Hw uns almost black
★ Sexes similar
★ Looks very dark on the wing
🐛 One generation between late June and late September, and after hibernation from March to mid-June, depending on locality. Mostly cultural environments: parks and gardens, diverse meadows and pastures, fallow land and edges of fields, road verges, also forest clearings, edges of woods and rocky gullies up to 2,500 m.

⊕ Widespread and common in most of Europe, expanding northwards; absent from S Iberian Peninsula, some Mediterranean islands and N Fennoscandia, yet recorded in Iceland in far north. A tendency to migrate; in the northernmost range numbers fluctuate greatly from one year to another.

⬧ Mostly common nettle (*Urtica dioica*), sometimes *Parietaria* species or *Humulus lupulus*.

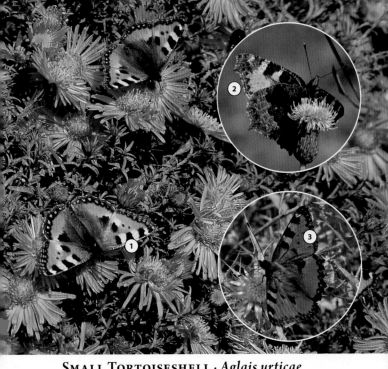

SMALL TORTOISESHELL · *Aglais urticae*

A mobile and adaptive species found wherever there are flowers to feed on, the Small Tortoiseshell is also often associated with cultural environments – gardens, parks and playgrounds. Its populations fluctuate markedly and the butterfly may almost disappear from certain areas for many years. But it always comes back.

Aglais ichnusa

It is sometimes regarded as a subspecies of *A. urticae*, endemic to Europe, restricted to Corsica and Sardinia. Two broods between May and early October, and again in early spring after hibernation, in various cultural environments on mountain ranges between 700 and 2,500 m. Larva feeds on nettles (*Urtica*).

① Fw ups three black costal spots and one white spot near to the tip
② Fw uns a yellowish postdiscal area
③ *Aglais ichnusa*, fw ups black spots small or missing
✱ Sexes similar

🦋 One to three generations depending on the latitude. In June–August where univoltine and between early May–October where polyvoltine; hibernating individuals in March–May. Diverse man-made cultural environments up to 3,000 m.

⊕ One of the most widespread and common nymphalid species in the whole of Europe, reaching Iceland in north; absent only from the Atlantic islands and most Mediterranean islands. Local migrations are rather frequent. Considerable individual and seasonal variability has resulted in many infrasubspecific categories; ssp. *polaris* in N Europe and several subspecies in the Asian range.

🜨 Mostly common nettle (*Urtica dioica*), seldom other nettles or *Arctium*, *Cirsium*, etc.

HA SE FINLAND IMATRA 9/09 · TH SE FINLAND SALO 8/09 · TH ITALY SARDINIA GENARGENTI 8/09

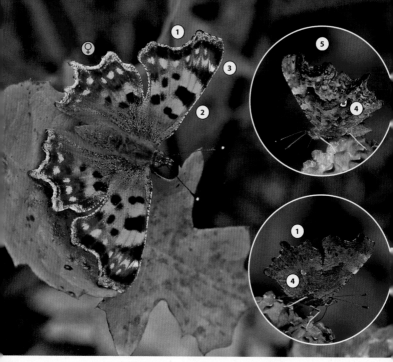

TM 5 FINLAND SALO 8/09 · HA SE FINLAND LEMI 7/10 · HA SE FINLAND LEMI 7/10

COMMA · *Polygonia c-album*

When a warm spring day awakens the hibernating Comma, it is easily eight months old and often tattered with faded wings. This may not be obvious though, as its wing shape is naturally ragged even when fresh. Commas are fiercely territorial challenging other passing butterflies. The larvae of the summer brood may take either of two developmental routes. One group develops more quickly and the resulting adults are paler than the spring ones (f. *hutchinsoni*). These produce a new late summer brood, which is again dark. The other larvae develop more slowly and emerge as normal dark adults. Therefore all hibernating Commas are of the dark form.

⊘ *Polygonia egea, Aglais urticae*

① Wings with ragged outline
② Fw ups ground colour orange with bold black spots (cf. *P. egea*)
③ No white spot on tip of the fw (cf. *Aglais urticae*)
④ Hw uns small white comma-shaped mark
⑤ f. *hutchinsoni*; uns very colourful
★ Sexes similar

𝺉 One to three generations; mostly two generations between June and October, and again after hibernation from March to early June, depending on latitude and altitude. Damp woodland clearings and glades, bushy margins of deciduous and mixed forests, hedgerows, parks and gardens up to 2,000 m.

⊕ Widespread and common through most of Europe except some Mediterranean islands, N British Isles and N Fennoscandia. An occasional migrant in the edges of the range, most likely expanding northwards.

⬨ A wide range of species such as *Urtica dioica, Humulus lupulus, Rubus idaeus, Ribes, Betula, Salix*, etc.

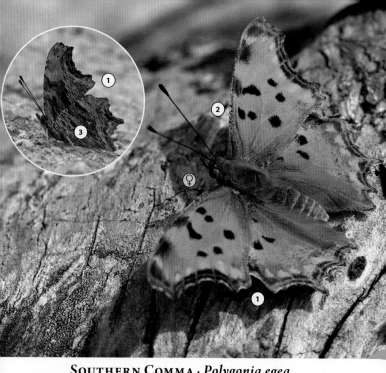

SOUTHERN COMMA · *Polygonia egea*

This is slightly larger than the Comma, with less black spotting on the wings and a distribution restricted mainly to coastal areas of the Mediterranean. The Southern Comma can be encountered almost anywhere within its range, from dry rocky places to lush orchards and gardens on the other. It is also a city dweller, basking on walls still warm from the afternoon sun in Forum Romanum, Rome, and the inner square of St Johannes Monasteri in Patmos, Greece. The spring specimens are a little paler than the later ones. In flight the insect may be confused with the Comma, Small Tortoiseshell or even Nettle-tree Butterfly.

⊖ *Polygonia c-album*
Aglais urticae

① Wings with ragged outline
② Ups ground colour light brown with small black spots on both wings (cf. *P. c-album*)
③ Hw uns white L-shaped mark (cf. *P. c-album*)
✹ Sexes very similar

🦋 Two or three generations between early May and October, and again in March–April after hibernation. Hot rocky slopes and gorges, warm river valleys, dry grasslands and dry scrub, hillsides and villages with old stony walls usually below 1,000 m, but goes up to 2,000 m.

⊕ Rather widespread and locally common in S and SE Europe in the E Mediterranean region, including many E Aegean islands. The range extends from SE France to Greece and Turkey in the east.

✤ Mostly *Parietaria officinalis*, sometimes nettles (*Urtica*).

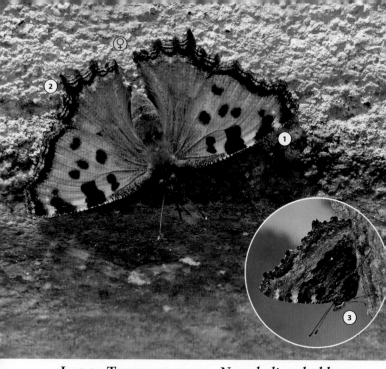

♀

① ② ③

LARGE TORTOISESHELL · *Nymphalis polychloros*

PO ITALY SICILY 6/09 · TR N GREECE 6/06

M more common than the very rare yellow-legged cousin and the False Comma. In the north it is rare but there may also be small resident populations in Saarenmaa, Estonia and S Scandinavia. The larvae eat elm leaves but also make use of several other deciduous trees as well as cultivated fruit trees. The butterfly occurs in light woodland and particularly in gardens and orchards. It thrives among apple, cherry, plum or orange trees, where it mates on a tree-trunk or amongst fallen leaves. Man-made environments like the Mediterranean pine alley providing shade at the ancient stadium in Delphi, Greece, appeal to the species.

⊙ *Nymphalis xanthomelas*
 Nymphalis vaualbum

① A yellowish spot near to the apex of fw
② Hw ups a narrow black marginal border (cf. *N. xanthomelas*)
③ Legs and palps dark brown or almost black (cf. *N. xanthomelas*)
★ Sexes similar
★ Resembles *Aglais urticae* but larger

🦋 Mostly one generation in July–August, which flies again after hibernation from March to early June in north; a possible 2nd brood in the southern range. Light mixed woodland, forest edges and clearings, also gardens and parks, up to 1,700 m.

⊕ Widespread in S and C Europe, including many of Mediterranean islands (Sicily, Corsica and Sardinia, Elba, Crete, most E Aegean islands). The range extends to S Fennoscandia in north; only as a migrant or vagrant in the northern range. Declined especially in NW Europe; probably extinct in Cyprus.

⬧ A range of deciduous trees such as *Salix*, *Populus*, *Ulmus*, *Prunus*, *Malus*, *Sorbus*, etc.

YELLOW-LEGGED TORTOISESHELL
Nymphalis xanthomelas

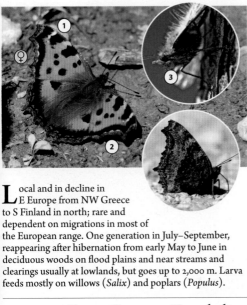

① A white spot near to the apex of fw
② Broad black marginal borders
③ Legs and palps light brown (cf. *N. polychloros*)
★ Sexes similar

Local and in decline in E Europe from NW Greece to S Finland in north; rare and dependent on migrations in most of the European range. One generation in July–September, reappearing after hibernation from early May to June in deciduous woods on flood plains and near streams and clearings usually at lowlands, but goes up to 2,000 m. Larva feeds mostly on willows (*Salix*) and poplars (*Populus*).

FALSE COMMA · *Nymphalis vaualbum*

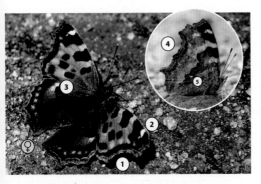

① Both wings strongly toothed and heavily marked with black
② Fw ups a black apical patch with conspicuous white spot
③ A large white spot at the hw front edge
④ Uns mottled brown with a broad light outer edge
⑤ A small white spot in the middle of hw
★ Sexes similar

An eastern rarity in decline, extending from N Balkans to S Finland. Very sporadic and rare in the westernmost range; permanent populations are scarce and the European range largely depends on migrations and local temporary colonies. One generation from July to September, and again after hibernation from April to early June in deciduous and mixed woodland, forest edges and clearings usually at lowlands. Larva feeds on willows (*Salix*), poplars (*Populus*) and other deciduous trees.

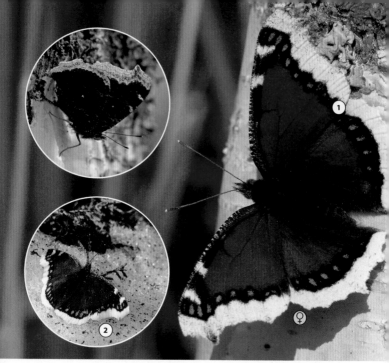

HA E FINLAND KERIMAKI 7/04 • TH S FINLAND SALO 8/10 • HA SE FINLAND PUUMALA 5/03

CAMBERWELL BEAUTY · *Nymphalis antiopa*

This large blackish butterfly with its cream-edged wings cannot fail to catch even the casual observer's eye. The territorial male keeps a look-out for intruders, dropping now and then to the ground or a roadside stone, where it rests with its wings held wide open. This species is fond of fallen and rotten fruit, or even dung, but especially sap oozing from wounded tree-trunks. A black and white birch trunk provides not only excellent camouflage, but also a plentiful supply of sugary sap all day long. This concoction also attracts many relatives like tortoiseshells, Commas and admirals. After its diapause the Camberwell Beauty reappears with faded creamy wing borders.

① A series of blue submarginal spots on both wings

② Ups marginal borders yellowish, after hibernation white

★ Sexes similar

🦋 One generation in June–July (south) or in August–September (north), and again after hibernation from April to early June. Woodland edges and clearings, forest roads and glades, scrub, bushy powerlines and edges of fields, watersides and sand dunes, gardens and parks, river valleys and rocky gullies up to 2,500 m.

⊕ Widespread and generally common in most of Europe, extending from N Portugal and N Spain to C Fennoscandia; a rare migrant or vagrant to the British Isles, northernmost Fennoscandia and Iceland. Absent from Mediterranean islands, yet recorded on Mallorca. Its abundance fluctuates greatly from one year to another; usually low in numbers.

🜨 Mostly willows (*Salix*), also other deciduous trees such as *Betula*, *Populus tremula* and other poplars.

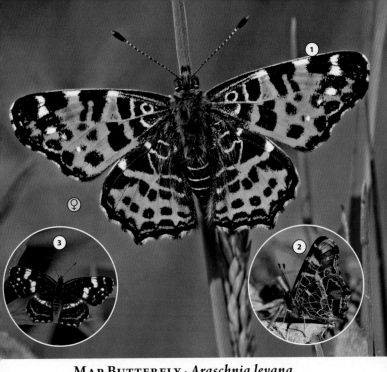

MAP BUTTERFLY · *Araschnia levana*

PO ESTONIA 5/08 · TH DENMARK SJELLAND 7/98 · MA S FINLAND KEIMOLA 5/05

B y 2010 the Map Butterfly had conquered southern Finland. It had arrived from the east in 1983, but 15 years later it also skipped over the Gulf of Finland from the Baltic area. This butterfly is noteworthy for its seasonal dimorphism: the spring brood is predominantly orange but the summer brood is black (f. *prorsa*). The length of day in the larval stage determines the adult form. Short days in the late summer and autumn, and hibernation as a pupa, ensure that the butterfly emerges in spring as the orange form. Longer days and rapid development in the summer produce the black *prorsa*. It is not clear what advantage this holds for the species.

⊝ *Aglais urticae*
 Limenitis camilla (f. *prorsa*)

① Ups orange with black and white spots
② Uns red-brown with white veins and cross-lines, resembling a road map
③ f. *prorsa*; fw ups dark brown or black with whitish postdiscal band
⊛ Sexes similar
⊛ Usually close to food plants (*Urtica*)

🦋 Mostly two generations; 1st brood in late April–June, 2nd brood in July–August. A partial 3rd brood in favourable conditions in the late autumn. Deciduous and mixed forests and forest clearings, coppices, lightly wooded meadows and pastures, hedgerows, farmyards, forest roads and bushy edges of woods usually below 1,200 m.

⊕ Widespread and generally common in most of C Europe, yet rare or absent from Mediterranean region, British Isles and most of Scandinavia. Expanding northwards. f. *prorsa* usually more abundant than the 1st brood.

🌿 Nettles (*Urtica*).

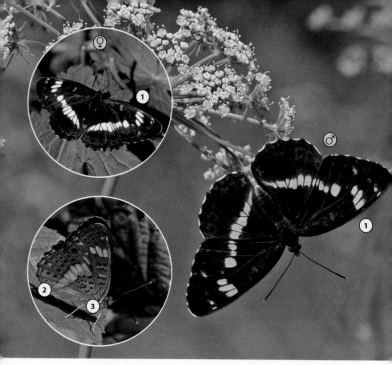

WHITE ADMIRAL · *Limenitis camilla*

HA SLOVENIY 7/06 · **PO** N ITALY 8/07 · **HA** N ITALY 8/07

HA SLOVENIY 7/06 · **PO** N ITALY 8/07 · **HA** N ITALY 8/07

The European distribution of the White Admiral coincides with that of beech forests. It is expanding its territory in Denmark and has recently re-visited Skåne, Sweden. In July 2003 one migrating female, probably from Estonia where it is fairly common, was recorded from eastern Helsinki, Finland. It was seen feeding from a creeping thistle, then shot across the road to a yarrow, and was gone in the space of a few seconds. This exceptionally elegant and graceful species is not really a migratory butterfly but favours lush woodlands with sunny glades and paths, especially if they offer plenty of bramble blossoms.

⊙ *Limenitis reducta*
 Araschnia levana

① Ups brownish-black with a white band on both wings

② Hw uns a double series of black postdiscal and submarginal spots (cf. *L. reducta*)

③ Hw uns inner margin silvery grey with short black stripes (cf. *L. reducta*)

★ Sexes similar

♀ One generation from mid-June to early August. Light and humid deciduous woodland, beech and mixed forests, luxuriant groves, woodland edges and clearings, usually near brooks and streams, in wooded river valleys up to 1,500 m.

⊕ Widespread in S and C Europe, extending from Cantabrian Mts to S Britain, Baltic states and S Scandinavia in north; expanding northwards, first records from Finland in 2003. Absent from Mediterranean islands.

◈ Mostly honeysuckles (*Lonicera periclymenum*, *L. caprifolium*, *L. xylosteum*), seldom *Symphoricarpus albus*.

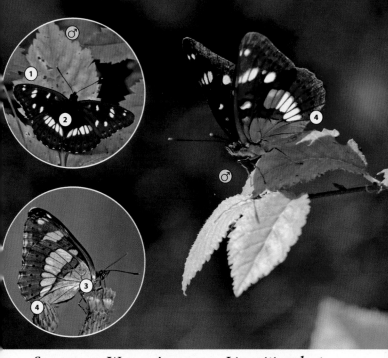

SOUTHERN WHITE ADMIRAL · *Limenitis reducta*

TH S BULGARIA 7/09 · PO N ITALY 8/07 · PO SPAIN MONTES UNIVERSALES 7/08

The Southern White Admiral and White Admiral may well occupy the same habitat, e.g. on the southern slopes of Monte Baldo, N Italy, which are covered with lush deciduous woodland and scrub. A freshly emerged Southern White Admiral is velvety black with a steely blue shine, gradually turning brownish-black. It is relatively common all summer and many will still be on the wing by the end of September in NW Greece for example. Like the White Admiral, this is a territorial species, monitoring its patch from a high perch or actively patrolling a small area. When alert the butterfly perches with wings half open.

↘ *Limenitis camilla*

① Male ups velvety black with bluish tinge (a fresh specimen)

② Hw ups a white stripe

③ Uns chestnut-brown; a basal area silvery grey without black stripes (cf. *L. camilla*)

④ Hw uns only one row of black postdiscal spots (cf. *L. camilla*)

⊛ Sexes similar

🦋 One or two generations; 1st brood from mid-May to late June and 2nd brood in July–August, univoltine in June–July north of the Alps. Sheltered woodland clearings and roads, dry pine forests, light woodland and scrub, wooded river valleys and shrubby rocky slopes up to 1,600 m.

⊕ Widespread in S Europe, including almost all Mediterranean islands (not in Crete and the Balearic Islands). The range extends from France in the west eastwards to S Poland, the Balkans, Cyprus and European Turkey.

◈ A range of honeysuckles such as *Lonicera periclymenum*, *L. etrusca*, *L. xylosteum*, etc.

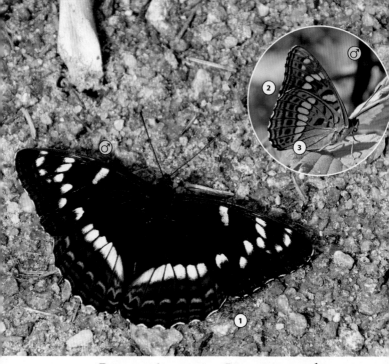

POPLAR ADMIRAL · *Limenitis populi*

The Poplar Admiral is apt to drink from puddles on the ground. It only gives a testy flap of the wings when disturbed. To see this gorgeous, velvety black butterfly, cycle slowly along gravel roads bordered by old aspens. Even a group of males may be found. The females appear a week later, circling up among the aspen branches, their striking black and white patterns obvious. The tiny caterpillar overwinters at the very end of an aspen twig by spinning a hibernaculum from a partly consumed leaf. In the north an exceptionally cold winter may kill it. This may be the reason why the Poplar Admiral practically vanished from Finland in the 1970s, to gradually reappear in the 1980s.

⊘ *Apatura iris, Apatura ilia*

① Male ups black with a white postdiscal band and orange lunules on hw; female has a broader postdiscal band
② Uns orange with bluish-grey border
③ Hw uns a white band with black veins
✱ Large and impressive
✱ Female has more white on wings

✿ One generation with a short flight period between late May and late July, depending on latitude. Luxuriant deciduous and mixed forests, roads and glades in woodland, edges of woods and wooded river valleys up to 2,000 m.

⊕ Widespread but rather local in C and E Europe, extending from SE France to C Fennoscandia in north, extinct in Denmark, but expanding northwards. Some isolated colonies in S Balkans.

◈ Mostly *Populus tremula*, seldom other poplars.

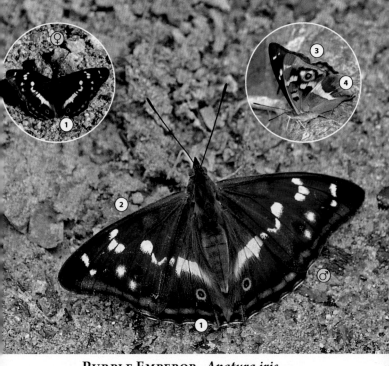

PURPLE EMPEROR · *Apatura iris*

One of the most gorgeous European butterflies. The deep black male has a violet and purple sheen, is a strong flyer, and has a curious nature – sometimes even downright aggressive. It is as liable to keep guard at the top of a 200-year-old oak in S England as on a young birch tree standing alone on a rock on the Finnish coast. Every passer-by receives its attention after causing it to take wing in alarm. The Purple Emperor has a taste for dung, carrion, tar, petrol and fumes of many kinds, yet it never thrusts its yellow proboscis into flowers. Like the Lesser Purple Emperor, the species has expanded further north in Europe and has established small colonies in S Fennoscandia.

⊝ *Apatura metis, Apatura ilia*

① One orange-ringed black spot near to the rear of hw (cf. *A. ilia*)
② Male ups a brilliant iridescence
③ Fw uns a large orange-ringed ocellus
④ Hw uns a white dentate band (cf. *A. ilia*)
✿ One generation from mid-June to mid-August.
Light deciduous and mixed forests, woodland clearings and margins, forest roads and rides, parks and gardens and wooded river valleys up to 1,500 m.
⊕ Widespread in most of Europe excluding Mediterranean regions (S Iberia, peninsular Italy, S Greece and Mediterranean islands) and northern parts of the British Isles and Fennoscandia. A tendency to migrate; expanding northwards.
◈ A range of willows (*Salix*), mostly *Salix caprea*.

LESSER PURPLE EMPEROR · *Apatura ilia*

A typical locality for this species is Haanja, S Estonia, where there is a mosaic of low hills, small river valleys, flowery meadows, and narrow, dusty roads. This large and striking butterfly is attracted by cattle dung and is often accompanied by Map Butterflies, Commas, or even the majestic Purple Emperor itself. It is also attracted to the salts found on sweaty human arms or foreheads. Both sexes are polymorphic, f. *clytie*, with a regionally varying occurrence, being orange-brown and resembling Freyer's Purple Emperor. The f. *barcina* of Catalonia, Spain and W Italy has more white on its wings.

⊙ *Apatura iris*
 Apatura metis

① Ups brown with an orange-ringed black ocelli on both wings (cf. *A. iris*)
② Male ups bright purple iridescence
③ Uns greyish-brown with orange mottling and a small ocellus on hw (cf. *A. iris*)
④ Ups light brown, f. *clytie*

🦋 One or two generations; 1st brood in May–June and 2nd brood in August–September; mostly univoltine from early June to late July to the north of the Alps and at high altitudes. Light deciduous and mixed forests, woodland clearings and margins, forest roads and glades, wooded river valleys and banks up to 1,500 m.

⊕ Widespread in S and C Europe, with a few isolated colonies in the Iberian Peninsula and C Italy. Absent from the Mediterranean islands, the British Isles and most of Fennoscandia; expanding northwards, recorded in Finland for the first time in 2000.

⬦ A range of poplars (*Populus*) and willows (*Salix*), mostly *Populus tremula*.

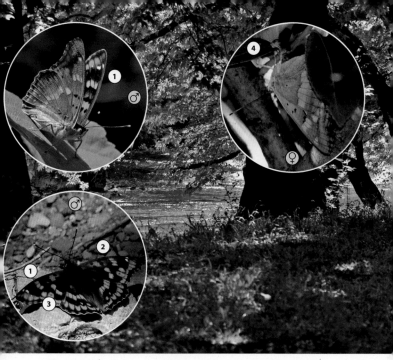

FREYER'S PURPLE EMPEROR · *Apatura metis*

TH N GREECE VOIDOMATIS 6/09 · TH N GREECE ZAGORA 6/06 · PO BULGARIA 7/10 · TH N GREECE ZAGORA 6/06

Freyer's Purple Emperor is rare and local. One place where it can be observed is in Zagori, N Greece, along dry stream beds branching off from the Voidomatis river shines green and light blue as it flows along. It perches high in the trees along the stream banks, with the females being particularly shy, but the more adventurous males may descend to bask on the warm, dry stones in the beds. The very similar f. *clytie* of the Lesser Purple Emperor is also found in the Voidomatis waterway – careful scrutiny is required to detect the difference. Other strongholds include parts of southern Hungary.

↝ *Apatura iris, Apatura ilia*

① Both sexes orange-brown, ups a wavy yellowish discal band
② Male ups a slight purple iridescence
③ Fw ups a small black postdiscal dot (cf. *A. ilia*)
④ Female ovipositing on *Salix* leaf
⍟ Mostly close to river banks
⍟ Strong territorial behaviour
⍟ Sometimes considered as a ssp. *A. ilia*, usually smaller
⍦ One or two generations between May and August. Wooded habitats along the rivers and streams, usually with numerous larval food plants, hot river valleys and banks with willows at lowlands below 700 m.
⊕ Restricted to SE Europe from Greece and European Turkey to Slovenia and eastwards. Rather widespread but only locally common along the bigger rivers, particularly the Danube and its tributaries.
⍓ Mostly *Salix alba*.

COMMON GLIDER · *Neptis sappho*

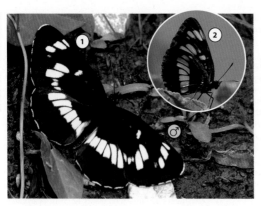

① Fw ups velvety black with a broad white streak and a band
② Hw ups two white bands
③ Uns rust-coloured with white stripes
⊛ Sexes similar
⊛ A characteristic gliding flight

Rather widespread in SE Europe, but very local and never abundant. Two broods in May–June and July–September in damp deciduous woodland, forest roads and clearings and river valleys between 200 and 1,500 m; often together with *Leptidea morsei*. Larva feeds on *Lathyrus vernus* and *L. niger*.

HUNGARIAN GLIDER · *Neptis rivularis*

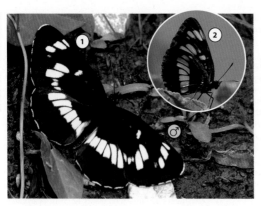

① Ups velvety black with one white band across both wings (cf. *N. sappho*)
② Uns rusty brown with a broad white band
⊛ Sexes similar

Somewhat wider distribution compared to *N. sappho*; confined to SE Europe, extending to N Italy and SE Switzerland in west. Very sporadic and local in the Balkans. One brood from late May to August in light deciduous woodland, forest margins and clearings and bushy glades in wooded river valleys between 500 and 1,600 m. Larva feeds on rosaceous plants (*Spiraea, Aruncus, Filipendula*).

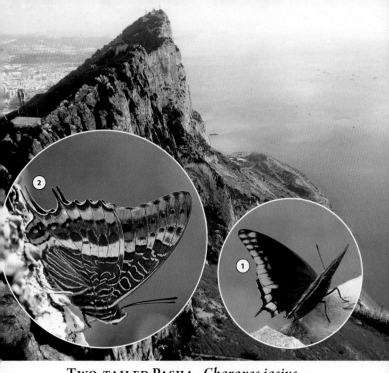

HA GIBRALTAR 5/08 · TH ITALY ELBA 6/09 · HA GIBRALTAR 5/08

TWO-TAILED PASHA · *Charaxes jasius*

The Two-tailed Pasha in the photograph was hilltopping at the highest point of the Italian island of Elba, which has been taken over by a jungle of TV and radio masts. When disturbed, it circles around before settling head downwards on the same side of a large rock. Its closed wings ensure the butterfly merges in with its grey, white and brown surroundings. The species' territorial behaviour is very apparent – it is so robust and such a strong flier that it can even drive small birds out of its territory. In flight it resembles the Camberwell Beauty but the two hindwing tails are clearly visible from a closer viewpoint. Many species of the *Charaxes* genus originate from Africa, where the Two-tailed Pasha is widely distributed and has two subspecies.

① Ups dark brown with broad orange borders on both wings
② Two tails on hw
✱ Sexes similar
✱ A large and unique looking butterfly
✱ Exhibits territorial and hilltopping behaviour

🦋 Two generations; 1st brood in May–June and 2nd brood from August to October. Hot and dry scrub, olive groves and orchards, villages, river banks and shrubby hillsides up to 1,300 m, but usually at low altitudes near the sea level.

⊕ Restricted to coastal Mediterranean districts, including most of the islands from Menorca in west to Cyprus in the east, but absent from the coast of E Peninsular Italy. Also recorded in Portugal and S Spain.

♠ Mostly strawberry tree (*Arbutus unedo*) or *Arbutus andrachne* (on Cyprus), seldom other plants (*Nicotiana*, *Citrus*).

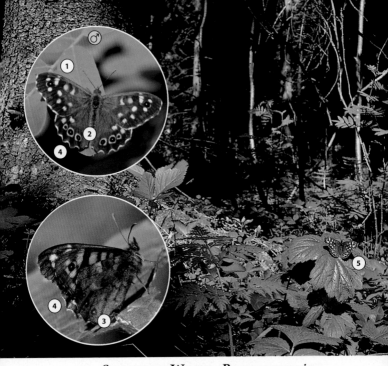

SPECKLED WOOD · *Pararge aegeria*

PO SE FINLAND, LAPPEENRANTA 6/85 · TH S BULGARIA, KRESNA 7/09 · HA N ITALY 6/06

This is a true woodland butterfly. Males appear a few days before females and each adopts a small patch as a territory. A male keeps a look out for other males from a handy branch and is ready for action when the first female hatches. The Speckled Wood jumps from one sunny forest spot to another but also requires shade. It often basks on sunlit leaves, but seldom visits flowers. Two distinct subspecies occur in Europe. The reddish-brown nominate subspecies has a more southerly distribution, while the subspecies *tircis* occurs further north. The latter prefers old spruce forests but is also found in mixed woodland.

⊘ *Pararge xiphia*
 Pararge megera

① Male ups dark brown with orange blotches
② Hw ups three to four orange-ringed eye-spots
③ Hw uns an arc of rusty-brown eye-spots with yellow pupils
④ Outer wing margin scalloped
⑤ ssp. *tircis*
✶ Sexes similar

🦋 One to three generations. Mostly one brood in May–June in the northern range (ssp. *tircis*), in more southern areas two or three overlapping broods between late February and early October. Old coniferous forests and mixed woodland, oak and beech forests, forest clearings and rides, riversides and also urban gardens and parks in south up to 1,800 m.

⊕ Widespread and common in most of Europe, but absent from N Fennoscandia and parts of northern British Isles. Recorded also on Madeira.

🍃 Various grasses such as *Brachypodium*, *Holcus*, *Agrostis*, etc.

CANARY SPECKLED WOOD · *Pararge xiphioides*

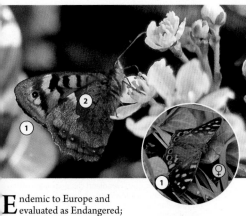

① Ups dark brown with orange blotches
② Fw outer margin linear (cf. *P. xiphia*)
③ Hw uns a white band extending from costa to cell
★ Sexes similar
★ Closely resembles *P. aegeria*

Endemic to Europe; restricted to the Canary Islands (Gomera, Gran Canaria, La Palma, Tenerife). Several overlapping broods all year round in forests dominated by laurel and chestnut, up to 2,000 m. Relatively common also in urban parks, if there are hedges and trees to create sunny spots alternating with shady areas. Larva feeds on various grasses (*Brachypodium*, *Agrostis*, *Dactylis*, etc.).

MADEIRAN SPECKLED WOOD · *Pararge xiphia*

① Fw outer margin slightly convex (cf. *P. xiphioides*)
② Hw uns small white mark on costa (cf. *P. xiphioides*)
★ Sexes similar
★ Closely resembles *P. aegeria*

Endemic to Europe and evaluated as Endangered; confined to Madeira only. Several overlapping broods all year round, less frequent in summer months (June–August), in laurel and chestnut forests from sea level to 1,000 m. Mostly uncommon, but sometimes abundant even in towns and villages. Larva feeds on various grasses (*Brachypodium*, *Holcus*, etc.).

LARGE WALL BROWN · *Lasiommata maera*

HA.E FINLAND KERIMÄKI 6/10 · TH SPAIN CATALONIA 8/08 · PO S SPAIN 5/07 · HA SWITZERLAND 7/07

In the northern parts of its range, the first Large Wall Browns appear in mid-June when the white butterfly orchids have flowered and the daisies are coming into bloom. The butterfly does not have any special requirements regarding its environment. Rocky terrain suits it, as long as there is light and flowers. The male is easy to spot, the larger and more fulvous females being less often seen. In the far north Large Wall Browns of f. *borealis* are smaller, darker and have less orange than southern individuals. The f. *adrasta* of the Iberian Peninsula and Mediterranean region has more orange and yellow than the nominate subspecies.

⊙ *Lasiommata petropolitana*
 Lasiommata megera

① Male ups dark brown with a faint orange postdiscal band and an apical eye-spot on fw, f. b*orealis*
② Hw ups no transverse discal line (cf. *L. petropolitana*)
③ Fw ups orange areas extended, f. *adrasta*
④ Uns closely resemble *L. petropolitana*

♈ One or two generations, depending on latitude; 1st brood in late April–June and 2nd brood from early July to September; the only brood in north from mid-June to August. Woodland clearings and cutting areas, flowery meadows and road verges amongst woods, light grassy woodland and scrub, steep screes up to 2,000 m.

⊕ Widespread and relatively common throughout Europe, but absent from the British Isles, Denmark and N Fennoscandia.

⬙ Various grasses such as *Calamagrostis epigejos*, *Deschampsia flexuosa*, *Festuca*, *Nardus*, *Poa*, etc.

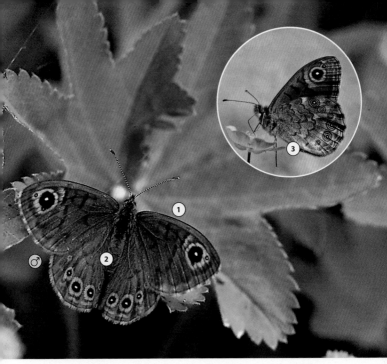

NORTHERN WALL BROWN · *Lasiommata petropolitana*

This species begins to emerge soon after the roadsides start to acquire new grass and wood anemones in the spring. The butterfly rises early in the morning after warming up on a stone and roosts or rests on road banks sheltered by exposed tree roots or rocks. It is very cautious and not at all easy to approach. Close views are thus difficult to obtain, though it can be admired from a distance as it basks with wings half open, showing off its prominent eye-spots. The Large Wall Brown looks similar but does not emerge until some three weeks later.

⊗ *Lasiommata maera*
 Lasiommata megera

① Fw ups sooty brown with three dark bars crossing the cell (cf. *L. maera*)

② Hw ups an irregular transverse discal line (cf. *L. maera*)

③ Hw uns no yellow colour beside dark stripes (cf. *L. megera*)

⊛ Sexes similar

✇ One generation from late April to early August; a partial 2nd brood possible in the southern range. Light coniferous woodland, forest margins and clearings, usually on dry, stony or sandy terrain, old gravel pits and quarries; between 500 and 2,300 m in south and lower altitudes in the northern range.

⊕ Distribution in separate parts in Europe; most widespread in N Europe in S and C Fennoscandia and N Baltic states. In south, restricted to higher mountain ranges from the Pyrenees in west to N Greece and the Balkans in the east. Local throughout the range and never abundant.

⊕ Various grasses such as *Dactylis glomerata*, *Festuca*, *Melica nutans*, *Calamagrostis*, *Elymus caninus*, etc.

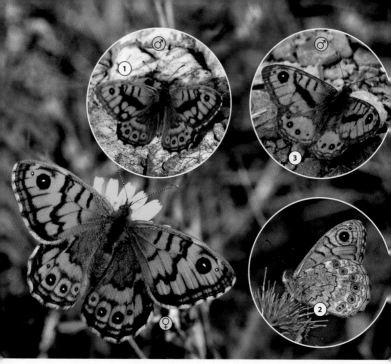

WALL · *Lasiommata megera*

TH NE SPAIN 10/07 · TH S SPAIN SIERRA NEVADA 3/07 · TH FRANCE CORSICA 6/08 · PO N GREECE 9/08

If you wander around in grassy and rocky areas, especially where there is stony ground and walls, you stand a good chance of encountering the Wall. This does not apply to the northernmost parts of Europe, however. In good habitat for this species, vegetation is usually sparse. The butterfly basks on stones at side of a track and is not easy to approach.

CORSICAN WALL BROWN
Lasiommata paramegaera

Endemic to Europe; confined to Corsica, Sardinia and nearby islands. Smaller than *L. megera* with less contrasting markings, more yellow on hindwing. Three broods between April and September in rocky habitats and heaths in uplands, usually together with *Coenonympha corinna*.

① Male fw ups a broad brown sex brand running diagonally through the centre

② Hw uns yellow colour beside dark stripes (cf. *L. petropolitana*)

③ *L. paramegaera*

🦋 Two to four generations between early April and October. The second brood in early summer is usually the most abundant. Grassy, rocky, stony but partly open ground, stone walls, paths and tracks, agricultural areas, woodland clearings, flowery meadows and rocky gullies up to 3,000 m.

⊕ Widespread and common throughout most of Europe, but sporadic and local in S Scandinavia and S Baltic states; a few old records from S Finland.

🌱 Various grasses such as *Agrostis*, *Festuca*, *Poa*, *Cynosurus*, *Dactylis*, etc.

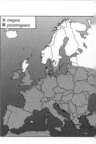

◾ megera
◾ paramegaera

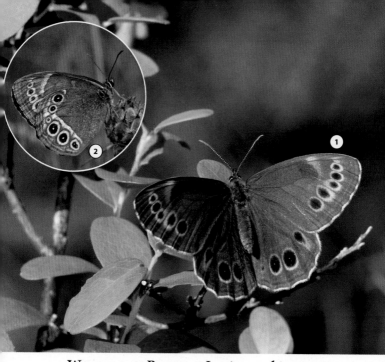

WOODLAND BROWN · *Lopinga achine*

An infrequent woodland species with its large black eyes each surrounded by a yellow ring. On the islands of Saarenmaa (Estonia) and Gotland (Sweden) the butterfly thrives in deciduous forest clearings and bushy margins where hazel and hawthorn bushes, as well as elm trees, are flourishing. The milk chocolate brown coloration creates an illusion in the ever changing play of light and shadow, so that you are often uncertain about what you have seen. Due to increasingly efficient forest management and the drainage of damp soils the Woodland Brown is apparently in decline in many of its scattered localities.

➲ *Lasiommata maera*
Lasiommata petropolitana

① Ups sooty brown with large yellow-ringed eye-spots on both wings

② Uns pale brown with large eye-spots and a white band on hw

✪ Sexes similar

♀♂ One generation from early June to late July. Small clearings of deciduous woodland, edges of woods, forest meadows, outskirts of marshes and peat bogs and swampy coniferous forests up to 1,500 m.

⊕ Widespread but very sporadic and local in C and E Europe; widely absent from maritime regions in south, west and north. Local populations are widely in decline, and the species is protected by European legislation. Evaluated as Vulnerable.

✤ Many grasses (*Festuca*, *Poa*, etc.) and hedges (*Carex*), including *C. globularis*, *C. canescens* and *C. montana*.

LATTICE BROWN · *Kirinia roxelana*

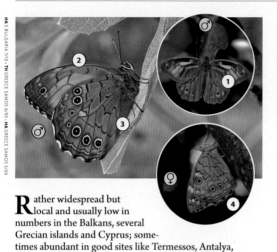

Rather widespread but local and usually low in numbers in the Balkans, several Grecian islands and Cyprus; sometimes abundant in good sites like Termessos, Antalya, Turkey. Mostly one brood with a long flight period between May and September in light pine forests, hot scrubby grasslands, river banks and dry stream beds up to 2,300 m. Larva feeds on various grasses.

① Male fw ups sex-brand conspicuous
② Fw uns orange; female with more white near the tip
③ Hw uns greyish-brown with brown wavy cross-lines
④ Outer edge scalloped
✱ Sexes similar (uns)
✱ Flies fast and hides on tree trunks or bushes
✱ Ups rarely seen at rest

LESSER LATTICE BROWN · *Kirinia climene*

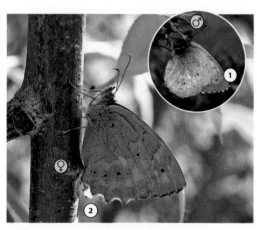

Scattered colonies in SE Europe. A very local and sporadic forest species with one brood from June to August in bushy meadows and grassy clearings in woodland and forest glades and roads between 700 and 1,600 m. Larva feeds on coarse grasses.

① Male fw uns orange with brown borders and a small apical eye-spot
② Hw uns greyish-brown and outer margin scalloped
✱ Smaller than *K. roxelana*
✱ Ups rarely seen at rest
✱ Sexes similar (uns)
✱ Hides on trunks and branches

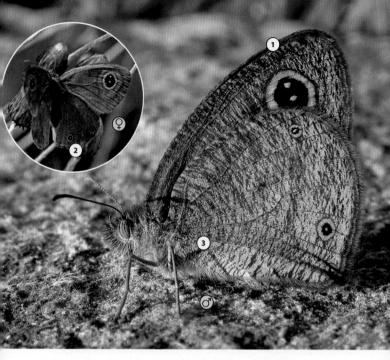

♀

♂

① ② ③

AFRICAN RINGLET · *Ypthima asterope*

A rare species in the eastern Aegean islands, the African Ringlet can be more readily found at localities like Antalya and Alanya on the Turkish Riviera. It flies fast over dry fields and rocky slopes, usually near the seaside. This is a small butterfly which keeps its wings closed when resting, and so is hard to find among the low vegetation if you lose track of where it has settled. With its large two-pupilled eye on the forewing, which is more prominent in the female, the African Ringlet is unmistakable. The hindwing underside is a faintly mottled black with small, variable eye-spots.

① Fw ups and uns grey-brown with a large yellow-ringed subapical eye-spot with two blue pupils
② Hw ups and uns with small eye-spots
③ Hw uns brown, faintly mottled with dark
★ Sexes similar
★ Small in size
★ Prefers very hot environments

♔ Two or three generations between April and October. Very hot and dry grasslands and short scrub, grassy hollows at steep slopes and dry river-beds, usually at lowlands (<300 m); recorded up to 1,200 m in E Aegean islands.

⊕ A local species with a very limited range in SE Europe; some larger islands of Greece (Samos, Rhodes, Simi, Kastellorizo) and Cyprus, in particular the northern coast of Karpasia. More common in Turkey and eastwards.

♙ Most likely various grasses (Poaceae).

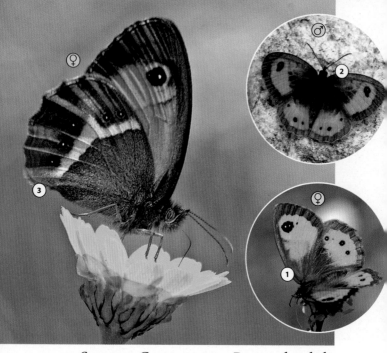

SPANISH GATEKEEPER · *Pyronia batsheba*

This is perhaps the most attractive of the three gate-keeper species, having a wide pale band with well-developed ocelli on the hindwing underside, and distinctly scalloped edges to the hindwings. According to history, Bathsheba (Hebrew: Bat Sheva) was seduced by King David and subsequently gave birth to his successor, Solomon. On the Iberian Peninsula and in S France, the eyecatching *P. batsheba* flits in and out of hedgerows on sunny days, feeding avidly from flowers and pausing to bask on sunlit leaves.

⊘ *Pyronia tithonus*
 Pyronia cecilia

① Ups orange-red with dark borders and dark brown dusting at the base of both wings
② Male fw ups sex-brand enclosed in dark basal area
③ Hw uns dark brown with a distinctive yellowish band and eye-spots outside the band

🦋 One generation between late April and July, depending on altitude. Rough grasslands and scrub, bushy forest clearings and light woodland up to 1,700 m.

⊕ Widespread and locally common in SW Europe, including most of the Iberian Peninsula and SE France

◆ Grasses, mostly *Brachypodium sylvaticum*.

GATEKEEPER (HEDGE BROWN) · *Pyronia tithonus*

TH N SPAIN 8/08 · TH N SPAIN 8/08 · HA SPAIN MONTSENY 7/08

① Male fw ups a brown sex brand runs diagonally through the wing
② Female fw ups orange with broad brown borders
③ Hw ups one small eye-spot (cf. *P. cecilia*)
④ Hw uns dark brown with a white irregular band and small eye-spots on both sides (cf. *P. cecilia*)

Widespread, rather common and often abundant in S and C Europe, including England and S Ireland. In S Europe f. *decolorata*; more yellowish hw uns. One brood from late June to September in hedge-rows, flowery margins and glades of woodland, light shrubland and rocky slopes up to 2,300 m, but mostly at lowland grasslands. Larva feeds on a wide range of grasses.

SOUTHERN GATEKEEPER · *Pyronia cecilia*

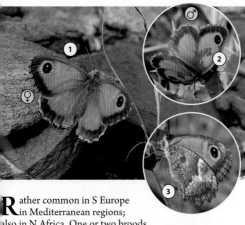

HA S SPAIN 5/08 · HA S SPAIN 5/08 · TH N SPAIN 8/08

① Female ups bright orange with dark-brown borders
② Male fw ups a large sex brand broken up by orange veins
③ Hw uns without eye-spots (cf. *P. tithonus, P. bathseba*)

Rather common in S Europe in Mediterranean regions; also in N Africa. One or two broods (in SE Europe) between early June and September on scrubby grassland or rocky slopes in drier habitats than the other two gatekeepers. Mainly in fields and grass-lands of medium altitude below 1,200 m, but goes up to 2,300 m in the mountains. Larva feeds on various grasses.

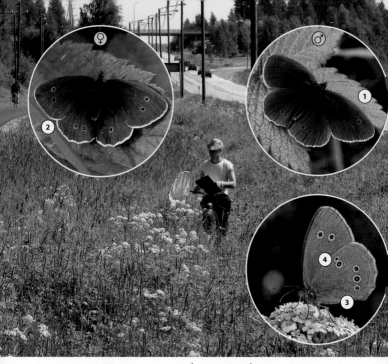

RINGLET · *Aphantopus hyperantus*

JJ SE FINLAND JOUTSENO · TH N LATVIA 6/04 · HA HUNGARY 7/06 · PO SE FINLAND LAPPEENRANTA 7/92

Each year the Ringlet has been one of the most commonly reported butterflies in the Finnish butterfly monitoring scheme (field observation, catch & release if needed). The other common species has been the Green-veined White. The Ringlet flies from first light right into the mid-evening, though it may pass the hottest part of the day resting in the shade. It readily opens its wings to catch the first warm rays but keeps them closed for most of the day, revealing the attractive – and highly variable – underside pattern with its row of yellow-ringed eye-spots on all wings. The odd cloud does not bother it but rain drives the insect to take shelter under a leaf.

⊙ *Coenonympha oedippus*
 Maniola jurtina

① Male ups dark brown with white fringes
② Female ups some faint eye-spots on both wings
③ Uns uniform brown with variable number of yellow-ringed eye-spots on both wings
④ Hw uns two anterior eye-spots closer to the base than others (cf. *Coenonympha oedippus*)
⊛ Sexes similar

� One generation between early June and early August. Dry to damp grassy habitats; meadows and pastures, fallow land, hedgerows and road verges, edges of fields and forests, grassy clearings and rides in woods, also parks and gardens, up to 1,600 m.

⊕ Widespread and generally very common in most of Europe from N Iberian Peninsula to C Fennoscandia in north; expanding northwards. Absent from Mediterranean islands, most of Iberian Peninsula, peninsular Italy and S Greece.

⬘ A wide range of grasses

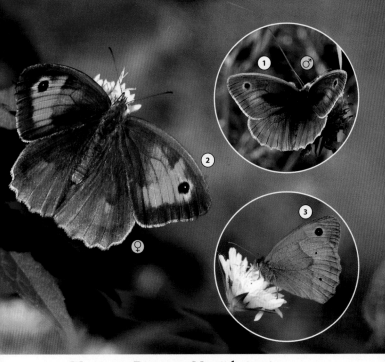

MEADOW BROWN · *Maniola jurtina*

T he Meadow Brown is a mid-
to dark brown butterfly
that exhibits the same type of
rather floppy flight in grass-
lands as the Ringlet, though is
sufficiently different in pattern
that it is unlikely to be mistaken
for that species. The Meadow
Brown female has only one large
ocellus on the forewing on both
the upperside and underside,
while the similar Dusky Meadow
Brown has two. This grassland
species has taken full advan-
tage of agricultural legislation
requiring farmers to leave some
land as set aside – meadows with
plenty of flowers and a tall grass
sward suit its needs very well.
Today it is one of the commonest
butterflies on the continent.

➲ Hyponephele lycaon
 Maniola nurag

① Male fw ups
 smoky-brown with a
 broad black sex brand
 (cf. *Hyponephele lycaon*)
② Female fw ups one
 apical eye-spot and
 orange smudge
 (cf. *Hyponephele lycaon*)
③ Fw uns an orange
 basal half and a large
 yellow-ringed eye-spot

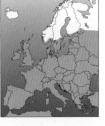

🦋 One generation with a long flight period between
late May and September; a summer aestivation in the
southern range, recorded as early as March on Canary
Islands and mostly in June–July in the northern range.
Dry to damp grassy habitats of all kind; meadows and
unploughed fallow land, hedgerows and road verges,
clearings and margins of forests up to 1,600 m.

⊕ Widespread, common and abundant in most of
Europe, including Mediterranean islands, the Canary
Islands and the British Isles. Absent only from most of
Fennoscandia in north, but expanding northwards.
Larger f. *hispulla* in SW range and the Canary islands,
ssp. *splendida* in NW Scotland and the Isle of Man.

⊕ A wide variety of grasses

SARDINIAN MEADOW BROWN · *Maniola nurag*

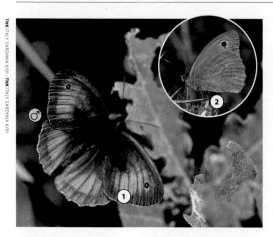

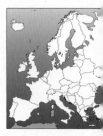

① Ups dull brown with extensive pale-orange patches (cf. *M. jurtina*)

② Hw uns uniform brown (cf. *M. jurtina*)

⊛ Closely resembles *M. jurtina* but smaller

⊛ Mostly above 500 m from the sea level

⊛ Only in Sardinia

Endemic and restricted to Sardinia; rather common but local with one brood in May–August in grassy, flowery, scrubby and stony areas between 400 and 1,300 m. The Meadow Brown flies at lower altitudes, not together with *M. nurag*. Larva feeds on various grasses.

AEGEAN MEADOW BROWN · *Maniola telmessia*

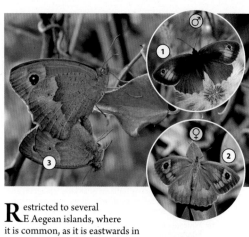

① Male fw ups with a black sex brand and a large orange postdiscal patch

② Female ups an orange band on both wings

③ Hw uns grey-brown with two to five small orange-ringed postdiscal eye-spots

⊛ Sexes similar

⊛ Closely resembles *M. jurtina* but smaller

⊛ Variable in appearance

Restricted to several E Aegean islands, where it is common, as it is eastwards in Turkey. External characteristics vary slightly from one island to another. One brood mostly between April and October, with a long summer aestivation, in diverse grassy and bushy areas, olive groves, vineyards and cultivated ground up to 1,300 m. Larva feeds on grasses.

Thomson's Meadow Brown · *Maniola halicarnassus*

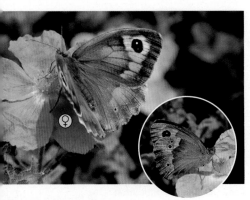

TNK GREECE NISSIROS 6/09 · NK GREECE NISSIROS 6/09

- ★ Male ups dark brown with a large triangular sex brand
- ★ Closely resembles *M. jurtina*
- ★ Only meadow brown on Nissiros

A very limited range restricted to E Aegean island Nissiros. Evaluated as Near Threatened. Also in SW Turkey, where flies together with *M. telmessia*; somewhat larger and the black sex brand in male is large, conspicuous and triangular. Male genitalia are different from *M. jurtina*, *M. chia* and *M. megala*. One brood between late May and late August in grassy shrubland and cultivated areas below 500 m. Larva feeds on grasses.

Chios Meadow Brown · *Maniola chia*

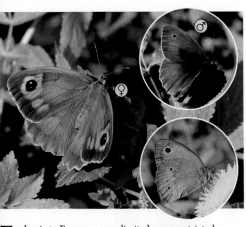

TNK GREECE CHIOS 5/09 · TNK GREECE CHIOS 5/09 · TNK GREECE CHIOS 5/09

- ★ Closely resembles *M. jurtina*
- ★ Only meadow brown on Chios and Inousses

Endemic to Europe; a very limited range restricted to E Aegean islands, Chios and Inousses, where it is common. One brood with a long flight period between May and September in flower-rich and shrubby dry grasslands, scrub and cultivated areas at lowlands (<500 m). Larva feeds on grasses.

TURKISH MEADOW BROWN · *Maniola megala*

AB TURKEY ALANYA DIMÇAYI 5/04 · OY S TURKEY 6/06

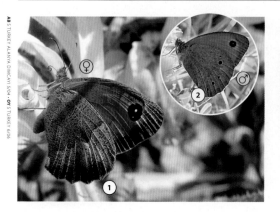

① Hw uns uniform dark yellowish-grey, an outer margin scalloped

② Male hw uns two to five eye-spots, variable in size

★ Closely resembles *M. jurtina* and *M. telmessia* but larger

Restricted to E Aegean island of Lesbos and eastwards to SW, S and C Turkey. Flies together with *M. telmessia* from which it is difficult to distinguish in the field; somewhat larger and darker. One brood in May–June (Lesbos) but till late September in Turkey. Habitats as for *M. telmessia*, but also wet places in light shrubland from sea level to 500 m. Larva feeds on grasses.

CYPRUS MEADOW BROWN · *Maniola cypricola*

PO CYPRUS 9/08 · PO CYPRUS 9/08

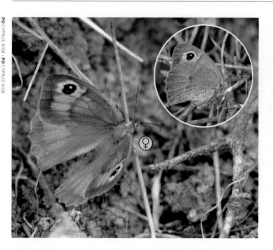

★ Only meadow brown on Cyprus

★ Closely resembles *M. jurtina* and *M. telmessia*

Endemic to Cyprus; externally similar to *M. jurtina*, which is not present in the island. One brood between April and October in diverse grassy habitats, common at all altitudes. Larva feeds on grasses.

DUSKY MEADOW BROWN · *Hyponephele lycaon*

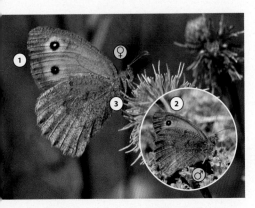

① Female fw uns orange with grey borders and two pupillate eye-spots

② Male fw uns with greyish-brown borders and one pupillate eye-spot

③ Hw uns uniform brown with dusting of grey scales (cf. *M. jurtina*)

★ Ups never seen at rest

★ Smaller than *M. jurtina* and *M. lupina*

Widespread and common in the Iberian Peninsula; more sporadic and locally scarce in E Europe extending from Greece to S Finland in north. One brood from June to September in diverse grassy habitats; mainly dry, hot and stony or sandy grasslands, dry meadows, gravel pits and south-facing slopes up to 2,500 m. Larva feeds on fescues and other fine-leaved grasses.

ORIENTAL MEADOW BROWN · *Hyponephele lupina*

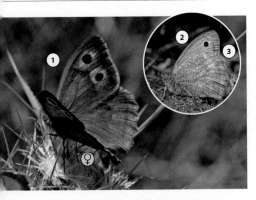

① Female fw ups sooty brown with two orange-ringed eye-spots

② Fw uns orange with grey borders

③ Hw uns uniform grey, outer margin scalloped (cf. *M. jurtina*)

★ Male fw ups a broad dark sex brand not broken by veins (cf. *M. lycaon*)

Local in S Europe from Portugal to Greece, including many Mediterranean islands; more common in Turkey. A variable species; f. *mauretanica* (male darker, female paler than the nominate subspecies) in N Africa, Iberian Peninsula and SE France; f. *rhamnusia* (male larger, paler) in Sicily, Balkans and Greece. One brood between May and September in hot and dry rocky grasslands and forest margins up to 2,000 m. Larva feeds on grasses.

SMALL HEATH · *Coenonympha pamphilus*

TH SPAIN PYRENEES 8/08 · PO ITALY SICILY 8/08 · HA S SPAIN 5/08

The Small Heath is an ubiq-uitous butterfly which is on the wing throughout the year, with the exception of December and January, in hot southern localities. Several males may gather at grassy places for a communal display aimed at enticing females. This increases the odds of mating, as a lone patrolling male has less chance of catching a female's eye. The Small Heath varies a lot in Europe. In the south it may be only half the size as it is in the north. The pale yellow ssp. *winbladi* occurs in Norrbotten, Sweden. In SW Europe the upperside of f. *lyllus* has broader dark borders, and f. *sicula* in Sicily looks much the same as Cretan *C. thyrsis*.

⊙ *Coenonympha glycerion*
Coenonympha tullia

① Fw uns orange with grey borders and a yellow-ringed eye-spot
② Hw uns greyish-brown at base and with a paler outer region separated by a pale streak
③ f. *sicula*
★ Ups rarely seen at rest
★ Sexes similar

🦋 One to three generations, depending on latitude and altitude – occasionally even four broods between February and October, but only one brood in June–July in the northernmost range and at high altitudes. All types of grasslands; meadows and pastures, road verges, fallow and waste land, edges of agricultural land, woodland clearings and coastal sand dunes and rocky islands, up to 2,000 m in the mountains.

⊕ Widespread and very common throughout the whole Europe; scarce in N Fennoscandia, absent from Crete and Atlantic islands. One of the most abundant butterflies in Europe.

🍃 A wide range of grasses such as *Festuca ovina*, *Anthoxanthum odoratum*, *Deschampsia*, *Cynosurus*, *Poa*, etc.

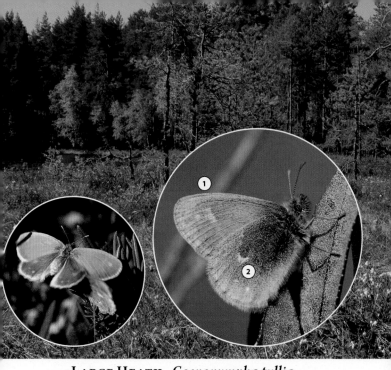

LARGE HEATH · *Coenonympha tullia*

A pair of Wellington boots is needed when visiting habitats of the Large Heath. Mires and bogs supporting small and medium-sized pines, possibly with birches, willow, bilberry and cotton grass are the places to search. The Large Heath shuns open areas in addition to avoiding sorties into stands of scattered pines. It prefers strips of bog with metre-high sedges, the edges of a mire, or small openings among the trees. It is extremely flighty and difficult to approach, making a rather panicky escape when the observer is within a couple of metres. A sensitivity to changes in habitat moisture has led to the disappearance of the species from many localities.

⊖ *Coenonympha glycerion*
 Coenonympha pamphilus

① Fw uns orange with wide grey borders and a pale postdiscal line

② Hw uns an irregular pale streak reaches the front edge (cf. *C. rhodopensis*)

⊛ Ups never seen at rest

⊛ Sexes similar

☥ One generation from mid-June to early August. Cool and moist biotopes; marshes and peat bogs, moorland, damp grasslands and riverside meadows at lowlands (<800 m). Widely declined due to habitat drainage.

⊕ A very variable taiga species with a lot of subspecific geographical races and forms, such as *tiphon*, *rothliebii*, *scotica*, *lorkovici*, *isis*, *orstadii*, etc. Widespread with scattered local colonies in C and N Europe; very sporadic in the western range, most common in Fennoscandia. Evaluated as Vulnerable in Europe.

⬖ Cotton grasses (*Eriophorum*), marsh grasses (e.g. *Molinia caerulea*), beak-sedges (*Rhynchospora*) and various sedges (*Carex*).

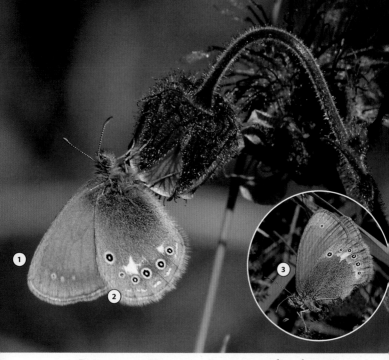

CHESTNUT HEATH · *Coenonympha glycerion*

In Somero, SW Finland, there is a beautiful river valley, a hot spot for butterflies. It is home to a colony of the attractive, coffee-coloured Chestnut Heath, but also for other species such as Clouded Apollo, Purple-edged Copper and Amanda's Blue. The area is officially protected and kept open mainly by controlled cattle grazing. If tree saplings, bracken and raspberry bushes are ever allowed to encroach completely over the meadows forming its habitat, the Chestnut Heath will be gone from this site. It is still a fairly common species across a wide swathe of Europe.

⊙ *Coenonympha pamphilus*
Coenonympha tullia

① Fw uns orange with a grey apical patch
② Hw uns greyish-brown with white patches and shining, yellow-ringed eye-spots and a narrow orange marginal line
③ ssp. *iphioides*
✴ Ups never seen at rest
✴ Sexes similar

🦋 One generation between early June and August, depending on latitude. Diverse grassy environments; meadows and other grasslands, neglected cultivations and fallow land, edges of fields, road verges and woodland clearings up to 2,100 m.

⊕ Widespread and common in C and N Europe with an eastern emphasis. In Finland the range has expanded northwards during the recent decades. At higher altitudes in the southern range ssp. *iphioides* is found in N Spain from the Pyrenees to Montes Universales; regarded as a full species by some authors.

� A wide range of grasses such as *Deschampsia*, *Brachypodium*, *Dactylis*, *Festuca*, *Bromus*, etc.

PEARLY HEATH · *Coenonympha arcania*

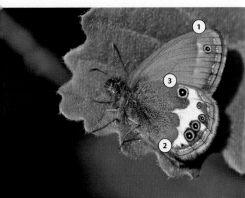

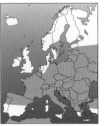

① Fw uns orange with a brown border and a small apical eye-spot

② Hw uns brown with a broad white or cream-coloured postdiscal band

③ One of the orange-ringed eye-spots situated on inner side of white stripe

★ Ups never seen at rest

★ Sexes similar

Widespread and relatively common in most of Europe from C Spain to S Scandinavia and the Baltic states. Usually single-brooded from late May to August, but a partial 2nd brood in far south in September, in light woodland clearings, dry to damp scrub and grasslands up to 2,300 m. Larva feeds on many grasses (*Poa, Holcus, Melica*, etc.).

FALSE RINGLET · *Coenonympha oedippus*

① Female uns uniform chocolate-brown with a white streak and five or six yellow-ringed eye-spots (cf. *Aphantopus hyperanthus*)

② Hw uns an ocellus displaced towards wingbase

★ Ups rarely seen at rest

★ Sexes similar

Extremely local with very isolated colonies in C Europe from the Atlantic coast, W France to Hungary and Poland. Disappeared from many of the known localities; one of Europe's most threatened butterflies, evaluated as Endangered. One brood from early June to late July in damp meadows, grassy marshes and woodland clearings associated with rivers or lakes at lowlands (<500 m). Larva feeds on meadow-grasses (*Poa*) and other grasses.

DUSKY HEATH · *Coenonympha dorus*

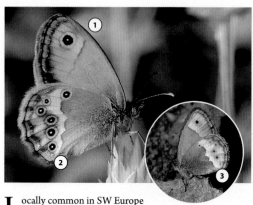

① Fw uns yellowish with a pale postdiscal stripe and a large apical eye-spot
② Hw uns yellowish-brown with an irregular white postdiscal stripe and an inwardly curving arc of eye-spots
③ f. *microphtalma*; hw uns eye-spots small
★ Ups never seen at rest
★ Sexes similar

Locally common in SW Europe from Portugal to NW Italy; some isolated colonies in the peninsular Italy (Apennines). The range extends to N Africa (ssp. *fettigii* and *austauti*). One brood from June to August in rough dry grasslands and scrub, woodland clearings, rocky slopes and gullies up to 2,200 m. Larva feeds on fescues and other fine-leaved grasses (*Festuca, Agrostis,* etc.).

SCARCE HEATH · *Coenonympha hero*

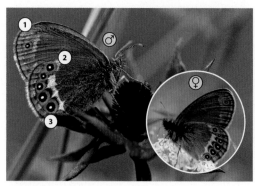

① Uns sooty brown with a small apical eye-spot on fw
② Hw uns a white postdiscal stripe dentate
③ Hw uns a broad orange band with five or six black eye-spots
★ Ups never seen at rest
★ Damp or wet, grassy meadows
★ Sexes similar

Rare and very local with small scattered colonies in rapid decline in C Europe from E France to Estonia in north and eastwards. Evaluated as Vulnerable in Europe. One brood from mid-May to early July in moors, damp grasslands and meadows, also in dry woodland clearings in the northern range, usually at lowlands below 1,000 m. Larva feeds on many grasses (*Deschampsia, Dactylis glomerata, Hordeum, Elymus, Melica, Poa,* etc.).

ALPINE HEATH · *Coenonympha gardetta*

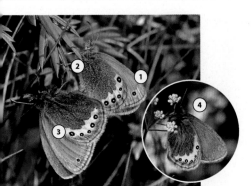

① Fw uns brick-red with a grey border and usually a small apical eye-spot

② Hw uns dusky brown or grey with a pale postdiscal band

③ Hw uns a complete series of eye-spots not ringed with yellow (cf. *C. darwiniana*)

④ High alpine grey form

✱ Ups never seen at rest

✱ Sexes similar

Endemic to Europe; a montane species confined to the Alps and high mountains in Albania, Serbia and Bosnia. One brood between June and September, depending on altitude, in alpine meadows above the tree line, sometimes also at lower altitudes (f. *macrophthalmica*; hw uns ocelli larger) on montane grasslands and slopes with sparse bushes; mostly between 1,200 and 2,400 m, but goes up to 3,000 m. Larva feeds on various grasses.

DARWIN'S HEATH · *Coenonympha gardetta f. darwiniana*

① Hw uns a white postdiscal band with a variable number of yellow-ringed eye-spots (cf. *C. gardetta*)

✱ Ups never seen at rest

✱ Sexes similar

The status of this taxon is unclear; it is most likely a natural hybrid of the Alpine Heath (*C. gardetta*) and the Pearly Heath (*C. arcania*). A rare and local butterfly with a limited range in the Alps (France, Switzerland, Italy). One brood from June to early August in alpine meadows between 800 and 2,100 m. Larva feeds on various grasses.

CORSICAN HEATH · *Coenonympha corinna*

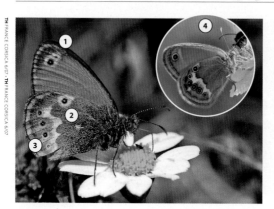

Endemic to Europe; rather common in Corsica and Sardinia, ssp. *elbana* restricted to Elba and the nearby islands and mainland (Italy). Two or three broods between mid-May and September in open grasslands, scrub, bushy and rocky slopes, light woodland clearings and margins up to 2,000 m; most often around 1,000 m. Larva feeds on grasses and sedges.

① Fw uns orange with an apical eye-spot
② Hw uns brown with an irregular white streak and whitish veins (cf. *C. pamphilus*)
③ Hw uns four or five eye-spots, three eye-spots co-linear
④ ssp. *elbana*
★ Ups never seen at rest
★ Sexes similar

RUSSIAN HEATH · BALKAN HEATH
Coenonympha leander · C. orientalis

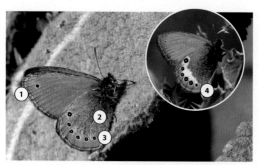

Resembles *C. glycerion*; rather common but local in SE Europe from Albania and N Greece to S Bulgaria, Carpathian Mountains in Romania and eastwards. One brood between mid-May and early August in rough and bushy fields and woodland margins between 500 and 2,000 m. Larva feeds on grasses. *Coenonympha orientalis* is sometimes regarded as a subspecies or form of *C. leander*, with a prominent creamy white postdiscal band on hw uns. Endemic to Europe, restricted to Pindos Mts. in W Greece; evaluated as Vulnerable in Europe.

① Fw uns orange with one or two apical yellow-ringed eye-spots
② Hw uns orange-brown with a grey basal area and no white streak
③ Hw uns an arc of eye-spots bordered by an orange submarginal band
④ *C. orientalis*; hw uns a distinct white band
★ Sexes similar
★ Larger than other heaths

EASTERN LARGE HEATH · *Coenonympha rhodopensis*

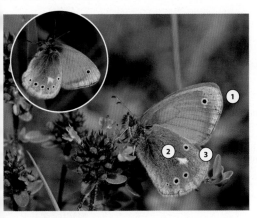

① Fw uns orange with a greyish apex and one or two eye-spots

② Hw uns greyish-brown with a pale patch near to the centre

③ The patch does not reach the costa (cf. *C. tullia*)

⊛ Ups never seen at rest

⊛ Sexes similar

⊛ Closely resembles *C. tullia*

Endemic to Europe; sporadic distribution from C Italy (Apennines) to N Balkan mountains and from Adriatic to the Black Sea. One brood in June–August mostly in alpine fields above the tree line, road verges, light shrubland and damp forest clearings between 1,000 and 2,500 m. Larva feeds on grasses.

CRETAN SMALL HEATH · *Coenonympha thyrsis*

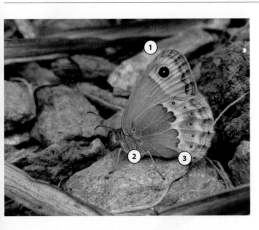

① Fw uns orange with a large apical eye-spot

② Hw uns base dark brown

③ Hw uns eye-spots small

⊛ Ups never seen at rest

⊛ Sexes similar

⊛ Resembles *C. pamphilus* (not recorded in Crete)

Endemic to Crete; common and widespread in diverse grassy habitats, light shrubland, forest roads and glades, also damp areas and mountain fields up to 1,800 m. Mostly one brood between May and early July; sometimes recorded in the late summer till October, indicating a possible 2nd brood. Larva feeds on grasses.

PO BULGARIA PIRIN 7/09 · TH N GREECE PHALAKRON 6/06

PO GREECE CRETE 5/10

NYMPHALIDAE · II

RINGLETS

ARRAN BROWN · *Erebia ligea* – DALMATIAN RINGLET · *Proterebia afra*

A total of 48 species in Europe · 38 endemics, 5 Threatened or Near Threatened

Ringlets of the genus *Erebia* are rather similar mountain or forest species which have one brood a year. The upperside varies from light brown to almost black, often with some orange markings. The dark wing coloration catches all the available heat from the sun in often extreme conditions. The hindwing underside is variably brown and grey, sometimes with orange spots. Nearly all the species have conspicuous eye-spots (ocelli), usually located near the tip of the forewing. The Central Alps constitute the evolutionary centre of the genus, and some of the rare montane species live there in very restricted areas. The Pyrenees are also home to a broad variety of species but the Balkan mountains and Turkey have far fewer endemics. *Erebia* ringlets are also found in the far north, where they inhabit peat bogs and mires, as well as forest clearings and edges.

As an aid to identification the ringlets are here grouped according to: 1) size, 2) hindwing underside colouring, 3) distribution, and finally their systematic order.

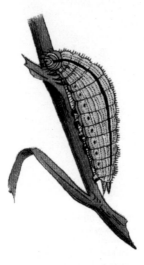

Woodland Ringlet · *Erebia medusa*

Arran Brown · *Erebia ligea*

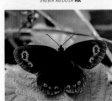

EREBIA MEDUSA **TH**

EREBIA MEDUSA **HA**

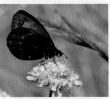

EREBIA STIRIA **PO**

EREBIA AETHIOPS **TH**

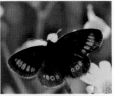

EREBIA MELAMPUS **TH**

EREBIA MELAMPUS **PO**

EREBIA GORGE **HA**

EREBIA PANDROSE **HA**

EREBIA NIVALIS **TH**

EREBIA RONDOUI **HA**

EREBIA RHODOPENSIS **HA**

EREBIA POLARIS **PO**

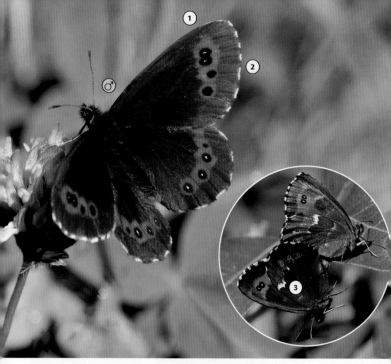

ARRAN BROWN · *Erebia ligea*

n northern Europe, the Arran Brown dominates the late summer butterfly fauna in almost all types of woodland. In August, a walk through a dry pine forest via a small gravel road may reveal hundreds of Arran Browns; sometimes dozens of individuals are densely packed on goldenrod blossoms. However, it may be almost absent the following year, as it takes two years for the larvae to develop to full size. Northern populations vary greatly, both spatially and with time. In Finland, 2009 was an excellent year for the Arran Browns.

Erebia euryale

① Ups dark chocolate-brown with broad red or orange postdiscal bands

② Fringes strongly chequered

③ Hw uns brown with a distinctive white streak and white markings

⊛ Sexes similar

⊛ Large for a ringlet, hw uns orange spots

🜊 One generation between early July and late August. Sheltered forest edges and clearings, verges of forest roads, heaths and rough grasslands near woods and birch forests in its northernmost range (ssp. *dovrensis*) occurs up to 2,500 m in the mountains.

⊕ Widely distributed in N Europe throughout most of Fennoscandia and the Baltic states. In C Europe, most common in the mountain ranges above 500 m from S France and C Italy throughout N Balkans and E Europe.

◬ A wide range of grasses (*Milium*, *Deschampsia*, *Dactylis*, *Molinia*, etc.), seldom some sedges (*Carex*).

M 5 FINLAND SALO 7/09 · TM 5 FINLAND SALO 7/08

74 · Nymphalidae II · Butterflies of Britain and Europe

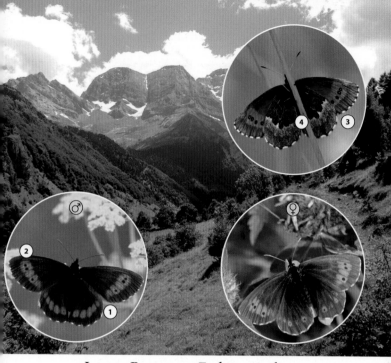

Large Ringlet · *Erebia euryale*

This is a common species of mountain forests, rarely seen at altitudes below 1,000 metres. The Large Ringlet is often seen along a shady forest trail, alternately basking on bare ground, drinking on damp soil or nectaring at wild flowers. In the taiga zone, a distinct lowland distribution of the subspecies *euryaloides* extends from Ural to easternmost Finland. The species closely resembles Arran Brown, but absence of androconial patches on the forewings is always indicative to the Large Ringlet. The species' English name is rather misleading – the Large Ringlet is really of very average size among the European *Erebia* species.

⊃ *Erebia ligea*

① Male ups dark brown or black with an orange postdiscal band on both wings
② Eye-spots relatively small
③ Fringes strongly chequered
④ Hw uns a white or yellowish postdiscal band, inner margin dentate
✺ Sexes similar

♈ One generation between late June and late August. Light woodland, pinewood clearings, grasslands near woods and grassy slopes above the tree line generally between 1,000 and 2,000 m; also light deciduous and mixed forests in the northern lowlands.

⊕ Widely distributed and locally common in the mountain ranges of S and C Europe from the Cantabrian Mts through the Alps to Balkans and N Greece. Several forms (f. *adyte*, f. *isarica*, f. *ocellaris*) indicate marked local and regional variation.

⚘ A wide range of grasses (*Sesleria*, *Poa*, *Festuca* etc.), seldom some sedges (*Carex flacca*).

HA SWITZERLAND 7/08 · TH S BULGARIA PIRIN 7/09 · PO S BULGARIA PIRIN 7/09 · PO FRANCE PRENEES 7/08

WOODLAND RINGLET · *Erebia medusa*

Widespread and locally common in SE Europe, more patchily distributed in the western and the northern ranges, also in lowlands. One brood between early May and late July, depending on altitude, in diverse grassy and humid woodland habitats, damp grasslands and moors up to 2,300 m. Larva feeds on various grasses (*Milium, Festuca, Bromus*).

① Ups dark brown with an orange postdiscal band and a variable amount of pupillate eye-spots on both wings
② Tip of antennal club buff beneath (cf. *E. oeme*)
③ Hw uns eye-spot white-pupilled
⊛ Sexes similar
⊛ Large for a ringlet, hw uns orange spots

BRIGHT-EYED RINGLET · *Erebia oeme*

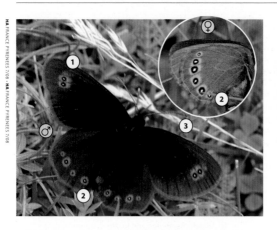

Endemic to Europe; confined to higher mountains from W Pyrenees through the Alps to N Greece. One brood between mid-June and early August in damp grassy meadows, stream beds and hillside marshes generally between 1,500 m and 2,100 m. Larva feeds on grasses (*Poa, Festuca, Molinia*), sedges (*Carex*) and rushes (*Juncus*).

① Ups sooty brown, variable amount of orange in the postdiscal area
② Eye-spots vary in number, but the white pupils are very bright
③ Tip of antennal club black beneath (cf. *E. medusa*)
⊛ Sexes similar
⊛ Closely resembles *E. medusa*
⊛ Large for a ringlet, hw uns orange spots

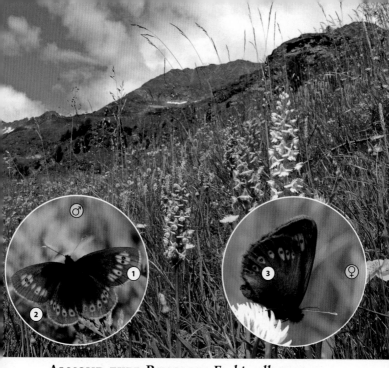

ALMOND-EYED RINGLET · *Erebia alberganus*

The Almond-eyed Ringlet is so called because the orange rings around the ocelli on both upperside and underside are elongated and oval in shape. It is an upland species, to be found in alpine meadows which are full of flowers. In the right conditions, dozens of individuals may be seen nectaring and fluttering around in the bright sunshine, but they can all disappear in an instant when clouds blot out the sun. An interesting note: a single specimen was found among the set of Mountain Ringlets, which were collected between 1880 and 1914 in the mountains east of Bridge of Orchy, Argyll in Scotland.

➲ *Erebia medusa*
 Erebia oeme

① Ups a orange postdiscal band broken into oval or almond-shaped spots
② Eye-spots small
③ Hw uns uniform brown with orange or yellowish ovals
✪ Sexes similar
✪ Large for a ringlet, hw uns orange spots

🦋 One generation between mid-June and late August depending on altitude. Sheltered meadows near woodland, south-facing mountain slopes and sub-alpine grasslands, generally between 1,000 and 2,300 m.

⊕ Endemic to Europe; a montane species restricted to Cantabrian Mts, C European Alps, Dolomites and Apennines and some mountains in the Balkans. Most common in the Alps.

🌿 Various grasses, including *Festuca ovina* and *Anthoxanthum odoratum*.

DE PRUNNER'S RINGLET · *Erebia triaria*

Another fairly large ringlet of the mountains, de Prunner's Ringlet has a third spot in a straight line with the other two on the forewing, which separates it from the very similar Piedmont's Ringlet. The two species may be seen flying in the same habitats at the same time, with Piedmont's typically the commoner of the two, so careful study is necessary to pick out the scarcer species. As well as having a different pattern and being slightly darker, the early-emerging de Prunner's Ringlet is beginning to look a little worn when Piedmont's Ringlets start to appear.

⊙ *Erebia meolans*

① Fw ups a postdiscal orange band tapers sharply towards the rear

② Three anterior eye-spots lie in a straight line (cf. *E. meolans*)

③ Hw uns with small white-pupiled eye-spots

✱ Sexes similar

✱ Closely resembles *E. meolans* but darker

✱ Large for a ringlet, uns grey/brown

🦋 One generation between late April and mid-July depending on altitude. Light woodland, forest clearings and dry montane grasslands with scattered rocks often near to the tree line up to 2,500 m.

⊕ Endemic to Europe; rather widespread but sporadic distribution confined to the mountain ranges in the Iberian Peninsula, the Alps and in the Balkans between Croatia and Albania. Most common in Spain, but colonies are very local.

⬧ A range of grasses (*Festuca ovina*, *Poa pratensis*, *Stipa pinnata*).

Marbled Ringlet · *Erebia montana*

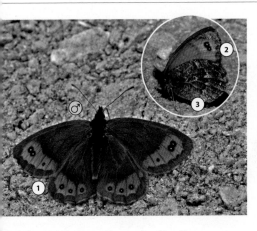

HA N ITALY 7/07 · HA N ITALY 7/07

① Ups chocolate-brown with an orange-red postdiscal band crossing both wings

② Fw uns a brown marginal border with undulating inside edge (cf. *E. styx*, *E. stiria*)

③ Hw uns a wavy white discal stripe and veins

★ Sexes similar

★ Large for a ringlet, hw uns mottled with grey/brown

Endemic to Europe; widespread and locally common in C European Alps, more local in N and mid-Apennines. One brood between mid-July and mid-September, depending on altitude, in woodland clearings, rocky slopes and alpine meadows between 1,200 and 2,500 m. Larva feeds on grasses (*Nardus stricta*, *Festuca*).

Piedmont Ringlet · *Erebia meolans*

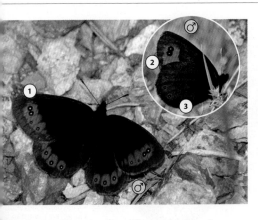

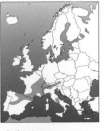

PO SPAIN PYRENEES 7/08 · TH N SPAIN 8/08

① Fw ups two apical eye-spots and sometimes one smaller, not in a straight line (cf. *E. triaria*)

② Fw uns a conspicuous red postdiscal band

③ Male hw uns very dark (lighter in female) with small spots

★ Several subspecies and forms, eg. ssp. *bejarensis* (C Spain)

★ Large for a ringlet, hw uns grey/brown

Endemic to Europe; rather widespread and locally common from the Iberian Peninsula to W Tirol in Austria, more sporadic in peninsular Italy. One brood between late May and mid-August, depending on altitude, in grassy habitats in and near woodland often between 600 and 1,500 m. Larva feeds on grasses (*Festuca*, *Agrostis*, *Nardus*, *Descampsia* etc.).

STYRIAN RINGLET · *Erebia stiria*

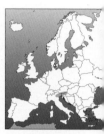

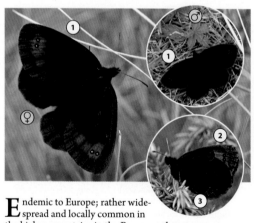

E ndemic to the Alps, distribution extending from NE Italy to Croatia. One brood between late July and early September in steep limestone slopes, screes and cliffs with sparse vegetation between 700 and 1,800 m. Larva feeds on grasses (*Sesleria*, *Poa*).

① Fw uns orange with a brown border tapering slightly towards the rear corner of the wing

② Hw uns dark brown (male) or grey (female) with two to five black, white-pupilled eye-spots

★ Large for a ringlet, hw uns grey/brown

★ Closely resembles *E. styx*

WATER RINGLET · *Erebia pronoe*

E ndemic to Europe; rather wide-spread and locally common in the higher mountains in the Pyrenees, the Alps and E Europe (Rila Mts, Tatra Mts, Carpathians). One brood between late June and late September, depending on altitude, in damp woodland clearings, grassy slopes near streams and flower-rich grasslands between 1,000 and 2,800 m. Larva feeds on grasses (*Festuca*, *Poa*).

① Ups sooty brown or black with a reduced orange postdiscal band on fw

② Fw uns brown with broad greyish margins and an orange postdiscal band with two eye-spots

③ Hw uns mottled with brown and grey, greyish bands

★ Sexes similar

★ Large for a ringlet, hw uns grey/brown

STYGIAN RINGLET · *Erebia styx*

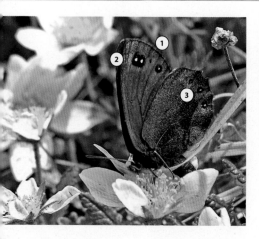

PO N ITALY MONTE BALDO 6/06

① Fw uns dark orange with a brown border (cf. *E. stiria*)

② Eye-spots vary in number, large apical eye-spots twinned

③ Hw uns grey-brown with small white-pupilled eye-spots

⍟ Sexes similar

⍟ Closely resembles *E. stiria*

⍟ Large for a ringlet, hw uns brown mottled with grey

Endemic to the Alps; distribution confined to E Alps from E Switzerland to Slovenia. One brood between early July and early September, depending on altitude, in dry and steep limestone slopes and cliffs between 600 and 2,200 m. Colonies are very local. Larva feeds on *Sesleria albicans*.

AUTUMN RINGLET · *Erebia neoridas*

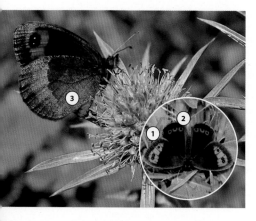

TN N SPAIN 8/08 · JMS SPAIN CATALONIA RASOS DE PEGUERA 8/07

① Fw ups sooty brown with a orange band tapering towards the rear

② Hw ups reddish spots with outer sides straight-edged (cf. *E. meolans*)

③ Hw uns brown with a greyish postdiscal band and no eye-spots

⍟ Sexes similar

⍟ A late summer species

⍟ Large for a ringlet, hw uns grey/brown

Endemic to Europe; distribution is very sporadic and restricted to the mountain ranges from E Pyrenees to mid-Apennines in Italy. Local colonies are usually numerous. One brood between early August and early October in light woodland and rough grasslands between 500 and 1,700 m. Larva feeds on grasses (*Festuca, Digitaria, Poa*).

SCOTCH ARGUS · *Erebia aethiops*

HA: ITALY DOLOMITES 7/07 · TH: SWITZERLAND 8/07 · PO: N ITALY 8/07

Most European ringlets have evolved and become adapted to the harsh environments of higher mountain ranges. The Scotch Argus is an exception, by flying among coastal dunes at sea level. It is one of only two representatives of *Erebia* in the British Isles, the Mountain Ringlet (*E. epiphron*) being the scarcer one in Scotland. Males focus on mate location in the mornings, but devote most of their time to nectaring in the afternoons. Unlike many of its relatives, the Scotch Argus is fearless and rather easy to approach. Sometimes it is attracted to a sweaty sock or cap and will settle on an observer.

⊘ *Erebia pronoe*

① Ups brown with a deep orange postdiscal band restricted in the middle
② Hw ups separate orange spots
③ Fringes weakly chequered grey
④ Hw uns four bands, discal and postdiscal bands similarly coloured
✳ Female hw uns lighter brown than in male
✳ Large for a ringlet, hw uns grey/brown

♈ One generation from late July to early September. Woodland clearings and edges, forest glades and roads, wooded heathland and river valleys, moors and grassy marshes often between 300 and 1,500 m, but sometimes up to 2,100 m.

⊕ Widespread and locally common in S and C Europe, especially in the SE range, from S France and N Italy to southern Baltic states and eastwards.

⬗ A wide range of grasses (*Molinia, Sesleria, Brachypodium, Calamgarostis*, etc.) and some sedges (*Carex*).

Sooty Ringlet · *Erebia pluto*

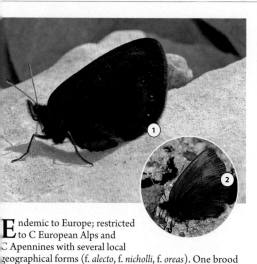

HA N ITALY MONTE BALDO 6/06 · OV SWITZERLAND ZERMATT 8/10

① Hw uns dark and unmarked or with small black, white pupillated eye-spots, f. *nicholli*
② Fw uns faint red flush
✱ Ups sooty black without ocelli
✱ Male dark brown, female lighter brown
✱ Large for a ringlet, hw uns grey/brown

E ndemic to Europe; restricted to C European Alps and C Apennines with several local geographical forms (f. *alecto*, f. *nicholli*, f. *oreas*). One brood between late June and late August, depending on altitude, on steep limestone screes and rocky moraines between 2,000 and 3,000 m. Larva feeds on *Festuca* and *Poa*.

Larche Ringlet · *Erebia scipio*

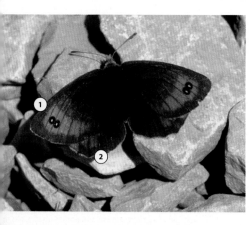

TNK FRANCE PROVENCE 8/07

① Fw ups brown with an orange postdiscal band and two apical eye-spots
② Hw ups an orange band without eye-spots
✱ Sexes similar
✱ Fw uns orange with apical eye-spots and grey borders
✱ Hw uns uniform pale grey without any markings
✱ Large for a ringlet, hw uns grey/brown

E ndemic to the Alps; recorded only in SE France and adjacent NW Italy with very local colonies in possible decline. One brood between late July and late August in steep mountain slopes, limestone screes and rocky moraines between 1,500 and 2,600 m. Larva feeds exclusively on *Helicotrichon sedenense*.

Yellow-spotted Ringlet · *Erebia manto*

The Yellow-spotted Ringlet is a prime candidate for the most common *Erebia* species of European mountain ranges. It is capable of thriving in a variety of habitats on mountain slopes both below and above the tree line, but it clearly prefers grassy to barren habitats. Local colonies are usually abundant and it is not uncommon to see many individuals at rest on the same grass stem. The Yellow-spotted Ringlet is an extremely variable butterfly in terms of its size, wing pattern and coloration, but females are easier to identify. In C Alps f. *pyrrhula* (very small, dark), In Voges Mts ssp. *voge-siaca* (male larger), In N Spain and in S and C France ssp. *constans* (dark without spots).

⊙ *Erebia eriphyle*

① Ups dark brown with orange postdiscal markings on all wings

② Fw ups an orange band, wider at the front than in the middle

③ Hw ups reddish spots regular in size (cf. *E. eriphyle*)

④ Hw uns with yellow or whitish postdiscal spots

★ Sexes similar

★ Small for a ringlet, hw uns orange spots

🦋 One generation between early July and early September. Woodland clearings and glades, damp subalpine meadows and open mountain slopes often between 1,200 and 1,900 m, sometimes up to 2,400 m

⊕ Endemic to Europe; a widespread and usually common montane species from Cantabrian Mts through the Alps to Tatra Mts and the Carpathians in E Europe. Local populations differ markedly in size, wing pattern and coloration.

◈ Some grasses, mostly *Festuca rubra*.

Eriphyle Ringlet · *Erebia eriphyle*

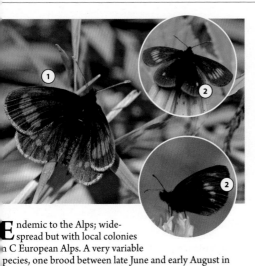

TH AUSTRIA 8/07 · HA SWITZERLAND 7/09 · OV SWITZERLAND 7/07

① Ups dark brown with variable orange markings (f. *tristis*)

② Hw ups and uns postdiscal orange spots lack black pupils, one spot larger than others

★ Sexes similar

★ Small for a ringlet, hw uns orange spots

Endemic to the Alps; widespread but with local colonies in C European Alps. A very variable species, one brood between late June and early August in lush alpine meadows, scrubby gullies and rough north-facing slopes between 1,200 and 2,200 m. Larva feeds mainly on *Deschampsia cespitosa* and *Anthoxanthum odoratum*.

Lesser Mountain Ringlet · *Erebia melampus*

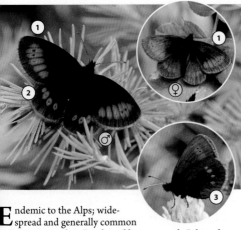

HA SWITZERLAND 7/09 · TH SWITZERLAND 7/07 · TH SWITZERLAND 8/07

① Ups dark brown with a red postdiscal band on both wings

② Hw ups usually four rounded orange spots with black dots in irregular series (cf. *E. sudetica*)

③ Hw uns orange spots with black dots

★ Sexes similar

★ Small for a ringlet, hw uns orange spots

Endemic to the Alps; widespread and generally common in C European Alps. One brood between early July and mid-September, depending on altitude, in diverse habitats from woodland clearings to alpine meadows and grassy mountain slopes mostly between 1,500 and 2,000 m. Larva feeds on grasses (*Anthoxanthum, Festuca, Poa*).

Sudeten Ringlet · *Erebia sudetica*

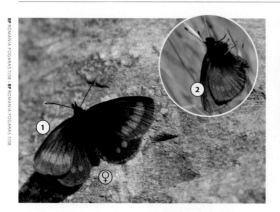

E ndemic to Europe and evaluated as Vulnerable; sporadic and local in SE France and Switzerland (ssp. *liorana*), more common in the eastern range (Tatra Mts, Carpathians). One brood from late June to early August in light woodland, forest clearings, grassy damp meadows and glacial cirques generally between 600 and 1,200 m. Larva feeds mainly on *Anthoxanthum odoratum*.

① Ups dull brown with an orange band on fw and four to five orange spots on hw
② Hw uns orange spots equal in size and in regular row (cf. *E. melampus*)
★ Sexes similar
★ Closely resembles *E. melampus*
★ Small for a ringlet, hw uns orange spots

White Speck Ringlet · *Erebia claudina*

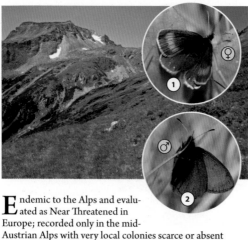

E ndemic to the Alps and evaluated as Near Threatened in Europe; recorded only in the mid-Austrian Alps with very local colonies scarce or absent in alternate years. One brood, mostly in July, in sunny edges of woods and grassy mountain slopes usually near to the tree line between 1,800 and 2,300 m. Larva feeds on grasses (*Deschampsia cespitosa*, *Nardus stricta*).

① Hw ups dark brown with white submarginal spots
② Male hw uns dark brown with small white dots
★ Female hw uns greyish
★ Small for a ringlet, hw ups and uns white spots
★ Restricted to Austrian Alp

BF ROMANIA FOGARAS 7/08 · BF ROMANIA FOGARAS 7/08

HA AUSTRIA HOHE TAUERN 7/09 · HA AUSTRIA HOHE TAUERN 7/09 · HA AUSTRIA HOHE TAUERN 7/09

BLIND RINGLET · *Erebia pharte*

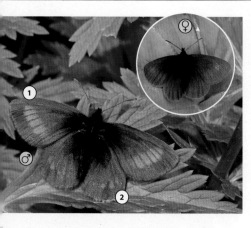

HA AUSTRIA 7/08 · **PO** N ITALY 8/07

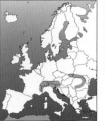

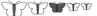

① Fw ups dark brown with a reddish postdiscal band with no ocelli or dots
② Hw ups with orange spots
★ Sexes similar
★ Small for a ringlet, hw uns orange spots

ndemic to Europe; rather widespread and locally common in C European Alps, Tatra Mts and the Carpathians. One brood from early July to late August in light woodland and montane grasslands with tall vegetation generally above 1,500 m. Larva feeds on grasses (*Festuca, Nardus*) and sedges (*Carex*).

YELLOW-BANDED RINGLET · *Erebia flavofasciata*

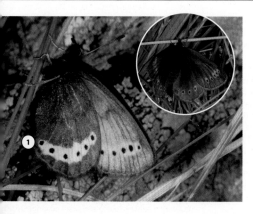

WW SWITZERLAND TICINO CAMPOLUNGO 5/07 · WW SWITZERLAND TICINO CAMPOLUNGO 5/07

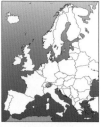

① Hw uns a unique yellow postdiscal band with a series of black ocelli
★ Sexes similar
★ Restricted to the C Alps
★ Small for a ringlet, hw uns orange spots

ndemic to the Alps and evaluated as Near Threatened in Europe; confined to SE Switzerland and neighbouring parts of Italian and Austrian Alps with very local but often abundant colonies. One brood between late June and mid-August in rocky montane grasslands and grassy mountain slopes above the tree line between 2,100 and 2,600 m. Larva feeds on *Festuca ovina*.

Silky Ringlet · *Erebia gorge*

W here glaciers and perma- nent snow dominate the landscape, the chances of seeing the Silky Ringlet are much increased. Despite the cold breeze, the butterflies tend to fly over barren and rocky soils close to the ice, but they hardly ever venture into more grassy environments nearby. Usually there are only Sooty Ringlets around to keep them company. Although Silky Ringlets constantly bask on stones with opened wings, they are very difficult to approach. After a long and arduous climb across barren mountain slopes, the observer needs luck as well as skill to obtain good views of the Silky Ringlet.

⮞ *Erebia aethiopella*

① Male ups chocolate- brown with a shiny appearance
② Male fw ups a broad brick-red band with two white-pupilled apical eye-spots
③ A short projection (bump) on hw outer margin
⊛ Female ups less brick-red
⊛ Small for a ringlet, hw uns grey/brown

� One generation between early July and late August depending on altitude. Limestone screes, rocky slopes, stone falls and moraines with very little vegetation between 2,000 and 3,000 m; range usually reaches higher altitudes than other *Erebia* species.

⊕ Endemic to Europe; widespread but very sporadic distribution in the higher mountains from the Iberian Peninsula to the Balkans, Carpathians and Tatra Mts in E Europe. Many geographical forms (f. *ramondi*, f. *erynis*, f. *triopes*, f. *albanica*) are designated, due to marked variation in wing coloration and pattern.

⬕ A variety of grasses such as *Poa, Festuca, Sesleria* etc.

FALSE MNESTRA RINGLET · *Erebia aethiopella*

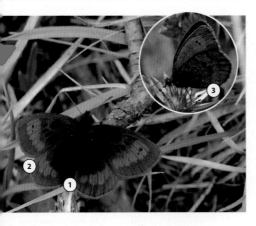

BF N ITALY 7/06 · RV N ITALY SESTRIERE

① Hw ups postdiscal band tapers toward inner margin

② No ocelli on hw postdiscal band

③ Hw uns dark brown with a pale postdiscal band, speckled white

★ Sexes similar

★ Closely resembles *E. mnestra*

★ Small for a ringlet, hw uns grey/brown

Endemic to the Alps; recorded only in SE France and adjacent NW Italy with very local but sometimes abundant colonies. One brood between mid-July and late August in steep grassy mountain slopes with larval foodplants between 1,800 and 2,400 m. Larva feeds only on *Festuca paniculata*.

MOUNTAIN RINGLET · *Erebia epiphron*

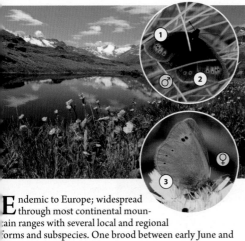

HA AUSTRIA OBERGURGL 7/08 · HA FRANCE PYRENEES 7/08 · HA FRANCE PYRENEES 7/08

① Ups orange band often broken into small blotches

② Bands contain small black dots on both wings (usually four on fw, three on hw)

③ Hw uns postdiscal spots obscure or missing

★ Several subspecies, forms and local races; photo ssp. *fauveaui*

★ Small for a ringlet, hw uns grey/brown

Endemic to Europe; widespread through most continental mountain ranges with several local and regional forms and subspecies. One brood between early June and late August, depending on altitude and locality, in pine forest clearings, heaths and moors, marshy mountain slopes and grassy tundra generally above the tree line (>1,200 m). Larva feeds on grasses (*Nardus stricta*, *Festuca*, *Danthonia*).

MNESTRA'S RINGLET · *Erebia mnestra*

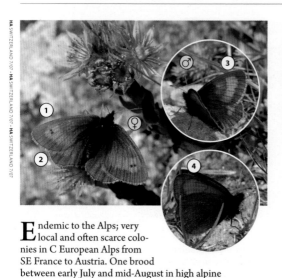

Endemic to the Alps; very local and often scarce colonies in C European Alps from SE France to Austria. One brood between early July and mid-August in high alpine meadows and steep grassy mountain slopes, often above 2,000 m. Larva feeds on grasses (*Festuca, Sesleria*).

① Female fw ups brown with a broad brick-red postdiscal band
② Hw ups a postdiscal band reduced
③ Male ups brown with a postdiscal band serrated on outer edge
④ Fw uns orange with broad dark borders
★ Sexes similar
★ Small for a ringlet, hw uns grey/brown

RÄTZER'S RINGLET · *Erebia christi*

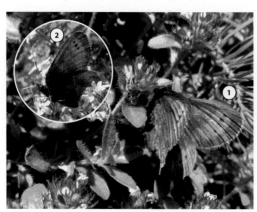

Endemic to the Alps and evaluated as Vulnerable in Europe; confined to SW Switzerland and NW Italy with six or seven very local and scarce colonies in decline, usually more abundant in alternate years. One brood in July in steep rocky mountain slopes with grasses and larch trees between 1,300 and 2,100 m. Larva feeds on *Festuca ovina*.

① Ups brown with an orang postdiscal band and smal elongated black dots
② Fw uns orange with greyish borders and three to four black dots
★ Sexes similar
★ A very limited range
★ Small for a ringlet, hw uns grey/brown

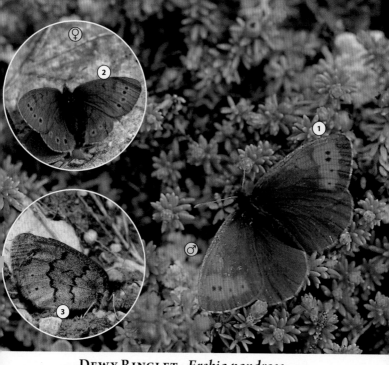

DEWY RINGLET · *Erebia pandrose*

If the July weather is especially bad, there will be few butterflies to see in Lapland. But this is one species that refuses to be put off by inclement conditions. Almost uniquely among arctic butterflies, Dewy Ringlets continue to fly in steady drizzle, in both moist and barren habitats. In sunny weather they need only a few degrees of warmth to encourage them to fly. Yet, common and prominent as the species is, it can be difficult to observe closely. Individuals have an annoying habit of bouncing up and bobbing away at the slightest disturbance, not settling again for dozens of metres, if then. This can happen time and again, much to the entomologist's frustration.

→ *Erebia sthennyo*
 Erebia polaris

① Male fw ups a broad orange/red postdiscal band with black dots

② Fw ups dark discal and cellular lines (cf. *E. sthennyo*)

③ Hw uns silvery grey with two dark wavy lines (cf. *E. sthennyo*)

⊛ Sexes similar

⊛ Closely resembles *E. sthennyo* (E Pyrenees)

⊛ Small for a ringlet, hw uns grey/brown

🦋 One generation between early June and mid-August. Rocky mountain slopes, screes and stony alpine meadows between 1,500 and 3,000 m in the southern range; heaths, moors and tundras even at sea level in N Fennoscandia.

⊕ Highly disjunct distribution in Europe. Widespread and common montane species from E Pyrenees through the Alps to Tatra Mts, Carpathians and high mountains of Balkans; common and widely distributed in N Fennoscandia.

⬧ A variety of grasses (*Festuca, Sesleria, Poa, Nardus stricta*).

PO N FINLAND KILPISJARVI 6/03 · HA AUSTRIA 7/08 · HA AUSTRIA 7/08

Swiss Brassy Ringlet · *Erebia tyndarus*

HA N ITALY 6/08 · HA N ITALY 6/07 · TH N ITALY 7/07

The *Erebia tyndarus* complex is a good example of evolution proceeding under geographical isolation. Nowadays some authorities consider it to comprise at least eight species inhabiting mountain ranges from Spain to the Altai Mountains of Asia and the Rocky Mountains of North America. These differ only slightly in coloration and wing pattern, but more markedly in their genetic make-up and ecology. All three alpine brassy ringlets still possess 10 or 11 chromosomes, but detailed studies support the speciation and even offer an estimate of the time of divergence: 440,000 years ago.

⊙ *Erebia cassioides*
 Erebia nivalis

① Male ups brown with a metallic-green sheen
② Fw ups a postdiscal band triangular and broken into several rectangular patches
③ Two small eye-spots
④ Hw uns shiny grey with darker smudges near to the outer margin
★ Small for a ringlet, hw uns grey/brown

☁ One generation between early July and late August, sometimes until October, depending on altitude and season. Woodland clearings, alpine grasslands, rocky slopes and screes near to the tree line between 1,200 and 2,700 m, but usually above 2,000 m.

⊕ Endemic to the Alps; widespread and often very common in C European Alps, mostly in S Switzerland and adjacent Italy, but also in Allgäuer Alps in Germany and Alps of Austrian Tirol.

◮ Mainly *Nardus stricta* and *Festuca ovina*.

DE LESSE'S BRASSY RINGLET · *Erebia nivalis*

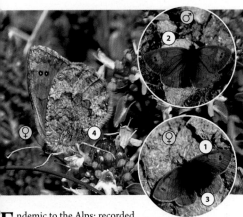

PO AUSTRIA 8/07 · TH AUSTRIA 8/07 · PO AUSTRIA 8/07

① Fw ups an orange band extending towards cell
② Male ups with bright green reflections
③ Hw ups small orange spots (cf. *E. tyndarus*)
④ Female hw uns greyish with pale veins
★ Male hw uns silvery grey with bluish sheen
★ Small for a ringlet, hw uns grey/brown

E ndemic to the Alps; recorded in W Switzerland (sporadic), NE Italy and Austria, where rather common. One brood between early July and late August in grassy patches of limestone outcrops above the tree line between 2,100 and 2,600 m, usually 300 m higher than *E. cassioides* in the overlapping range. Larva feeds on *Festuca quadriflora*.

COMMON BRASSY RINGLET · *Erebia cassioides*

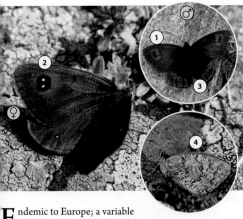

ZK SW BULGARIA RILA 8/08 · HA AUSTRIA 8/07 · PO AUSTRIA 8/07

① Fw orange patch rounded or rectangular
② Two eye-spots together (cf. *E. tyndarus, E. nivalis*)
③ Hw ups postdiscal orange markings well developed (cf. *E. tyndarus*)
④ Hw uns grey with dark wavy band
★ Small for a ringlet, hw uns grey/brown

E ndemic to Europe; a variable species with sporadic distribution from Cantabrian Mts through the Alps to C Apennines, Carpathians and higher mountains in the Balkans and NW Greece. One brood between early July and early September in montane grasslands, grassy slopes and screes between 1,600 and 2,600 m. Larva feeds on grasses (*Festuca*).

Ottoman Brassy Ringlet · *Erebia ottomana*

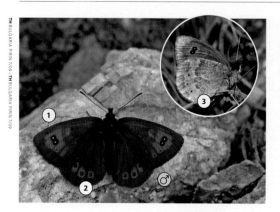

① Fw ups chocolate-brown with orange postdiscal bands and two eye-spots touching each other
② Hw ups separate orange spots and three to four eye-spots
③ Hw uns a discal band tinged brown or reddish (cf. *E. cassioides*)
⊛ Sexes similar
⊛ Small for a ringlet, hw uns grey/brown

Sporadic but locally common in the mountain ranges of the Balkan Peninsula; a few isolated populations in France and Italy. One brood mostly in July, somewhat earlier than *E. cassioides*, until late August in damp woodland clearings, bogs, montane grasslands and grassy subalpine slopes generally between 1,400 and 2,200 m. Larva feeds on grasses (*Festuca ovina*).

Lorkovic's Brassy Ringlet · *Erebia calcaria*

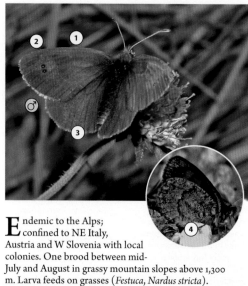

① Ups chocolate-brown
② Fw ups an orange postdiscal band poorly developed with two small eye-spots
③ No eye-spots on hw ups (cf. *E. cassioides*)
④ Hw uns silvery grey
⊛ Sexes similar
⊛ Closely resembles *E. tyndarus*
⊛ Small for a ringlet, hw uns grey/brown

Endemic to the Alps; confined to NE Italy, Austria and W Slovenia with local colonies. One brood between mid-July and August in grassy mountain slopes above 1,300 m. Larva feeds on grasses (*Festuca*, *Nardus stricta*).

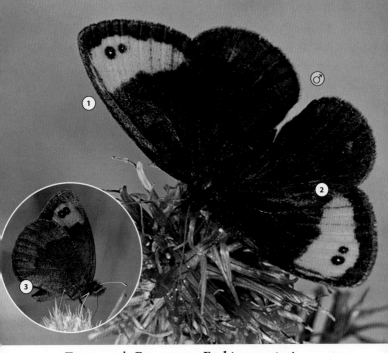

ZAPATER'S RINGLET · *Erebia zapateri*

Zapater's Ringlet is one of the rare European *Erebia* endemics, found only in Spain, Montes Universales. The *Erebia* genus has its evolutionary hub in the Alps and adjacent mountains (38 species out of 47 recorded are endemic to Europe – in other words, they are found nowhere else in the world). Many high mountains also have characteristic species assemblages. Individuals of this and other restricted-range *Erebia* species are often recorded wandering long distances, but it remains a mystery why only particular sites are acceptable for breeding. Possibly it is just 'written in their genes'.

⊘ *Erebia neoridas*

① Ups dark brown with a very bright yellow-orange postdiscal band on fw
② The band tapers strongly towards the rear
③ Hw uns dark brown with a greyish postdiscal band
★ Female ups more small eye-spots
★ A late summer species
🦋 One generation between late July and late August. Light coniferous forests, grassy pine forest clearings and scrubby grasslands mostly on calcareous soils between 1,200 and 1,700 m.
⊕ Endemic to SW Europe; confined to Montes Universales in E Spain. Rather common and widespread, but colonies are local.
🍃 A range of grasses (*Festuca, Poa*).

CHAPMAN'S RINGLET · *Erebia palarica*

RE N SPAIN ORENSE SIERRA DE TREVINCA 7/05 · **MSF** NW SPAIN SEGOVIA 8/04

C hapman's Ringlet, the
largest *Erebia* in Europe,
has an unconfirmed life-cycle
length. Most *Erebia* species
are restricted to higher moun-
tains with colder climates and
shorter summer periods, and so
larval development often takes
two seasonal cycles. As a conse-
quence, adults may fly only in
odd or even years in small popu-
lations. A recent DNA study,
however, supported the notion
of an annual cycle for Chapman's
Ringlet, leading researchers to
wonder what other adaptive
strategies this montane species
may have resorted to as a means
to coping with colder climates.

⊙ *Erebia meolans*

① Ups dark brown with a
conspicuous brick-red
postdiscal band and
large white-pupiled
eye-spots on both wings

② Hw uns dark greyish-
brown mottled with
gray scales with a
darker discal area

✱ Sexes similar

✱ Closely resembles
E. meolans bajarensis

✱ Largest ringlet in Europe

🜊 One generation between early June and late July,
depending on altitude and season. Rocky mountain
slopes and stony landscapes with tall grasses and
bushes (*Cytisus*) on acid soils between 1,000 and
1,800 m.

⊕ Endemic to SW Europe; locally common only in the
Cantabrian Mts in NW Spain.

⬦ A range of grasses (*Festuca, Poa*).

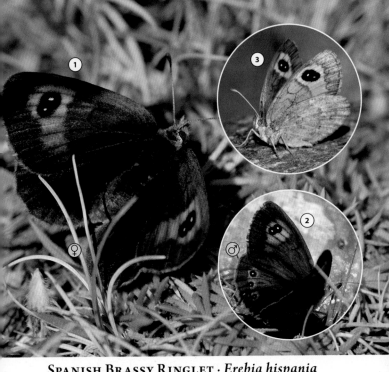

SPANISH BRASSY RINGLET · *Erebia hispania*

The Spanish Brassy Ringlet is one of three brassy ringlet species on the Iberian Peninsula. It has larger eye-spots on its forewings than the others. With almost 50 European *Erebia* species, identification can be a daunting task (though a population's locality often provides a vital clue). With their glorious metallic violet or green forewing coloration, the brassy ringlets are indisputable gems among the *Erebias*.

PYRENEES BRASSY RINGLET
Erebia rondoui

Sometimes regarded as a subspecies of *E. hispania*. It is smaller with three separate orange spots on hindwing upperside. Endemic to the Pyrenees; Spain, Andorra and adjacent France.

① Female ups brown with a triangular orange postdiscal band and two large apical eye-spots twinned in an oblique black patch, *E. hispania*

② Male ups metallic-green sheen, *E. rondoui*

③ *E. hispania*

⚥ *E. hispania* one generation between mid-June and late August, depending on altitude and locality. Montane grasslands, rocky mountain slopes and screes between 1,800 and 2,900 m.

⚥ *E. rondoui* one generation in July-August, alpine grasslands between 1,600 and 2,300 m.

⊕ *E. hispania* endemic to SW Europe; local but sometimes abundant colonies are confined to S Iberian Peninsula in Sierra Nevada.

⊕ *E. rondoui* endemic to the Pyrenees.

◗ Various grasses (*Festuca ovina*, *Poa*).

■ hispania
■ rondoui

MC S SPAIN SIERRA NEVADA 8/08 · RO S SPAIN SIERRA NEVADA 7/09 · HA SPAIN PYRENEES 7/08

Lefébvre's Ringlet · *Erebia lefebvrei*

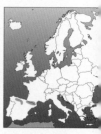

E ndemic to SW Europe; sporadic distribution with local, scarce colonies in Cantabrian Mts and the Pyrenees in the Iberian Peninsula. One brood between late June and late August in steep limestone and shale screes, moraines and open grassy slopes between 1,700 and 2,700 m. Larva feeds on grasses (*Festuca, Poa*).

① Ups jet black with a diffuse dark red postdiscal band
② Fw ups two black white-pupilled apical eye-spots close to the wing margin
③ Hw ocelli close to the margin on both sides
⊛ Male ups almost black
⊛ Restricted to the Pyrenees (f. *pyrenea*) and Cantabrian Mountains (f. *astur*)

False Dewy Ringlet · *Erebia sthennyo*

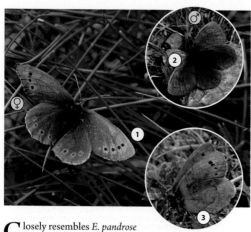

C losely resembles *E. pandrose* but their ranges may not overlap; endemic to the Pyrenees (Spain, France) with local colonies. One brood between late June and early August in steep rocky slopes and rough grasslands and pastures above 1,900 m. Larva feeds on grasses (*Poa, Festuca*).

① Female ups smoky brown with some blind eye-spots close to the outer margin (cf. *E. pandrose*)
② Fw ups no dark discal and cellular lines (cf. *E. pandrose*)
③ Hw uns pale grey, markings weak and obscure (cf. *E. pandrose*)
⊛ Sexes similar
⊛ Closely resembles *E. pandrose* (E Pyrenees)

Gavarnie Ringlet · *Erebia gorgone*

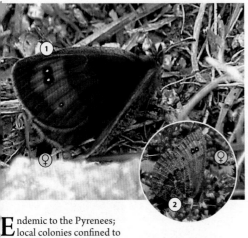

MR FRANCE PYRENEES 8/03 · TN N SPAIN 8/08

① Ups dark brown, dark red postdiscal band with small eye-spots on both wings

② Hw uns greyish-brown with pale veins

★ Sexes similar

★ Restricted to the Pyrenees

Endemic to the Pyrenees; local colonies confined to Spain, Andorra and France. One brood between mid-July and late August in steep slopes and screes with patches of grass and montane grasslands between 1,800 and 2,500 m. Larva feeds on grasses (*Poa*).

Spring Ringlet · *Erebia epistygne*

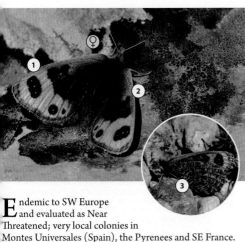

BF SPAIN 4/08 · BF SPAIN 4/08

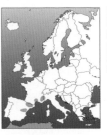

① Fw ups brown with a pale postdiscal band and numerous white-pupilled black ocelli

② Fw cell a reddish patch

③ Hw uns mottled with brown, veins pale

★ Sexes similar

★ An early spring species

Endemic to SW Europe and evaluated as Near Threatened; very local colonies in Montes Universales (Spain), the Pyrenees and SE France. One brood between late March and late May, depending on altitude and season, in light woodland, shrubby pine forest clearings and rough grasslands near woods between 500 and 1,500 m. Larva feeds on *Festuca ovina*.

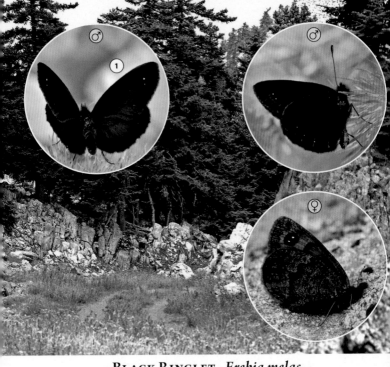

BLACK RINGLET · *Erebia melas*

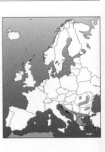

The Black Ringlet is one of three *Erebia* ringlets whose distribution is restricted to the Balkans and eastern Europe. In mid-July all three can be recorded together on the wing, for example on rocky slopes in south-western Bulgaria. The Black Ringlet is the most widespread of the trio and easy to identify when fresh: it is almost black with striking white dots on the forewings. The butterfly flies close to the ground but takes suddenly a jump high up to the slope. It often rests with wings outspread. Black Ringlet often shares its mountain habitat with a few other ringlet species plus the Dusky Grizzled Skipper and the Balkan Fritillary.

⊙ *Erebia pluto* (the ranges do not overlap)

① Ups almost black with two large white-pupilled black eye-spots
✳ Female hw uns mottled greyish-brown.
✳ Restricted to the Balkans
🦋 One generation between early July and late September, depending on altitude. Moraines, alpine fields, rocky mountain slopes and screes, often on calcareous terrain between 1,200 and 2,200 m, but a marked altitudinal range between 200 and 2,900 m.

⊕ Endemic to SE Europe; widespread but local in the mountain ranges across the Balkans from Greece to Slovenia and Romania. Many local forms (f. *leonhardi*, f. *runcensis*, f. *schawerdae*) are due to marked variation in the wing patterns.

🌿 A range of grasses, including *Festuca ovina*.

TH GREECE PARNASSOS 7/10 · TH GREECE PARNASSOS 7/10 · TH GREECE PARNASSOS 7/10 · ZR SW BULGARIA RILA 8/08

BULGARIAN RINGLET · *Erebia orientalis*

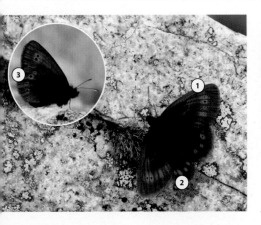

PO BULGARIA RILA 7/10 · PO BULGARIA RILA 7/10

① Fw narrow and pointed, ups with weak orange band and some black ocelli

② Hw ups one orange spot slightly larger than others

③ Hw uns orange black-pupilled spots circular

★ Sexes similar

★ Closely resembles *E. medusa* and *E. oeme*

★ Restricted to Pirin and Rila Mts.

Closely resembles *E. epiphron*; endemic to SE Europe, confined to the mountains in Bulgaria and adjacent Serbia (Stara Planina). One brood between early July and early September in montane grasslands and grassy slopes often near to woodland and the tree line between 1,900 and 2,700 m. Larva probably feeds on grasses.

NICHOLL'S RINGLET · *Erebia rhodopensis*

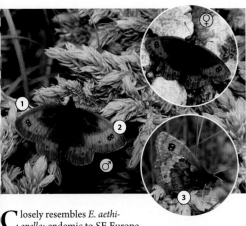

PO BULGARIA RILA 7/10 · ZK SW BULGARIA RILA 8/08 · HA BULGARIA RILA 7/10

① Ups sooty brown with a broad orange postdiscal band on both wings

② Fw ups two white-pupilled eye-spots

③ Hw uns brown with two pale basal and postdiscal bands, speckled with white

★ Sexes similar

★ Restricted to Bulgaria, Macedonia and N Greece

Closely resembles *E. aethiopella*; endemic to SE Europe, very local colonies restricted to mountains in Bulgaria and adjacent countries (Albania, Serbia, Macedonia, Greece). One brood in July–August in alpine fields, open grassy mountain slopes and ridge crests between 1,500 and 2,900 m. Larva feeds on grasses.

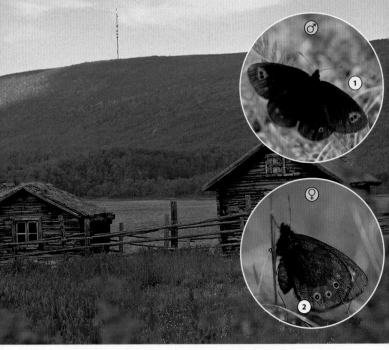

ARCTIC WOODLAND RINGLET · *Erebia polaris*

TH N FINLAND UTSJOKI 7/03 · PØ N FINLAND UTSJOKI 7/10 · TH N FINLAND UTSJOKI 7/03

O n the northern rim of Europe, by the icy Arctic Ocean, lives one of the most difficult *Erebias* to track down. This, the Arctic Woodland Ringlet, is patchily distributed from northern Fennoscandia to the Ural mountains of Russia. In Utsjoki, for just a few short weeks the dark butterflies flutter around low junipers on sandy river banks in search of nectar-giving thyme. But if a high-pressure front from Siberia brings fine weather to Lapland in July, bright midnight sun keeps Arctic Woodland Ringlets on the wing almost 24 hours a day.

⊙ *Erebia pandrose*

① Ups dark brown with an orange postdiscal band and small ocelli
② Hw uns brown with a paler postdiscal band and small eye-spots
✳ Sexes similar
✳ Restricted to Arctic Norway and Finland
♉ One generation in July. Coastal river valleys, damp grasslands, flower-rich meadows and sand dunes along streams, road verges and abandoned gravel pits between sea level and 300 m.
⊕ Sometimes regarded as a subspecies of *E. medusa*; distribution restricted to most N Europe in Arctic Norway and adjacent Finland. Local colonies are usually abundant, but numbers vary markedly between years.
⬙ A range of grasses (*Festuca ovina, Poa palustris, Milium effusum*).

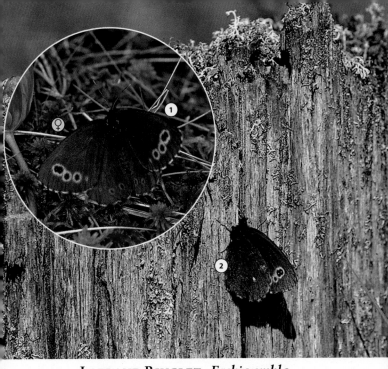

LAPLAND RINGLET · *Erebia embla*

PO N FINLAND KUUSAMO 7/91 · PO N FINLAND KUUSAMO 6/89

The Lapland Ringlet is worthy of its name. It can be found among Lapland's vast peat bogs and airy, typically pine-dominated coniferous forests. It rises up suddenly from its perch to engage in a strong but haphazard flight, usually ending up on the trunk of a pine with wings tightly closed. Unfortunately, an excavator in a bog all too often spells disaster for a local population, the Lapland Ringlet being one of the first butterflies to disappear once a mire is drained. In the southern part of its range hundreds of local populations have probably already been lost thanks to 'ditching'.

⊖ *Erebia disa*

① Ups chocolate-brown with yellow-ringed eye-spots on both wings

② Hw uns plain brown with a short zig-zag white stripe in the middle

✹ Sexes similar

✹ Moors and marshes

✹ Restricted to Finland

🦋 One generation between early June and mid-July. Pristine marshes and bogs with small pines, damp spruce forests, swampy meadows and slopes with small streams; also dry pine and birch forests in the northern range, usually at low altitudes only.

⊕ Widespread and rather common in N Fennoscandia, but has declined in the southern range due to large-scale drainage of mires. A few isolated populations in NE Latvia and S Estonia. Biennial cycle in abundance; mostly in odd years in Finland.

🍂 Probably many sedges (*Carex*) and grasses (*Deschampsia*)

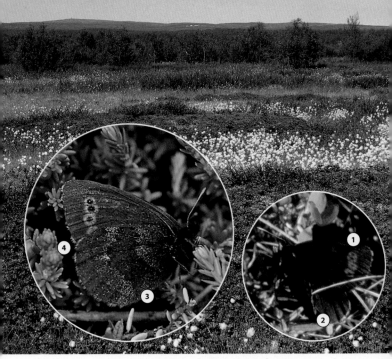

ARCTIC RINGLET · *Erebia disa*

TH N FINLAND NUORGAM 7/05 · PO N FINLAND NUORGAM 7/05 · PO N FINLAND NUORGAM 7/05

This is a mire species of most northern latitudes. An ideal site for it would consist of a wet hollow at the foot of a fell with scattered groups of willows and arctic birches. Only when the sun comes out will the first black Arctic Ringlet spring up from the shelter of some sedges. There may be dozens of individuals on the wing at once in suitable sites when the sun is shining brightly, but even a hint of cloudiness will cause them all to vanish in an instant. Although the Arctic Ringlet closely resembles the Lapland Ringlet in appearance, they are never found together on the same site.

⊙ *Erebia embla*

① Fw ups dark brown with a narrow orange band and four blind eye-spots

② Hw ups no eye-spots (cf. *E. embla*)

③ Uns greyish-brown with darker discal bands well delineated

④ Fringes chequered with brown and grey

✷ Sexes similar

✷ Moors and open damp grasslands

✷ Restricted to northern Scandinavia

♈ One generation between mid-June and mid-July. Open marshes and bogs with stunted willows and other bushes, humid coniferous forests and light birch forests along fells, damp spots in mountain tundra often above 300 m.

⊕ Widespread and locally common in N Fennoscandia (Norway, Sweden, Finland) and Kola Peninsula in Russia. Biennial cycle in abundance; mostly in even years in Finland.

⬧ Most likely sedges (*Carex*) or grasses.

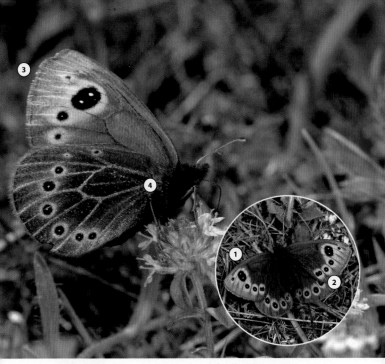

RV CROATIA KELAMI 4/07 · RV CROATIA KELAMI 4/07

Dalmatian Ringlet · *Proterebia afra*

An odd one out among the nymphalids, this species is a primitive relative of the *Erebia* ringlets. However, only its wing venation makes it technically different from the true *Erebia* species. Within its very restricted distribution in southeastern Europe, the Dalmatian Ringlet is easily identified through its very early appearance. When it was recorded, surprisingly, on the island of Pag, Croatia, in 2004, dozens of males were already on the wing during the last few days of April in stony pastures grazed by sheep. An undulating flight of black Dalmatian Ringlets just above the fresh green grass is very distinctive and the individuals can be detected from large distances.

① Ups dark brown with a pale apical area

② An irregular series of white-pupilled black ocelli on both wings

③ Fw uns chestnut-brown with a grey apical area

④ Hw uns sooty brown with pale veins

★ Sexes similar

🦋 One generation between early April and late May. Dry and rocky limestone slopes up to 1,500 m in the mountains, pastures and coastal rough grasslands often with abundant juniper shrubs and rocks.

⊕ A sporadic distribution confined to SE Europe in Dalmatian coastal districts in Croatia, N Greece and Turkey. Generally local but usually rather common in its habitat.

🌱 Exclusively *Festuca ovina*.

NYMPHALIDAE · III

MARBLED WHITES, GRAYLINGS AND MONARCHS
MARBLED WHITE · *Melanargia galathea* – DANAID EGGFLY · *Hypolimnas misippus*

A total of 58 species in Europe · 29 endemics, 12 Threatened or Near Threatened

Grayling
Hipparchia semele

Marbled whites are all superficially similar black and white butterflies, which fly slowly from one flower to another. They inhabit dry grasslands all over Europe except for the Baltic countries and Fennoscandia in the north. Graylings are not so ready to fly, preferring to dash rapidly from one stone or tree trunk to another. Their undersides are well camouflaged, as they spend a lot of time resting on the ground or amongst vegetation. They occur from sea level to mountain tops but often prefer sparse woodland where it is easy to hide. The wings are closed immediately upon landing but one or two underside apical eye-spots tend to be displayed for a few seconds. Then they conceal the eyes by pulling the forewings down between the hindwings. The larvae are green or brown with a fork-like tail. They feed exclusively on grasses or sometimes sedges. Europe has only two species of monarchs (Danaidae), although there are eight altogether in the Palaearctic region. Both of ours are well-known migrants. The brightly coloured caterpillars feed mainly on ornamental non-native plants. The larvae, pupae and adults are all toxic to birds.

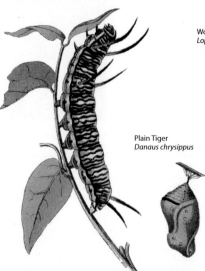

Woodland Brown
Lopinga achine

Plain Tiger
Danaus chrysippus

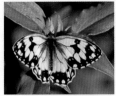
MELANARGIA LACHESIS **HA**

MELANARGIA LACHESIS **TH**

SATYRUS FERULA **HA**

SATYRUS ACTAEA **HA**

MINOIS DRYAS **HA**

BRINTESIA CIRCE **PO**

PSEUDOCHAZARA GEYERI **TH**

PSEUDOCHAZARA ORESTES **TH**

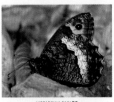
HIPPARCHIA FAGI **PO**

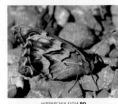
HIPPARCHIA FIDIA **PO**

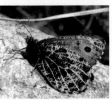
OENEIS GLACIALIS **HA**

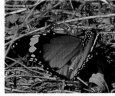
DANAUS CHRYSIPPUS **TH**

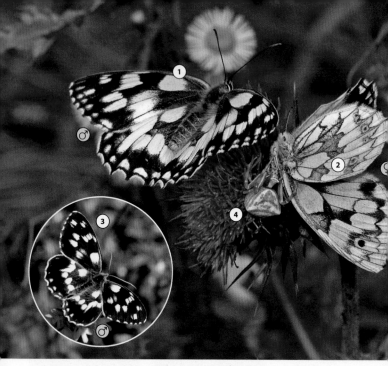

MARBLED WHITE · *Melanargia galathea*

HA N ITALY 7/07 · TM N GREECE METSOVO 6/06

A single meadow full of flowers and tall grasses offers all that the Marbled White needs – ample nectar for adults to feed on in company with dozens or even hundreds of conspecifics, shelter against the rain and cold, sunny spots for finding a mate, and an endless variety of grasses for the caterpillars to consume. This attractive butterfly has a lazy, rather clumsy flight and spends long spells nectaring, permitting easy observation. Often, close examination will reveal the presence of bright crimson blood-sucking mites on its head or thorax. On a few occasions, strong wind currents have taken it to S Fennoscandia and Estonia.

⊙ *Melanargia russiae*
Melanargia lachesis

① Fw ups no black stripe at the white cell area (cf. *M. occitanica*, *M. russiae*)
② Hw uns with irregular grey bands disrupted at the cell-end (cf. *M. russiae*)
③ f. *procida*
④ Flower crab spider *Misumena*
✱ Male uns white, female yellowish

One generation from June to early August. Diverse grassy and flowery habitats, meadows and steppe, poor agricultural land, rough hillsides and grassy clearings of woods up to 2,000 m.

⊕ Widespread and common in S and C Europe; absent from most of Iberian Peninsula, many Mediterranean islands, N British Isles and the whole of Fennoscandia. Many colour forms described; f. *procida* (more dark suffusion) common in Greece, f. *magdalena* (sometimes almost black) in NE Italy, f. *leucomelas* (hw uns almost white without markings).

Various grasses such as *Phleum pratense*, *Agropyron*, *Festuca*, *Bromus*, *Holcus*, *Brachypodium*, etc.

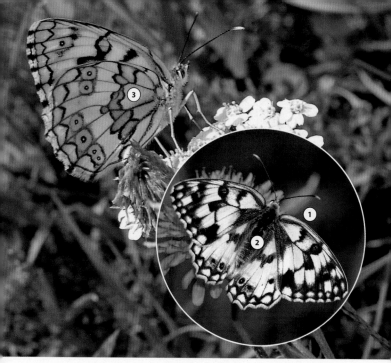

ESPER'S MARBLED WHITE · *Melanargia russiae*

The nominate of this species is aptly named, for it is to be found only in southern Russia. Previously the species also occurred in Hungary but it is now considered to be extinct there. The ssp. *cleanthe* occurs in the Iberian Peninsula and the French Alps, while in Italy (including N Sicily), Albania, Macedonia and N Greece there is ssp. *japygia* with more extensive dark markings on the upperside. This is, however, a variable characteristic, being more distinctive in the Italian specimens. Esper's Marbled White has scattered upland colonies and is declining, but *cleanthe* is quite easy to find in the E Pyrenees.

⟩ *Melanargia galathea*
Melanargia larissa

① Ups chalky white with an irregular black stripe in the middle of the cell (cf. *M. galathea*)

② Hw ups a large white patch bordered black at the base

③ Hw uns with irregular band not disrupted at cell-end (cf. *M. galathea*)

✱ Sexes similar

🦋 One generation mostly between late June and mid-August, sometimes recorded until September. Dry grassy meadows and steppe, light coniferous woodland, bushy forest clearings and rocky limestone slopes usually between 700 and 2,300 m.

⊕ Distribution scattered in separate areas; most widespread in N Iberian Peninsula, more sporadic and local in SE France, C and S Italy, N Sicily and S Balkans. The nominate subspecies has a wide Asian range from Ukraine and the Caucasus eastwards.

◈ A variety of grasses (*Stipa*, *Brachypodium*, *Elytrigia*, *Agropyron*, *Dactylis*, *Bromus*, etc.).

HA SPAIN 7/08 · HA SPAIN 7/08

WESTERN MARBLED WHITE · *Melanargia occitanica*

The Western Marbled White flies among sparse vegetation including small evergreen *Cistus* shrubs in dry areas, such as the hillsides overlooking Monaco. It appears early in the year, reaching its peak in mid-May. It is a restless flier, but pauses often to feed on flowers like scabious or thistles. While feeding, it flaps its wings or closes them to reveal the intricate brown outlining of the veins on the hindwing underside. There is some debate concerning whether the marbled white *M. pherusa* found on Sicily is in fact a full species, or whether it should be regarded only as a subspecies of *M. occitanica*. All the Italian populations appear to be declining.

⊙ *Melanargia pherusa*
 Melanargia ines

① Ups chalky white with black markings mainly on outer parts of the wings

② Fw ups an irregular black bar linking with the adjacent black spots on cell

③ Hw ups four or five blue-pupilled eye-spots and black-bordered, white triangles

④ Hw uns large brown eye-spots with pale blue centres, veins outlined brown

✪ Sexes similar

� One generation between late April and late June. Dry, hot, rocky hills with sparse vegetation up to 1,500 m; mostly in uplands.

⊕ Confined to SW Europe; rather widespread but local from the Iberian Peninsula to S France and NW Italy (Maritime Alps). Subspecies *pelagia* occurs in Morocco and W Algeria.

⬧ Many grasses such as *Dactylis glomerata*, *Lygeum*, *Cynodon*, *Brachypodium*, etc.

IBERIAN MARBLED WHITE · *Melanargia lachesis*

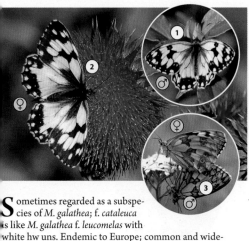

S ometimes regarded as a subspecies of *M. galathea*; f. *cataleuca* is like *M. galathea* f. *leucomelas* with white hw uns. Endemic to Europe; common and widespread but confined to the Iberian Peninsula and S France. One brood from June to early August in dry flowery shrubs, hedgerows and wooded edges up to 2,000 m. Larva feeds on various grasses (*Festuca*, *Bromus*, etc.).

① Ups white with black markings, but not any in the basal and discal areas (cf. *M. galathea*)

② Fw ups no black stripe at the cell (cf. *M. russiae*, *M. occitanica*)

③ Hw uns black discal band disrupted at cell-end (cf. *M. russiae*)

⊛ Sexes similar

⊛ Closely resembles *M. galathea*

SPANISH MARBLED WHITE · *Melanargia ines*

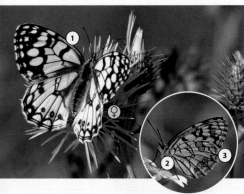

C onfined to SW Europe; widespread and rather common in S and C Iberian Peninsula south of Cantabrian Mts and the Pyrenees. Also in Morocco, Algeria and Tunisia. One brood in April–June in dry, bushy and rocky grasslands and slopes up to 1,500 m, in Morocco (High Atlas) even 2,700 m; mostly between 900 and 1,200 m, often in the same habitats with *M. occitanica*. Larva feeds on grasses (*Brachypodium*, *Bromus*).

① Fw ups chalky white with a strong black bar at the cell (cf. *M. russiae*)

② Hw uns dark lines and veins black and weak (cf. *M. occitanica*)

③ Hw uns five large eye-spots with blue pupils

⊛ Sexes similar

ITALIAN MARBLED WHITE · *Melanargia arge*

MR ITALY PICOSONE 5/03 · MR ITALY PICOSONE 5/03

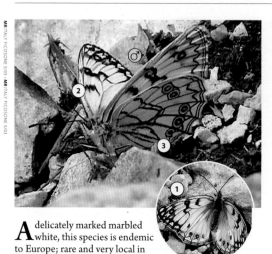

A delicately marked marbled white, this species is endemic to Europe; rare and very local in S Italy and NE Sicily. One brood from May to June in dry, rough and stony grasslands and slopes on calcareous terrain between 300 and 1,500 m. Larva feeds on grasses (*Stipa*, *Brachypodium*).

① Ups postdiscal black markings reduced on both wings
② Fw ups a black cell-stripe, not reaching median vein (cf. *M. pherusa*)
③ Hw uns five brown eye-spots with blue pupils, veins black
★ Sexes similar
★ Closely resembles *M. pherusa*

SICILIAN MARBLED WHITE · *Melanargia pherusa*

TM ITALY SICILY 5/10 · TM ITALY SICILY 5/10

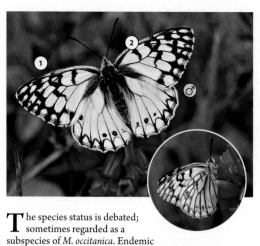

T he species status is debated; sometimes regarded as a subspecies of *M. occitanica*. Endemic to Europe; rare and very local in NW Sicily in the mountains S of Palermo. One brood in May–June in dry, rough and stony grasslands between 600 and 1,000 m. Larva feeds on grasses (*Brachypodium*).

① Ups black markings reduced
② Fw ups a black cell-stripe linked to the median vein (cf. *M. arge*)
★ Sexes similar
★ Closely resembles *M. arge*

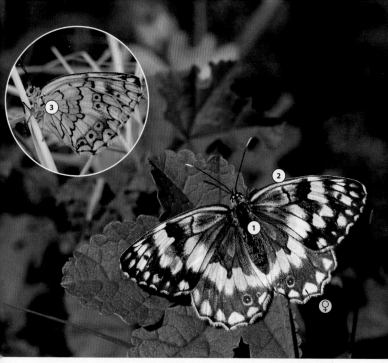

BALKAN MARBLED WHITE · *Melanargia larissa*

This butterfly often outnumbers all other species at a suitable site. It is an impressive insect, but can be mistaken for several other species. The size is variable, with rather small individuals giving the impression of large hairstreaks, and the robust females recalling the glorious apollos. The alternating wing pattern of brown and black with white and the zigzag markings look different in direct sunshine compared to shade, or from different distances. The dark suffusion on the wings may be reduced (f. *herta*, S Dalmatia) or quite extensive (f. *lesbina*, Lesbos, Limnos, and Greece), and other forms cover all the possibilities in between.

⮑ *Melanargia russiae*
 Melanargia galathea

① Ups basal areas suffused dark grey on both wings
② Fw ups a narrow black stripe positioned away from the wing base
③ Hw uns irregular dark discal markings do not disrupt at cell-end (cf. *M. galathea*)
⊛ Sexes similar

🦋 One generation between early May and mid-August, depending on altitude. Dry and rocky grasslands and slopes, open scrub, bushy clearings in sparse woodland and rocky rough hillsides up to 2,200 m, usually on calcareous soils.

⊕ Rather widespread but local in SE Europe, extending from Greece, E Aegean islands Corfu, Lesbos, Lefkas, Limnos, Siros and European Turkey to coastal zone of Croatia and Montenegro in north.

🌱 Meadow-grasses (*Poa*), probably other grasses as well.

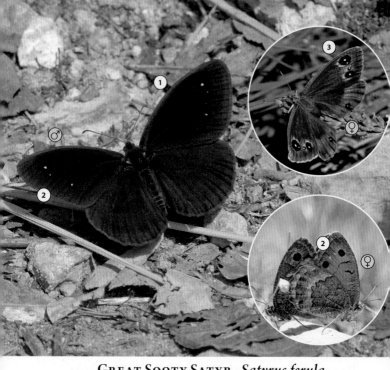

HA N ITALY 6/08 · PO FRANCE PROVENCE 7/07 · TH SWITZERLAND 7/07

GREAT SOOTY SATYR · *Satyrus ferula*

Large butterfly and often abundant at good sites. It shows remarkable degree of sexual dimorphism. Males are very dark, almost black, and clearly inspired the species' common name. However, females have a more typical combination of greys and browns with a dash of orange on the forewing, and show a chain of prominent eye-spots on the upperside. Several subspecies are described across the species' extensive range, which stretches right across Europe and Asia as far as China. Unlike many other graylings, the Great Sooty Satyr can often be observed basking in the sun with wings open.

⊘ *Satyrus actaea*
 Minois dryas

① Male ups sooty brown or black with metallic sheen and two white-pupilled ocelli
② Fw ups and uns small white spots between ocelli (cf. *S. dryas*)
③ Female fw ups brown with an orange postdiscal patch around eye-spots

🦋 One generation from early June to late August. Dry, warm and grassy clearings in woods, bushy and rocky edges of oak forests, rough hillsides and rocky mountain slopes mostly between 500 and 1,800 m; steppe-clad slopes up to 2,500 m in the eastern range.

⊕ Widespread and locally common in S Europe from C Pyrenees to S Balkans in the east; more sporadic with widely dispersed colonies in the western range and peninsular Italy (Apennines, Calabria). Also in W Morocco (ssp. *atlantea*).

◊ Fescues (e.g. *Festuca ovina*) and other grasses (*Stipa*, *Brachypodium*, *Deschampsia*, etc.).

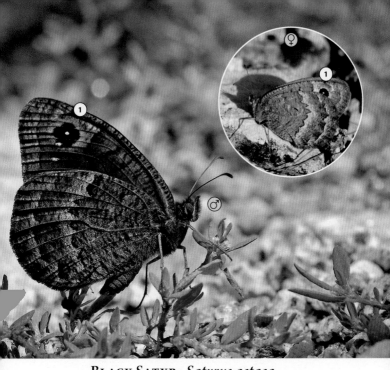

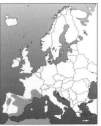

BLACK SATYR · *Satyrus actaea*

The Black Satyr butterfly is found in rocky woodland at lower altitudes as well as on high mountains. It shows great variation in all of its wing markings and possesses a white-pupilled eye-spot on the outer edge of the forewing – perhaps to startle predators when it is suddenly revealed, or to trick them into attacking the wrong 'head'. This butterfly genus takes its name from the satyrs of Greek mythology, which had the upper bodies of men but the hind legs of goats. Indeed, the Black Satyr and its relatives will often share a meadow with a grazing herd of goats.

⊃ *Satyrus ferula, Minois dryas*

① Ups and uns dark brown or black (male) or lighter brown (female) with one apical eye-spot on fw (cf. *S. ferula*)

⍟ Ups rarely seen at rest

⍟ Closely resembles *S. ferula* but smaller

⍦ One generation between early June and late August, depending on altitude. Rocky scrub, grassy hillsides and stony mountain slopes up to 2,000 m; usually in uplands above 1,000 m.

⊕ Endemic to Europe; rather widespread and locally common in SW Europe in most of W Iberian Peninsula and SE France, extending to most NW Italy in the east.

⍟ Bromes (*Bromus*) and other grasses.

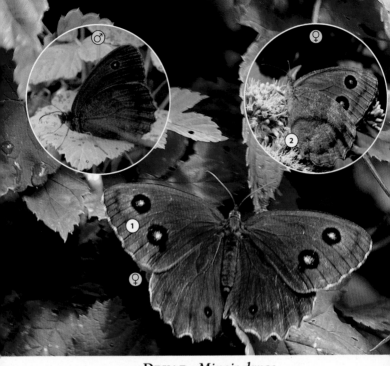

DRYAD · *Minois dryas*

This subtly attractive butterfly, with its two large, blue-centred eye-spots on each forewing, is shy and furtive. It will not tolerate close approach, and despite its size remains relatively inconspicuous by flying close to the grass and often going to rest in very sheltered spots to avoid detection. Males defend a small territory, and both sexes are rather sedentary. Early-morning or late-afternoon visits are best to observe the Dryad at its most active, as it tends to hide in sheltered spots in the middle of the day. It is found right across Eurasia, including Japan, though has declined across parts of its range as modern farming methods can render habitat unsuitable for its needs.

⊙ *Satyrus ferula, Satyrus actaea*

① Fw ups two distinctive, blue-pupilled eye-spots, no white dots in between

② Female very large; variable markings on hw uns

✱ Male ups sometimes with metallic sheen

♀ One generation between June and September.
Rough and bushy margins of deciduous woodland, grassy clearings and rides in forests and wooded slopes up to 1,600 m; also on damp grasslands and fens in the northern range.

⊕ Widespread and locally common in S and C Europe, extending from the Pyrenees to S Germany, S Poland and eastwards through C Balkans. Largely absent from the southernmost Mediterranean regions, NW coastal districts and the British Isles.

◊ A wide range of grasses such as *Molinia*, *Calamagrostis*, *Arrhenatherum*, *Avena*, *Brachypodium*, *Bromus*, etc.

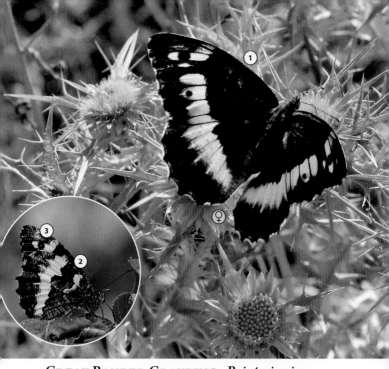

GREAT BANDED GRAYLING · *Brintesia circe*

This large, strongly patterned butterfly is distinctive and attractive, and occurs everywhere in southern Europe. On the wing it resembles the Woodland, Rock or Eastern Rock Grayling but it is bigger and glides far more gracefully than the smaller graylings, which all give a more hasty impression in flight. It dominates the habitat, stopping wherever it likes, on tree trunks, rocks, stone fences, bare ground or trails. The butterfly has a versatile appetite, ranging between nectar from flowers like thistles or the spiny field Eryngo and cattle dung on the road, from which it imperiously displaces the far smaller blues.

➔ *Chazara briseis*
 Chazara prieuri

① Ups sooty brown or black with a broad white postdiscal band on both wings

② Hw uns blackish-brown with one short and one broad white band

③ Fw uns eye-spot rounded with white, not yellow (cf. *Hipparchia fagi*)

✱ Sexes similar

♈ One generation from early June to late September, depending on altitude and locality. Diverse grassy environments; sparse deciduous woodland, oak forests, dry forest edges and road verges, cultivated ground, steppes, rough hillsides and grassy mountain slopes up to 2,000 m.

⊕ Widespread, common and abundant in S and C Europe, including the largest Mediterranean islands (Corsica, Sardinia, Sicily, Thassos, Lesbos), up to S Poland in north and eastwards all the way to the Himalayas.

◗ Many grasses such as *Festuca*, *Bromus*, *Anthoxanthum*, *Sesleria*, etc.

TH ITALY SARDINIA 8/09 · PG SLOVENI 7/06

HERMIT · *Chazara briseis*

① Male hw uns grey with a white band and bold brown markings
② Fw uns greyish-brown with a black bar in the middle of cell
③ Ups sooty brown with a broad cream-coloured postdiscal band, rarely seen at rest
⊛ Female larger with faint markings on hw uns

Widespread and locally abundant in most of S and C Europe from W Iberian Peninsula eastwards; subspecies *larnacana* is endemic to Cyprus. Evaluated as Near Threatened in Europe; widely declined in France. One brood between late May and October, depending on altitude and locality, in dry stony grasslands, steppe and bushy woodland margins up to 2,500 m. Larva feeds on grasses (*Festuca, Sesleria, Bromus*).

SOUTHERN HERMIT · *Chazara prieuri*

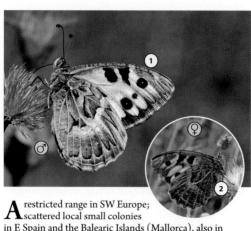

① Male fw uns largely white with black eye-spots and a black square in cell
② Female hw uns mottled brown with pale veins and black chevrons

A restricted range in SW Europe; scattered local small colonies in E Spain and the Balearic Islands (Mallorca), also in Morocco. In Spain, about half of the females are f. *uhagonis*, upperside white markings replaced by fulvous ones. One brood in July–August in rocky scrub, steppe-like grasslands and stony mountain slopes between 600 and 1,500 m. Larva feeds on grasses (*Lygeum, Poa, Festuca*).

Nevada Grayling · *Pseudochazara hippolyte*

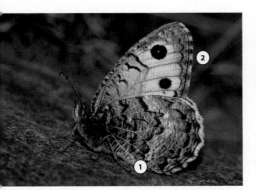

① Hw uns uniform
brown with a paler
postdiscal band and
three black cross-lines

② Fringes chequered
brown and white

★ Ups never seen at rest

★ Sexes similar

★ Only at Sierra Nevada,
H. semele may fly at
the same time

Confined to SW Europe in S Iberian Peninsula;
very local and rare in mountain ranges in Sierra
Nevada area, SE Spain. Sometimes regarded as a distinct
European species (*P. williamsi*) rather than a subspe-
cies of *P. hippolyte*, which has a wide Asian range. One
brood from late June to late July in dry, grassy and
stony high mountain slopes and screes between 1,400
and 2,700 m. Larva feeds on grasses (*Festuca ovina*).

Grey Asian Grayling · *Pseudochazara geyeri*

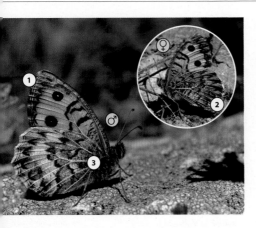

① Male fw uns a light
postmedian band
and two eyespots,
fringes chequered

② Hw uns greyish-
brown with large
dark arrow-shaped
submarginal chevrons

③ Hw uns white veins

★ Ups rarely seen at rest

★ Sexes similar

A very limited range in S Balkans; very local and rare in
E Albania, SW Republic of Macedonia and NW Greece,
more common in E Anatolia, Turkey. One brood in July–
August in dry, stony and grassy slopes in alpine fields,
usually on calcareous terrain above the tree line between
1,250 and 1,750 m. Larva feeds on grasses (*Festuca, Poa*).

MACEDONIAN GRAYLING · *Pseudochazara cingovskii*

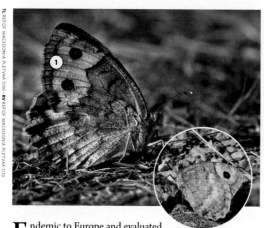

① Fw ups and uns two small white dots between the large postdiscal eye-spots (only one faintly visible in picture)
⊛ Ups never seen at rest
⊛ Sexes similar
⊛ Known only from Pletvar massif

Endemic to Europe and evaluated as Critically Endangered; very local and rare in Pletvar Mountains, S Republic of Macedonia and maybe in Albania. One brood from July to August in calcareous rocky environments with sparse vegetation between 1,000 and 1,200 m. Larva feeds on grasses.

DILS' GRAYLING · *Pseudochazara orestes*

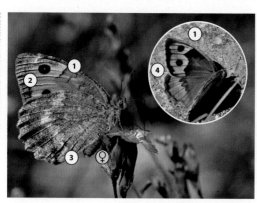

① Fw ups and uns large bright orange bands
② Fw ups and uns two small white dots between the large postdiscal eye-spots (only faintly visible in picture)
③ Hw uns grey with a conspicuous white postdiscal band
④ Fringes chequered
⊛ Ups rarely seen at rest
⊛ Sexes similar

Endemic to Europe and evaluated as Vulnerable; very local and rare in the mountain ranges in NE Greece (e.g. Phalakron Massif) and SW Bulgaria. One brood between late June and mid-August in dry calcareous grasslands, limestone cliffs, steep rocky slopes and stony clearings near to the tree line mostly between 500 and 1,700 m. Larva feeds on grasses (*Agrostis*).

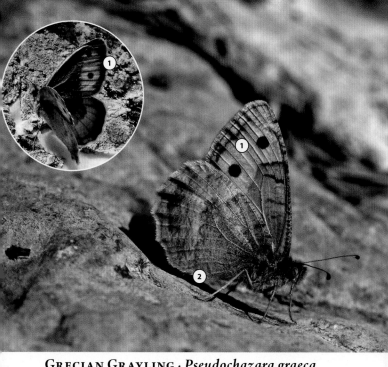

GRECIAN GRAYLING · *Pseudochazara graeca*

The Grecian Grayling can be observed at places such as Mt. Taygetos, Peloponnese. The species tends to make short flights in between resting on the whitish rocks and slopes, the rather plain grey colouration on its underside matching this background perfectly. At rest the wings are kept tightly closed but when the butterfly is alarmed and ready to fly, it opens them for a second, revealing the brighter orange coloration on the uppersides. Subtle variation in this species' underside colour and pattern may reflect habitat differences across its range.

⊋ *Pseudochazara orestes*
 Pseudochazara mnszechii

① Fw ups and uns no white dots between the two eye-spots (cf. *P. mniszechii*)

② Hw uns pale grey with brownish shading in postdiscal area; no white band (cf. *P. orestes*)

✷ Ups rarely seen at rest

✷ Sexes similar

♈ One generation from late June to late August. Calcareous grassy mountain fields and slopes associated with scrub and light coniferous woodland near to the tree line between 1,000 and 2,200 m.

⊕ Endemic to Europe; confined to SE Europe in the mountain ranges of SW Macedonia and mainland Greece.

⊕ Probably various grasses.

Brown's Grayling · *Pseudochazara amymone*

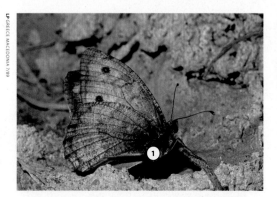

① Hw uns dark grey at the base

⭐ Ups never seen at rest

⭐ Closely resembles *P. orestes*, but hw uns white band weaker

⭐ Sexes similar

⭐ Restricted to NW Greece, very rare

Previously considered as a natural hybrid and a subspecies of *P. mamurra*; the nominate subspecies in Asia extends to NE Turkey in the west. Endemic to NW Greece; one of the rarest of all European graylings, extremely local and evaluated as Vulnerable. One brood from late June to late July in rough and grassy fields of medium altitude with light scrubland and clearings near to the tree line between 600 and 1,400 m. Larva feeds on grasses.

Dark Grayling · *Pseudochazara mniszechii*

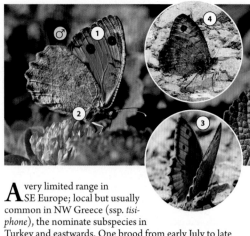

① Fw uns two small white dots between the eyes-pots (cf. *P. graeca*)

② Hw uns greyish-brown with no markings (cf. *P. orestes*)

③ Ups a deep orange postdiscal band

④ ssp. *tisiphone;* very local in NW Greece and Albania

⭐ Ups rarely seen at rest

⭐ Sexes similar

A very limited range in SE Europe; local but usually common in NW Greece (ssp. *tisiphone*), the nominate subspecies in Turkey and eastwards. One brood from early July to late August in mountain slopes and clearings near to the tree line, light scrub and sparse woods mostly between 700 and 1,700 m. Habitat usually has robust, purple-flowered thistles, used as nectar sources. Larva feeds on grasses (*Festuca*).

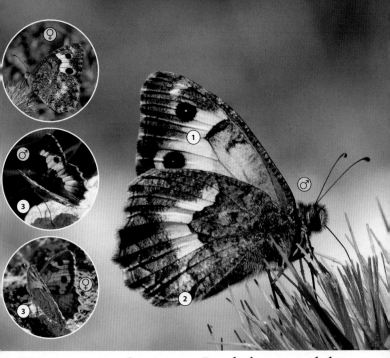

WHITE-BANDED GRAYLING · *Pseudochazara anthelea*

This striking butterfly can be seen from late spring through the whole summer in Balkan peninsula and Turkey. The nominate form, *anthelea anthelea* occurs in the Eastern Aegean islands and eastwards, while subspecies *amalthea*, which has more white markings, is found in the Balkan Peninsula. The females of the two are quite different, *anthelea anthelea* upperside orange is replaced by white in *a. amalthea*. They frequently rest on rocks with wings closed, using their long legs to help angle their bodies relative to the sun in the best position to absorb or avoid heat, as required. Females are considerably larger and less contrastingly coloured than males.

⊖ *Chazara briseis*

① Fw uns wide white areas with two large eye-spots, ssp. *amalthea*
② Hw uns grey-brown with a white postdiscal band
③ ssp. *anthelea*
✶ Ups rarely seen at rest
🦋 One generation with a long flight period between late May and late September. Light scrub, bushy clearings in coniferous woods, stony hillsides and dry and rocky mountain slopes usually on calcareous terrain; mostly between 500 and 2,000 m, sometimes near to sea level.

⊕ Confined to SE Europe; subspecies *amalthea* is widespread and locally common in the Balkan Peninsula, Crete and Turkey; ssp. *acamanthis* is restricted to the mountain ranges of Cyprus (>1,000 m). In Europe, the nominate form *anthelea* is found only in E Aegean islands (Chios, Kalimnos, Kos, Lesbos, Rhodes and Samos).

🌢 Probably various grasses.

PO S GREECE 6/09 · TH S TURKEY ISPARTA 6/10 · TH S TURKEY CIMI 6/10 · TH S TURKEY ISPARTA 6/10

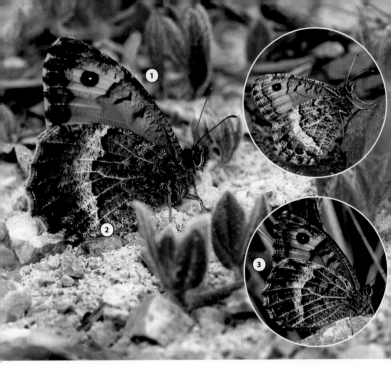

FALSE GRAYLING · *Arethusana arethusa*

TH N SPAIN 8/08 · TH GREECE PARNASSOS 7/10 · DJ SPAIN SIERRA NEVADA 7/98

The False Grayling looks like the Grayling (*Hipparchia semele*) and its relatives, with similar silvery undersides to its hindwings, but it is classified in a different genus. Like *H. semele* it is found of dry places, but it is a much more frequent visitor to flowers, and may occasionally briefly open its wings while nectaring. A male False Grayling was caught in 1974 on heathland in Surrey, in the UK, well beyond its natural range. This may have been a genuine immigrant, or the result of accidental introduction in an immature stage.

⊙ *Pseudochazara graeca*
Pseudochazara orestes

① Fw uns widely orange with brown borders and one pupilled ocellus (cf. *Hipparchia semele*)

② Hw uns mottled brown with a pale discal band and white-lined veins

③ ssp. *boabdil*

★ Sexes similar

★ Smaller than similar graylings

🦋 One generation between late July and September, depending on altitude and locality. Dry scrubby grasslands and heaths, steppes, edges of sparse woodland and rocky gullies mostly between 500 and 2,000 m; usually on calcareous terrain.

⊕ Widespread but sporadic distribution in S and C Europe from S Iberia to Turkey, also in Morocco. Occurrence varies from rather common in west to very sporadic and rare in parts of C Europe and NW Balkans. A very variable species; ssp. *dentata* in Catalonia, Spain, the French Pyrenees and Provence; ssp. *boabdil* (white veins distinctive on hw uns) in S Spain.

🌱 Fescues (*Festuca*) and other grasses.

Woodland Grayling · *Hipparchia fagi*

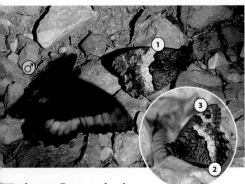

① Hw uns dark brown at basal half, bounded with wavy black line
② Hw uns a number of faint eye-spots
③ Fw uns eye-spot rounded with yellow, not white (cf. *Brintesia circe*)
⊛ Sexes similar
⊛ Closely resembles *H. alcyone*, *H. genava* and *H. syriaca*; identification based on the genitalia only

Endemic to Europe and evaluated as Near Threatened; rather widespread but local in S Europe (Sicily, Lefkas) sporadic in C Europe up to S Poland and commonest in SE parts extending Turkey and eastwards. One brood from June to September in warm light woodland and scrubby clearings, woodland rides up to 1,800 m; usually at low altitudes (<1,000 m). Larva feeds on grasses (*Brachypodium, Holcus, Bromus, Festuca*, etc.).

Rock Grayling · *Hipparchia alcyone*

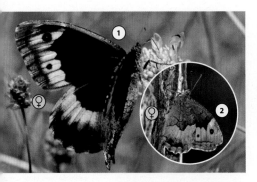

① Ups dark brown with a pale postdiscal band and two eye-spots
② Uns dark chocolate-brown with a broad white or yellowish outer part
⊛ Ups rarely seen at rest
⊛ Sexes similar
⊛ Closely resembles *H. fagi*, *H. genava* and *H. syriaca*; identification based on the genitalia only

Rare and local in S and C Europe eastwards to Belarus and Ukraine; several local forms, including ssp. *pyrenaea* in Hautes-Pyrenees and ssp. *vandalusica* in Sierra Nevada. In Norway an isolated northern relict, ssp. *norvegica*, smaller and darker. Evaluated as Near Threatened in Europe. One brood from late June to mid-August in light woodland, forest clearings and margins, rock masses and rocky mountain slopes mostly between 500 and 1,600 m. Larva feeds on grasses (*Brachypodium, Festuca, Holcus*).

Swiss Grayling · *Hipparchia genava*

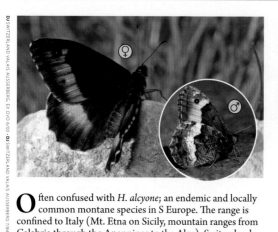

O ften confused with *H. alcyone*; an endemic and locally common montane species in S Europe. The range is confined to Italy (Mt. Etna on Sicily, mountain ranges from Calabria through the Apennines to the Alps), Switzerland (Wallis, Jura) and France (the Alps, Central Massif, Jura and NE parts). One brood in June-August in hot dry places in light woodland and dry bushy grasslands between 200 and 1,300 m; individuals frequently rest on hot rocks. Larva feeds on grasses (*Brachypodium, Festuca*, etc.).

(★) Closely resembles *H. alcyone*; the number of Jullien rods in male genitalia is generally smaller (8-12)

(★) Sexes similar

Eastern Rock Grayling · *Hipparchia syriaca*

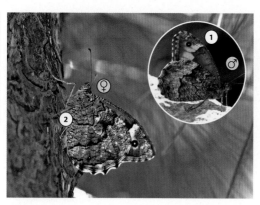

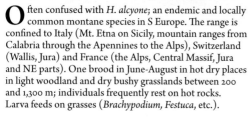

W idespread and rather common in the Balkans, S Greece (incl. many islands), Cyprus (ssp. *cypriaca* on higher altitudes) and eastwards to Caucasus. One brood from May to September, sometimes aestivating in mid-summer, in sparse coniferous woodland and oak forests, forest clearings and margins, open scrub, rough grass-lands and hillsides up to 2,000 m. Larva feeds on grasses.

(1) Fw uns a broad irregular whitish or yellowish postmedian band

(2) Hw uns mottled with grey and brown with fine striations

(★) Ups never seen at rest

(★) Sexes similar

(★) Closely resembles *H. fagi*, *H. alcyone* and *H. genava*

Tree Grayling · *Hipparchia statilinus*

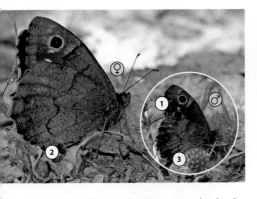

PO SPAIN MONTES UNIVERSALES 7/08 · TH N SPAIN 8/08

① Fw uns brown with two yellow-ringed ocelli and small white spots in between (cf. *H. fagi*, *H. alcyone*, *H. syriaca*)
② Hw pale grey with one dark wavy line through the centre (cf. *H. fatua*)
③ Hw uns submarginal area often darkened (cf. *H. fatua*)
★ Ups rarely seen at rest
★ Sexes similar

Evaluated as Near Threatened in Europe; very local and rare in the northern range extending to S Lithuania, extinct in Germany. Still widespread and common in S Europe. One brood with a long flight period between June and October, mostly in July–August, in dry rocky scrub, light woodland, heaths and steppe, wooded fields and mountain grasslands up to 2,000 m. Larva feeds on many grasses (*Bromus*, *Stipa*, etc.); adults never visit flowers.

Striped Grayling · *Hipparchia fidia*

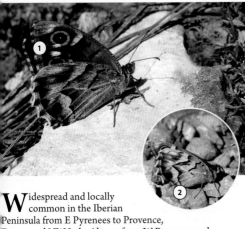

TH SPAIN CATALONIA 8/08 · PO FRANCE PROVENCE 7/07

① Fw uns and ups two distinctive white dots between eye-spots
② Hw uns grey and brown with bold zig-zag stripes
★ Ups rarely seen at rest
★ Sexes similar

Widespread and locally common in the Iberian Peninsula from E Pyrenees to Provence, France and NW Italy. Absent from W Pyrenees and N Spain. One brood from June to August (and till October in NW Africa) in rocky woodland areas often with pine trees and scrub, usually between 1,000 and 1,400 m. Larva feeds on grasses (*Cynodon*, *Brachypodium*, *Poa*, *Dactylis*, etc.).

Freyer's Grayling · *Hipparchia fatua*

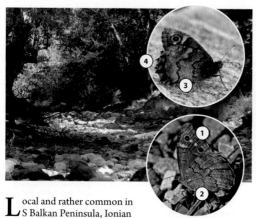

L ocal and rather common in S Balkan Peninsula, Ionian Island of Lefkas, most E Aegean Islands and eastwards. One brood from late May to early October in sparse coastal woods, dense thickets, orchards and olive groves, dry river-beds shaded by trees and bushes and sparsely wooded rocky slopes up to 1,800 m; usually at lowlands (<500 m). Larva feeds on grasses.

① Fw ups and uns two white dots between eye-spots (cf. *H. statilinus*, *H. fagi*, *H. syriaca*)
② Hw uns greyish-brown, mottled with grey and black, no spots (cf. *H. statilinus*)
③ Hw uns two black discal and postdiscal lines clearly defined (cf. *H. statilinus*)
④ Hw outer margin scalloped
★ Ups never seen at rest
★ Sexes similar

Grayling · *Hipparchia semele*

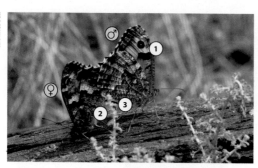

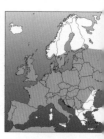

E ndemic to Europe; widespread and common in most of Europe. Southern distribution uncertain due to confusion with similar species. A variable species with many subspecies and forms; In Gotland and Öland, Sweden f. *tristis*, smaller and paler. One brood between June and September in dry coastal heaths, diverse bushy meadows and grasslands, coastal cliffs and sandy dunes and dry rocky mountain slopes up to 2,000 m. Larva feeds on many grasses (*Agrostis*, *Deschampsia*, *Leymus*, *Ammophila*, *Festuca*, *Lolium*, etc.).

① Fw uns largely orange with two eye-spots and borders mottled brown
② Hw uns mottled with grey and brown
③ Hw uns dark zig-zag line separates a darker basal area from the lighter outer part
★ Ups never seen at rest
★ Sexes similar

BALKAN GRAYLING · *Hipparchia senthes*

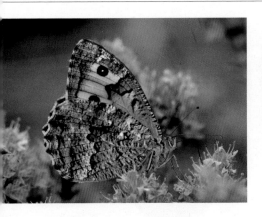

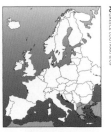

- (★) Closely resembles *H. aristaeus* and *H. semele*
- (★) Ups yellowish areas reduced and suffused greyish-brown
- (★) Sexes similar

S ometimes regarded as a subspecies of *H. aristaeus*; widespread and rather common in S Balkan Peninsula, European Turkey and many Grecian islands (not in Crete, Karpathos or Rhodes). One brood with a long flight period between early May and October in dry and rocky grassland, scrub and small woodland clearings up to 2,000 m. Larva feeds on grasses.

DELATTIN'S GRAYLING · *Hipparchia volgensis*

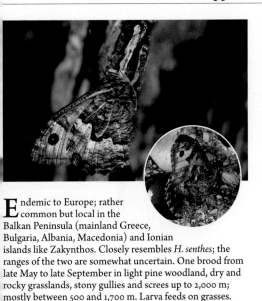

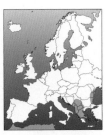

- (★) Externally inseparable from *H. senthes* but male genitalia distinct
- (★) Sexes similar
- (★) Mostly in woodland, often on tree trunks
- (★) A taxon with controversial status; the relationship between *H. volgensis delattini* and *H. semele* needs further studies

E ndemic to Europe; rather common but local in the Balkan Peninsula (mainland Greece, Bulgaria, Albania, Macedonia) and Ionian islands like Zakynthos. Closely resembles *H. senthes*; the ranges of the two are somewhat uncertain. One brood from late May to late September in light pine woodland, dry and rocky grasslands, stony gullies and screes up to 2,000 m; mostly between 500 and 1,700 m. Larva feeds on grasses.

AZOREAN GRAYLING · *Hipparchia azorina*

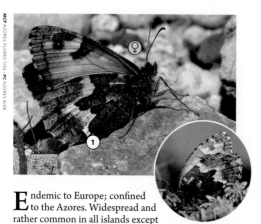

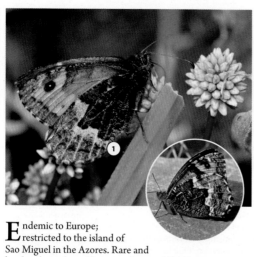

① Hw uns dark with a strong white discal band

★ Ups orange markings weak

★ Sexes similar

★ Only grayling in the Azores except the island of Sao Miguel

Endemic to Europe; confined to the Azores. Widespread and rather common in all islands except Sao Miguel (see *H. miguelensis*), including several local subspecies or forms: *barbarensis* (Terceira), *caldeirense* (Flores), *jorgense* (Sao Jorge), *ohsimai* (Faial), *picoensis* (Pico). One brood between June and October in sheltered grassy slopes and small valleys above 500 m, up to 2,000 m in Pico. Larva feeds on grasses (*Festuca jubata*).

MIGUEL'S GRAYLING (LE CERF'S GRAYLING)
Hipparchia miguelensis

① Hw uns dark with a strong white discal band

★ Sexes similar

★ Closely resembles *H. azorina*

★ Restricted to the island of Sao Miguel

Endemic to Europe; restricted to the island of Sao Miguel in the Azores. Rare and local with one brood between June and October in various uncultivated habitats in the mountains between 500 and 1,000 m. Larva feeds on *Festuca jubata* only.

Madeira Grayling · *Hipparchia maderensis*

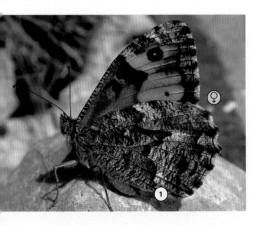

MCP MADEIRA BICO DA CANNA 6.08

① A white discal band on hw uns, more prominent on male

★ Ups mottled with dark brown suffusion, especially in male

★ Sexes similar

★ Smaller than *H. aristaeus*

★ Restricted to Madeira

Sometimes regarded as a subspecies of *H. aristaeus*; endemic to Europe, recorded only in Madeira where it is rare and local in the mountain ranges. One brood from July to September in sparse deciduous, bushy and rocky southern hillsides and mountain slopes between 600 and 1,800 m. Larva feeds on grasses (*Aira, Agrostis, Holcus*).

Canary Grayling · *Hipparachia wyssii*

UA CANARY ISLANDS TENERIFE 9/07

① Fw uns two orange-bordered black eye-spots with white dots in between (not visible in picture)

② Black zigzag line bordered on outside with white on both wings

★ Ups greyish-brown with fringes chequered

★ Sexes similar

★ No other graylings on the island of Tenerife

A group of endemic species restricted to the Canary Islands. The Canary Grayling *H. wyssii* is widespread and locally common in Tenerife; rocky slopes and gullies in sparse pine forests and grassy cliffs in central mountains between 800 and 2,000 m. The following are sometimes regarded as subspecies of *wyssii*: *H. tamadabae* (Cran Canaria, Pinar de Tamadaba), *H. tilosi* (La Palma, Los Tilos; evaluated as Vulnerable), *H. gomera* (La Gomera) and *H. bacchus* (El Hierro; evaluated as Vulnerable). All appear in one brood between June and September; *H. tamadabae* somewhat earlier. Larva feeds on grasses.

MCP CANARY ISLANDS LA PALMA 6/03 • MCP CANARY ISLANDS GRAN CANARIA 6/03 • MCP CANARY ISLANDS EL HIERRO 8/04 • MCP CANARY ISLANDS LA GOMERA 7/02

Hipparchia tilosi (La Palma)

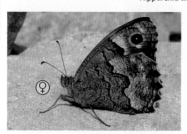

Hipparchia tamadabae (Gran Canaria)

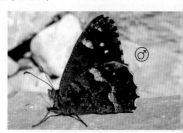

Hipparchia bacchus (El Hierro)

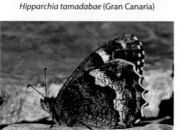

Hipparchia gomera (La Gomera)

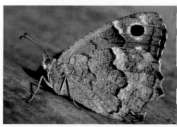

Hipparchia gomera (La Gomera)

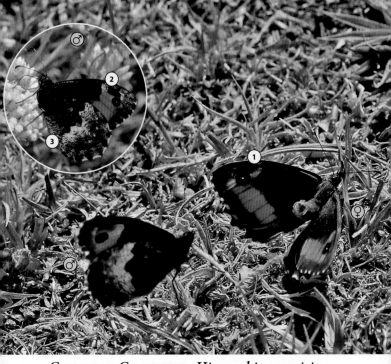

CORSICAN GRAYLING · *Hipparchia neomiris*

In mid-June in Elba, the earliest Corsican Graylings will begin to fly. By early August, the mountain fields of Gennargentu in Sardinia are dry and most of the flowers have gone, but everywhere the large, yellow and spiky *Carlina* thistles attract Corsican Graylings. This grayling is rather colourful and distinctive with strongly contrasting patterns compared to the other *Hipparchia* species, though on the islands where it occurs, the only other *Hipparchia* is the Southern Grayling.

⊘ *Hipparchia aristaeus*

① Ups dark brown with a broad orange postdiscal band on both wings
② Fw uns very dark at base; an orange outer region with one eye-spot
③ Hw uns dark brown with a white and wavy postdiscal band on the inner edge (cf. *H. aristaeus*)

★ Ups rarely seen at rest
★ Sexes similar

🦋 One generation from mid-June to August. Dry and rocky hillsides and mountain slopes with scrub, associated with coniferous forests or above the tree line between 300 and 2,000 m.

⊕ Endemic to Europe; restricted to Corsica, Sardinia, Elba and Capraia.

◊ Grasses, including *Festuca morisiana*.

TH ITALY SARDINIA 8/09 · TH ITALY ELBA 6/09

SOUTHERN GRAYLING · *Hipparchia aristaeus*

The *semele–aristaeus* groups of *Hipparchia* graylings are a source of constant confusion. The Southern Grayling (*H. aristaeus*) lives in Corsica and Sardinia, while the Grayling (*H. semele*) is found almost all over Europe except for the Balkan Peninsula, and Corsica and Sardinia. Both species have numerous relatives, more or less indistinguishable from each other. The male genitalia are used as an aid to identification. Males of the *semele* group (*H. cretica*, *H. christenseni*, *H. leighebi*, *H. mersina*, *H. pellucida*, *H. sbordonii* and *H. volgensis*) have large genitalia. Those of the *aristaeus* group (*H. aristaeus*, ssp. *blachieri*, *H. neapolitana* and *H. senthes*) have smaller ones. Location helps to identify them.

⊙ *Hipparchia semele*

① Fw uns orange with brown borders and one (male) or two (female) eye-spots

② Hw uns mottled brown and grey with an irregular dark median line protruding out in the middle

③ A diffuse white central band

④ ssp. *blachieri*

⭐ Ups rarely seen at rest

⭐ Fw ups orange markings bright and well developed

⭐ Sexes similar

🦋 One generation from June to August. Dry and rocky mountain heaths with sparse scrub between 500 and 1,800 m; ssp. *blachieri* in Sicily on somewhat higher altitudes.

⊕ Endemic to Europe; restricted to a few Mediterranean islands (Corsica, Sardinia and the adjacent Italian islands Capraia, Elba, Giglio). Ssp. *blachieri* occurs in Sicily.

🌾 Probably various grasses.

Italian Grayling · *Hipparchia neapolitana*

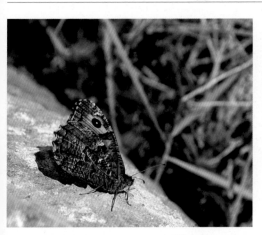

- (*) Closely resembles
 H. aristaeus and *H. semele*
- (*) Ups rarely seen at rest
- (*) Sexes similar
- (*) Restricted to S Italy

Sometimes regarded as a subspecies of *H. aristaeus*; endemic to Europe, with a very limited distribution in Campania region, S Italy. One brood from June to August in dry and stony grasslands between 800 and 1,100 m in the mountain ranges. Larva feeds on grasses.

Ponza Grayling · *Hipparchia sbordonii*

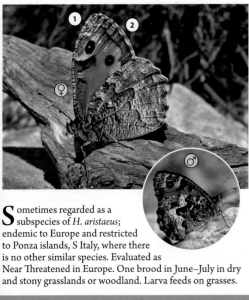

- ① Fw less pointed than in all other similar species
- ② Female fw outer margin curved outwards (convex)
- (*) Closely resembles
 H. aristaeus and *H. semele*
- (*) Sexes similar
- (*) Restricted to the Ponza islands, only grayling on the islands

Sometimes regarded as a subspecies of *H. aristaeus*; endemic to Europe and restricted to Ponza islands, S Italy, where there is no other similar species. Evaluated as Near Threatened in Europe. One brood in June–July in dry and stony grasslands or woodland. Larva feeds on grasses.

Eolian Grayling · *Hipparchia leighebi*

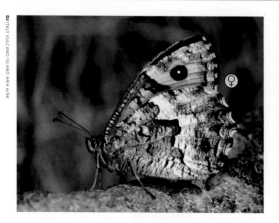

DJ ITALY VULCANO ISLAND ARIA 6/94

★ Closely resembles
H. aristaeus and *H. semele*

★ Male androconial
scales long

★ Ups rarely seen at rest

★ Restricted to the
Eolian Islands, only
grayling on the island

Sometimes regarded as a subspecies of *H. semele*; endemic to Europe with a very limited range confined to Eolian Islands (e.g. Vulcano, Lipari), S Italy. Evaluated as Near Threatened in Europe. One brood from mid-May to early August in dry, stony, bushy grassland or woodland with sparse pines below 500 m. Larva feeds on grasses.

Samos Grayling · *Hipparchia mersina*

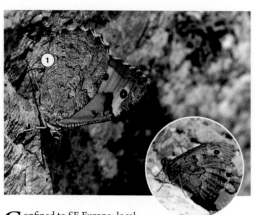

TH.S TURKEY TERMESSOS 6/10 · PQ GREECE SAMOS 5/09

① Hw uns uniform dark
grey-brown with
weak or missing white
markings (cf. *H. senthes*)

★ Ups rarely seen at rest

★ Sexes similar

Confined to SE Europe; local and rare in Lesbos and Samos of E Aegean Islands, but common in SW Turkey. One brood with a long flight period between early June and October in dry and stony grasslands with sparse bushes and trees and open coniferous woods up to 1,100 m in Samos. Larva feeds on grasses.

KARPATHOS GRAYLING · *Hipparchia christenseni*

TNK GREECE KARPATHOS 6/09 · TNK GREECE KARPATHOS 6/09

- ✪ Closely resembles *H. aristaeus* and *H. semele*
- ✪ Ups rarely seen at rest
- ✪ Sexes similar
- ✪ Restricted to Karpathos, only grayling on the island

A very limited range in SE Europe; endemic, rare and very local, only on the island of Karpathos, Greece. One brood in June–July in rocky slopes covered with open scrub, small forest clearings and forest roads and shrubby grasslands between 250 and 750 m. Larva feeds on grasses.

CRETAN GRAYLING · *Hipparchia cretica*

PO GREECE CRETE 5/10

- ✪ Closely resembles *H. aristaeus* and *H. semele*
- ✪ Ups rarely seen at rest
- ✪ Sexes similar
- ✪ Restricted to Crete, only grayling on the island

Endemic to Europe with a limited range confined to Crete, Greece; widespread and common. One brood with a long flight period between early May and October in dry and scrubby grasslands and mountain slopes, olive groves and light woodland up to 1,500 m. Larva feeds on grasses.

EASTERN GRAYLING · *Hipparchia pellucida*

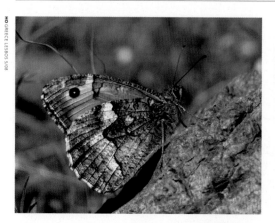

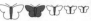

- ★ Closely resembles *H. aristaeus* and *H. semele* but hw uns darker grey
- ★ Ups never seen at rest
- ★ Sexes similar
- ★ In Europe restricted to the islands of Lesbos and Ikaria

Confined to SE Europe; local but rather common on E Aegean Islands of Lesbos and Ikaria, Greece, extending to Turkey and eastwards. One brood mostly in June and again in late summer (September–October) in dry, grassy and rocky slopes and screes with bushes and scattered pine trees up to 850 m. Larva feeds on grasses.

CYPRUS GRAYLING · *Hipparchia cypriensis*

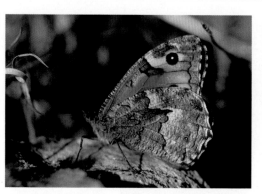

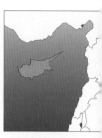

- ★ Closely resembles *H. aristaeus* and *H. semele*
- ★ Ups rarely seen at rest
- ★ Sexes similar
- ★ Restricted to Cyprus

Sometimes regarded as a subspecies of *H. pellucida*; endemic and very common in Cyprus. Only *H. syriaca* ssp. *cypriaca* could be confused with it on the island. Cyprus Graylings congregate in large numbers in the mountains during the summer months and return to the coastal regions in autumn. One brood from April to October in diverse habitats from sea level to higher mountains. Larva feeds on grasses.

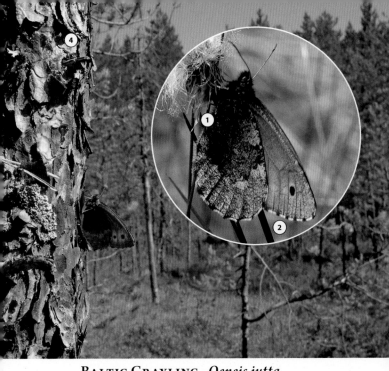

BALTIC GRAYLING · *Oeneis jutta*

T his species is larger than the related *Oeneis* species and flies erratically but at high speed, perhaps stopping abruptly to rest on a grey, lichen-covered tree trunk in a pine bog. It weaves through the small pines, its jerky movements making it very difficult to track in flight, and finds a perfect place to hide in the shade. In the species' southern range the butterfly only flies in 'even years' but up in Lapland, north of the Arctic Circle, it may also appear in 'odd years'. The slow growth of the caterpillars may be an adaptive mechanism to the threat of some parasites with a one-year life cycle.

⟳ *Oeneis norna*
 Oeneis bore

① Hw uns mottled with grey and brown with a darker discal band and some very small eye-spots
② Fringes chequered
✱ Ups rarely seen at rest
✱ Sexes similar
✱ Often rests on pine trunks

🜊 One generation between early June and late July, depending on latitude. Peat bogs and fens, marshes with scattered pine trees, swampy pinewoods and shores of small lakes, usually at lowlands.

⊕ Widespread in N Europe in most of Fennoscandia, more sporadic in the Baltic states and NE Poland, extending to Russia eastwards. Locally common but abundance varies greatly between the years; most abundant in the even years. Declined in the southern range due to large-scale drainage of peatlands.

🌿 Mostly sedges such as *Carex nigra*, *C. canescens* and *C. ovalis*; also cotton grasses (*Eriophorum vaginatum*).

PO S FINLAND TAIPALSAARI 6/10 · HA E FINLAND UUKUNIEMI 6/06

ALPINE GRAYLING · *Oeneis glacialis*

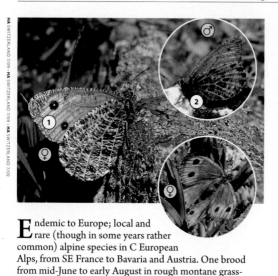

① Fw uns yellowish-brown usually with two black eye-spots, smaller in male

② Hw uns mottled brown with white-lined veins

★ Ups rarely seen at rest

★ Sexes similar

Endemic to Europe; local and rare (though in some years rather common) alpine species in C European Alps, from SE France to Bavaria and Austria. One brood from mid-June to early August in rough montane grasslands and rocky slopes near the tree line between 1,400 and 2,900 m. Larva feeds on sheep's fescue (*Festuca ovina*).

NORSE GRAYLING · *Oeneis norna*

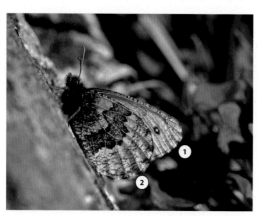

① Fw uns yellowish or greyish-brown with a variable amount of small eye-spots (cf. *O. bore*)

② Hw uns mottled brown or sandy with some small eye-spots, not always present

★ Ups never seen at rest

★ Sexes similar

Rather widespread in most of N Europe; local and rather common in N Fennoscandia, Kola Peninsula and eastwards to Siberia and N Japan. Evaluated as Near Threatened. One brood from mid-June to mid-July in birch scrub and woods, moors, boggy and rocky slopes with low shrubs up to 900 m. Larva feeds on sedges (*Carex*) and various grasses.

ARCTIC GRAYLING · *Oeneis bore*

In northernmost Lapland, at the summits of fells like Ailigas (Utsjoki, Finland), a handful of alert Arctic Graylings may be seen at the right time of year. The species' alternative habitat is sandy riverbanks along the coast of the Arctic Ocean. The wings quickly lose their scales, making a week-old butterfly look as translucent as frosted glass. Females are often flying at a slightly lower altitude than the males. It helps to remember that the Arctic Grayling, in contrast to the similar Norse Grayling, does not have ocelli on both sides of the wings. When sitting on the ground both butterflies turn obliquely to catch as much sunshine as possible on their closed wings.

⊘ *Oeneis norna, Oeneis glacialis*

① Uns dull brown, often translucent, no eye-spots (cf. *O. norna*)

(★) Ups never seen at rest

(★) Sexes similar

♈ One generation from mid-June to late July, depending on the season. Stony fell slopes above the tree line, barren rocky slopes and arctic tundra up to 1,000 m; also open heaths and sandy river banks at lower altitudes.

⊕ Very sporadic and narrow distribution restricted to N Fennoscandia; locally common in N Norway, N Sweden and N Finland, extending to Kola Peninsula in NW Russia.

◈ Mostly *Festuca ovina*, probably other grasses as well.

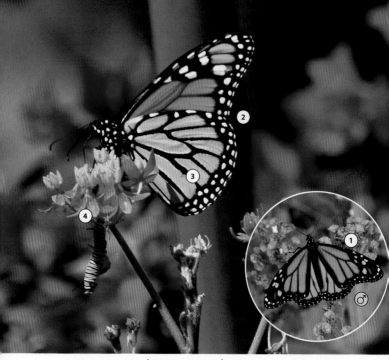

MONARCH (MILKWEED) · *Danaus plexippus*

This is the world's most famous butterfly, thanks to its spectacular autumn migration from N America to certain restricted areas in Mexico, Florida and California where it spends the winter. The Monarch has been extending its range for the last 150 years. It was first noted on the Canary Islands in 1880 and as a resident of Costa del Sol, Spain in 1980. It was then reported from S France and Corsica in 1983. The Monarch is also an occasional vagrant in the Azores, S and W Portugal, Ireland and SW England. In 2009 it certainly was resident in Gibraltar and the Marbella region, with many individuals on the wing in December.

⏵ *Danaus chrysippus*

① Ups orange with strong black borders and black veins
② Ups and uns two rows of white spots (cf. *D. chrysippus*)
③ Hw uns yellowish with strong black veins
④ A host plant *Asclepias curassavica* with a larva
★ Sexes similar
★ The largest butterfly in Europe
🦋 Several consecutive broods throughout the year on the Canary Islands; elsewhere mostly in the late summer. Various open environments near to cultivations, erosion gullies, flowery grasslands, gardens and parks usually at lowlands (<100 m).
⊕ Confined to W and SW Europe; resident colonies restricted to the coastal areas of most Canary Islands and S Spain (Malaga). Vagrants and migrants recorded in the Azores, mainland Portugal, France and W British Isles.
🌿 Cultivated milkweeds such as *Asclepias curassavica*, *Gomphocarpus fruticosus*, *Calotropis procera*, etc.

PLAIN TIGER · *Danaus chrysippus*

A powerful migrant with a broad distribution, this species originates in Africa, where it is one of the commonest butterflies. It started to appear in Europe in larger numbers during the 1980s. The species may be resident on the Canary Islands (La Palma, La Gomera and Fuerteventura), but temporary breeding populations have become established in many localities in coastal Mediterranean areas. In NW Greece, in late September 2008, a few Plain Tigers in good condition were engaging in territorial fights with Southern White Admirals in a dry river gorge lined by deciduous trees and bushes.

⊙ *Danaus plexippus*
 Hypolimnas misippus

① Ups light orange-brown with black tips and borders
② Black marginal with one row of white spots (cf. *D. plexippus*)
③ Veins not lined black
⊛ Sexes similar
♈ Several broods throughout the year on the Canary Islands; mostly between May and October in Mediterranean region and N Africa. Rocky gullies with scrub near to the cultivations, gardens and parks up to 600 m.

⊕ Confined to Mediterranean coastal districts; mostly vagrants and migrants from S Spain in west through peninsular Italy (incl. Corsica, Sardinia, Sicily) to Albania, Greece, Crete, Cyprus and Turkey. Long-term colonies recorded in the Canary Islands (La Palma, La Gomera, Fuerteventura).

⬠ Milkweeds such as *Asclepias curassavica*, *Gomphocarpus fruticosus*, *Calotropis procera*, *Cynachum acutum* etc.

Danaid Eggfly (Common Diadem, Mimic) · *Hypolimnas misippus*

Males of this species are blackish with distinctive white spots fringed with blue, the wings stunningly iridescent in the sunshine. Sexual dimorphism is pronounced, the females not only being strikingly different from the males but occurring in many colour forms, depending on the need for environmental adaptation. Some forms closely resemble the black males, differing only in being larger and having a heavier abdomen. Others are basically orange like Plain Tiger or even Monarch. Called polymorphism, this variability is controlled by only three or four genes. The female does not produce predator-deterring toxic substances, but mimics species that do.

⊙ *Danaus chrysippus*
 Danaus plexippus

① Male ups velvety black with big white patches on both wings
② Fringes chequered
③ Female ups yellow-reddish with a black tip and white spots

🦋 Several broods throughout the year; European records mostly between October and February. Cities, gardens and parks in coastal regions.

⊕ A rare migrant from tropical Africa; records only from the Atlantic islands. Resident colonies in Gomera in the Canary Islands, occasional vagrants or migrants in Tenerife, Madeira and the Azores.

◖ Unknown in Europe, elsewhere *Amaranthus*, *Ipomoea*, *Hibiscus*, *Portulaca*, *Ficus*, etc.

BUTTERFLIES OF EUROPEAN ISLANDS,
EASTERN EUROPE AND ADJACENT REGIONS

Local butterfly faunas of the islands include many endemic species, subspecies and other interesting forms, usually with a limited distribution. Butterflies of some of the most frequently visited islands are presented here. In addition, insight is given to butterfly faunas of Eastern Europe and adjacent regions such as Northern Africa and Mediterranean Turkey. They are probable source areas for new butterfly species which may expand into Europe in future.

Pieris brassicae azorensis, Azores **TH**

AZORES, MADEIRA (Portugal) AND CANARY ISLANDS (Spain)

THE AZORES · A total of ten species including three endemic species or subspecies: *Pieris brassicae azorensis*, *Hipparchia azorina* and *H. miguelensis* (only on Sao Miguel). Other interesting species include *Vanessa virginiensis*, *Danaus plexippus* and *Hypolimnas misippus*. Sao Miguel is the only island with all ten species, whereas only four species have been recorded in Graciosa.

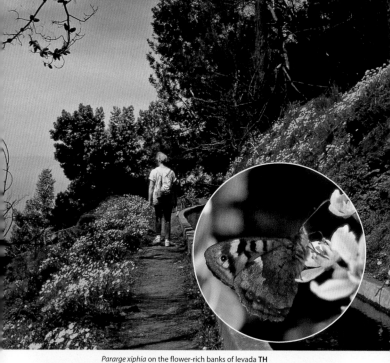

Pararge xiphia on the flower-rich banks of levada **TH**

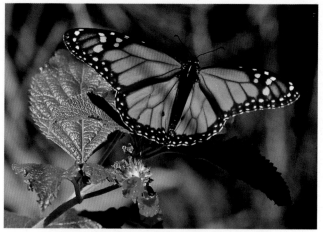

Danaus plexippus **TH**

MADEIRA · A total of 22 species including four endemics: *Pieris wollastoni, Gonepteryx maderensis, Pararge xiphia* and *Hipparchia maderensis*. Other species of interest include *Catopsilia florella, Vanessa vulcania, Danaus chrysippus, D. plexippus* and *Hypolimnas misippus*. Only ten species have been recorded on Porto Santo.

Euchloe eversi, Tenerife, Las Cañadas **HA**

CANARY ISLANDS · A total of 32 species with a high number of endemics (15)
Thymelicus christi, *Pieris cheiranthi*, Green-striped Whites *Euchloe eversi* (Tenerife), *E.*
grancanariensis (Gran Canaria, Lanzarote) and *E. hesperidum* (Fuerteventura), Brim-
stones *Gonepteryx cleobule* (Tenerife), *G. palmae* (La Palma) and *G. eversi* (La Gomera),
Cyclyrius webbianus, *Pararge xiphioides* and a range of Canary Graylings *Hipparchia wyssii*
(Tenerife), *H. tilosi* (La Palma), *H. tamadabae* (Gran Canaria), *H. bacchus* (El Hierro) and
H. gomera (La Gomera). Other interesting species include *Euchloe charlonia*, *Catopsilia*
florella, *Zizeeria knysna*, *Azanus ubaldus* (a few records on Gran Canaria), *Polyomma-*
tus celina, which replaces *P. icarus* in Canary Islands and NW Africa, *Vanessa vulcania*,
V. virginiensis, both *Danaus* species (*chrysippus*, *plexippus*) and *Hypolimnas misippus*. The
number of species varies from 25 in Tenerife to 16 in Lanzarote.

Gonepteryx palmae and *Pieris cheiranthi*, La Palma **HA**

Danaus chrysippus alcippoides, Gran Canaria HA

Euchloe charlonia, Fuerteventura **HA**

Carcharodus tripolinus, Morocco, Agadir **TH**, *Polyommatus celina*, NW Africa **ZK**

NORTHERN AFRICA AND BALEARIC ISLANDS

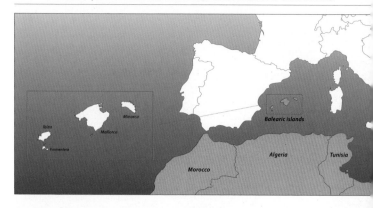

Ibiza

Minorca

Mallorca

Formentera

Balearic islands

Algeria

Tunisia

Morocco

NORTHERN AFRICA (ALGERIA, MOROCCO, TUNISIA) · There are approximatel[y] 144 butterfly species in the northernmost parts of Africa ranging from Morocco in th[e] west to Tunisia in the east. The following species list is according to The Butterflies o[f] Morocco, Algeria and Tunisia (John Tennent 1996); asterisks indicate the ones (4o) which do not occur in Europe.

HESPERIIDAE
Borbo
 borbonica
Carcharodus
 flocciferus
 lavatherae
 stauderi
 tripolinus
Gegenes
 nostrodamus
 pumilio
Hesperia
 comma
Muschampia
 leuzeae *
 mohammed *
 proto
Pyrgus
 alveus
 armoricanus
 onopordi
Spialia
 doris *
 sertorius
Thymelicus
 acteon
 hamza *
 lineola
 sylvestris

PAPILIONIDAE
Iphiclides
 podalirius feisthamelii
Papilio
 machaon
 saharae *
Zerynthia
 rumina africana

PIERIDAE
Anthocharis
 belia *
Aporia
 crataegi
Belenois
 aurota *
Catopsilia
 florella
Colias
 crocea
Colotis
 evagore
 chrysonome *
 liagore *
 phisadia *
Euchloe
 ausonia
 belemia
 charlonia
 falloui *
 tagis
Gonepteryx
 cleopatra
 rhamni
Pieris
 brassicae
 mannii
 napi
 rapae
Pontia
 daplidice
 glauconome *
Zegris
 eupheme

LYCAENIDAE
Apharitis
 acamas
 myrmecophila *
 allardi *
 siphax *
 zohra *
Azanus
 jesous
 ubaldus
Aricia
 agestis
 montensis
Callophrys
 avis
 rubi
Celastrina
 argiolus
Cupido
 lorquinii
Cyaniris
 semiargus
Deudorix
 livia
Favonius
 quercus
Glaucopsyche
 alexis
 melanops
Iolana
 iolas
Lampides
 boeticus
Leptotes
 pirithous
Lycaena
 alciphron
 phlaeas
Maurus
 vogelii *
Plebejus
 allardi *
 martini *
Polyommatus
 albicans
 amandus
 atlantica *
 celina
 escheri
 icarus
 punctifera *
 thersites
Pseudophilotes
 abencerragus
 bavius
Satyrium
 esculi
Tarucus
 balkanicus
 rosacea *
 theophrastus
Thersamonia
 phoebus *
Tomares
 ballus
 mauretanicus *
Zizeeria
 karsandra
 knysna
Zizina
 antanossa *

NYMPHALIDAE
Arethusana
 arethusa

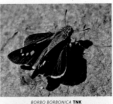

BORBO BORBONICA **TNK**

APHARITIS ALLARDI **MR**

DEUDORIX LIVIA **OBY**

DEUDORIX LIVIA **OBY**

MAURUS VOGELII **MR**

TARUCUS ROSACEA **TH**

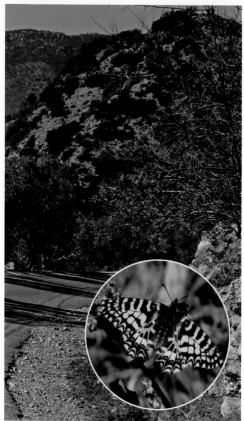

ZERYNTHIA RUMINA AFRICANA, MOROCCO IMMOUZER **TH**

Argynnis
 aglaja
 auresiana *
 pandora
 paphia
Berberia
 abdelkader *
 lambessanus *
Charaxes
 jasius
Chazara
 briseis
 prieuri
Coenonympha
 arcanioides *
 dorus
 fettigii *
 pamphilus
 vaucheri *
Danaus
 chrysippus
Euphydryas
 aurinia
 desfontainii
Hipparchia
 alcyone
 aristaeus
 ellena *
 fidia
 hansi *
 powelli *
 statilinus
Hyponephele
 lupina
 maroccana *
Issoria
 lathonia
Lasiommata
 maera
 meadewaldoi *
 megera
Libythea
 celtis
Maniola
 jurtina
Melanargia
 galathea
 ines
 lucasi
 occitanica
Melitaea
 aetherie
 cinxia
 deione
 deserticola *
 didyma
 punica *
Nymphalis
 polychloros
Pararge
 aegeria
Polygonia
 c-album
Pseudochazara
 atlantis *
Pyronia bathseba
 cecilia
 janiroides *
 tithonus
Satyrus
 ferula
Vanessa
 atalanta
 cardui

TOMARES MAURETANICUS **MR**

BERBERIA ABDELKADER **MR**

BERBERIA LAMBESSANUS **MR**

COENONYMPHA ARCANIOIDES **MR**

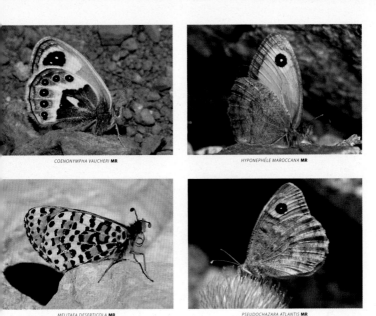

COENONYMPHA VAUCHERI **MR**

HYPONEPHELE MAROCCANA **MR**

MELITAEA DESERTICOLA **MR**

PSEUDOCHAZARA ATLANTIS **MR**

MALLORCA, MENORCA AND IBIZA · A total of 45 species with no endemic taxa. Most species can be found on Mallorca (41), including the Southern Hermit (*Chazara prieuri*). In addition, there is a good set of many Mediterranean species, such as both *Gegenes* skippers, *Charaxes jasius* and *Danaus chrysippus*. The number of species in Menorca is 33, and on Ibiza 31.

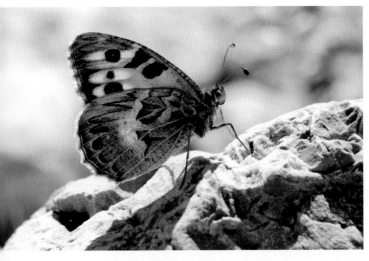

Chazara prieuri **PO**

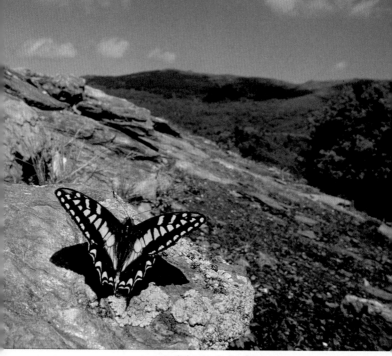

Papilio hospiton, Sardinia **TNK**

CORSICA (France), SARDINIA AND ELBA (Italy)

CORSICA AND SARDINIA · A total of 69 species including 16 endemic taxa confined only to Corsica, Sardinia and some of smaller nearby islands: *Spialia therapne, Papilio hospiton, Euchloe insularis, Pseudophilotes barbagiae* (Sardinia), *Plebejus bellieri, P. argus corsicus* (Corsica), *Polyommatus coridon gennargenti* (Sardinia), *P. coridon nufrellensis* (Corsica), *Argynnis paphia immaculata, A. elisa, Aglais ichnusa, Lasiommata paramegaera, Coenonympha corinna, Maniola nurag* (Sardinia), *Hipparchia neomiris* and *H. aristaeus*.

ELBA · A total of 38 species with no endemic taxa. However, *Coenonympha corinna elbana* occurs only in Elba and in islands of Giglio and Giannutri, and the coastal area of Tuscany. *Plebejus idas villai* resembles *P. bellieri*, but wing undersides are greyer. The endemics mentioned for Corsica and Sardinia are not present in Elba except *Hipparchia neomiris*.

Hipparchia neomiris and *H. aristaeus*, Sardinia **TH**

Coenonympha corinna elbana, Elba **TH**

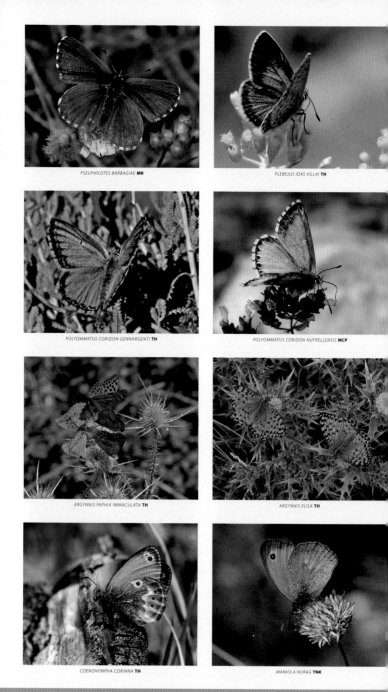

PSEUPHILOTES BARBAGIAE **MR**

PLEBEJUS IDAS VILLAI **TH**

POLYOMMATUS CORIDON GENNARGENTI **TH**

POLYOMMATUS CORIDON NUFRELLENSIS **MCP**

ARGYNNIS PAPHIA IMMACULATA **TH**

ARGYNNIS ELISA **TH**

COENONYMPHA CORINNA **TH**

MANIOLA NURAG **TNK**

Lycaena alciphron gordius, Sicily **TH**

SICILY (Italy) AND MALTA

SICILY · A total of 101 species with two endemic species or subspecies: *Melanargia pherusa* and *Hipparchia aristaeus blachieri*. Other species of interest include *Spialia orbifer, Gegenes nostrodamus, G. pumilio, Zerynthia polyxena, Papilio alexanor, Anthocharis damone, Zizeeria karsandra, Melitaea telona, M. aetherie, Charaxes jasius, Melanargia arge* and *Danaus chrysippus*. The seven Aeolian Islands situated off the north-eastern coast of Sicily are the home for an endemic *Hipparchia leighebi*. In addition, Pontine Islands further north in the Tyrrhenian Sea are the only place to encounter the endemic *Hipparchia sbordonii*.

MALTA · A total of 24 species with two endemic subspecies: *Papilio machaon melitensis* and *Maniola jurtina hyperhispulla*. The African Migrant (*Catopsilia forella*) has been recorded once, in 1963.

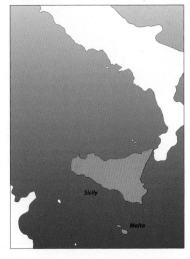

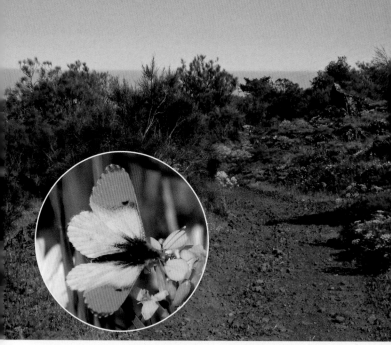

Anthocharis damone, Sicily **TH**

ANTHOCHARIS DAMONE **TH**

MELANARGIA PHERUSA **TH**

MELITAEA AETHERIE **PO**

HIPPARCHIA ARISTAEUS BLACHIERI **PO**

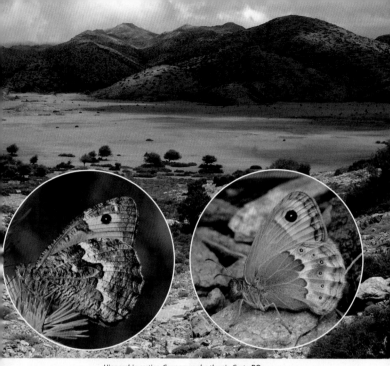

Hipparchia cretica, Coenonympha thyrsis, Crete **PO**

CRETE AND OTHER GREEK ISLANDS

Approximately 110 species of butterflies have been recorded in the islands across the Aegean Sea. The number of species varies greatly between the islands, the highest diversity being in Samos (64) and Lesbos (63); *Satyrium ledereri* is restricted to Samos only. Although the number of species is lower, for example, in Chios (49), Rhodes (47), Kos (45), Ikaria (37) and Karpathos (22), there are many endemics in the area: *Maniola chia* in Chios, *Hipparchia christenseni* in Karpathos and two unique subspecies (*Gonepteryx cleopatra fiorii, Hipparchia syriaca gighii*) in Rhodes. Crete (43) has a wider variety of endemics, including

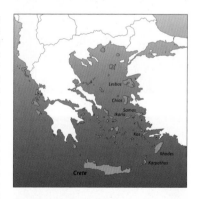

Zerynthia cretica, Plebejus psyloritus, Coenonympha thyrsis and *Hipparchia cretica*. Other species of interest across the Aegean Sea include *Carcharodus stauderi, Pelopidas thrax, Zizeeria karsandra* (Crete), *Plebejus loewii, P. eurypilus* (Samos), *Ypthima asterope, Maniola telmessia, M. halicarnassus* (Nissiros), *M. megala* (Lesbos), *Hipparchia mersina* (Samos, Lesbos) and *H. pellucida* (Lesbos, Ikaria), among others.

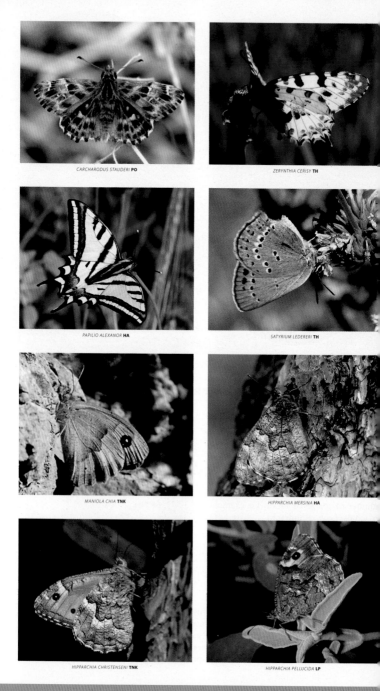

CARCHARODUS STAUDERI **PO**

ZERYNTHIA CERISY **TH**

PAPILIO ALEXANOR **HA**

SATYRIUM LEDERERI **TH**

MANIOLA CHIA **TNK**

HIPPARCHIA MERSINA **HA**

HIPPARCHIA CHRISTENSENI **TNK**

HIPPARCHIA PELLUCIDA **LP**

Apharitis acamas **CM**, *Chazara briseis larnacana*, Cyprus **PO**

CYPRUS AND THE SOUTH AND WEST COAST OF TURKEY

CYPRUS · A total of 52 species are confirmed for the island, including five endemic taxa: *Glaucopsyche paphos*, *Maniola cypricola*, *Chazara briseis larnacana*, *Hipparchia cypriensis* and *H. syriaca cypriaca*. Some other interesting species include *Pelopidas thrax*, *Papilio machaon syriacus*, *Anthocharis cardamines phoenissa*, *Catopsilia florella* (very rare migrant), *Pontia chloridice*, *Apharitis acamas*, *Deudorix livia* (very rare migrant), *Azanus jesous* (recorded once in 1940), *Zizeeria karsandra*, *Chilades galba*, *C. trochylus*, *Limenitis reducta herculeana*, *Charaxes jasius*, *Kirinia roxelana*, *Ypthima asterope* and *Pseudochazara anthelea*. In 2010, Great Steppe Grayling (*Chazara persephone*) was rediscovered in Cyprus.

Colias aurorina, Taurus Mountains, S Turkey **TH**

MEDITERRANEAN TURKEY · There are 350-400 butterfly species in Turkey, of which some 170 have been recorded in the S and W Turkey. The Turkish Riviera of the south western coast, near to the eastern Aegean islands of Greece, harbours 31 species which have never been recorded in Europe (indicated with an asterisk in the following list). In addition, many species rare in Europe are more easily observed, for example, in Antalya.

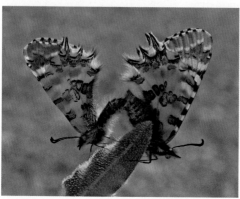

Zerynthia deyrollei **OY**

HESPERIIDAE
Carcharodus
 alceae
 lavatherae
 orientalis
 stauderi
Eogenes
 alcides *
Erynnis
 marloyi
 tages
Gegenes
 nostradamus
 pumilio
Hesperia
 comma
Muschampia
 nomas *
 poggei *
 proteides *
 proto
 tessellum
Ochlodes
 sylvanus

EOGENES ALCIDES **OY**

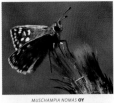

MUSCHAMPIA NOMAS **OY**

MUSCHAMPIA POGGEI **TH**

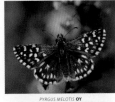

PYRGUS MELOTIS **OY**

ARCHON APOLLINUS **OY**

CALLOPHRYS PAULAE **OY**

GLAUCOPSYCHE ASTRAEA **TH**

LYCAENA ASABINUS **OY**

LYCAENA OCHIMUS **OY**

LYCAENA OCHIMUS **OY**

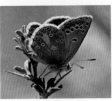

PLEBEJUS HYACINTHUS **OY**

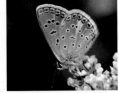

POLYOMMATUS CORNELIA **OY**

minimus
osiris
Favonius
quercus
Glaucopsyche
alexis
astraea *
Iolana
iolas
Lampides
boeticus
Leptotes
pirithous
Lycaena
alciphron
asabinus *
ochimus *
Favonius
phlaeas
thetis
thersamon
tityrus
Plebejus
argus
eurypilus
hyacinthus *
idas
isauricus *
loewii
pylaon
Polyommatus
admetus
amandus
bellargus
coelestinus
cornelia *
daphnis
icarus
iphigenia
lycius *
menalcas *
mithridates *
ossmar *
schuriani attalensis *
semiargus bellis *
sertavulensis *
thersites
wagneri *
Pseudophilotes
vicrama
bavius
Satyrium
abdominalis *
acaciae
ilicis
lederei
spini
w-album
Scolitantides
orion
Tarucus
balkanicus
Tomares
nesimachus *
nogelii
Turanana
endymion *
taygetica

NYMPHALIDAE
Aglais
urticae
Argynnis
adippe
aglaja
niobe
pandora
paphia

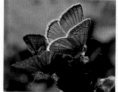

POLYOMMATUS IPHIGENIA **OY**

POLYOMMATUS LYCIUS **OY**

POLYOMMATUS MENALCAS **AG**

POLYOMMATUS MITHRIDATES **OY**

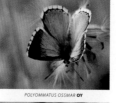

POLYOMMATUS OSSMAR **OY**

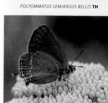

POLYOMMATUS OSSMAR **OY**

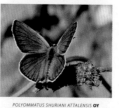

POLYOMMATUS SHURIANI ATTALENSIS **OY**

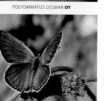

POLYOMMATUS SEMIARGUS BELLIS **TH**

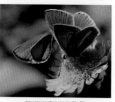

POLYOMMATUS WAGNERI **OY**

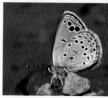

SATYRIUM ABDOMINALIS **OY**

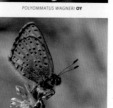

TOMARES NESIMACHUS **OY**

TURANANA ENDYMION **TH**

Arethusana
 arethusa
Brenthis
 daphne
Brintesia
 circe
Chazara
 bischoffi *
 briseis
 persephone *
Charaxes
 jasius
Coenonympha
 leander
 pamphilus
Danaus
 chrysippus
Euphydryas
 aurinia
Hipparchia
 fatua
 mersina
 senthes
 statilinus
 syriaca
Hyponephele
 kocaki *
 lupina
 lycaon
 wagneri *
Issoria
 lathonia
Kirinia
 climene
 roxelana
Lasiommata
 maera
 megera
Libythea
 celtis
Limenitis
 reducta
Maniola
 jurtina
 megala
 telmessia
Melanargia
 larissa
Melitaea
 arduinna
 cinxia
 didyma
 trivia
Nymphalis
 polychloros
Pararge
 aegeria
Polygonia
 egea
Pseudochazara
 anthelea
 beroe *
 lydia *
 mamurra *
 mniszechii
Satyrus
 favonius *
 ferula
Thaleropis
 ionia *
Vanessa
 atalanta
 cardui

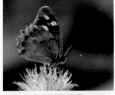

CHAZARA BISCHOFFI **OY**

CHAZARA PERSEPHONE **OY**

CHAZARA PERSEPHONE **TH**

HYPONEPHELE KOCAKI **OY**

HYPONEPHELE WAGNERI **OY**

PSEUDOCHAZARA LYDIA **TH**

THALEROPIS IONIA **OY**

THALEROPIS IONIA **OY**

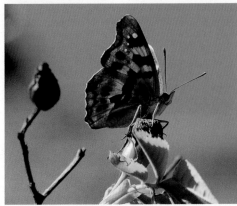

THALEROPIS IONIA **OY**

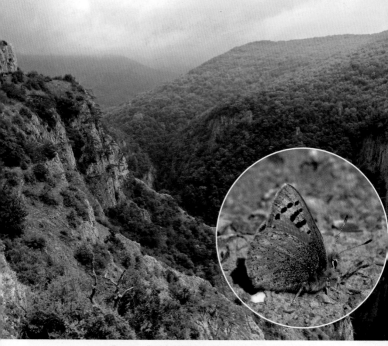

Tomares callimachus **TNK**, Grand Canyon, Crimea, Ukraine **PA**

EASTERN EUROPE: UKRAINE, EUROPEAN PART OF RUSSIA, URALS AND CAUCASUS

Nearly 300 butterfly species occur in easternmost Europe, reaching to the Ural Mountains in the east and the Caucasus in the south. Many of them are the representatives of the Asian fauna, many of which have not been recorded in western Europe. The following list contains 69 species which are additional to the European fauna presented in this guide. Many of these are found only in the mountain ranges of the Caucasus or Urals. In many cases, systematics at specific and subspecific level is not well understood and is in need of further study.

HESPERIIDAE
Pyrgus
 jupei (only Caucasus)
 melotis (only Caucasus)
Syrichtus
 proteides

PAPILIONIDAE
Zerynthia
 caucasica
Parnassius
 nordmanni (only Caucasus)

PIERIDAE
Colias
 *nastes (only Novaya
 Zemlya island)*
 thisoa (only Caucasus)
Zegris
 pyrothoe

LYCAENIDAE
Callophrys
 chalybeitincta
 suaveola (only S Ural)
Lycaena
 japhetica (only E Caucasus)
Neolycaena
 rhymnus
Polyommatus
 altivagans (only Caucasus)
 *aserbaidschanus (only
 Caucasus)*
 budashkini (only Crimea)
 corydonius
 cyane
 damocles
 damone
 demavendi (only E Caucasus)
 eros kamtschadalus
 melamarinus
 phyllis (only Caucasus)
 shamil (only Caucasus)
 teberdinus (only Caucasus)
 yurinekrutenko (only Caucasus)
Praephilotes
 anthracias
Pseudophilotes
 panope (only Kazakhstan)
Tomares
 callimachus
 *romanovi cachetinus
 (only Caucasus)*
Tongeia
 fischeri (only S Ural)

NYMPHALIDAE
Boloria
 alaskensis
 angarensis
 caucasica (only Caucasus)
 oscarus (only C Ural)
 selenis
 tritonia (only N Ural)
Chazara
 persephone
Coenonympha
 amaryllis (only S Ural)
 phryne
Erebia
 cyclopius (only S Ural)
 dabanensis (only N Ural)
 discoidalia
 edda (only N Ural)

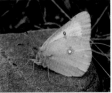

COLIAS THISOA **OEK**

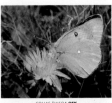

COLIAS THISOA **OEK**

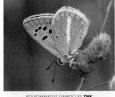

POLYOMMATUS BUDASHKINI **PA**

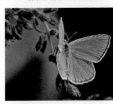

POLYOMMATUS CORYDONIUS **OEK**

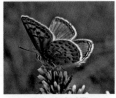

POLYOMMATUS CYANE **OEK**

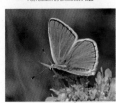

POLYOMMATUS DAMOCLES **TNK**

POLYOMMATUS DAMOCLES **TNK**

POLYOMMATUS DAMONE **TNK**

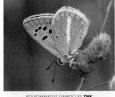

POLYOMMATUS DAMONE **TNK**

POLYOMMATUS DAMONE **OEK**

POLYOMMATUS EROS KAMTSCHADALUS **JK**

TONGEIA FISCHERI **PA**

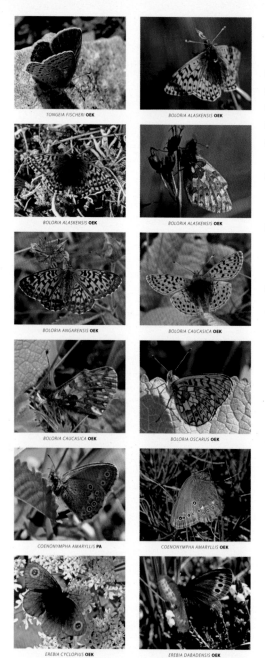

fasciata
graucasica (only Caucasus)
iranica (only Caucasus)
jeniseiensis (only N Ural)
melancholica (only Caucasus)
rossii
Euphydryas
sareptensis
Hipparchia
autonoe
Issoria
eugenia (only N Ural)
Lasiommata
deidamia (only Srednyi Ural)
Melitaea
caucasogenita (only Caucasus)
interrupta (only Caucasus)
persea (only Caucasus)
Oeneis
magna (only N Ural)
melissa (only N Ural)
norna patrushevae
polixenes (only N Ural)
tarpeia
Pseudochazara
alpina (only Caucasus)
daghestana (only E Caucasus)
euxina (only Crimea)
hippolyte
mamurra (only E Caucasus)
pelopea (only E Caucasus)
Satyrus
amasinus (only Caucasus)
virbius
Thaleropis
ionia (only E Caucasus)

TONGEIA FISCHERI **OEK**

BOLORIA ALASKENSIS **OEK**

BOLORIA ALASKENSIS **OEK**

BOLORIA ALASKENSIS **OEK**

BOLORIA ANGARENSIS **OEK**

BOLORIA CAUCASICA **OEK**

BOLORIA CAUCASICA **OEK**

BOLORIA OSCARUS **OEK**

COENONYMPHA AMARYLLIS **PA**

COENONYMPHA AMARYLLIS **OEK**

EREBIA CYCLOPIUS **OEK**

EREBIA DABADENSIS **OEK**

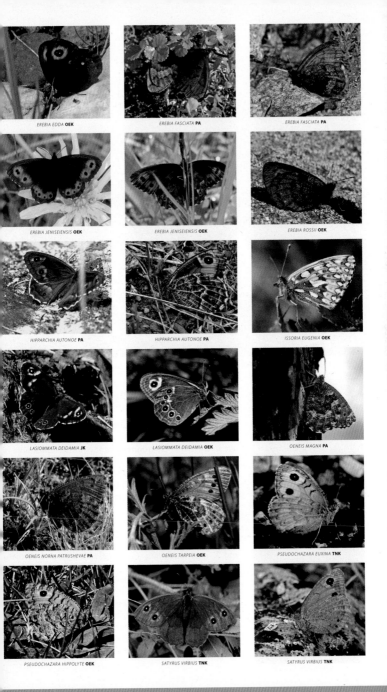

EREBIA EDDA **OEK**

EREBIA FASCIATA **PA**

EREBIA FASCIATA **PA**

EREBIA JENISEIENSIS **OEK**

EREBIA JENISEIENSIS **OEK**

EREBIA ROSSII **OEK**

HIPPARCHIA AUTONOE **PA**

HIPPARCHIA AUTONOE **PA**

ISSORIA EUGENIA **OEK**

LASIOMMATA DEIDAMIA **JK**

LASIOMMATA DEIDAMIA **OEK**

OENEIS MAGNA **PA**

OENEIS NORNA PATRUSHEVAE **PA**

OENEIS TARPEIA **OEK**

PSEUDOCHAZARA EUXINA **TNK**

PSEUDOCHAZARA HIPPOLYTE **OEK**

SATYRUS VIRBIUS **TNK**

SATYRUS VIRBIUS **TNK**

Colias tyche **PO**, Euphydryas iduna **TH**, Kilpisjärvi, Finnish Lapland **HA**

COLIAS HECLA **HA**

PLEBEJUS AQUILO **PO**

BOLORIA POLARIS **HA**

LAPLAND

There are not more than around 130 resident butterfly species in Nordic and Baltic countries. Fifteen of them live in the harsh environment of the norhernmost area of Fennoscandia: *Pyrgus andromedae, Colias hecla, C. tyche, Plebejus aquilo, P. orbitulus, Boloria chariclea, B. improba B. napaea, B. polaris, Euphydryas iduna, Erebia disa, E. pandrose, E. polaris, Oeneis bore* and *O. norna*.

Another 15 species have a stronghold in the far north or exist as a distinct subspecies that only thrives there: *Pyrgus centaureae, Hesperia comma catena, Pieris napi bicolorata* and *P. napi adalwinda, Colias palaeno lapponica, Lycaena helle, L. hippothoe stiberi, L. phlaeas polaris, Plebejus idas lapponicus, Boloria euphrosyne hela, B. euphrosyne lapponica, B. euphrosyne septentrionalis, B. freija, B. frigga, B. thore borealis, Melitaea athalia, Erebia embla* and *E. ligea dovrensis*. In order to absorb the warm solar radiation more efficiently, many of them are darker than their southern cousins. A few are paler in the north like *Lycaena phlaeas polaris* and *Boloria euphrosyne septentrionalis*.

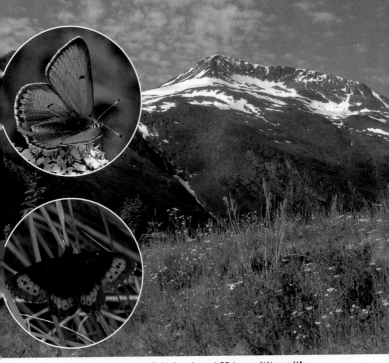

Lycaena hippothoe stiberi **HA**, *Erebia ligea dovrensis* **PO**, Lyngen, N Norway **HA**

BOLORIA NAPAEA **JM**

BOLORIA IMPROBA **TH**

EREBIA PANDROSE **TH**

OENEIS NORNA **HA**

Butterflies on the Internet

European butterflies in general

learnaboutbutterflies.com
www.eurobutterflies.com
www.euroleps.ch
www.lepidopterology.com/directory
ftp.funet.fi/index/Tree_of_life/intro.html
www.butterfly-guide.co.uk
www.leps.it
www.pyrgus.de
www.guypadfield.com
tolweb.org/True_Butterflies/12027
www.tyllinen.eu/Butterflies/Butterflies.htm
www.bc-europe.eu/category.asp?catid=14
members.chello.nl/~h.albertso1
www.motyle.com.pl
www.xs4all.nl/~fransenb/EuropeanButterflies
www.mapeurbutt.de
www.pieris.ch
goran.waldeck.se/paindex.htm
www.nature-of-oz.com/butterflies.htm
www.chebucto.ns.ca/Environment/NHR/
 lepidoptera.html

Belgium / Luxembourg

webho1.ua.ac.be/vve/Checklists/Lepidoptera/
 LepMain.htm

Bulgaria

www.butterfliesofbulgaria.com

Cyprus

www.cyprusbutterflies.co.uk

Denmark

www.danske-natur.dk/indexsyv.html
www.lepidoptera.dk

Estonia

www.lepidoptera.ee

Finland

www.perhostutkijainseura.fi/historia/aahisto.htm
www.kolumbus.fi/esko.viitanen/index_e.htm

France

www.butterfliesoffrance.com
pagesperso-orange.fr/felixthecatalog.tim
www.papillons-fr.net

Germany

www.schmetterling-raupe.de
www.tagfalter-monitoring.de
schmetterlinge-deutschlands.de

Greece

users.auth.gr/~efthymia/Butterflies/
 Butterflies_of_Greece.html

Hungary

lepidoptera.fw.hu
macrolepidoptera.hu

Ireland

www.irishbutterflies.com
www.butterflyireland.com/contents.htm
www.habitas.org.uk/moths
irishbutterflymonitoringscheme.biodiversityireland.ie

Italy

www.lifeinitaly.com/garden/swallowtail-butterfly.asp

Netherlands

www.leps.nl/index.php
www.vlinderstichting.nl
www.vlinderskieken.nl
www.vlindernet.nl
www.vlindersindrenthe.nl

Norway

www.nhm.uio.no/fagene/zoologi/insekter/norlep
www.nagypal.net/norway.htm
folk.ntnu.no/dagfinnr/lepido/lepframe.htm

Poland

www.lepidoptera.pl

Portugal

www.lusoborboletas.org

Romania

www.romaniamylove.com/butterfl.htm

Russia

rusinsects.com/lep.htm
Serbia and Montenegro
leptiri.beograd.com

Slovenia

biodiversityslovenia.net/listbutterfly.htm

Spain

waste.ideal.es/mariposa.html

Sweden

www.pbase.com/bister/butterflies
www.lepidoptera.se
www2.nrm.se/en/svenska_fjarilar/svenska_fjarilar.html

Switzerland

www.schmetterlinge.ch

Ukraine

www.alexanor.uzhgorod.ua
babochki-kryma.narod.ru/main.htm

United Kingdom

www.ukbutterflies.co.uk/index.php
www.britishbutterflies.co.uk
www.butterfly-conservation.org
www.nhm.ac.uk/research-curation/research/
 projects/cockayne
www.ukleps.org

LITERATURE

ESSENTIAL BUTTERFLY GUIDES OF EUROPE

Benton T, Bernhard T. *Easy Butterfly Guide*. Duncan Petersen Publishers, London 2006.

Chinery M. *Butterflies of Britain & Europe*. HarperCollins, London 1998.

Higgins LG, Riley ND. *A field guide to the butterflies of Britain and Europe*. Collins, London 1984 (first 1970).

Lafranchis T. *Butterflies of Europe*. Diatheo 2004 (in French 2007).

Sterry P, Mackay A. *Butterflies and Moths (northwest Europe)*. Dorling Kindersley 2010 (first 2004)

Tolman T, Lewington R. *Collins Butterfly Guide*. HarperCollins, London 2008 (first 1997).

Tolman T. *Photographic Guide to the Butterflies of Britain & Europe*. Oxford University Presss, Oxford 2001.

Whalley P. *Butterflies*. Mitchell Beazley Publishers, London 1981.

Butterfly Guides of regional fauna, with special relevance to the present work

Baytas A. *A Field Guide to the Butterflies of Turkey*. NTV Yayinlari, Istanbul 2007 (in Turkish 2008).

Haahtela T, Saarinen K, Ojalainen P, Aarnio H. *Päiväperhoset*. Suomi, Pohjola, Baltia (Nordic Butterflies, in Finnish with guidance to English readers). Tammi, Helsinki 2006.

Hesselbarth G, van Oorschot H, Wagner S. *Die Tagfalter der Türkei I-III*. Selbstverlag Sigbert Wagener, Germany 1995.

Makris C. *Butterflies of Cyprus*. Bank of Cyprus Cultural Foundation, Nicosia 2003.

Pamperis LN. *The Butterflies of Greece*. Editions Pamperis, KOAN Editions 2009 (first 1997).

Tennent J. *The Butterflies of Morocco, Algeria and Tunisia*. Germ Publishing Co, Oxfordshire 1996

Tshikolovets V. *The Butterflies of Eastern Europe, Urals and Caucasus*. Kyiv-Brno 2003.

BUTTERFLY LITERATURE

There is a wide range of publications about butterfly ecology, behaviour and systematics available for the advanced reader. The following list consists of some 160 species-specific articles on European butterflies published in scientific journals during the last few decades.

Aagaard K, Hindar K, Pullin AS, James CH, Hammerstedt O, Balstad T, Hanssen O. *Phylogenetic relationships in brown argus butterflies (Lepidoptera: Lycaenidae: Aricia) from northwestern Europe*. Biological Journal of Linnean Society 2002; 75: 27-37.

Acosta Fernández B. *Una nueva subespecie de Euchloe belemia (Esper, [1800]) de la isla de Gran Canaria, Islas Canarias, España (Lepidoptera: Pieridae)*. SHILAP Revta. lepid. 2008; 142:173-182.

Albrea J, Gersa C, Legal L. *Molecular phylogeny of the Erebia tyndarus (Lepidoptera, Rhopalocera, Nymphalidae, Satyrinae) species group combining CoxII and ND5 mitochondrial genes: A case study of a recent radiation*. Molecular Phylogenetics and Evolution 2008; 47(1): 196-210.

Als TD, Villa R, Kandul NP, Nash DR, Yen S-H, Hsu Y-F, Mignault AA, Boomsma JJ, Pierce NE. *The evolution of alternative parasitic life histories in large blue butterflies*. Nature 2004; 432: 386-389.

Anthes N, Fartmann T, Hermann G, Kaule G. *Combining larval habitat quality and metapopulation structure - the key for successful management of pre-alpine Euphydryas aurinia colonies*. Journal of Insect Conservation 2003; 7: 175-185.

Artemeva EA. *Phenotypic diversity in populations of the common blue butterfly Polyommatus icarus as a trend in the ecocenotic strategy of the species*. Russian Journal of Ecology 2007; 38(1): 58-67.

Aubert J, Descimon H, Michel F. *Population biology and conservation of the Corsican swallowtail butterfly Papilio hospiton*. Biological Conservation 1996; 78: 247-255.

Axen AH. *Variation in behaviour of lycaenid larvae when attended by different ant species*. Evolutionary Ecology 2000; 14: 611-625.

Baguette M, Mennenchez G, Petit S, Schtickzelle N. *Effect of habitat fragmentation on dispersal in the butterfly Proclossiana eunomia*. C. R. Biologies 2003; 326: S200-S209.

Baguette M, Vansteenwegen C, Convi I, Neve G. *Sex-biased density-dependent migration in a metapopulation of the butterfly Proclossiana eunomia*. Acta Oecologia 1998; 19(1): 17-24.

Baguette M. *Long distance dispersal and landscape occupancy in a metapopulation of the cranberry fritillary butterfly*. Ecography 2003; 26: 153-160.

Batary P, Örvössy N, Körösi A, Valyinagy M, Peregovits L. *Microhabitat preferences of Maculinea teleius (Lepidoptera: Lycaenidae) in a mosaic landscape*. European Journal of Entomology 2007; 104: 731-736.

Baz A. *Nectar plant sources for the threatened Apollo butterfly (Parnassius apollo) in populations of central Spain*. Biological Conservation 2002; 103: 277-282.

Benes J, Kepka P, Konvicka M. *Limestone quarries as refuge for European xerophilous butterflies*. Conservation Biology 2003; 17(4): 1058-1069.

Bergman K-O. *Habitat utilization by Lopinga achine (Nymphalidae: Satyrinae) larvae and ovipositing females: implications for conservation*. Biological Conservation 1999; 88: 69-74.

Bergman K-O, Landin J. *Population structure and movements of a threatened butterfly (Lopinga achine) in a fragmented landscape in Sweden*. Biological Conservation 2002; 108: 361-369.

Berwaerts K, Van Dyck H, Aerts P. *Does flight morphology relate to flight performance? An experimental test with the butterfly Pararge aegeria*. Functional Ecology 2002; 16: 484-491.

Besold J, Huck S, Schmitt T. *Allozyme polymorphisms in the small heath, Coenonympha pamphilus: recent ecological selection or old biogeographical signal? Annales Zoologici Fennici 2008; 45: 217-228.

Besold J, Schmitt T, Tammaru T, Cassel-Lundhagen A. *Strong genetic impoverishment from the centre of distribution in southern Europe to peripheral Baltic and isolated Scandinavian populations of the pearly heath butterfly*. Journal of Biogeography 2008; 35(11): 2090-2101.

Bink FA, Siepel H. *Nitrogen and phosphorus in Molinia caerulea (gramineae) and its impact on the larval development in the butterfly-species Lasiommata megera (Lepidoptera: Satyridae).* Entomologia generalis 1996; 20(4): 271-280.

Bitzer RJ, Shaw KC. *Territorial behavior of the red admiral, Vanessa atalanta (Lepidoptera: Nymphalidae) I.* The role of climatic factors and early interaction frequency on territorial start time. Journal of Insect Behavior 1995; 8(1): 47-66.

Brattström O, Åkesson S, Bensch S. *AFLP reveals cryptic population structure in migratory European red admirals (Vanessa atalanta).* Ecological Entomology 2010; 35(2): 248-252.

Brommer JE, Fred MS. *Movement of the apollo butterfly Parnassius apollo related to host plant and nectar plant patches.* Ecological Entomology 1999; 24: 125-131.

Brunton CFA. *The evolution of ultraviolet patterns in European Colias butterflies (Lepidoptera, Pieridae) a phylogeny using mitochondrial DNA.* Heredity 1998; 80: 611-616.

Burghardt F, Knüttel H, Becker M, Fiedler K. *Flavonoid wing pigments increase attractiveness of female common blue (Polyommatus icarus) butterflies to mate-searching males.* Naturwissenschaften 2000; 87: 304-307.

Cassel A, Tammaru T. *Allozyme variability in central, peripheral and isolated populations of the scarce heath (Coenonympha hero: Lepidoptera, Nymphalidae); implications for conservation.* Journal Conservation Genetics 2003; 4(1): 83-93.

Celik T, Vres B, Seliskar A. *Determinants of within-patch microdistribution and movements of endangered butterfly Coenonympha oedippus (Fabricius, 1787) (Nymphalidae: Satyrinae).* Hacquetia 2009; 8(2): 115-128.

Cizek O, Bakesova A, Kuras T, Benes J, Konvicka M. *Vacant niche in alpine habitat: the case of an introduced population of the butterfly Erebia epiphron in the Krkonose Mountains.* Acta Oecologia 2003; 24: 15-23.

Coutsis JG, De Prins J, De Prins W. *The chromosome number and karyotype of the two morphs of Polyommatus (Lysandra) coridon from Greece (Lepidoptera: Lycaenidae).* Phegea 2001; 29(2): 63-71.

Coutsis JG, De Prins J. *A new brown Polyommatus (Agrodiaetus) from northern Greece (Lepidoptera: Lycaenidae).* Phegea 2005; 33(4): 129-137.

Coutsis JG. *Revision of the Turanana endymion species-group (Lycaenidae).* Nota lepidopterologica 2005; 27(4): 251-272.

Damm Als T, Nash DR, Boomsma JJ. *Adoption of parasitic Maculinea alcon caterpillars (Lepidoptera: Lycaenidae) by three Myrmica ant species.* Animal Behaviour 2001; 62: 99-106.

Damm Als T, Nash DR, Boomsma JJ. *Geographical variation in a host-ant specificity of the parasitic butterfly Maculinea alcon in Denmark.* Ecological Entomology 2002; 27: 403-414.

Dapporto L. *Satyrinae butterflies from Sardinia and Corsica show a kaleidoscopic intraspecific biogeography (Lepidoptera, Nymphalidae).* Biological Journal of the Linnean Society 2010; 100: 195-212.

Dell D, Sparks TH, Dennis RLH. *Climate change and the effect of increasing spring temperatures on emergence dates of the butterfly Apatura iris (Lepidoptera: Nymphalidae).* European Journal of Entomology 2005; 102: 161-167.

Dempster JP. *The role of larval food resources and adult movement in the population dynamics of the orange-tip butterfly (Anthocharis cardamines).* Oecologia 1997; 111:549-556.

Dennis RLH, Eales HT. *Patch occupancy in Coenonympha tullia (Müller 1764): habitat quality matters as much as patch size and isolation.* Journal of Insect Conservation 1997; 1: 167-176.

Dennis RLH, Eales HT. *Probability of site occupancy in the large heath butterfly Coenonympha tullia determined from geographical and ecological data.* Biological Conservation 1999; 87: 295-301.

Dennis RHL, Sparks TH. *When is a habitat not a habitat? Dramatic resource use changes under differing weather conditions for the butterfly Plebejus argus.* Biological Conservation 2006; 129: 291-301.

Dennis RLH, Shreeve TG, Sparks TH. *The effects of island area, isolation and source population size on the presence of the grayling butterfly Hipparchia semele (L.) (Lepidoptera: Satyrinae) on British and Irish offshore islands.* Biodiversity and Conservation 1998; 7:765-776.

Dierks A, Fischer K. *Habitat requirements and niche selection of Maculinea nausithous and M. teleius (Lepidoptera: Lycaenidae) within a large sympatric metapopulation.* Biodiversity and Conservation 2009; 18(13): 3663-3673.

Dolek M, Geyer A, Bolz R. *Distribution of Maculinea rebeli and hostplant use on sites along the river Danube.* Journal of Insect Conservation 1998; 2: 85-89.

van Dyck H, Matthysen E, Dhondt AA. *The effect of wing colour on male behavioural strategies in the speckled wood butterfly.* Animal Behaviour 1997; 53: 39-51.

Ellers J, Boggs CL. *The evolution of wing color in Colias butterflies: heritability, sex linkage, and population divergence.* Evolution 2002; 56(4): 836-840.

Elligsen H, Beinlich B, Plachter H. *Effects of large-scale cattle grazing on population of Coenonympha glycerion and Lasiommata megera (Lepidoptera: Satyridae).* Journal of Insect Conservation 1997; 1: 13-23.

Ellis S. *Habitat quality and management for the northern brown argus Aricia artaxerxes (Lepidoptera: Lycaenidae) in North East England.* Biological Conservation 2003; 113: 285-294.

Elmes GW, Akino T, Thomas JA, Clarke RT, Knapp JJ. *Interspecific differences in cuticular hydrocarbon profiles of Myrmica ants are sufficiently consistent to explain host specificity by Maculinea (large blue) butterflies.* Oecologia 2002; 130: 525-535.

Elmes GW, Thomas JA, Munguira ML, Fiedler K. *Larvae of lycaenid butterflies that parasitize ant colonies provide exceptions to normal insect growth rules.* Biological Journal of Linnean Society 2001; 73: 259-278.

Elmes GW, Thomas JA, Wardlaw JC, Hochberg ME, Clarke RT, Simcox DJ. *The ecology of Myrmica ants in relation to the conservation of Maculinea butterflies.* Journal of Insect Conservation 1998; 2: 67-78.

Espeland M, Aagaard K, Balstad T, Hindar K. *Ecomorphological and genetic divergence between lowland and montane forms of the Pieris napi species complex (Pieridae, Lepidoptera).* Biological Journal of the Linnean Society 2007; 92: 727-745.

Fiedler K, Hagemann D. *The influence of larval age and ant number on myrmecophilous interactions of the African Grass Blue butterfly, Zizeeria knysna (Lepidoptera: Lycaenidae).* Journal of Research on the Lepidoptera 1995; 31(3-4): 213-232.

Figurny E, Woyciechowski M. *Flowerhead selection for oviposition by females of the sympatric butterfly species Maculinea teleius and M. nausithous (Lepidoptera: Lycaenidae).* Entomologia generalis 1998; 23(3): 215-222.

Fischer K. *Population structure, mobility and habitat selection of the butterfly Lycaena hippothoe (Lycaenidae: Lycaenini) in western Germany.* Nota Lepidoptera 1998; 21(1): 14-30.

Fischer K, Fiedler K. *Sex-related differences in reaction norms in the butterfly Lycaena tityrus (Lepidoptera: Lycaenidae).* Oikos 2000; 90(2): 372-380.

Fischer K, Fiedler K. *Resource-based territoriality in the butterfly Lycaena hippothoe and environmentally induced behavioural shifts.* Animal Behaviour 2001; 61: 723-732.

Fischer K, Beinlich B, Plachter H. *Population structure, mobility and habitat preferences of the violet copper Lycaena helle (Lepidoptera: Lycaenidae) in Western Germany: implications for conservation.* Journal of Insect Conservation 1999; 3: 43-52.

Fred M, Brommer JE. *Influence of habitat quality and patch size on occupancy and persistence in two populations of the Apollo butterfly (Parnassius apollo).* Journal of Insect Conservation 2003; 7: 85-98.

Friberg M. *A difference in pupal morphology between the sibling species Leptidea sinapis and L. reali (Pieridae).* Nota Lepidopterologica 2007; 30(1): 61-64.

Fric Z, Wahlberg N, Pech P, Zrzavy J. *Phylogeny and classification of the Phengaris–Maculinea clade (Lepidoptera: Lycaenidae): total evidence and phylogenetic species concepts.* Systematic Entomology 2007; 32(3): 558-567.

Fric Z, Konvicka M, Zrzavy J. *Red & black or black & white? Phylogeny of the Araschnia butterflies (Lepidoptera: Nymphalidae) and evolution of seasonal polyphenism.* Journal of Evolutionary Biology 2004; 17(2): 265-278.

Gadeberg RME, Boomsma JJ. *Genetic population structure of the large blue butterfly Maculinea alcon in Denmark.* Journal of Insect Conservation 1997; 1: 99-111.

Gil-T. F. *Description of the pre-imaginal stages of Agrodiaetus violetae and notes about compared ecology and morphology.* Atalanta 2008; 39: 343-346.

Goloborodko KK, Fedenko VS. *Parameters of the wing coloration in the butterfly genus Colias Fabr. (Lepidoptera, Pieridae) of the steppe zone of eastern and Central Europe.* Entomological Review 2007; 87: 1109-1114.

Gotthard K, Nylin S, Wiklund C. *Mating system evolution in response to search costs in the speckled wood butterfly, Pararge aegeria.* Behavioral Ecology and Sociobiology 1999; 45: 424-429.

Goverde M, Erhardt A. *Effects of elevated CO2 on development and larval food-plant preference in the butterfly Coenonympha pamphilus (Lepidoptera, Satyridae).* Global Change Biology 2003; 9: 74-83.

Greatorex-Davies JN, Hall ML, Marrs RH. *The conservation of the pearl-bordered butterfly (Boloria euphrosyne L.): preliminary studies of the creation and management of glades in conifer plantations.* Forest Ecology and Management 1992; 53: 1-14.

Griebeler EM, Seitz A. *An individual based model for the conservation of the endangered Large Blue butterfly, Maculinea arion (Lepidoptera: Lycaenidae).* Ecological Modelling 2002; 156: 43-60.

Grill A, de Vos R, van Arke J. *The shape of endemics: Notes on male and female genitalia in the genus Maniola (Schrank, 1801), (Lepidoptera, Nymphalidae, Satyrinae).* Contributions to Zoology 2004; 73 (4).

Grill A, Raijmann LEL, Van Ginkel W, Gkioka E, Menken SBJ. *Genetic differentiation and natural hybridization between the Sardinian endemic Maniola nurag and the European Maniola jurtina.* Journal of Evolutionary Biology 2007; 20(4): 1255-1270.

Gutierrez D, Thomas CD, Leon-Cortes JL. *Dispersal, distribution, patch network and metapopulation dynamics of the dingy skipper butterfly (Erynnis tages).* Oecologia 1999; 121: 506-517.

Gutierrez D, Thomas CD. *Marginal range expansion in a host-limited butterfly species Gonepteryx rhamni.* Ecological Entomology 2000; 25: 165-170.

Habel JC, Schmitt T, Meyer M, Finger A, Rödder D, Assmann T, Zachos FE. *Biogeography meets conservation: the genetic structure of the endangered lycaenid butterfly Lycaena helle (Denis & Schiffermüller, 1775).* Biological Journal of the Linnean Society 2010; 101: 155-168.

Habel JC, Meyer M, El Mousadic A, Schmitt T. *Africa goes Europe: The complete phylogeography of the marbled white butterfly species complex Melanargia galathea/ M. lachesis (Lepidoptera: Satyridae).* Organisms Diversity & Evolution 2008; 8: 121-129.

Haikola S, Fortelius W, O'Hara RB, Kuussaari M, Wahlberg N, Saccheri IJ, Singer MC, Hanski I. *Inbreeding depression and the maintenance of genetic load in Melitaea cinxia metapopulations.* Conservation Genetics 2001; 2: 325-335.

Haikola S, Singer MC, Pen I. *Has inbreeding depression led to avoidance of sib mating in the Glanville fritillary butterfly (Melitaea cinxia)?* Evolutionary Ecology 2004; 18: 113-120.

Hammouti N, Schmitt T, Seitz A, Kosuch J, Veith M. *Combining mitochondrial and nuclear evidences: a refined evolutionary history of Erebia medusa (Lepidoptera: Nymphalidae: Satyrinae) in Central Europe based on the COI gene.* Journal of Zoological Systematics and Evolutionary Research 2010; 48(2): 115-125.

Hanski I, Kuussaari M, Nieminen M. *Metapopulation structure and migration in the butterfly Melitaea cinxia.* Ecology 1994; 75(3): 747-762.

Hernandez-Roldan JL, Munguira ML. *Multivariate analysis techniques in the study of the male genitalia of Pyrgus bellieri (Oberthür 1910) and P. alveus (Hübner 1803) (Lepidoptera: Hesperiidae): species discrimination and distribution in the Iberian Peninsula.* Ann. soc. entomol. Fr. 2008; 44(2): 145-155.

Hernandez-Roldan JL, Munguira ML, Martin J. *Ecology of a relict population of the vulnerable butterfly Pyrgus sidae on the Iberian Peninsula (Lepidoptera: Hesperiidae).* European Journal of Entomology 2009; 106: 611-618.

Herrero S, Borja M, Ferré J. *Extent of variation of the Bacillus thuringiensis toxin reservoir: the case of the Geranium Bronze, Cacyreus marshalli Butler (Lepidoptera: Lycaenidae).* Applied and Environmental Microbiology 2002; 68(8): 4090-4094.

Hill JK, Thomas CD, Lewis OT. *Effects of habitat patch size and isolation on dispersal by Hesperia comma butterflies: implications for metapopulation structure.* Journal of Animal Ecology 1996; 65: 725-735.

Hill JK, Thomas CD, Lewis OT. *Flight morphology in fragmented populations of a rare British butterfly, Hesperia comma.* Biological Conservation 1999; 87: 277-283.

Hoole JC, Joyce DA, Pullin AS. *Estimates of gene flow between populations of the swallowtail butterfly, Papilio machaon in Broadland, UK and implications for conservation.* Biological Conservation 1999; 89: 293-299.

Janz N. *The relationship between habitat selection and preference for adult and larval food resources in the polyphagous butterfly Vanessa cardui (Lepidoptera: Nymphalidae).* Journal of Insect Behavior 2005; 18(6): 767-780.

Johannesen J, Schwing U, Seufert W, Seitz A, Veith M. *Analysis of gene flow and habitat patch network for Chazara briseis (Lepidoptera: Satyridae) in an agricultural landscape.* Biochemical Systematics and Ecology 1997; 25(5): 419-427.

Jordano D, Haeger JF, Rodríguez J. *The effect of seed predation by Tomares ballus (Lepidoptera: Lycaenidae) on Astragalus lusitanicus (Fabaceae): Determinants of differences among patches.* Oikos 1990; 57(2): 250-256.

Joy J, Pullin AS. *The effects of flooding on the survival and behaviour of overwintering large heath butterfly Coenonympha tullia.* Biological Conservation 1997; 82: 61-66.

Joyce DA, Pullin AS. *Phylogeography of the Marsh fritillary Euphydryas aurinia (Lepidoptera: Nymphalidae) in the UK.* Biological Journal of the Linnean Society 2001; 72: 129-141.

Joyce DA, Pullin AS. *Using genetics to inform re-introduction strategies for the Chequered Skipper butterfly (Carterocephalus palaemon, Pallas) in England.* Journal of Insect Conservation 2004; 8: 69-74.

Joyce DA, Dennis RLH, Bryant SR, Shreeve TG, Ready JS, Pullin AS. *Do taxonomic divisions reflect genetic differentiation? A comparison of morphological and genetic data in Coenonympha tullia (Müller), Satyrinae.* Biological Journal of the Linnean Society 2009; 97: 314-327.

Kadlec T, Vrba P, Konvicka M. *Microhabitat requirements of caterpillars of the critically endangered butterfly Chazara briseis (L.) (Nymphalidae, Satyrinae) in the Czech Republic.* Nota Lepidopterologica 2009; 32(1): 39-46.

Kaitala A, Wiklund C. *Female mate choice and mating costs in the polyandrous butterfly Pieris napi (Lepidoptera: Pieridae).* Journal of Insect Behavior 1994; 8(3): 355-363.

Karsholt O, Razowski J. *The Lepidoptera of Europe. A distributional checklist.* Apollo Books 1996.

Kery M, Matthies T, Fischer M. *The effect of plant population size on the interactions between the rare plant Gentiana cruciata and its specialised herbivore Maculinea rebeli.* Journal of Ecology 2001; 89: 418-427.

Kolev Z. *Notes on the distribution and ecology of Balkan populations of the Plebeius idas -group (Lepidoptera: Lycaenidae).* Phegea 2005; 33(1): 13-22.

Kolev Z. *Polyommatus dantchenkoi (Lukhtanov & Wiemers, 2003) tentatively identified as new to Europe, with a description of a new taxon from the Balkan Peninsula (Lycaenidae).* Nota lepid 2005;28:25-34.

Kolev Z. *New data on the taxonomic status and distribution of Polyommatus andronicus Coutsis & Ghavalas, 1995 (Lycaenidae).* Nota lepid 2005;28:35-48.

Komonen A, Tikkamäki T, Mattila N, Kotiaho JS. *Patch size and connectivity influence the population turnover of the threatened chequered blue butterfly, Scolitantides orion (Lepidoptera: Lycaenidae).* European Journal of Entomology 2008; 105: 131-136.

Konvicka M, Kuras T. *Population structure, behaviour and selection of oviposition sites of an endangered butterfly, Parnassius mnemosyne, in Litovelské Pomoraví.* Czech Republic. Journal of Insect Conservation 1999; 3: 211-223.

Konvicka M, Benes J, Kuras T. *Microdistribution and diurnal behaviour of two sympatric mountain butterflies (Erebia epiphron and E. euryale): relations to vegetation and weather.* Biologia 2002; 57(2): 223-233.

Konvicka M, Hula V, Fric Z. *Habitat of pre-hibernating larvae of the endangered butterfly Euphydryas aurinia (Lepidoptera, Nymphalidae): What can be learned from vegetation composition and architecture?* European Journal of Entomology 2003; 100: 313-322.

Konvicka M, Benes J, Cizek O, Kopecek F, Konvicka O, Vitaz L. *How too much care kills species: Grassland reserves, agri-environmental schemes and extinction of Colias myrmidone (Lepidoptera: Pieridae) from its former stronghold.* Journal of Insect Conservation 2008; 12(5): 519-525.

Konvička M, Dvořák L, Hanč Z, Pavlíčko A, Fric Z. *The Baton blue (Pseudophilotes baton) (Lepidoptera: Lycaenidae) in south-western Bohemia: iron curtain, military ranges and endangered butterfly.* Silva Gabreta 2008; 14(3): 187-198.

Krauss J, Steffan-Dewenter I, Tscharntke T. *Landscape occupancy and local population size depends on host plant distribution in the butterfly Cupido minimus.* Biological Conservation 2004; 120: 355-361.

Kudrna O. *The Distribution Atlas of European Butterflies.* Oedippus 2002.

Kuras T, Benes J, Konvicka M. *Differing habitat affinities of four Erebia species (Lepidoptera: Nymphalidae, Satyrinae) in the Hrudy Jesenik Mts, Czech Republic.* Biologia 2000; 55(2): 169-175.

Kuras T, Benes J, Konvicka M. *Behaviour and within-habitat distribution of adult Erebia sudetica sudetica endemic of the Hruby Jesenik Mts., Czech Rpublik (Nymphalidae, Satyrinae).* Nota Lepidopterologica 2001; 24(4): 69-83.

Kuras T, Konvicka M, Benes J. *Different frequencies of partial albinism in populations of alpine butterflies of different size and connectivity (Erebia: Nymphalidae, Satyrinae).* Biologia 2001; 56(5): 503-512.

Lafrancis T, Heaulme V, Lafrancis J. *Biology, ecology and distribution of the large copper (Lycaena dispar Haworth, 1803) in Quercy (southwest France) (Lepidoptera: Lycaenidae).* Linneana Belgica 2001; 18(1): 27-36.

Langan AM, Wheater CP, Dunleavy PJ. *Does the small white butterfly (Pieris rapae L.) aggregate eggs on plants with greater gas exchange activity?* Journal of Insect Behaviour 2001; 14(4): 459-468.

Leon-Cortes JL, Cowley MJR, Thomas CD. *The distribution and decline of a widespread butterfly Lycaena phlaeas in a pastoral landscape.* Ecological Entomology 2000; 25: 285-294.

Leveneu J, Chichvarkhin A, Wahlberg N. *Varying rates of diversification in the genus Melitaea (Lepidoptera: Nymphalidae) during the past 20 million years.* Biological Journal of the Linnean Society 2009; 97: 346-361.

Lukhtanov VA, Vila R, Kandul NP. *Rearrangement of the Agrodiaetus dolus species group (Lepidoptera, Lycaenidae) using a new cytological approach and molecular data.* Insect Systematics and Evolution 2006; 37(3): 325-334.

Lukhtanov VA, Budashkin YI. *The origin and taxonomic position of the Crimean endemic Agrodiaetus pjushtchi (Lepidoptera, Lycaenidae) based on the data on karyology, ecology, and molecular phylogenetics.* Entomological Review 2007; 87(8): 973-979.

Maes D, Vanreusel W, Talloen W, Van Dyck HV. *Functional conservation units for the endangered Alcon Blue butterfly Maculinea alcon in Belgium (Lepidoptera: Lycaenidae).* Biological Conservation 2004; 120: 229-241.

Marchi A, Addis G, Exposíto Hermosa V, Crnjar R. *Genetic divergence and evolution of Polyommatus coridon gennargenti (Lepidoptera: Lycaenidae) in Sardinia.* Heredity 1996; 77: 16-22.

Marttila O, Saarinen K, Marttila P. *Six years from passing bell to recovery. Habitat restoration of the threatened Chequered Blue butterfly (Scolitantides orion) in SE Finland.* Entomologica Fennica 2000; 11(2): 113-117.

Meglecz E, Neve G, Pecsenye K, Varga Z. *Genetic variations in space and time in Parnassius mnemosyne populations in north-east Hungary: implications for conservation.* Biological Conservation 1999; 89: 251-259.

Mendel H. *The decline and extinction of the pearl-bordered fritillary (Boloria euphrosyne L.) in Suffolk.* Transactions of the Suffolk Naturalists' Society 1999; 35: 85-97.

Meyer-Hozak C. *Population biology of Maculinea rebeli (Lepidoptera: Lycaenidae) on the chalk grasslands of eastern Westphalia (Germany) and implications for conservation.* Journal of Insect Conservation 2000; 4: 63-72.

Mikkola K. *Red Admirals Vanessa atalanta (Lepidoptera: Nymphalidae) select northern winds on southward migration.* Entomologica Fennica 2003; 14: 15-24.

Mitikka V, Hanski I. *Pgi genotype influences flight metabolism at the expanding range margin of the European map butterfly.* Annales Zoologici Fennici 2010; 47: 1-14.

Möllenbeck V, Hermann G, Fartmann T. *Does prescribed burning mean a threat to the rare satyrine butterfly Hipparchia fagi? Larval-habitat preferences give the answer.* Journal of Insect Conservation 2009; 13(1): 77-87.

Mousson L, Neve G, Baguette M. *Metapopulation structure and conservation of the cranberry fritillary Boloria aquilonaris (Lepidoptera, Nymphalidae) in Belgium.* Biological Conservation 1999; 87: 285-293.

Munguira ML, Martin J, Garcia-Barros E, Viejo JL. *Use of space and resources in a Mediterranean population of the butterfly Euphydryas aurinia.* Acta Oecologia 1997; 18(5): 597-612.

Napolitano M, Descimon H. *Genetic structure of French populations of the mountain butterfly Parnassius mnemosyne L. (Lepidoptera: Papilionidae).* Biological Journal of the Linnean Society 1994; 53(4): 325-341.

Nazari V, Hagen WT, Bozano GC. *Molecular systematics and phylogeny of the 'Marbled Whites' (Lepidoptera: Nymphalidae, Satyrinae, Melanargia Meigen).* Systematic Entomology 2010; 35(1): 132-147.

Nicholls CN, Pullin AS. *A comparison of larval survivorship in wild and introduced populations of the large copper butterfly (Lycaena dispar batavus).* Biological Conservation 2000; 93: 349-358.

Owen DF, Shreeve TG, Smith AG. *Colonization of Madeira by the speckled wood butterfly, Pararge aegeria (Lepidoptera: Satyridae), and its impact on the endemic Pararge xiphia.* Ecological Entomology 1986; 11(3): 349-352.

Pecsenye K, Bereczki J, Szilagyi M, Varga Z. *High level of genetic variation in Aricia artaxerxes issekutzi (Lycaenidae) populations in Northern Hungary.* Nota Lepidopterologica 2007; 30(2): 225-234.

Pecsenye K, Bereczki J, Tihanyi B, Toth A, Peregovits L, Varga Z. *Genetic differentiation among the Maculinea species (Lepidoptera: Lycaenidae) in eastern Central Europe.* Biological Journal of the Linnean Society 2007; 91: 11-21.

Pivnick KA, McNeil JN. *Puddling in butterflies: Sodium affects reproductive success in Thymelicus lineola.* Physiological Entomology 1987; 12(4): 461-472.

Plester L. *The life cycle of the Baltic grayling, Oeneis jutta (Lepidoptera, Satyridae) in southern Finland.* Notulae Entomologicae 1983; 63(4): 182-186.

Pollard E, Greatorex-Davies JN. *Increased abundance of the red admiral butterfly Vanessa atalanta in Britain: the roles of immigration, overwintering and breeding within the country.* Ecological Letters 1998; 1: 77-81.

Pollard E, van Swaay CAM, Stefanescu C, Lundsten KE, Maes D, Greatorex-Davies JN. *Migration of the painted lady butterfly Cynthia cardui in Europe: evidence from monitoring.* Diversity and Distributions 1998; 4: 243-253.

Porter AH, Geiger H. *Limitations to the inference of gene flow at regional geographic scales – an example from the Pieris napi group (Lepidoptera: Pieridae) in Europe.* Biological Journal of the Linnean Society 1994; 54(4): 329-348.

Ravenscroft NO. *Environmental influences on mate location in male chequered skipper butterflies, Carterocephalus palaemon (Lepidoptera: Hesperiidae).* Animal Behaviour 1994; 47(5): 1179-1187.

Ravenscroft NO. *The feeding behaviour of Carterocephalus palaemon (Lepidoptera: Hesperiidae) caterpillars: does it avoid host defences or maximize nutrient intake?* Ecological Entomology 1994; 19(1): 26-30.

Roland J, Keyghobadi N, Fownes S. *Alpine Parnassius butterfly dispersal: effects of landscape and population size.* Ecology 2000; 81(16): 1642-1653.

Saarinen K, Jantunen J, Valtonen A. *Resumed forest grazing restored a population of Euphydryas aurinia (Lepidoptera, Nymphalidae) in SE Finland.* European Journal of Entomology 2005; 102(4): 683-690.

Schmitt T, Seitz A. *Intraspecific allozymatic differentiation reveals the glacial refugia and the postglacial expansions of European Erebia medusa (Lepidoptera: Nymphalidae).* Biological Journal of the Linnean Society 2001; 74(4): 429-458.

Schmitt T, Seitz A. *Allozyme variation in Polyommatus coridon (Lepidoptera: Lycaenidae): Identification of Ice-Age refugia and reconstruction of post-glacial expansion.* Journal of Biogeography 2001; 28(9): 1129-1136.

Schmitt T, Seitz A. *Influence of habitat fragmentation on the genetic structure of Polyommatus coridon (Lepidoptera: Lycaenidae): implications for conservation.* Biological Conservation 2002; 107: 291-297.

Seymour AS, Gutierrez D, Jordano D. *Dispersal of the lycaenid Plebejus argus in response to patches of its mutualist ant Lasius niger.* Oikos 2003; 103: 162-174.

Sielezniew M, Stankiewicz AM. *Simultaneous exploitation of Myrmica vandeli and M. scabrinodis (Hymenoptera: Formicidae) colonies by the endangered myrmecophilous butterfly Maculinea alcon (Lepidoptera: Lycaenidae).* European Journal of Entomology 2004; 101(4): 693-696.

Smith DAS, Owen DF, Gordon IJ, Owiny AM. *Polymorphism and evolution in the butterfly Danaus chrysippus (L.) (Lepidoptera: Danainae).* Heredity 1993; 71: 242-251.

Spieth HR, Kaschuba-Holtgrave A. *A new experimental approach to investigate migration in Pieris brassicae L.* Ecological Entomology 1996; 21: 289-294.

Stefanescu C. *The nature of migration in the red admiral butterfly Vanessa atalanta: evidence from the population ecology in its southern range.* Ecological Entomology 2001; 26: 525-536.

Suárez NM, Betancor E, Pestano J. *Intraspecific evolution of Canarian Euchloe (Lepidoptera: Pieridae) butterflies, based on mtDNA sequences.* Molecular Phylogenetics and Evolution 2009; 51:601-605.

van Swaay C, Cuttelod A, Collins S, Maes D, Lopez Munguira M, Sasic M, Settele J, Verovnik R, Verstrael T, Warren M, Wiemers M, Wynhof I. *European Red List of Butterflies.* Publications Office of the European Union 2010.

Thomas CD, Jones TM. *Partial recovery of a skipper butterfly (Hesperia comma) from population refuges: lessons for conservation in a fragmented landscape.* Journal of Animal Ecology 1993; 62: 472-481.

Thomas JA, Simcox DJ, Wardlaw JC, Elmes GW, Hochberg ME, Clarke RT. *Effects of latitude, altitude and climate on the habitat and conservation of the endangered butterfly Maculinea arion and its Myrmica host ants.* Journal of Insect Conservation 1998; 2: 39-46.

Toth JP, Varga Z. *Morphometric study of the genitalia of sibling species Melitaea phoebe and M. telona (Lepidoptera: Nymphalidae).* Acta Zoologica Academiae Scientiarum Hungaricae 2010; 56(3): 273-282.

Vandewoestijne S, Neve G, Baguette M. *Spatial and temporal population genetic structure of the butterfly Aglais urticae L. (Lepidoptera, Nymphalidae).* Molecular Ecology 1999; 8: 1539-1543.

Valtonen A, Saarinen K. *A highway intersection as an alternative habitat for a meadow butterfly: Effect of mowing, habitat geometry and roads on the ringlet (Aphantopus hyperantus).* Annales Zoologici Fennici 2005; 42(5): 545-556.

Väisänen R, Heliövaara K, Somerma P. *Morphological variation of Parnassius mnemosyne (Linnaeus) in eastern Fennoscandia (Lepidoptera: Papilionidae).* Entomologica Scandinavica 1991; 22: 353-363.

Välimäki P, Itämies J. *Migration of the clouded apollo butterfly Parnassius mnemosyne in a network of suitable habitats - effects of patch characteristics.* Ecography 2003; 26: 679-691.

Verovnik R, Glogovcan P. *Morphological and molecular evidence of a possible hybrid zone of Leptidea sinapis and L. reali (Lepidoptera: Pieridae).* European Journal of Entomology 2007; 104: 667-674.

Vila R, Lukhtanov VA, Talavera G, Gil F, Pierce NE. *How common are dot-like distributions? Taxonomical oversplitting in western European Agrodiaetus (Lepidoptera: Lycaenidae) revealed by chromosomal and molecular markers.* Biological Journal of the Linnean Society 2010; 101(1): 130-154.

Vlasanek P, Konvicka M. *Sphragis in Parnassius mnemosyne (Lepidoptera: Papilionidae): male-derived insemination plugs loose efficiency with progress of female flight.* Biologia 2009; 64: 1206-1211.

Wahlberg N. *On the status of the scarce fritillary Euphydryas maturna (Lepidoptera: Nymphalidae) in Finland.* Entomologica Fennica 2001; 12: 244-250.

Wahlberg N, Klemetti T, Hanski I. *Dynamic populations in a dynamic landscape: the metapopulation structure of the marsh fritillary butterfly.* Ecography 2002; 25: 224-232.

Warren MS, Pollard E, Bibby TJ. *Annual and long-term changes in a population of the wood white butterfly Leptidea sinapis.* Journal of Animal Ecology 1986; 55: 707-719.

Warren AD, Ogawa JR, Brower AVZ. *Phylogenetic relationships of subfamilies and circumscription of tribes in the family Hesperiidae (Lepidoptera: Hesperioidea).* Cladistics 2008; 24(5): 642-676.

Wickman P-O, Jansson P. *An estimate of female mate searching costs in the lekking butterfly Coenonympha pamphilus.* Behavioral Ecology and Sociobiology 1997; 40: 321-328.

Wickman P-O. *Territorial defence and mating success in males of the small heath butterfly, Coenonympha pamphilus L. (Lepidoptera: Satyridae).* Animal Behaviour 1985; 33: 1162-1168.

Wiemers M, Gottsberger B. *Discordant patterns of mitochondrial and nuclear differentiation in the Scarce Swallowtail Iphiclides podalirius feisthamelii (Duponchel, 1832) (Lepidoptera: Papilionidae).* Entomologischke Zeitschrift 2010; 120: 111-115.

Windig JJ, Rintamäki PT, Cassel A, Nylin S. *How useful is fluctuating asymmetry in conservation biology: asymmetry in rare and abundant Coenonympha butterflies.* Journal of Insect Conservation 2000; 4: 253-261.

Witek M, Sliwinska EB, Skorka P, Nowicki P, Wantuch M, Vrabec V, Settele J, Woyciechowski M. *Host ant specificity of large blue butterflies Phengaris (Maculinea) (Lepidoptera: Lycaenidae) inhabiting humid grasslands in East-central Europe.* European Journal of Entomology 2008; 105: 871-877.

Wynhoff I. *Lessons from the reintroduction of Maculinea teleius and M. nausithous in the Netherlands.* Journal of Insect Conservation 1998; 2: 47-57.

INDEX OF ENGLISH NAMES